Oleg Cassini The pleasure of your company
is requested in honor, of RIZZOLI

Imagine, just imagine"

OLEG CASSINI

The Grace Kelly Suite, Hotel Bel Air, California

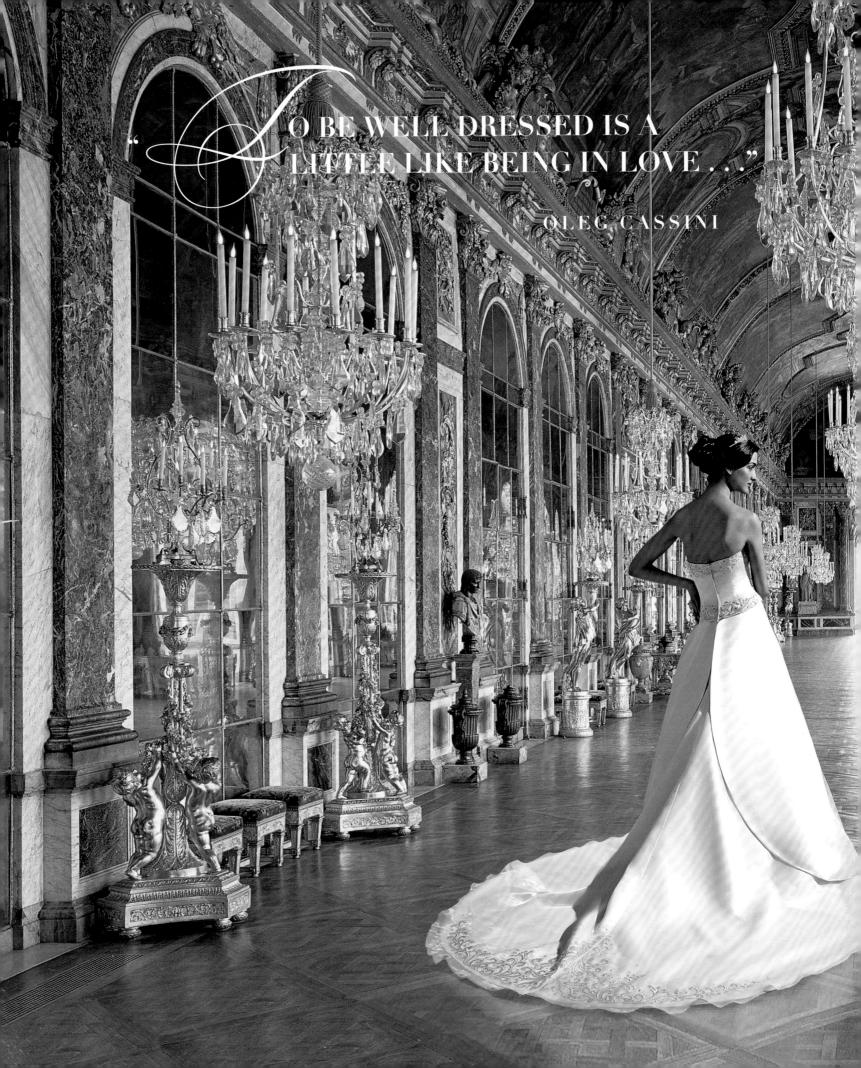

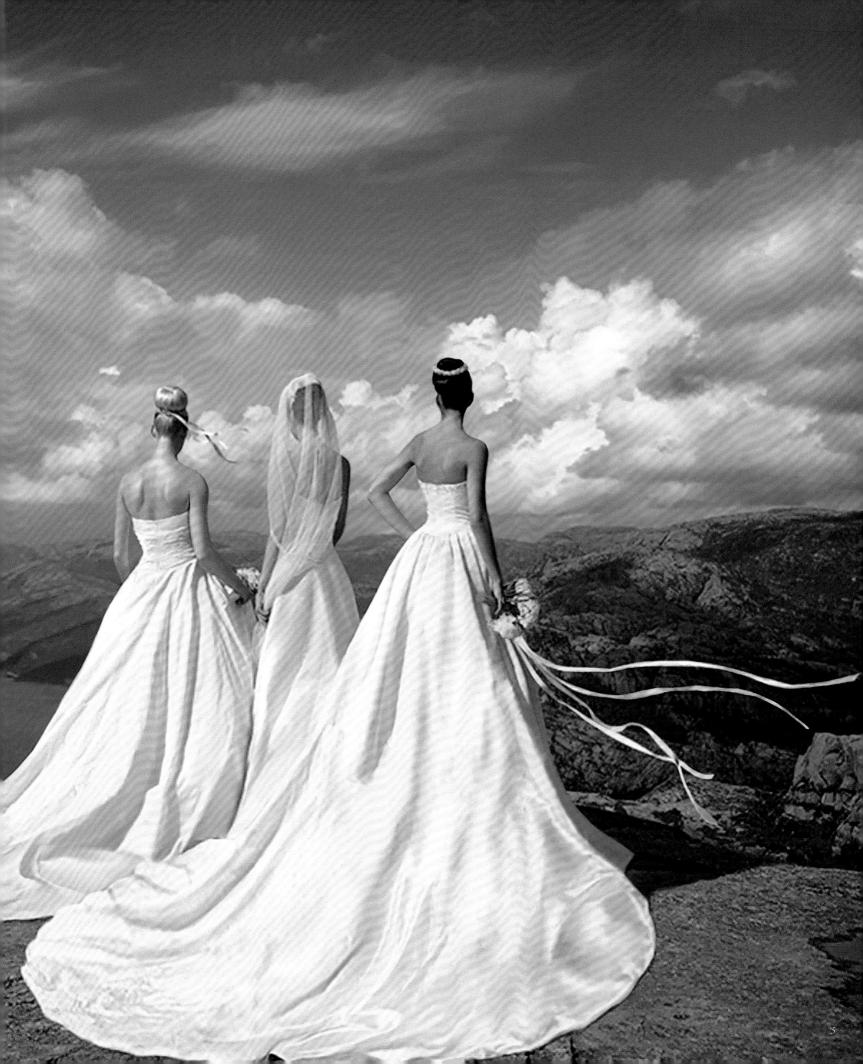

is meant to exude subtlety and femininity, be refined, yet gloriously romantic.

Beautiful shapes, simple lines and rich fabrics create a mood of absolute romanticism for a momentous gathering. Large or intimate, the gathering and the event itself is the most significant moment for the bride, who is the star of the show.

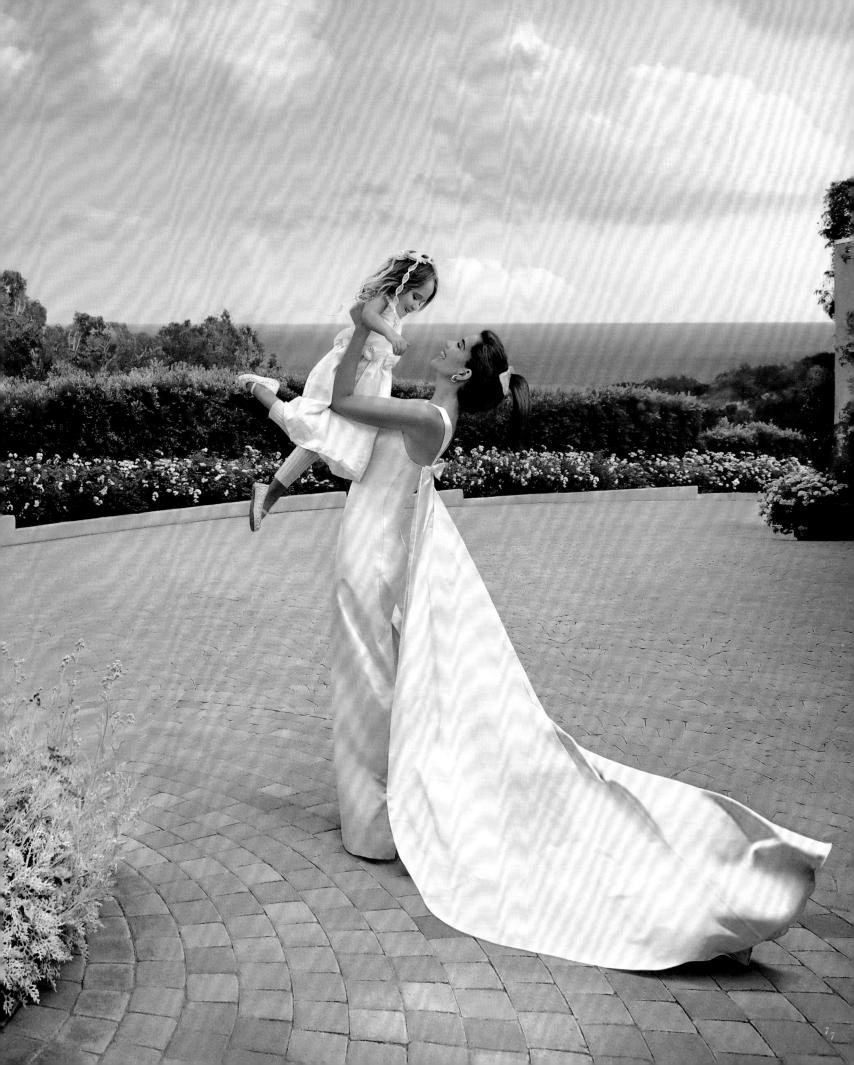

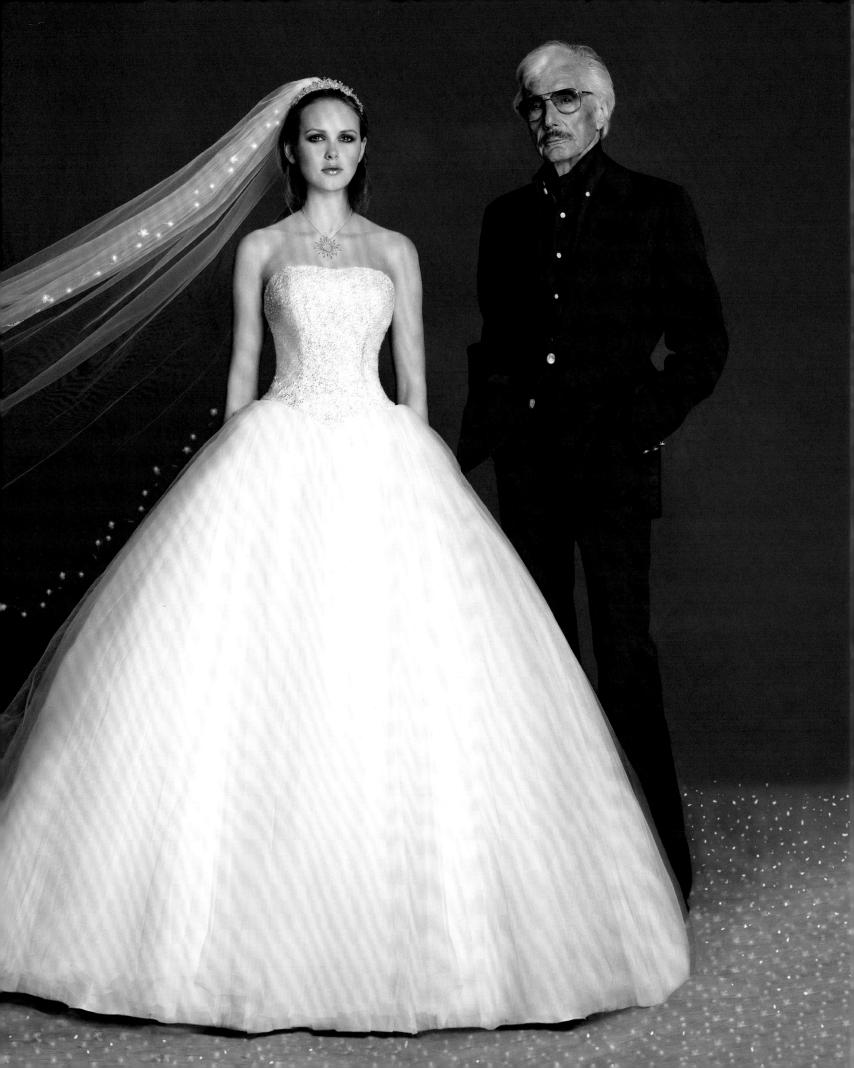

OLEG CASSINI

"Imagine, just Imagine"	1
Foreword	10-11
Decades of Design in the Art of Fashion	14
Elegance Knows Only One Name	14-63
The Royal Weddings	64-91
The Best Weddings in the World	92-115
It's All About the Dress	116-145

"Designing a Wedding Dress for the most memorable moment of her life is perhaps the most special task . . . The idea is to enhance the beauty of the bride."

OLEG CASSINI

The Silhouette

The Traditional White	146–151
"A Whisper of Rose"	152–155
The Art of Embroidery	156–165
The Cape	166–167
The Belle of the Ball	168
The Princess Bride	169–171
The A-Line	172–174
The Camelot	175
The Asymmetrical	176–177
The Grecian	178–181
The One Shoulder	182–185
The Empire	186-191
The Halter	192–201
The Daring Backless	202–203
The Illusion Lace	204–207
The Romantic Ruffle	208–221
The Ribbons & Bows	224–231

The Hemline

The Tea Length	256-261
The Hi-Lo	262–263
The Short & Flirty	264–269

The Neckline

The Strapless	270–271
The Sweetheart	272–275
The Notch	276–277
The Classic Cuff	278–281
The Off the Shoulder	282
The Portrait	283
The Tee	284–285
The Bride Wore Jeans	286–287
Tailored to Suit	288–291

The Bold & The Beautiful

The Colorful & Fun	306–313
Love is in the Hair - The Veil & Tiara	314-315
The Wedding Party	316-317
This is the Moment I Have Waited For	319
Credits	320-321

The Dress Is an Envelope for the Body

The Mermaid		234–239
The Sheath		240
The Twin Set		241
The Corset		242-245

232-233

The Corset	242-243
The Knot	246-249
The Bustle	251
The Train	252-253
The Pick Up	254-255

"I have dressed some of the most significant women of the centuries."

OLEG CASSINI

I see Oleg Cassini in my mind's eye on the dance floor of the glamorous El Morocco doing the Kozachok, a Russian dance where participants kick out their legs while bent down at the knee. An almost impossible feat, but Oleg and his brother Igor were experts at anything athletic or, for that matter, romantic. They were Russian Counts, born in Paris, emigrating to the U.S. serving in World War II, and earning their success. Like many White Russians driven from their native land, they had a great heritage to live up to.

My friend, Oleg Cassini was making bridal gowns for the fashionable women of the world—film stars, ladies headed for the Social Register: the crème de la crème of beautiful brides on the Riviera, in Paris and Beverly Hills and elsewhere.

I always thought, Oleg has a certain extra sense about dressing women, and to be frank, I think it may have been because he was also expert on undressing many of the beauties of our time. This, in his spare time.

A lot of men think everything to do with bridal gowns is silly, just women's business. But because Oleg was thrown into dressmaking for survival, he turned his hand to it all in a unique way. He never forgot the woman who would wear the dress. If he had to make her beautiful for just one day, her wedding day, he preferred to give her a classic touch for life.

But he has always been a hero to me; any man in black tie who can dance athletically while crouched on the floor or leap over a flaming sword with a champagne glass in hand is the man for me.

leg's belief is that life should be celebrated every day. After skiing the black diamonds for hours on end with the Kennedys, he could entertain them with stories as he whipped up dinner for forty, laughter was always in order. Known for his Intercontinental style, Oleg liked to say, "To be well dressed is a little like being in love." He arrived in the U.S. with a tennis racquet, a title, and a dinner jacket and made the most of all three. "I am a great believer in luck," he once said. He never eased up on the charm.

Oleg was at one point engaged to Grace Kelly who eventually sailed off to Monaco (wearing an Oleg Cassini dress) to marry Prince Rainier. She kept a telegram Cassini had sent her that read, "Imagine, just imagine." Romance and elegance were not lost on Oleg. As the American designer tapped to dress First Lady Jacqueline Kennedy, Oleg elevated American style at a time when his European counterparts ruled the fashion world. Many of his designs for her were variations of a T-shirt, one-shoulder styles or strapless silhouettes. Interestingly, the 'Jackie Look' is one of the most influential looks for today's wedding dresses. When a photographer praised one of his gown's intricate embroidery, Oleg replied, "The idea is to enhance the beauty of the bride."

Senator Edward M. Kennedy said, "Oleg is a true original, with an eye for beauty, a love of life and an infectious laughter that enriches all our lives." Although he lived in France, Russia, Denmark and Switzerland before the age of nine, as an adult he took great pride in being an American and the achievements he accomplished in the U.S. A tireless competitor, Oleg remarked, "In this materialistic world we live in, surviving is an important thing. That's what Americans love—the winners."

ROSEMARY FEITELBERG Women's Wear Daily

leg Cassini is the rarest of rare species: a man who genuinely loves women. And for all his talk, it is he who had served them for most of his years. He has devoted his life to making women look and feel beautiful with his classically designed clothes most famously creating "The Look" for Jacqueline Kennedy when she was the First Lady. As the first designer to license in 1951, he has been creating everything from evening dresses to sunglasses in more than 60 countries ever since. His name has always suggested glamour—champagne, polo ponies, a box at the opera, he was married to a movie star, and engaged to Grace Kelly before she became a princess. The son of Russian aristocrats banished to Europe after the revolution . . . he designs clothes that betray a lifelong ache for lost grandeur, there is about him in every gesture from knocking ash from his cigar to straightening his tie an echo of old world distinction.

ALEX WITCHEL The New York Times

In January, 1963 when Jacqueline Kennedy was named America's best-dressed woman for the third year in a row, her official fashion designer, Oleg Cassini, was cited as a symbol of fashion leadership to the average woman everywhere. The First Lady had chosen Cassini shortly after her husband's election to the presidency because the Parisian-born designer was uniquely qualified for the role. Not only could Jacqueline Kennedy converse with Cassini in French, but he was steeped in the history, literature, and art of 18th and 19th century Europe that she adored. When she asked for a dress in "Veronese green" or "Nattier blue," he would instantly understand. He, in turn, could feel comfortable creating what he called "fashion scripts" to evoke "a dramatic version of a look" that projected Jackie's goal of "sophisticated simplicity."

SALLY BEDELL SMITH Author The Kennedy White House

he timeless elegance of Oleg Cassini—the combination of European elegance and New World energy is a rare combination but they have formed a dynamic synthesis in one notable man, Oleg Cassini. Oleg Cassini is the great American success story and the triumph of the cultivated European aristocratic ideal. Surprisingly, the first impresion is one of delightful finesse, humour and genuine good manners of a man of great personal dignity. His great charm is that he likes people, especially beautiful women, and with this advantage, he has been able to create the fashion, the luxury, the ideas to enhance women everywhere.

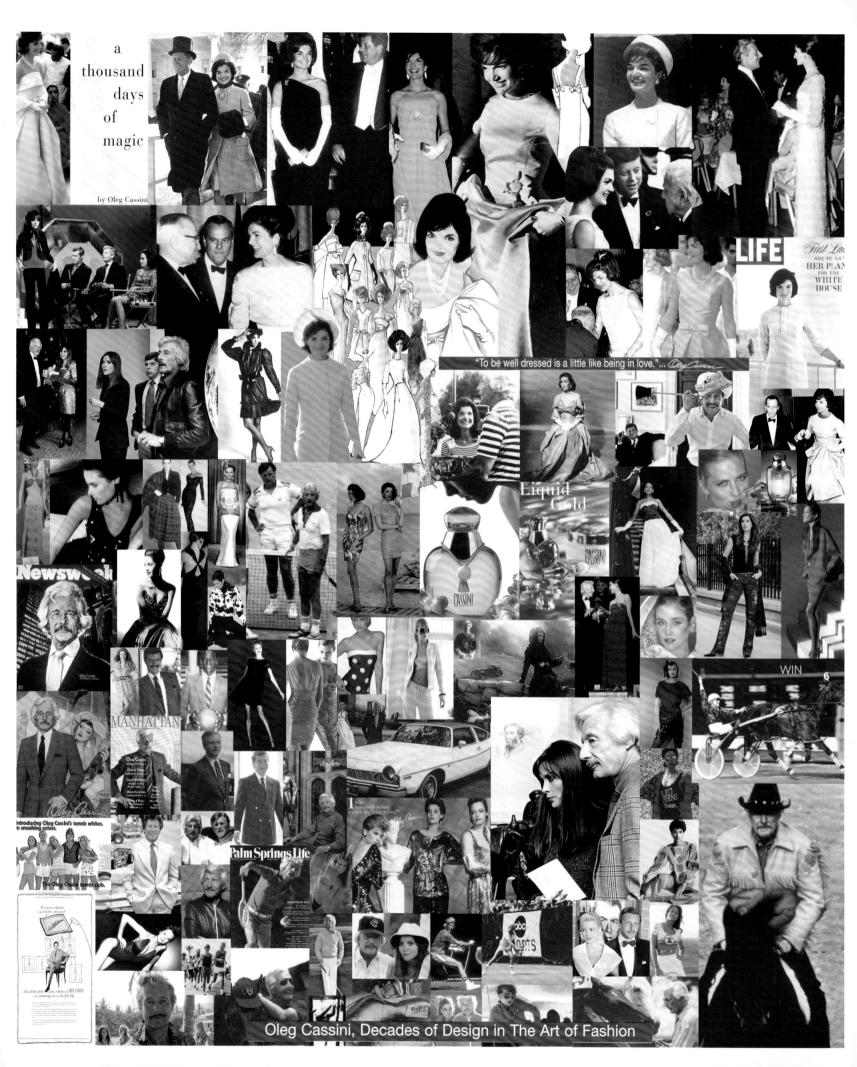

leg Cassini, a taste setter, a trend setter, and an icon of style, is known for creating some of the most memorable moments in fashion history, from Hollywood to the White House, to being named the 'King of Bridal,' the number one best selling designer name in bridal today.

Born in Paris to Count and Countess Cassini, Oleg's family ancestry dated back to the First Crusade. Oleg Cassini's grandfather was the influential Imperial Russian Ambassador to Peking, as well as Washington, under Presidents Theodore Roosevelt and William McKinley. Oleg wanted to be a soldier or diplomat, however, due to the collapse of the Russian Empire, the family moved to Florence, where Oleg studied art with the famous painter Giorgio de Chirico and after apprenticed

with Patou in Paris. Always intrigued by movies, Oleg went to Hollywood where he married a movie star and created magic for countless others. He arrived with a tennis racquet, tuxedo, a title and talent and turned it all into an empire. In Hollywood, as a ranked tennis player, Oleg won a doubles tournament. His partner was the head of Paramount Pictures. Oleg was looking for a job and Paramount a designer, so it was serendipity. His first film was I Wanted Wings starring Veronica Lake. Oleg designed for most of the major studios. The list of stars he dressed and undressed is impressive. After serving in the U.S. Cavalry during World War II, with Ronald Reagan, First Lieutenant Cassini returned to New York to open his own fashion business. He went on to become the Secretary of Style to the White House and America's most famous First Lady, Jacqueline Kennedy. His reputation developed as a result of his genius for original spontaneous design. He created the look for his fiancée, Grace Kelly, and is known as a prominent figure in fashion, Hollywood, and international society, designing for the legendary beauties of the 20th and 21st century. With great style and joie de vivre, Oleg Cassini epitomized the American Dream in all its hope and glory, and did so always with style and timeless elegance. An important influence in men's fashion, Oleg broke traditions with innovations impossible to be ignored. Revitalizing men's fashion by bringing color to shirts that had only been white, Oleg was the first celebrity designer, becoming as well known as his famous clients. He dressed film stars, business leaders, TV stars and sports personalities including Johnny Carson, Burt Reynolds, Regis Philbin, Ted Turner, and Michael Jordan. 'The Jackie Look' by Oleg Cassini resonated worldwide, and is credited with being the single most important influence in today's bridal wear.

Edith Head, a significant designer in Hollywood, said that, "The Jackie Look is the single biggest fashion influence in history." Oleg's trendsetting looks for Jackie, including the empire strapless, have had a major impact on wedding dress silhouettes. His strapless look is the predominant choice of today's bride.

LEFT The CFDA Board of Governors Excellence Award for Decades of Design in the Art of Fashion to Oleg Cassini.

RIGHT The group shot of the bridal gown collection, featuring a variety of styles including embroidered jeans and tee shirts.

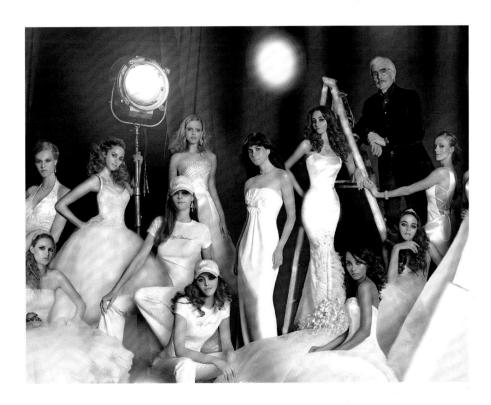

"Oleg, you are, and will be in fashion history, the designer who created the indelible and stylish image for the First Lady. You should be proud of your achievement, you are the designer who inaugurated her style."

SUZY MENKES

International *Vogue* Editor Condé Nast International

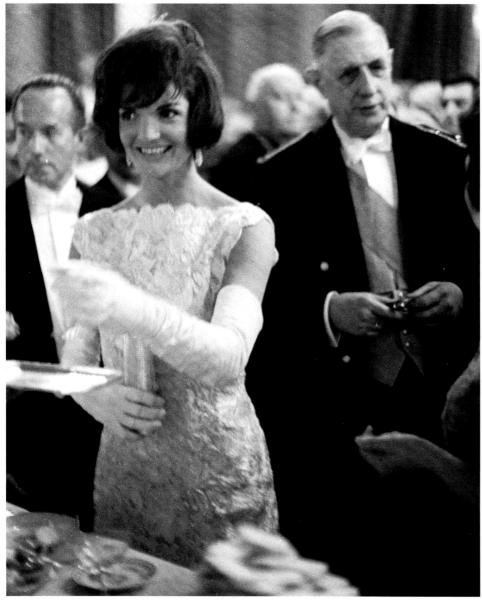

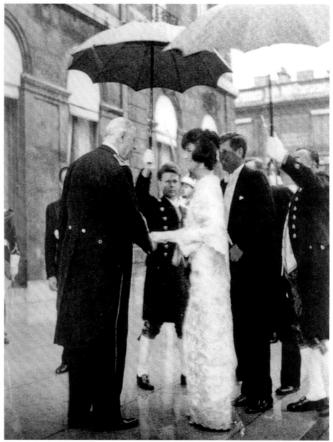

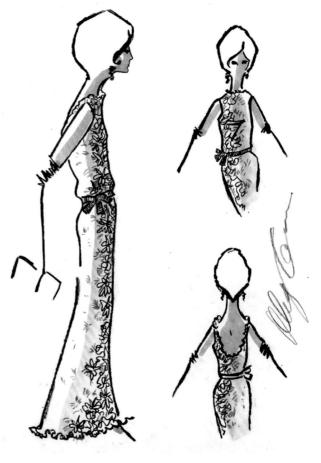

Jacqueline Kennedy & French President Charles de Gaulle at the Elysée Palace reception, Paris, France, May 31, 1961. President de Gaulle famously stated, "She knows more about France than most French women." He was effusive in his comments about, "the gracious and charmante Jacqueline."

Sketch of the pink straw lace gown worn at the reception. The back of the gown was dramatic, the scalloped effect of the simple bateau neckline in front set off both Jackie's neck and profile. A matching stole completed the outfit.

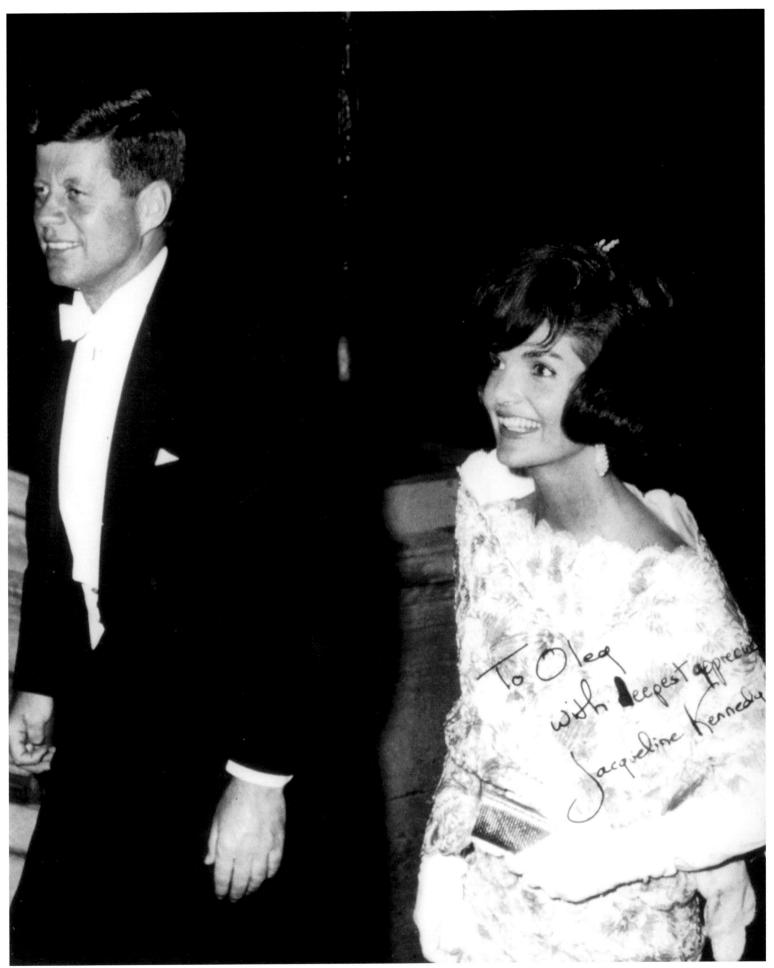

President John F. Kennedy and First Lady Jacqueline Kennedy arrive at the Elysée Palace.

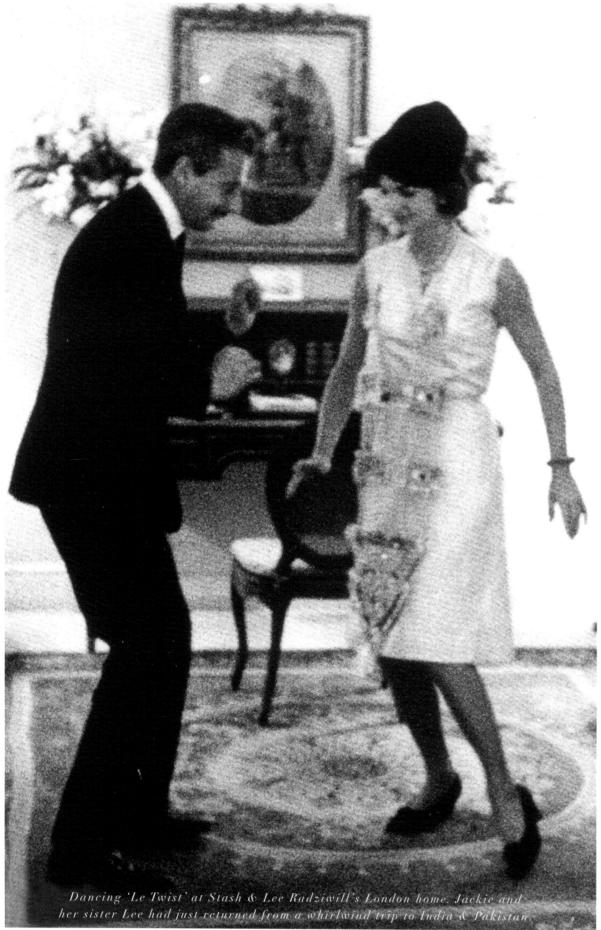

"My only addiction is the habit of winning."

OLEG CASSINI

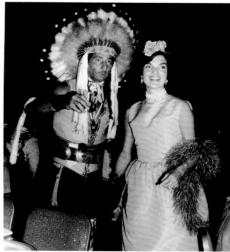

Jackie and Oleg at his charity ball for the benefit of Native Americans.

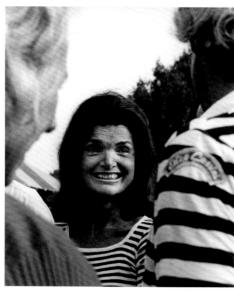

Ethel and Jackie congratulate Oleg.

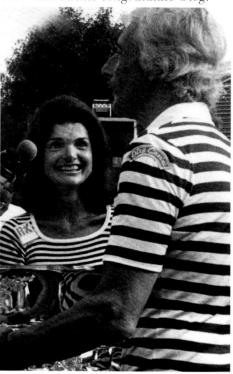

Oleg receiving the winners trophy from Jackie at the RFK Tennis Tournament hosted by Robert Kennedy's wife Ethel.

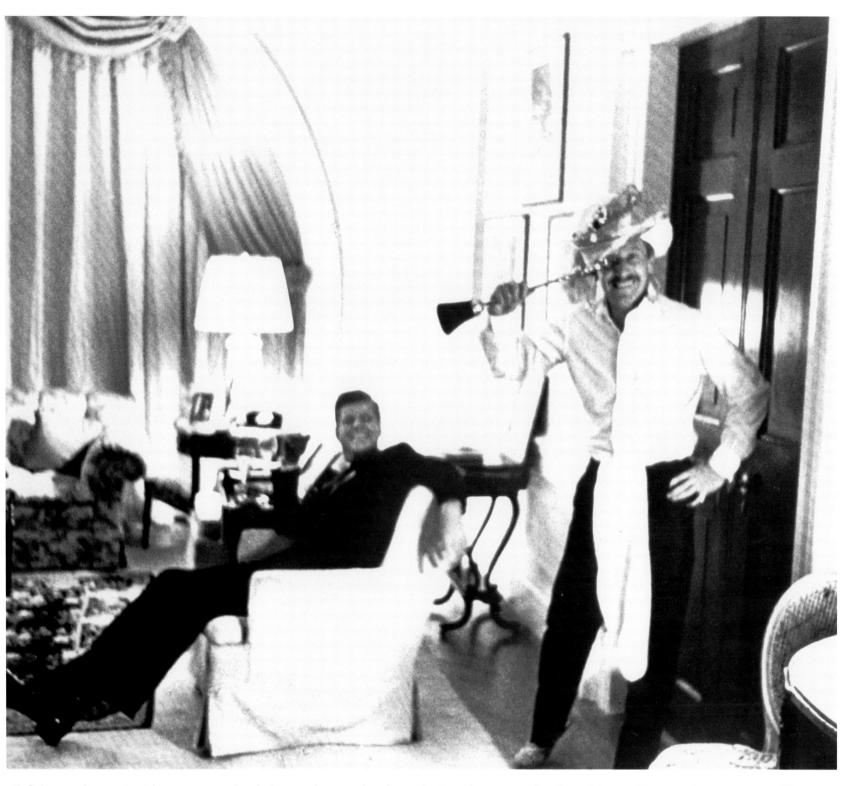

"Oleg Cassini's remarkable talent helped Jackie and the New Frontier get off to a magnificent start. This historic collaboration gave us memorable changes in fashion, and style classics that remain timeless to this day. Oleg's innovation and creativity have earned him worldwide recognition and admiration. His great warmth, twinkling humor; and enduring loyalty have earned him the respect and friendship of all the members of the Kennedy family."

EDWARD M. (TED) KENNEDY

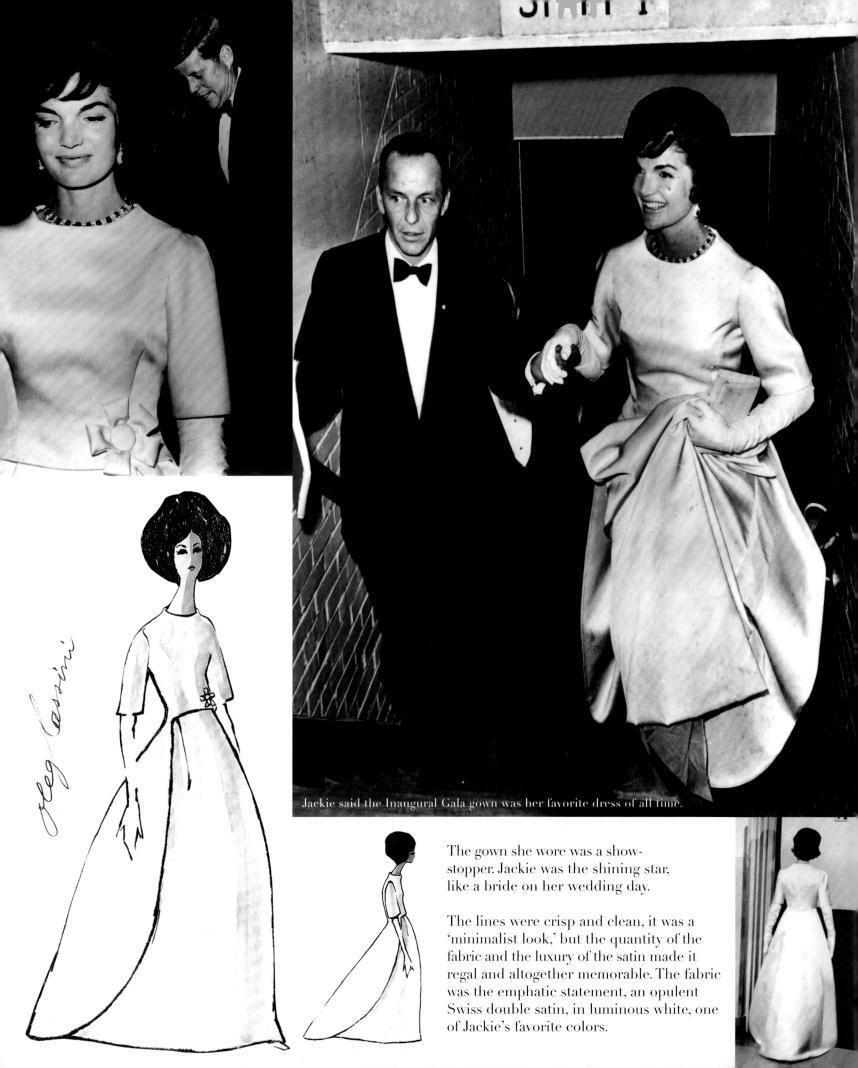

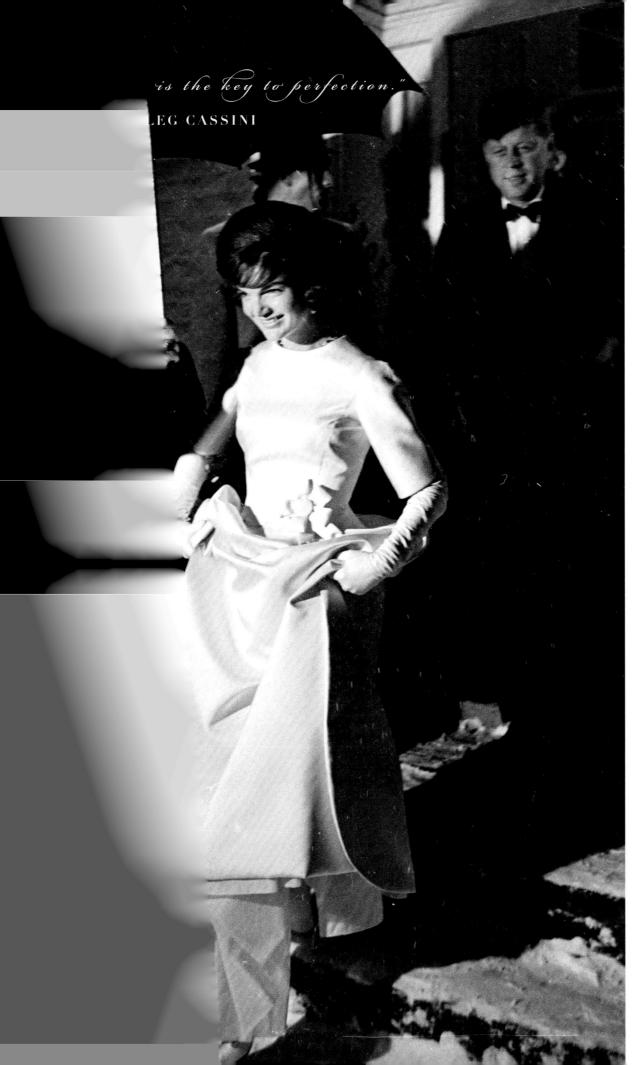

The Inaugural Gala Gown

On January 19, 1961, the Inaugural Gala was the first official event of the new Kennedy administration, the night before the swearing-in ceremony.

It was a star-studded evening; a black tie affair organized by Peter Lawford and Frank Sinatra who sang, "That Old Jack Magic," a parody of Frank's hit song, "That Old Black Magic." It would be Jackie's first major appearance as the glamorous new First Lady Elect.

Jack was very proud of Jackie and how she looked. He asked for the lights in the limousine to be turned on so the crowds could see Jackie enroute to the Gala. The gown was full length, of graphic simplicity, unadorned except for a French 'cocarde' at the waist. It was a tee shirt dress, but, what a tee shirt!

I told Jackie how it would set the tone for the new administration. We talked about history and the message her clothes would send, a simple, youthful, but magisterial elegance, and how she would reinforce the message of her husband's administration through her appearance.

For her, I envisioned a look of exquisite simplicity using the finest materials. I said, "You have an opportunity here for an American Versailles."

I also created gowns for the President's mother, Rose, who ordered a black lace ensemble, and his sisters, Eunice, Pat, Jean and Ted's wife, Joan.

This gown was included in the book, Fifty Dresses That Changed the World by the Design Museum, England.

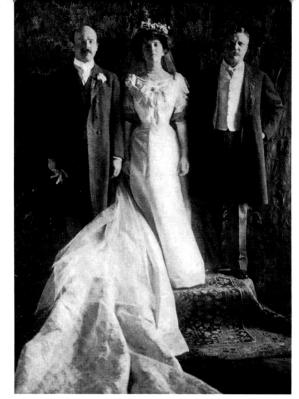

The 1906 White House Wedding of the season, President Teddy Roosevelt with his daughter, Alice at her marriage to Nicholas Longworth, who later became Speaker of the House of Representatives.

Lord Pauncefote, the British Ambassador, hosted a reception at the British Embassy in Washington. Baron von Hengelmuller, the Austro Hungarian Ambassador, is speaking with Countess Marguerite, and Count Arthur Cassini is speaking to Baroness Speck von Stenberg, wife of the German Ambassador.

A Wedding at The White House

On February 17, 1906, President Theodore (Teddy) Roosevelt's daughter, Alice Lee, married Nicholas Longworth, an Ohio Congressman, who later became Speaker of the House in 1931.

In 1961 Alice Roosevelt Longworth assisted Jacqueline Kennedy in restoring the White House which had been done during the time of her father, President Teddy Roosevelt's administration.

Known for her wit, Alice had an embroidered pillow stitched with her famous saying: "If you can't say something nice, then sit by me."

My maternal grandfather Arthur Paul Nicholas, Marquis de Capizzucchi de Bologna, Count de Cassini, was a famous Russian diplomat, the Czar's minister to China, and then Russian Ambassador to the United States during the administrations of Presidents William McKinley and Theodore Roosevelt. Arthur Cassini signed the Treaty of Portsmouth, ending the Sino-Japanese War and was honored by having both Port Arthur in Asia and Port Arthur, Texas named after him.

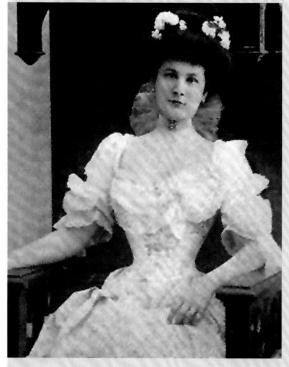

Countess Marguerite Cassini

My mother Countess Marguerite, daughter of the Russian Ambassador to the United States, the official hostess in Washington D.C. at the Russian Embassy was a trendsetter in fashion and society.

She designed her own clothes and had them executed by numerous dedicated seamstresses. Her strategy was to focus on her tiny waist. She introduced many fashion trends including the sash cummerbund look and

tulle bow that became quite the thing in turn of the century Washington D.C. Marguerite enjoyed audacity and was a glorious flirt. Along with her best friends, 'Princess' Alice Roosevelt, and Cissy Patterson (who were known as the 'three graces' by the press), she was one of the first women to smoke cigarettes in public and to win an automobile race from Washington, D.C. to Chevy Chase at breathtaking speeds up to fifteen miles an hour. One of Marguerite's suitors was Franklin Delano Roosevelt the thirty second President of the United States.

Oleg Cassini ivory satin wedding dress and jacket with signature bow.

Dressed in a sailor suit like many other young children in Imperial Russia.

RIGHT

Countess Marguerite, pictured in the painting, became a patron for the great painter Konstantin Egorovich Makovski. He executed a beautiful portrait of her wearing a grand tricorn hat swathed in glamorous tulle, setting a trend for tulle bows. She introduced the talented Makovski to her social and political circle of friends. Mother was also painted by John Singer Sargent, a full length portrait standing in a black dress with white tulle on the shoulders with her hair pulled back.

OVERLEAF

"A Boyar Wedding Feast" by Makovski is one of his most memorable paintings. This large painting depicts one of the most important social and political events of old Russia, a wedding uniting two families of the powerful boyar class that dominated Muscovite politics in the 16th and 17th centuries. The artist has singled out that moment during the wedding feast when the guests toast the bridal couple with the traditional chant of "gor'ko, gor'ko," meaning "bitter, bitter," a reference to the wine, which has supposedly turned bitter. The newlywed couple must kiss to make the wine sweet again. The toast occurs towards the end of the feast when a roasted swan is brought in, the last dish presented before the couple retires. The painting is at the Hillwood Museum, Washington, D.C., the former home of Marjorie Merriweather Post.

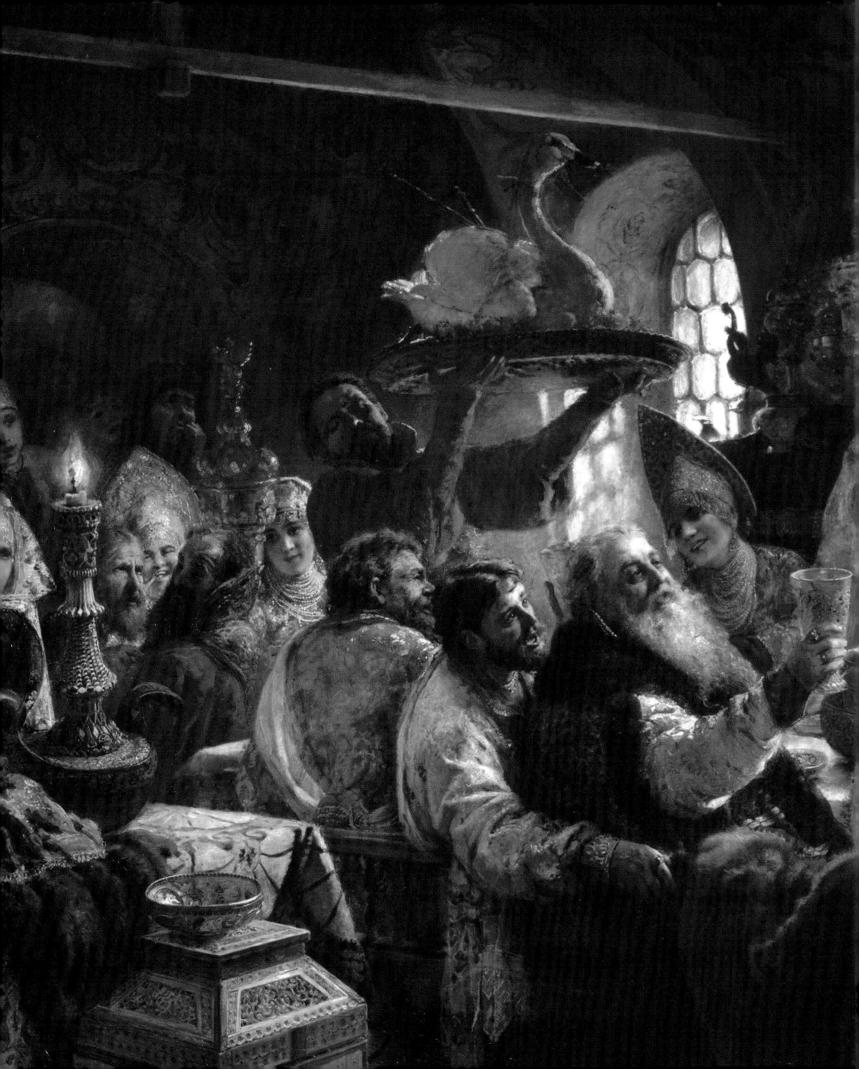

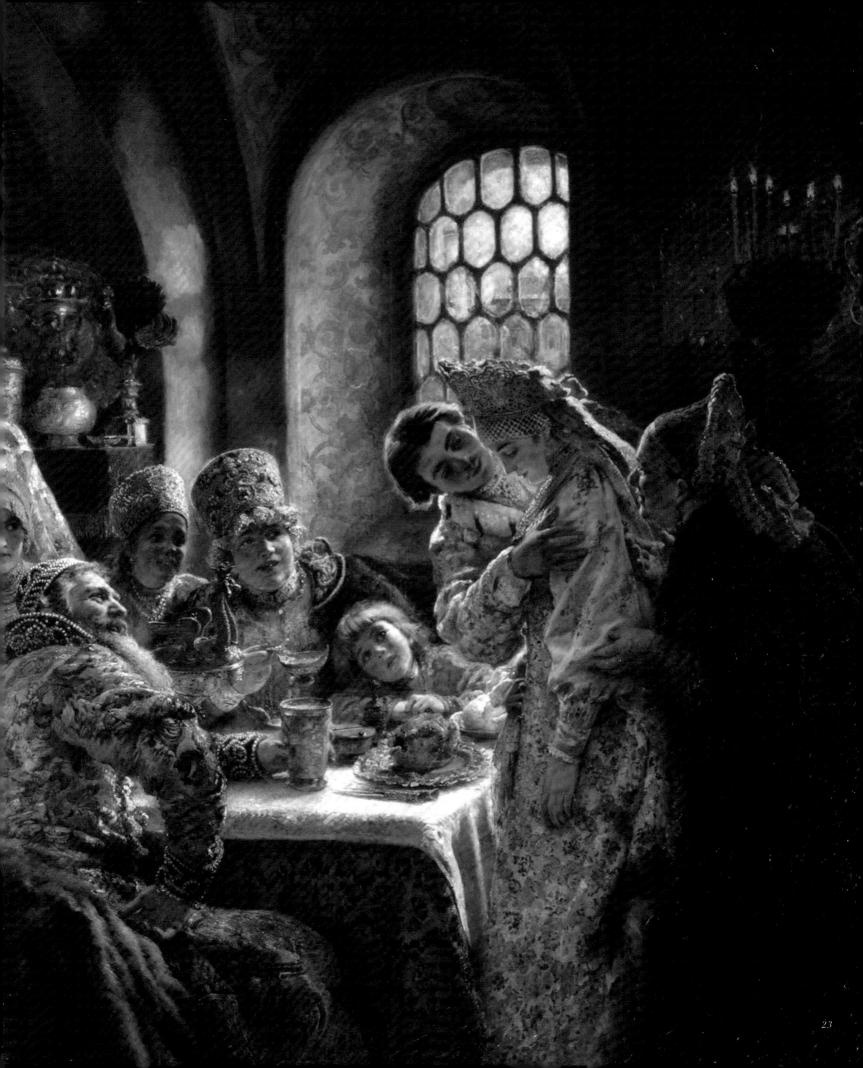

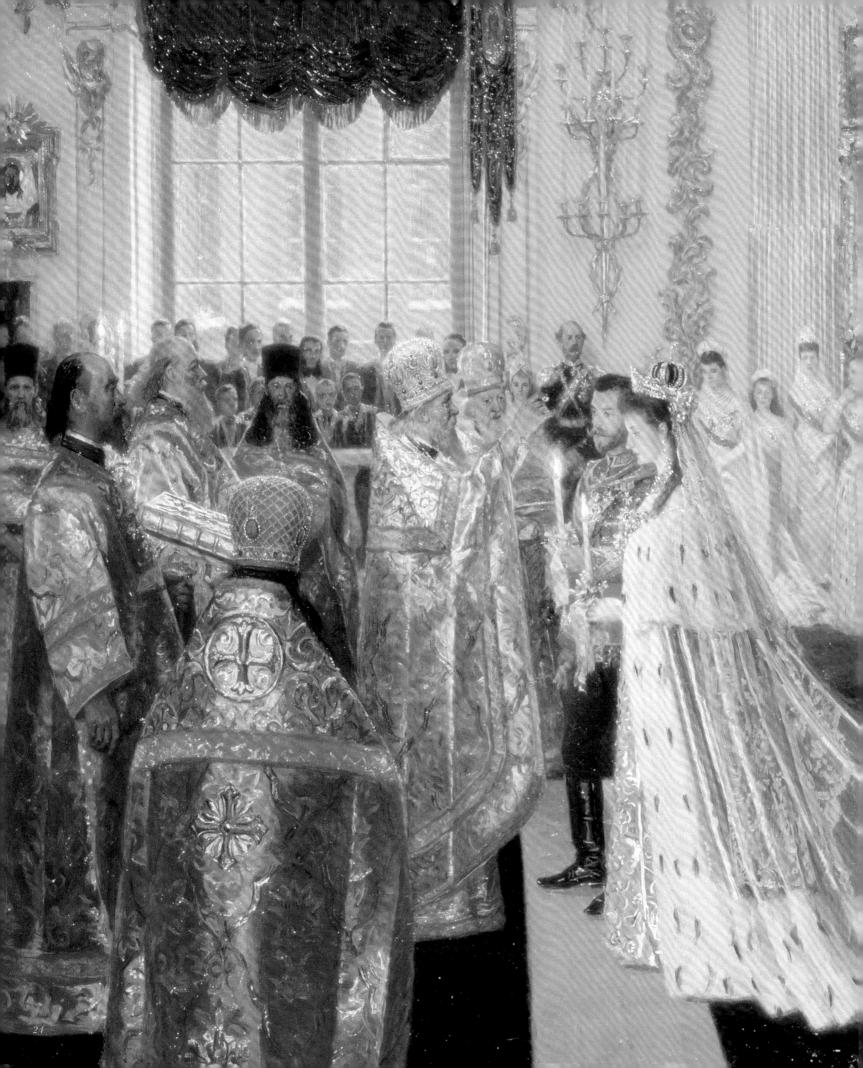

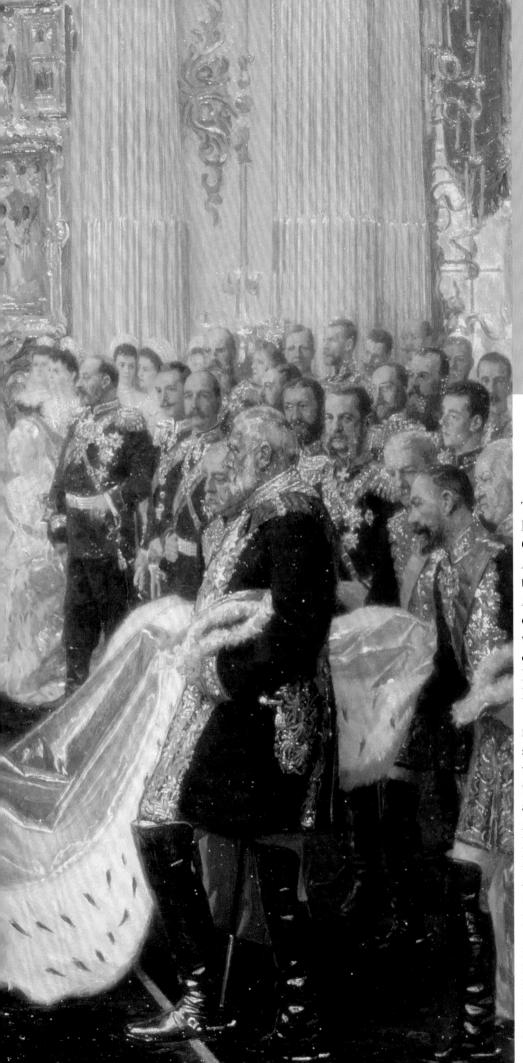

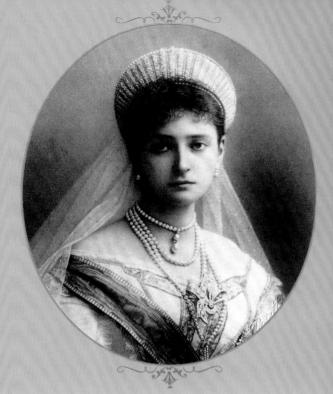

Nicholas & Alexandra

November 26, 1894

The Wedding of his Majesty, Emperor Nicholas II Emperor of Russia, and her Imperial Highness, the Grand Duchess Alexandra Feodorovna, Princess Alix of Hesse, took place in the Great Chapel of the Winter Palace, St. Petersburg, Russia. Princess Alix was dressed for her wedding in the Malachite drawing room of the Winter Palace. Her hair was done in traditional long side curls in front of the famous gold mirror of the Empress Anna Ioannovna, before which every Russian Grand Duchess dressed on her wedding day.

She wore a diamond nuptial crown and magnificent diamonds on her Russian Court Dress of silver 'tissu.' Her long train was lined and edged with ermine and over her shoulders was placed the Imperial Mantle of gold cloth. Princess Alexandra was the granddaughter of Queen Victoria. Among the guests were Alix's brother, the Grand Duke of Hesse, and her uncle, the Prince of Wales, Edward VII, son of Queen Victoria & Prince Albert of England. My Grandfather, Count Arthur Cassini was the diplomatic Ambassador to Emperors of Russia.

LEFT The large painting of the Wedding Ceremony of Emperor Nicholas II & Empress Alexandra Feodorovna by Laurits Regner Tuxen hangs in Buckingham Palace, London. Courtesy of the Royal Collection H.M. Queen Elizabeth II. Reproduced by permission of The State Hermitage Museum, St. Petersburg, Russia.

"The dress is an envelope for the body . . .".
OLEG CASSINI

The Cassini Mermaid Gown is smoothly fitted to the body with embroidered white ivory lace on champagne satin.

The fabulous organza skirt is worked in dramatic layers to the clongated hem.

This dress reflects the iconic red velvet Cassini Mermaid gown, a favorite of Marilyn Monroe, which she wore on numerous occasions.

"We were in Hollywood: a magical place, filled with perfect-looking people."

Inspired by American films, particularly Westerns, I went to Hollywood. Los Angeles was still a small town then; the air was fresh and clean, and smelled of gardenias and orange blossoms, the weather remarkable, the traffic minimal, the flowers lush and fragrant . . . the girls beyond belief. They ambled along Sunset Boulevard as if it were a fashion runway, displaying their wares with a somewhat studied abandon, hoping against hope to be discovered by some errant producer.

This was the era of Lana Turner getting 'noticed' while sitting at the counter at Schwab's Drugstore, and the town was just awash with stunning specimens. They came from all over the country, all over the world. I had expected beautiful girls in Hollywood, but the number, there always seemed to be three for every man, and the sheer beauty was enough to make any red blooded fellow lightheaded. I felt a real sense of accomplishment when I could read in the gossip columns, "Betty Grable and Oleg Cassini tripping the light fantastic at Ciro's" . . . It was music to my ears. She loved to dance, and so did I, Betty was one of the best dancers I've ever met.

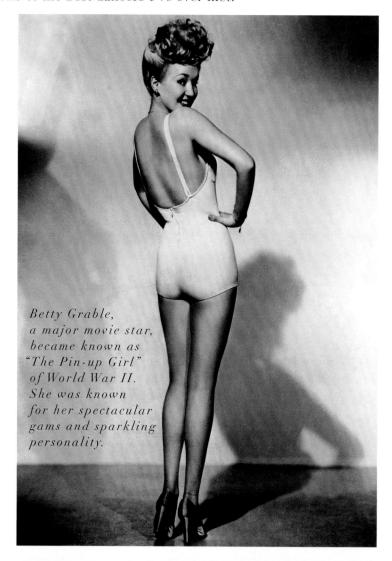

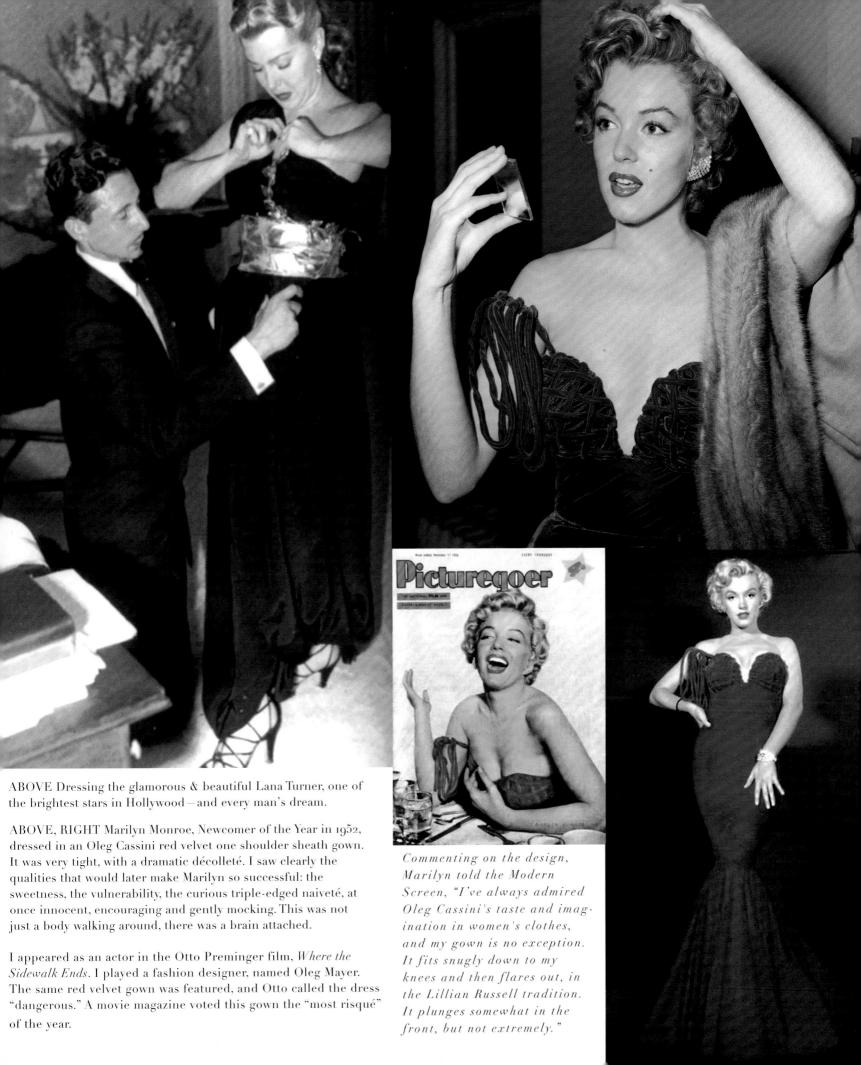

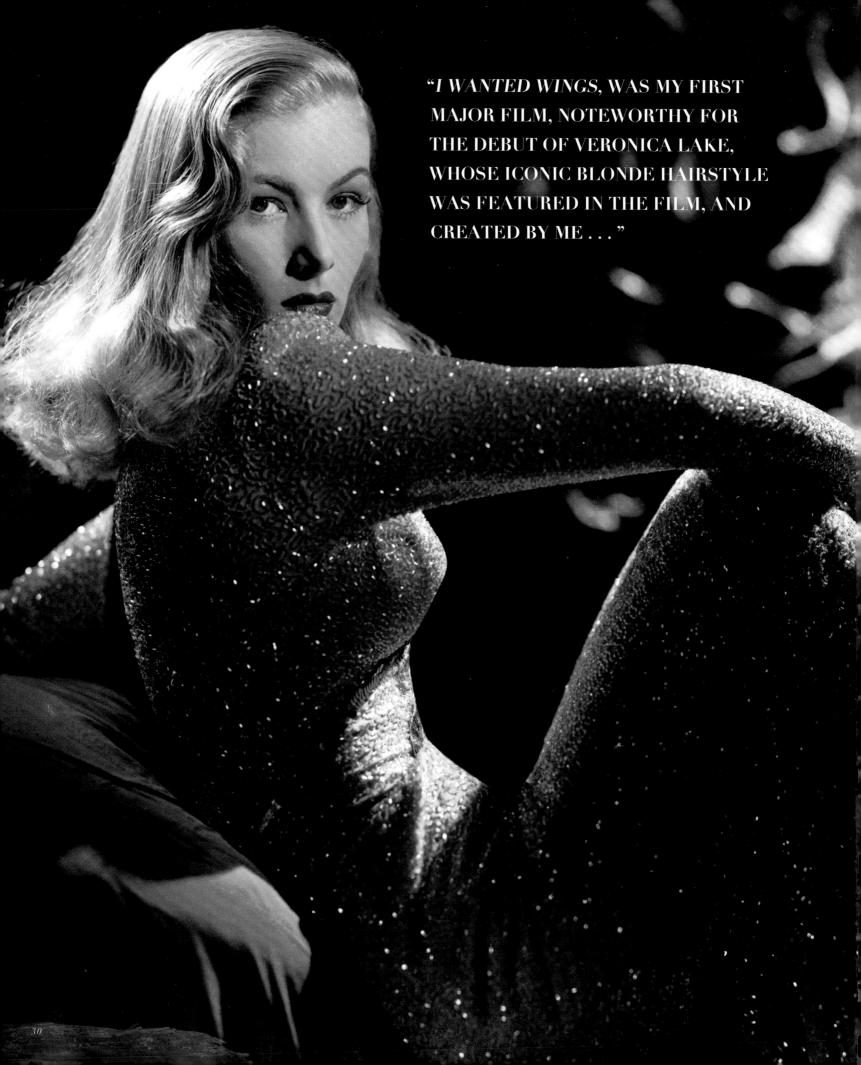

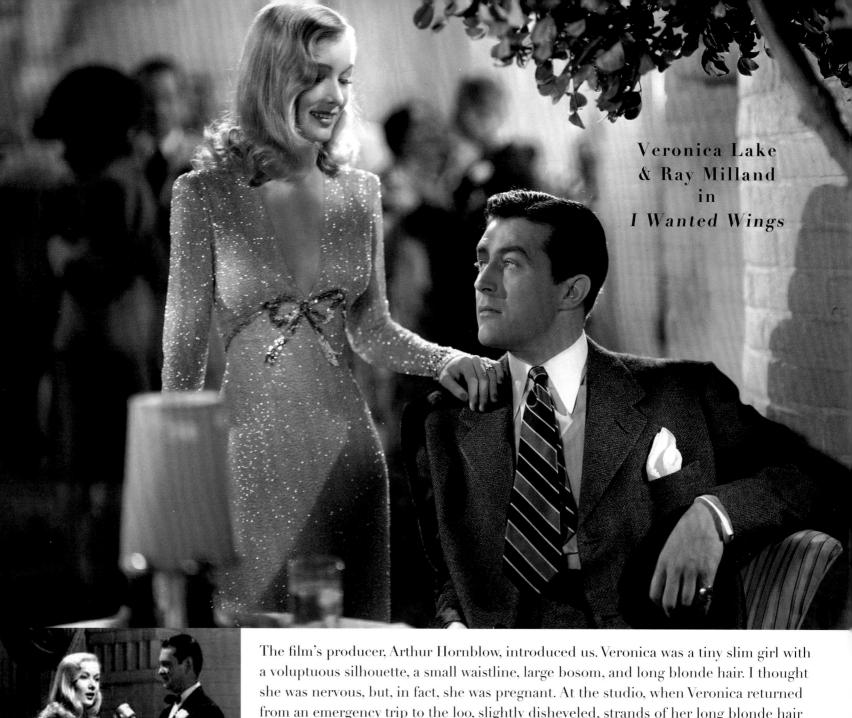

The film's producer, Arthur Hornblow, introduced us. Veronica was a tiny slim girl with a voluptuous silhouette, a small waistline, large bosom, and long blonde hair. I thought she was nervous, but, in fact, she was pregnant. At the studio, when Veronica returned from an emergency trip to the loo, slightly disheveled, strands of her long blonde hair were hanging in front of one eye. I thought it interesting, and it gave her a special allure. I had her wear it long and simple, a 'débutante look,' and dressed her in gowns to emphasize her bustline and narrow waist. Veronica was spectacular in this bugle beaded gown with trompe l'oeil bow. Her blonde peek-a-boo hairstyle created a sensation across the country, making Veronica Lake a star. Her 'look' was repeated in the film, LA Confidential winning an Academy Award for the beautiful Kim Basinger, who I also dressed for the 2006 movie, The Sentinel, starring Kim and Michael Douglas. Trompe l'oeil bows have always been a signature for me. I have used them consistently. It is a special French touch that is always flattering and feminine. I have always believed that the fabric is key to design and I like to use beading, lamé, satin, taffeta and lace, all of which are 'statement making' fabrics.

Veronica was memorable in this narrow gown with a dramatic trompe l'oeil beaded bow which I created for her.

RIGHT Stars I have dressed, Rita Hayworth in pleated lamé, Gina Lollobrigida in taffeta and OC in tweed, Lee Nestor sings in gold lace & Faye Dunaway plays a designer wearing Oleg Cassini bronze and silver lamé in the film, Say It in Russian.

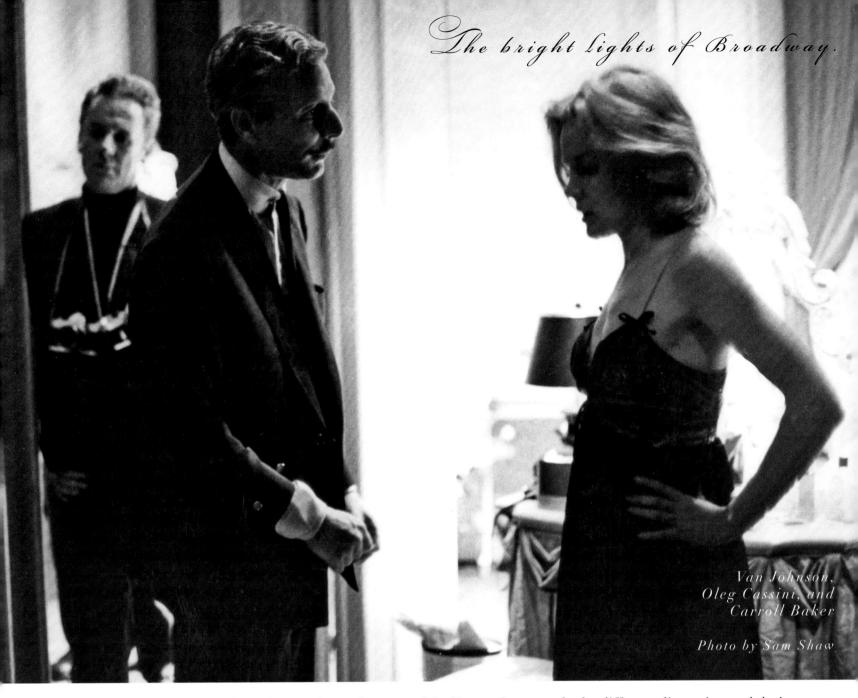

I enjoyed designing for the Broadway theater, the excitement of the live performance had a different dimension and design technique than film. On the Broadway stage set of *Come On Strong* at the Morosco Theatre I am discussing wardrobe with Carroll Baker and Van Johnson. Among other Broadway plays that I designed for were Mike Todd's *As The Girls Go*, Otto Preminger's *Critic's Choice* with Henry Fonda, and *His and Hers*, for Celeste Holm.

The Razor's Edge was a major film of 1946. The film was directed by Edmund Goulding, produced by Darryl Zanuck for 20th Century Fox. The film was adapted from the best selling novel *The Razor's Edge* by Somerset Maugham. It would be my first important film after serving in the U.S. Cavalry during WWII along with a future President, Ronald Reagan. My assignment was to dress the two female leads. I did an innovative wedding dress and took a chance on the dramatic sheath design, but in the end, the gown, like the film, was a great success. Lace from head to toe, a mermaid sheath gown with a long flowing train and a special Renaissance-inspired headpiece. Anne Baxter, who I dressed for her role in the film, won the Academy Award for Best Supporting Actress for *The Razor's Edge*. Anne went on to play the iconic Eve in *All About Eve* and along with Bette Davis was nominated for Best Actress. Marilyn Monroe, also played an unforgettable cameo role in that film. My red and violet draped silk jersey gown looked great on Marilyn.

When *The Razor's Edge* was completed, Darryl Zanuck sent me a note saying that I had done "a superb job." Although the film was set in the 1920s, I wanted the actors' costumes to look modern, timeless and relevant. There was one dress in particular, a slim black gown with fringes, suggesting the flapper style of the 1920s, which was the time period of the film, but appropriate for any era. It was very décolleté, with ribbon straps and a matching cape. I always include a fringe dress in my collections and

they are always well received.

I liked Tyrone Power quite a bit. He was handsome as a god, and enormously charming, in a naive way. Everything came easily for him and he assumed it was the same for the rest of the world. He, Errol Flynn, and Cary Grant were similar in that way. Each had an overwhelming charm that enabled them to live by their own rules.

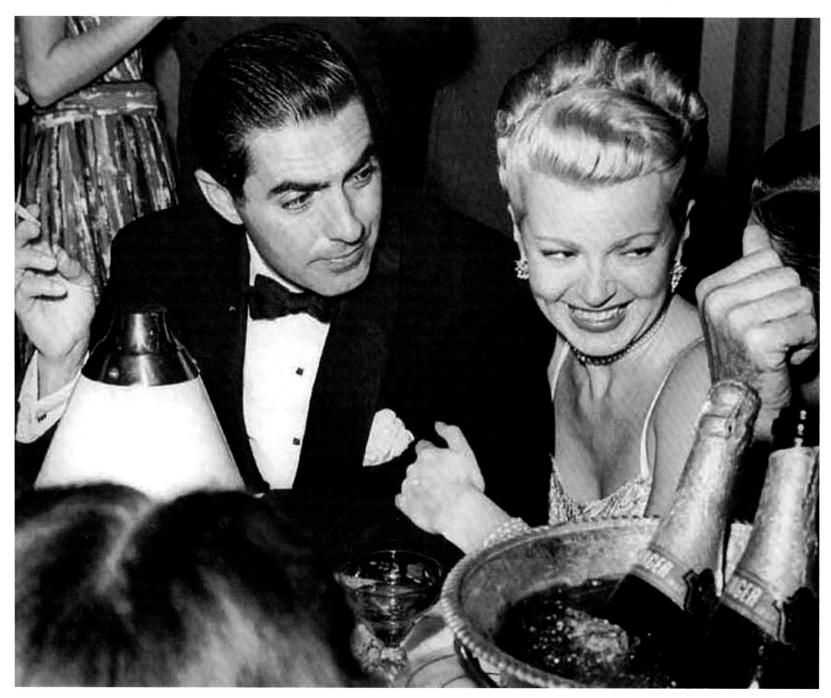

Lana Zurner & Zyrone Power

A stunning combination, the blond beauty of Lana Turner and the dark, classically handsome, matinee idol Tyrone Power. They were the romantic couple of their time. Pursued by photographers, they set the press world on fire. The 'one that got away,' they both went on to marry others.

Lana is quoted as saying, "But more important to me than money was as always the love I longed for and finally I found it, if only for a moment. The man was Tyrone Power. I had always been attracted to him, but I kept my distance because he was married. Then he and his wife Anabella, separated, and one night he invited me over for drinks. What an evening, all we did was talk and listen to music, but for hours on end. We discovered we had similar thoughts and feelings, much the same values and tastes. Before he took me home, he held me in his arms and kissed me, and my heart started beating faster. This was a man I could love."

"I planned on having one husband and seven children, but it turned out the other way round." LANA TURNER

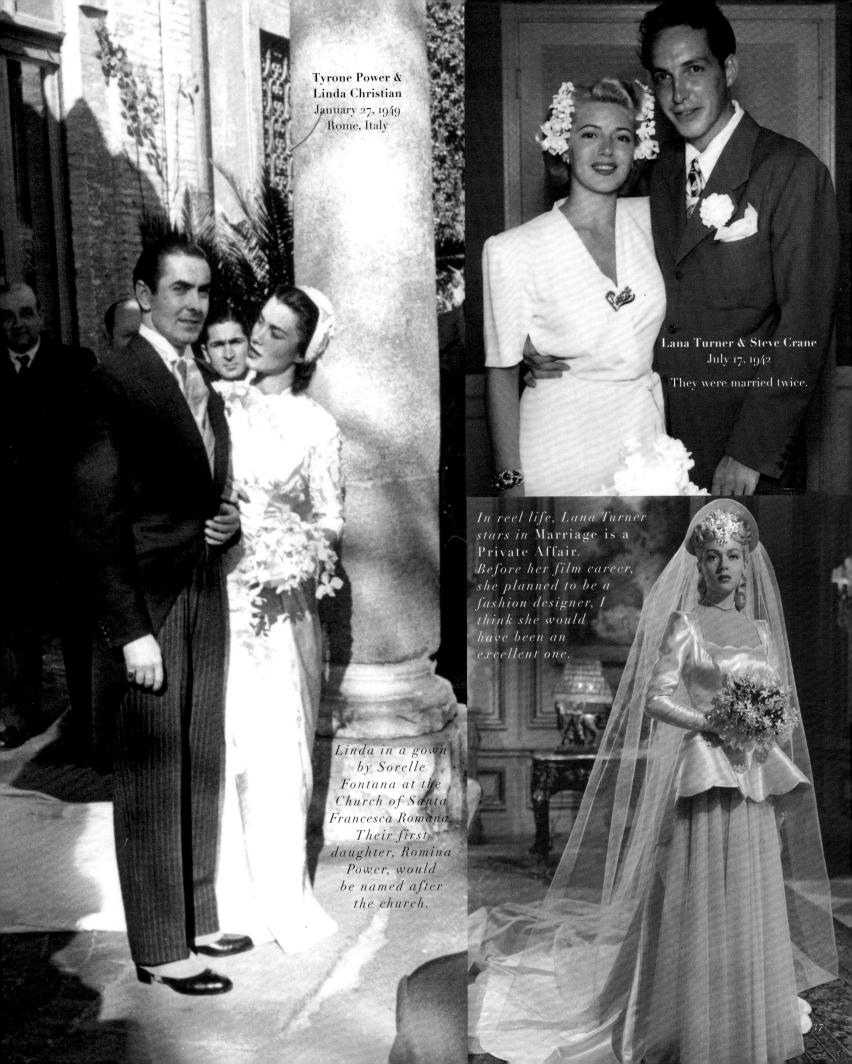

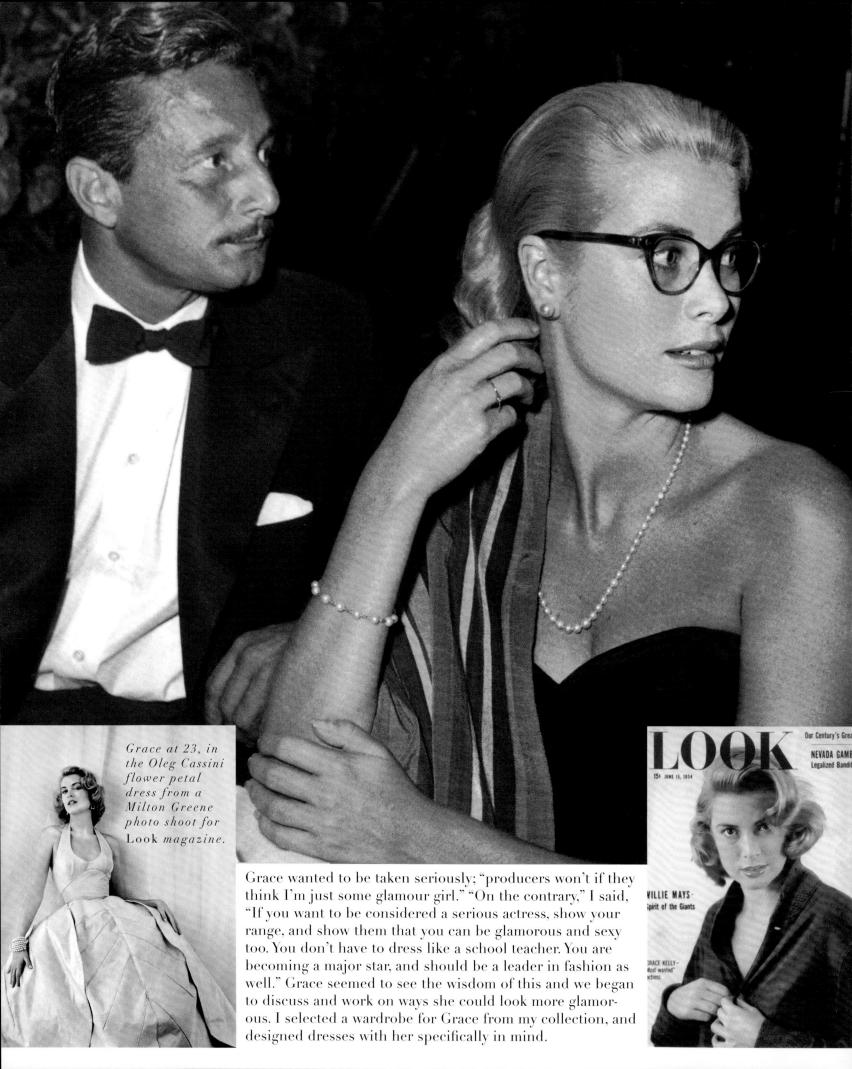

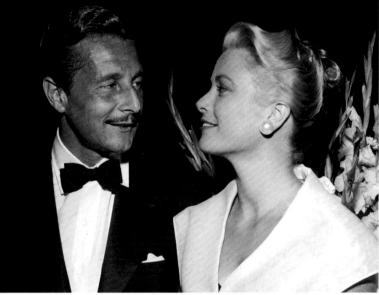

I asked Milton Greene, the famous photographer, "What do you think of her?" He said, "You must design a dress that conveys your sense of her." I thought of her as a pale, delicate English rose: the gown had a simple rounded halter top and a complicated, petal-like skirt. It was made of heavy taffeta, in an almost antique soft pink, carefully selected to compliment her skin tones. Milton photographed her in the dress, and some other informal photos of Grace in my oversized sweaters; which was Grace's favorite attire. Look magazine put Grace on the cover, in the sweater, and the photo of Grace in my pink dress was used inside. Within a matter of months, Dial M for Murder would be released, and she would no longer have to worry about her contract being renewed. She would also make the Best Dressed list for the first time, thanks to her new wardrobe. I created 'The Grace Kelly Look': I put her in subdued, elegant dresses that set off her patrician good looks. I told her that her beauty should be set off like a great diamond, in very simple settings. The focus was always to be on her . . .

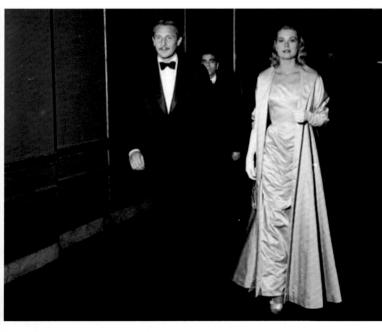

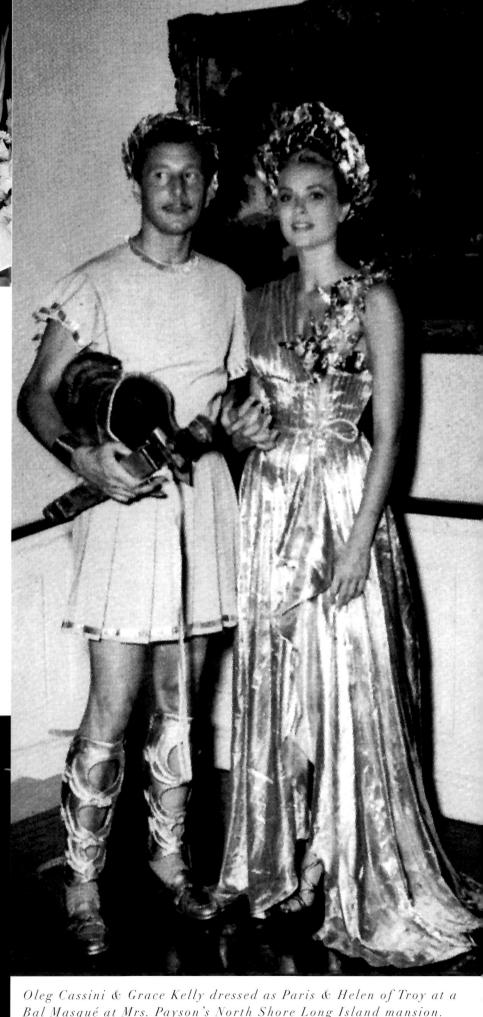

Bal Masqué at Mrs. Payson's North Shore Long Island mansion.

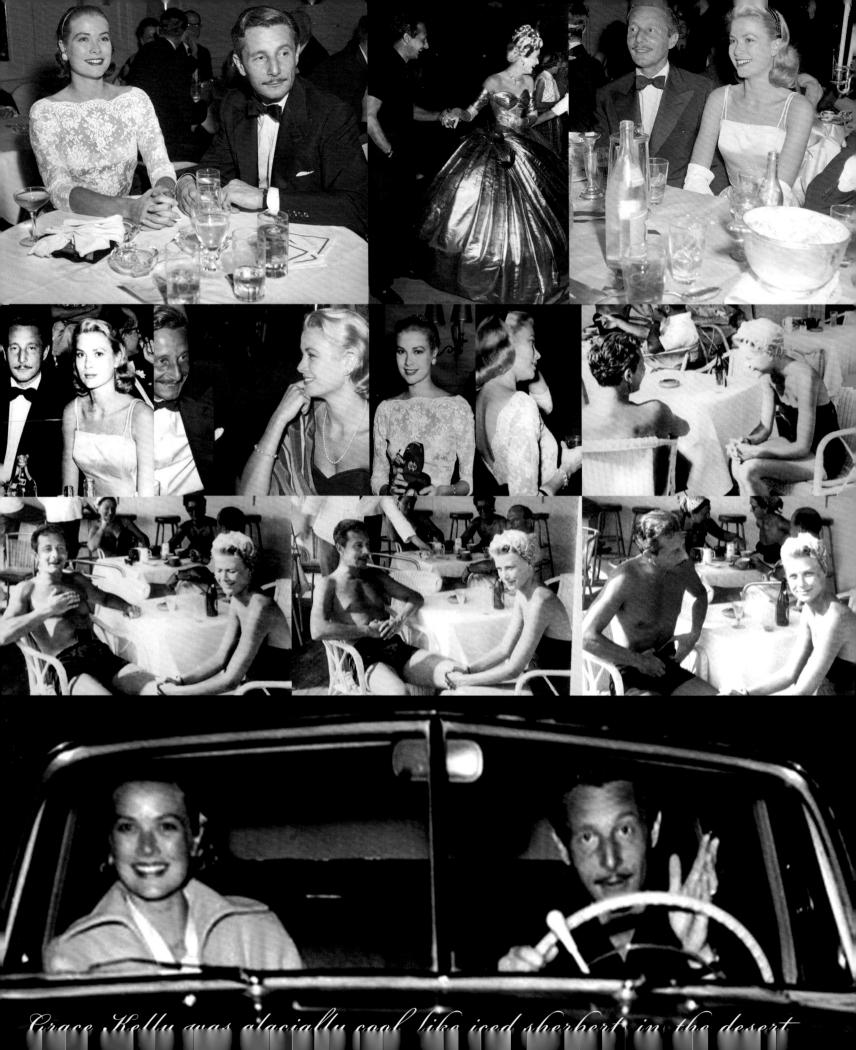

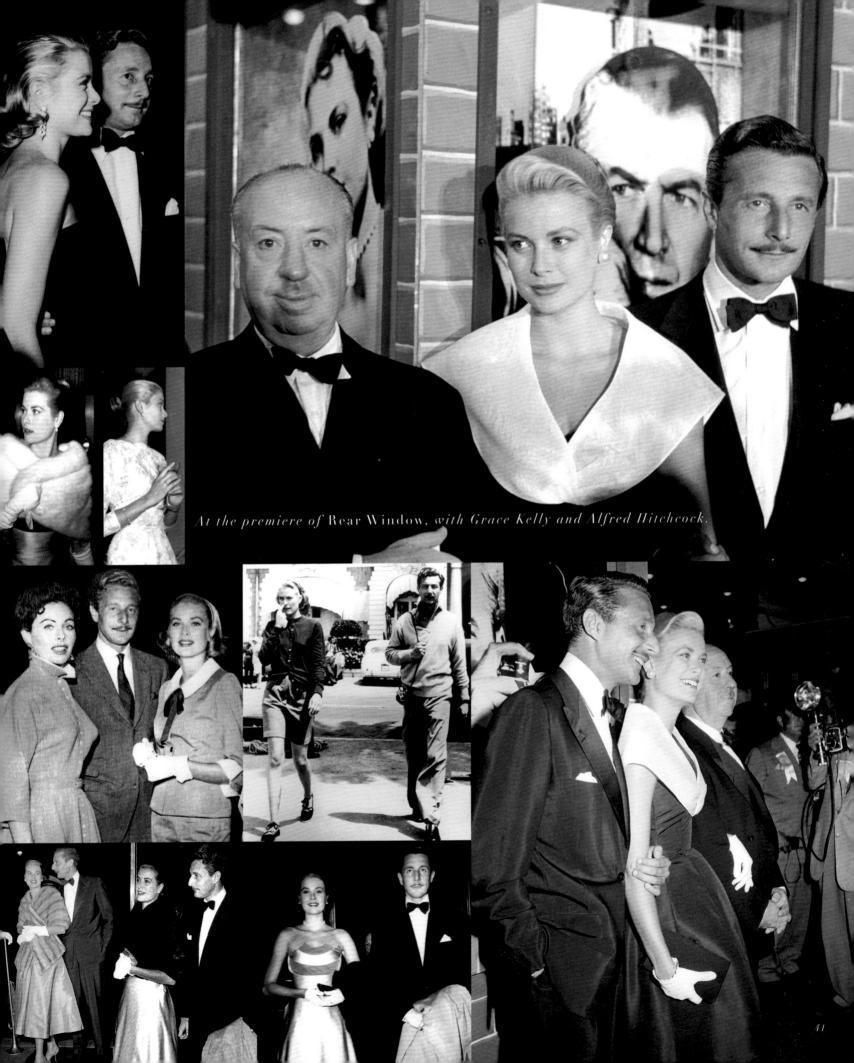

Those who love me shall follow me." GRACE KELLY

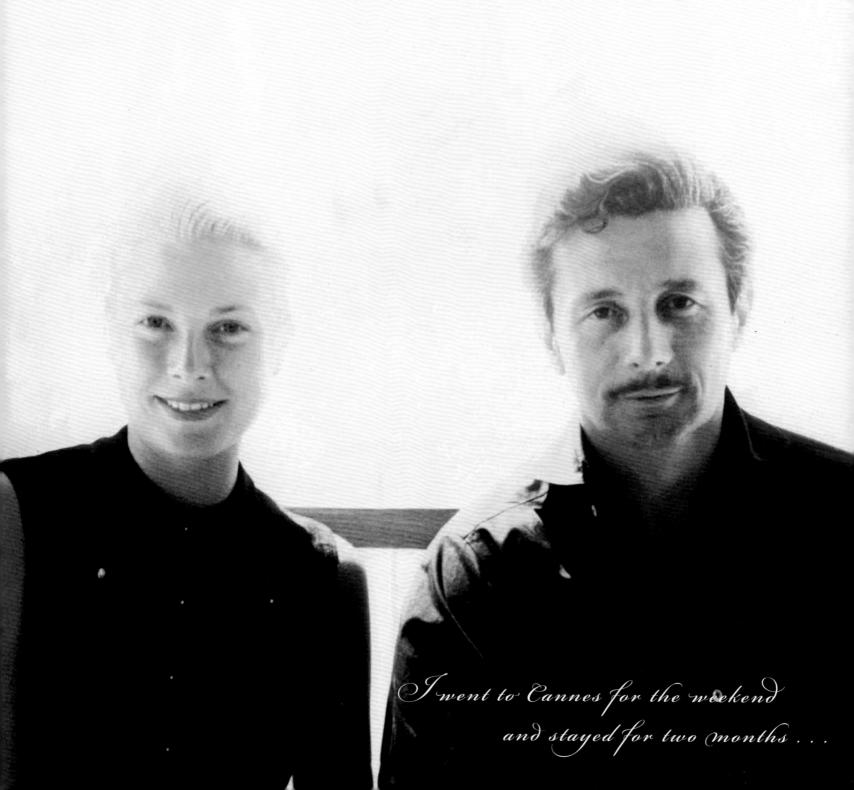

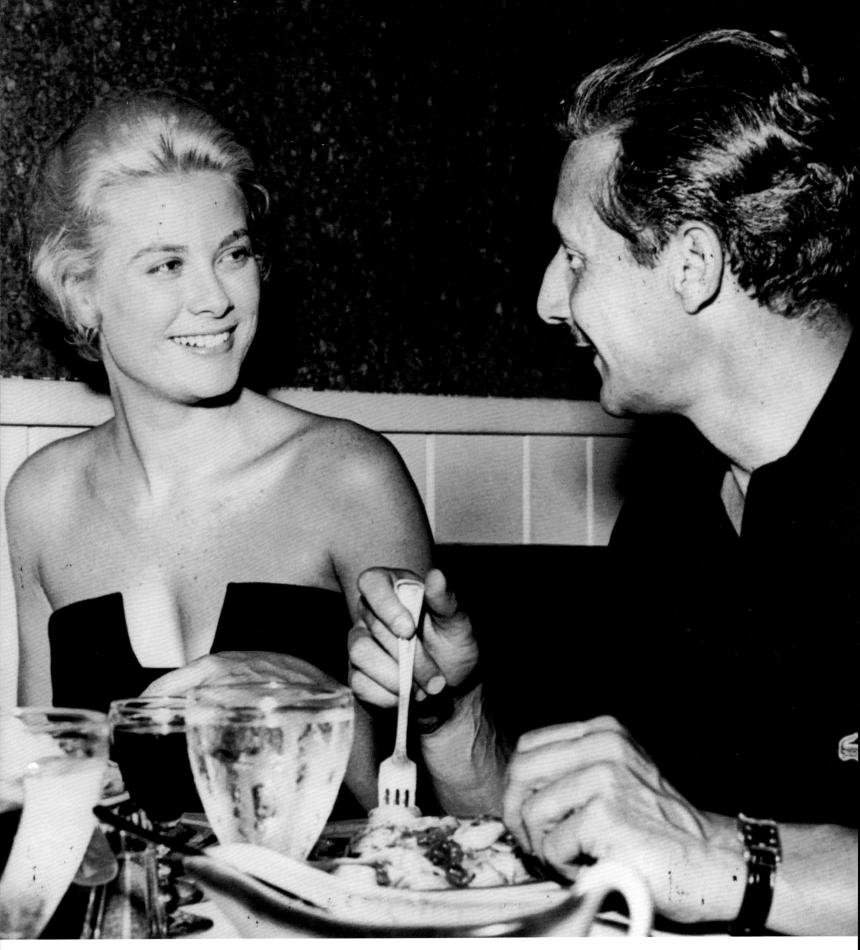

We ordered champagne to celebrate our engagement, it was an altogether magical evening. We danced and gambled a bit, and Grace won. She never gambled much, or out of control, but she always won. She was one of the lucky ones, one of those people to whom everything is given; all too often, in my experience, these are the people from whom the Gods also take everything, in a single blow.

o love your and want to be your wife -

CHARLES 2 4

niday

really easit wait to now that I tenow you - we marry learn so much to 2 want about thus one patience you go slowly results too we must be completely honest - at all beel for the first time approach love + au adult way

Jast november I hit
nock bottern and rever thought of
I could be capable of thinking of
and feeling this way
Thank God - I had my work

28 oci - Tuesday -Jo ti amo exi vojlio shosare O.

CHARLES 24

help me through that period-Thank God for you this last year sux hour taken so much me physically that it will take enling-try to understand and Relp me - I love you Every day and I hope free that way too tune you send to me you couldn't more than you did Their upset me Breause shall never WE growing and dweloping minds and souls and will tring us closer love you and want your well

"When I was working on these pictures, she and Oleg Cassini were in love. Oleg dropped in on the shooting session, I said, 'Oh Oleg, please find something romantic for Grace.' He went to the wardrobe and came out with the gauzy organza that perfectly framed the Madonna-like pose Grace struck so naturally."

ABOVE Personal letters and notes between Grace and Oleg.

OPPOSITE Grace Kelly in a photo by the glamorous Jean, a superb hostess and wife of agent and producer, Charles K. Feldman, was a talented photographer, who covered the private world of Hollywood. Photo: J. Howard / Vogue ©Condé Nast Publications

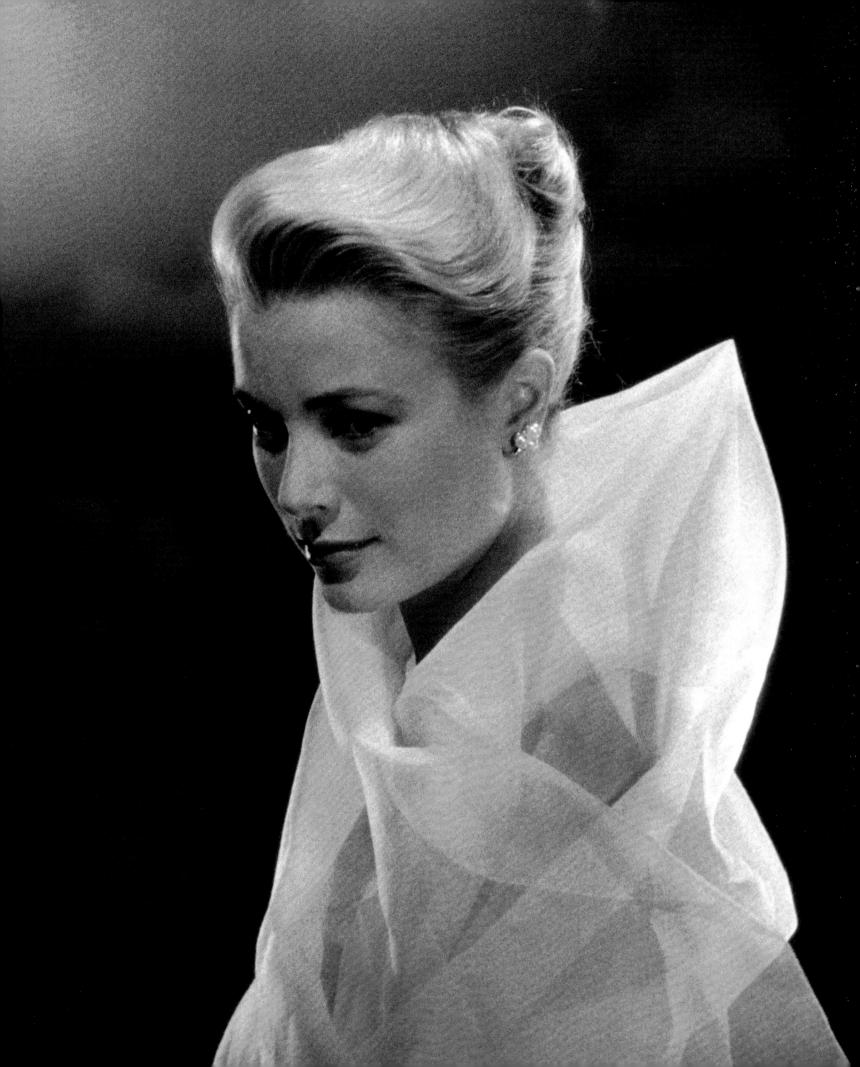

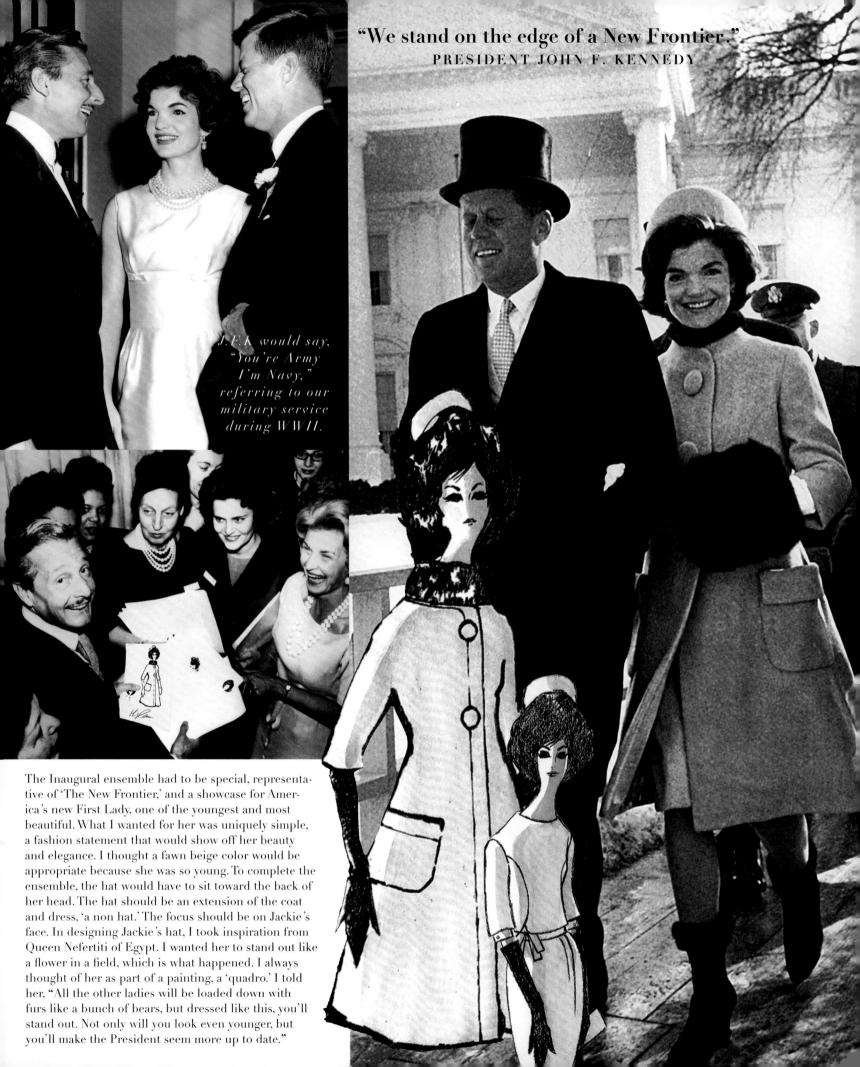

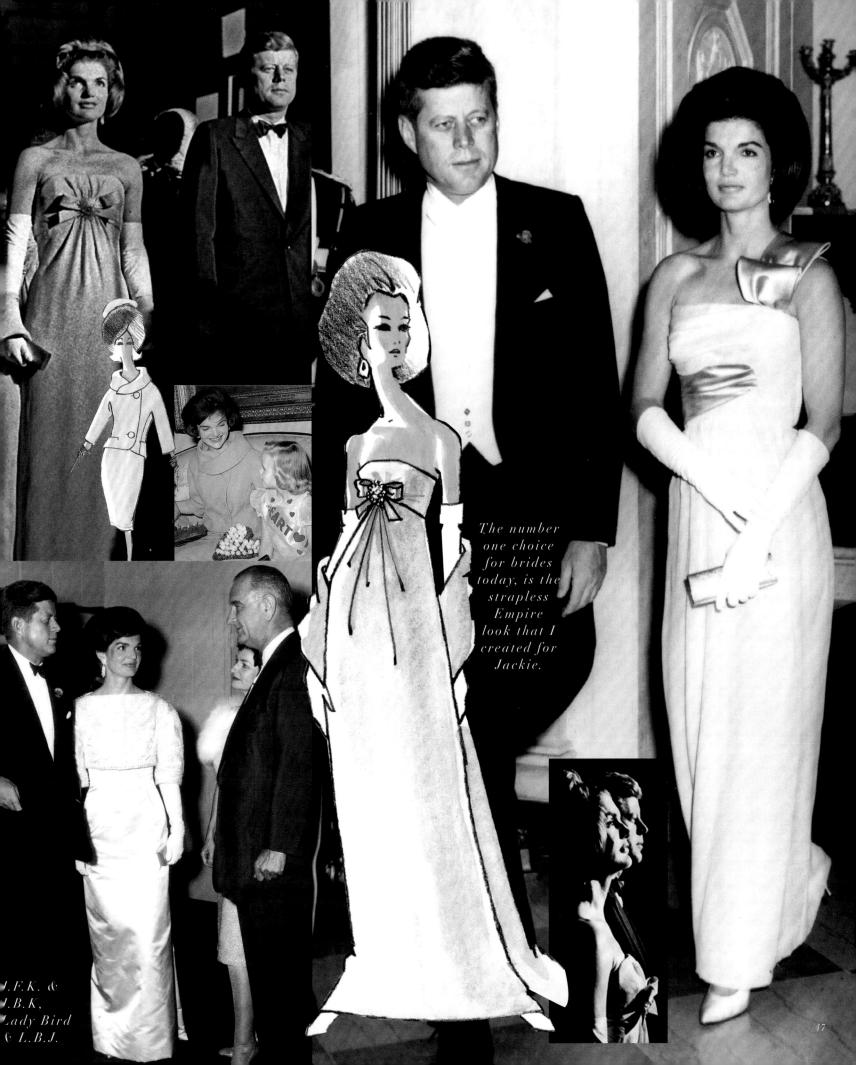

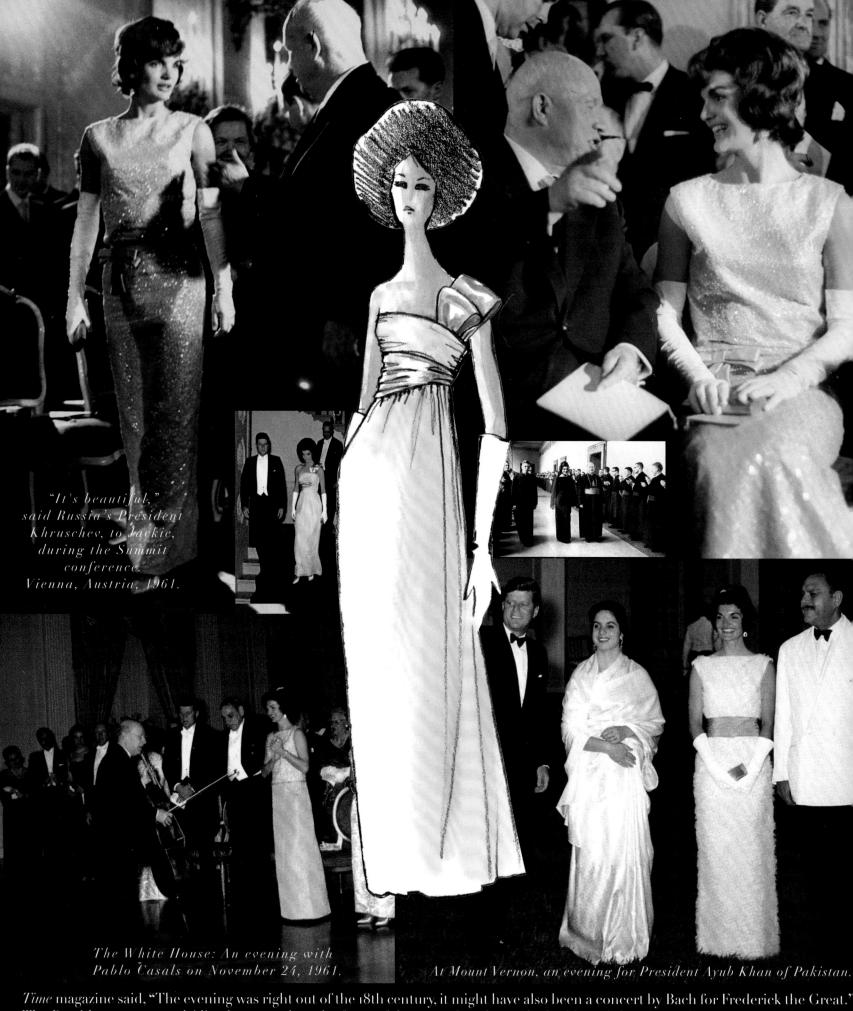

The President summaned Alice Langwarth to the front of the room for a how. She had heard the great cellist, 57 years before, when

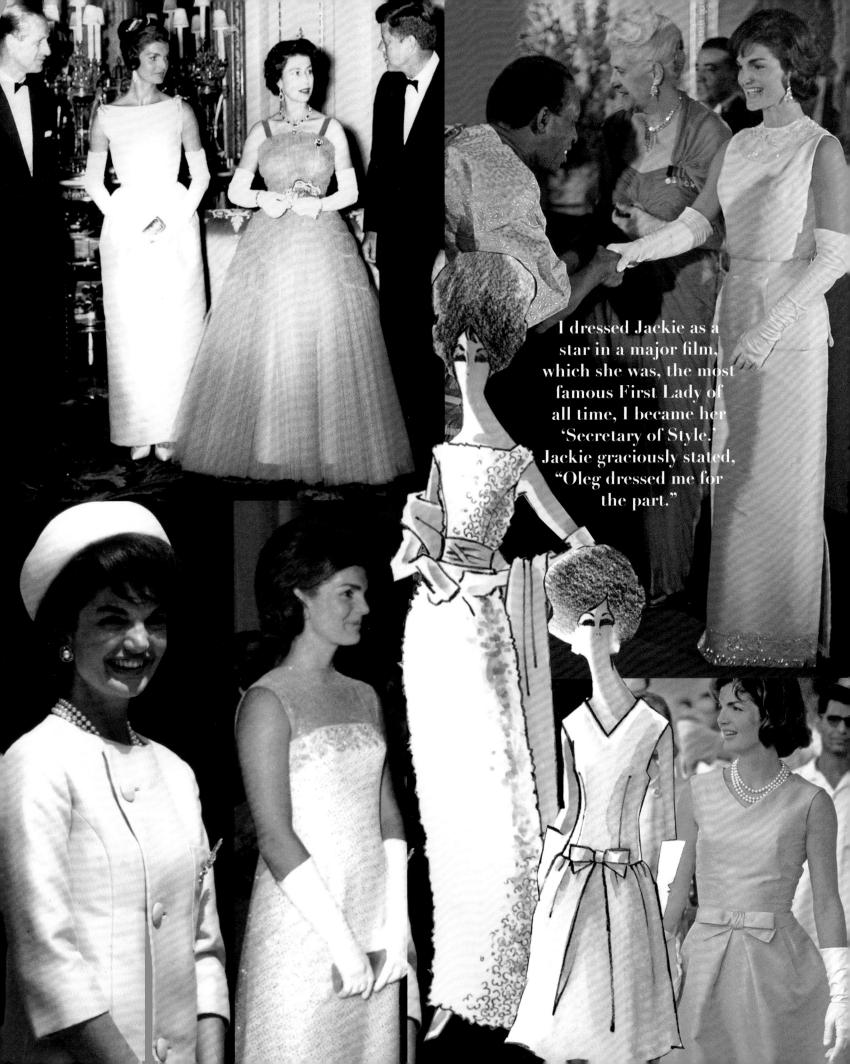

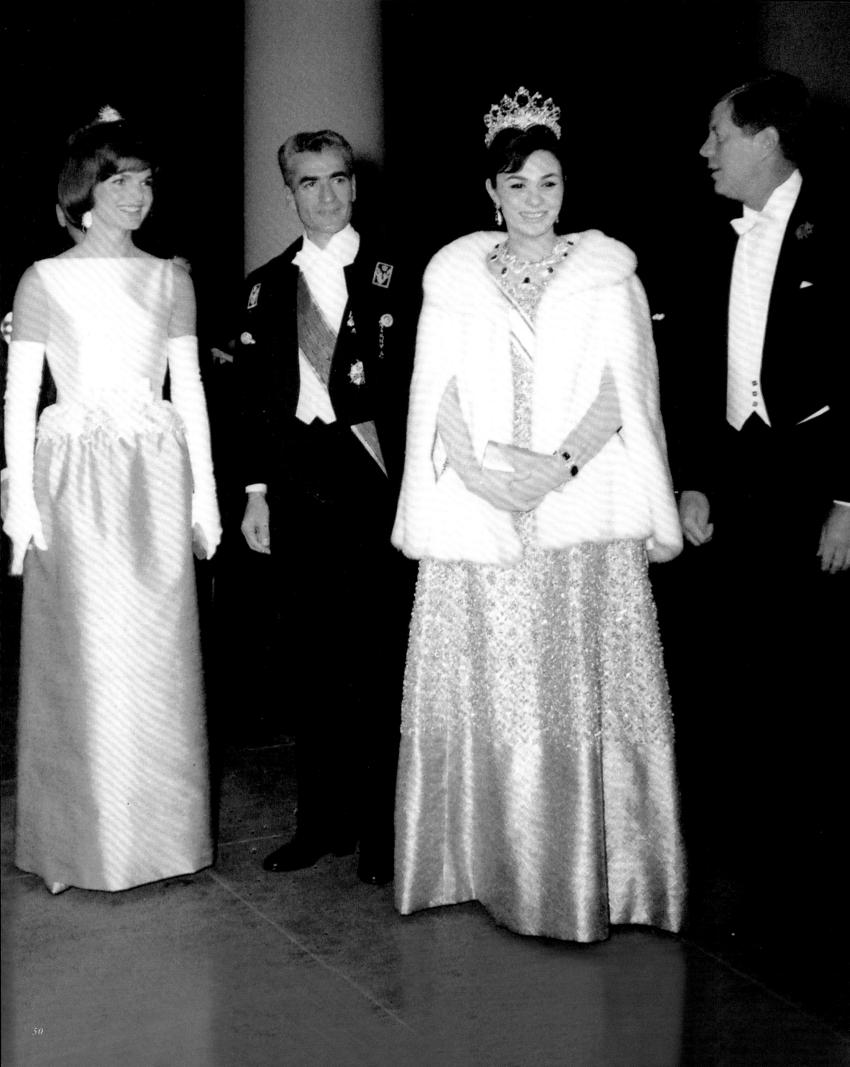

"A state dinner at the White House, planned like a wedding ..."

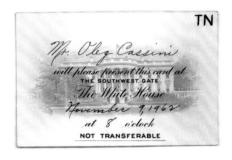

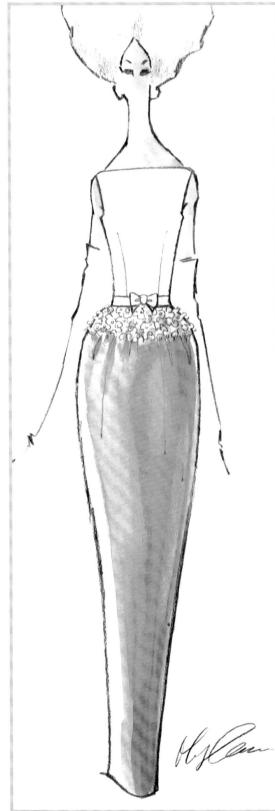

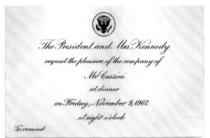

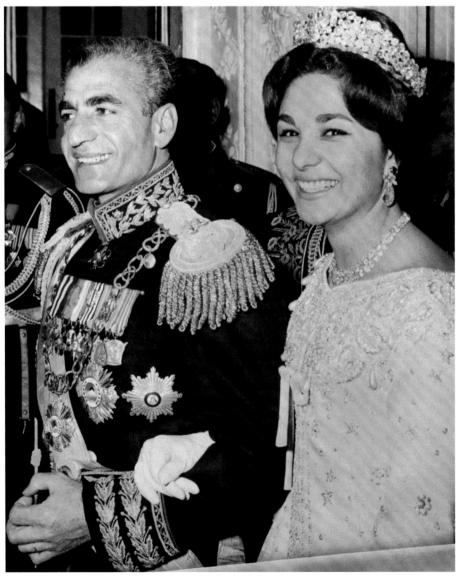

The Wedding Day of Shah Reza Pahlavi & Farah Diba

The Shah of Iran Mohammad Reza Pahlavi and his wife, 21 year old, Farah Diba during their wedding ceremony in Tehran, December 21st 1959. Queen Farah was crowned Shahbanou-Empress in 1967.

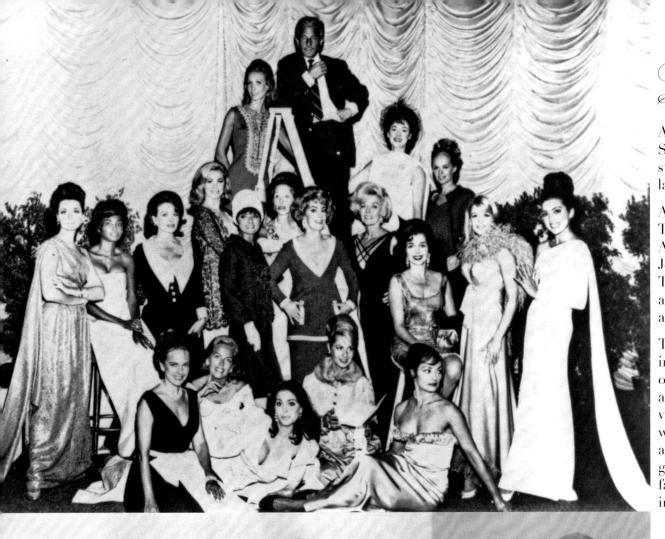

At a Cassini Charity Fashion Show, in Beverly Hills, I'm surrounded by stars on the ladder of success.

At the top of the ladder, with Tippi Hedren, Shirley Jones, Ann Miller, Gisele MacKenzie, Jeanne Crain, Paula Pritchett, Terry Moore, Jayne Meadows, and other models, socialites and actresses.

The wedding dresses featured in the collection: a white silk one shoulder sheath gown wit an attached train lined in a vivid ruby color, accessorized with rubies and diamonds; and, a Grecian one-shoulder gown of a sheer gold lamé fabric that draped and flowed into a swirling train.

Charlene my brother Igor's wife, is wearing a wedding dress of rich ivory silk accented by bold scarlet embroidery. Robin Butler wears a white silk suit ensemble, Joan Fontaine is wearing my bateau neck black velvet with silk taffeta ball gown. Alice Topping is wearing a Cassini black silk crepe sheath with pearls. Missy Weston wears the one-shoulder paisley floor length sheath. I am attired in tonal shades of stone and copper, with a 'Bermuda Sand' colored shirt and sienna suede laced shoes.

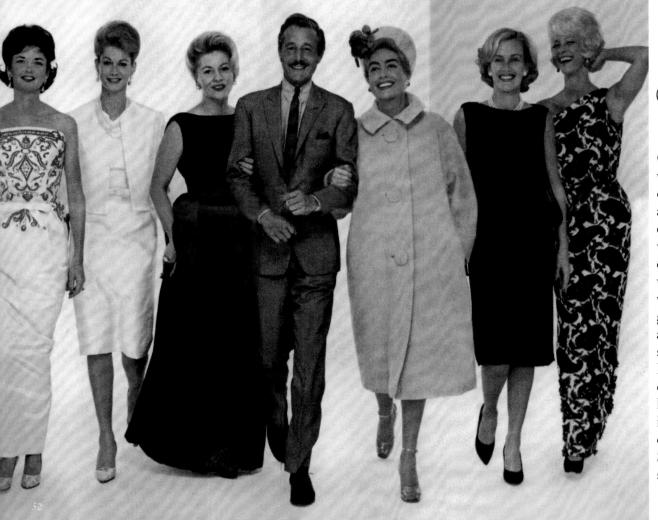

The wedding dress is traditionally the fanfare finale of fashion shows.

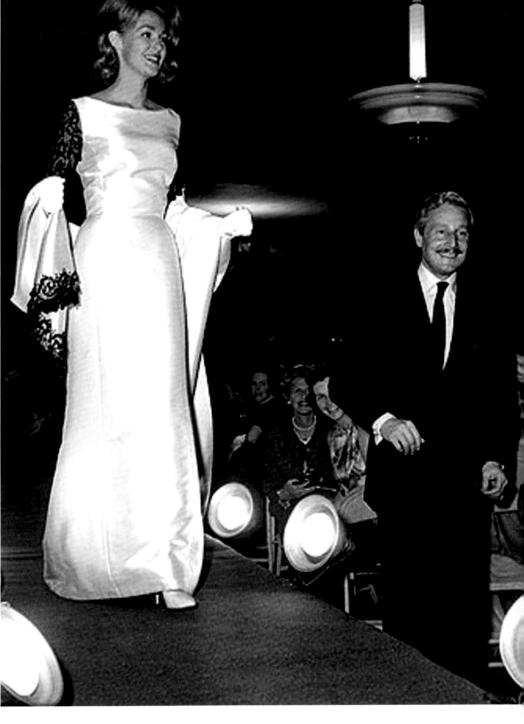

In Boston, a fashion show for Caritas, a favorite Kennedy charity, hosted by Cardinal Cushing. The beautiful blonde and glamorous Joan Kennedy, wife of Senator Teddy, was featured as my finale in a Princess gown of lustrous white satin trimmed with black lace and jet beads worn with a dramatic floor length stole.

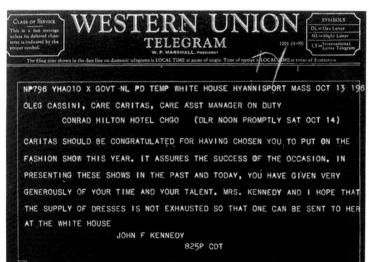

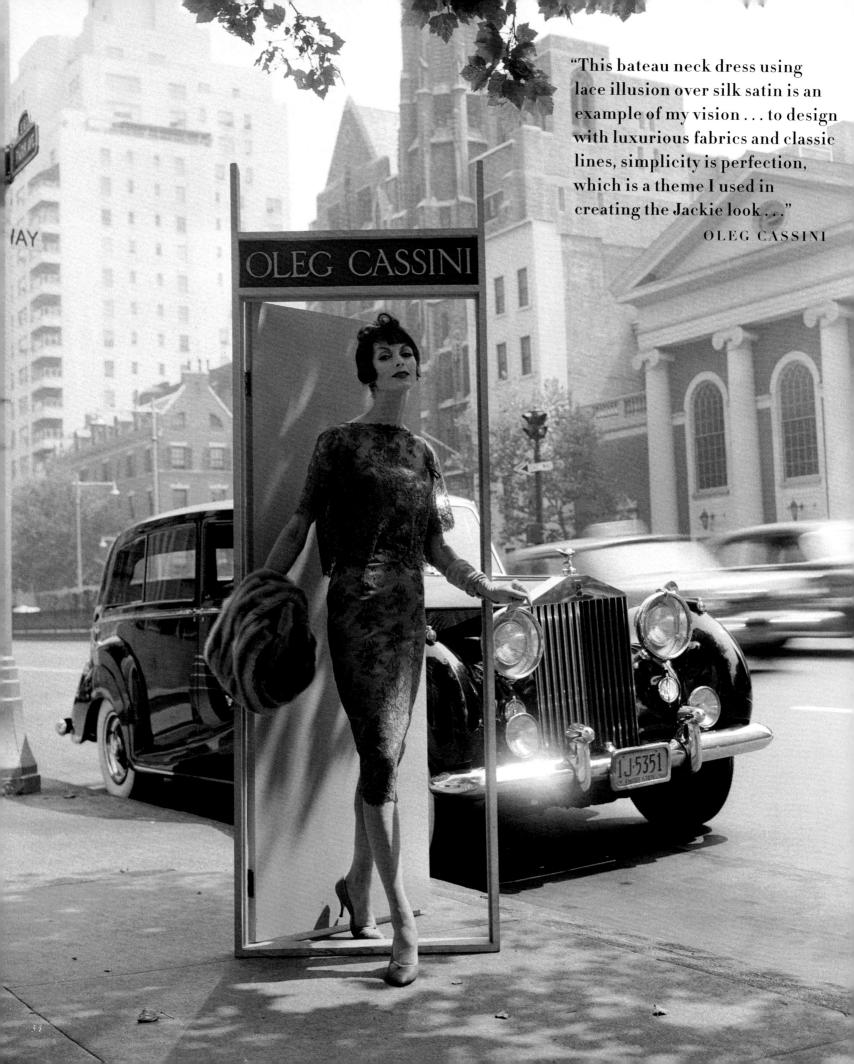

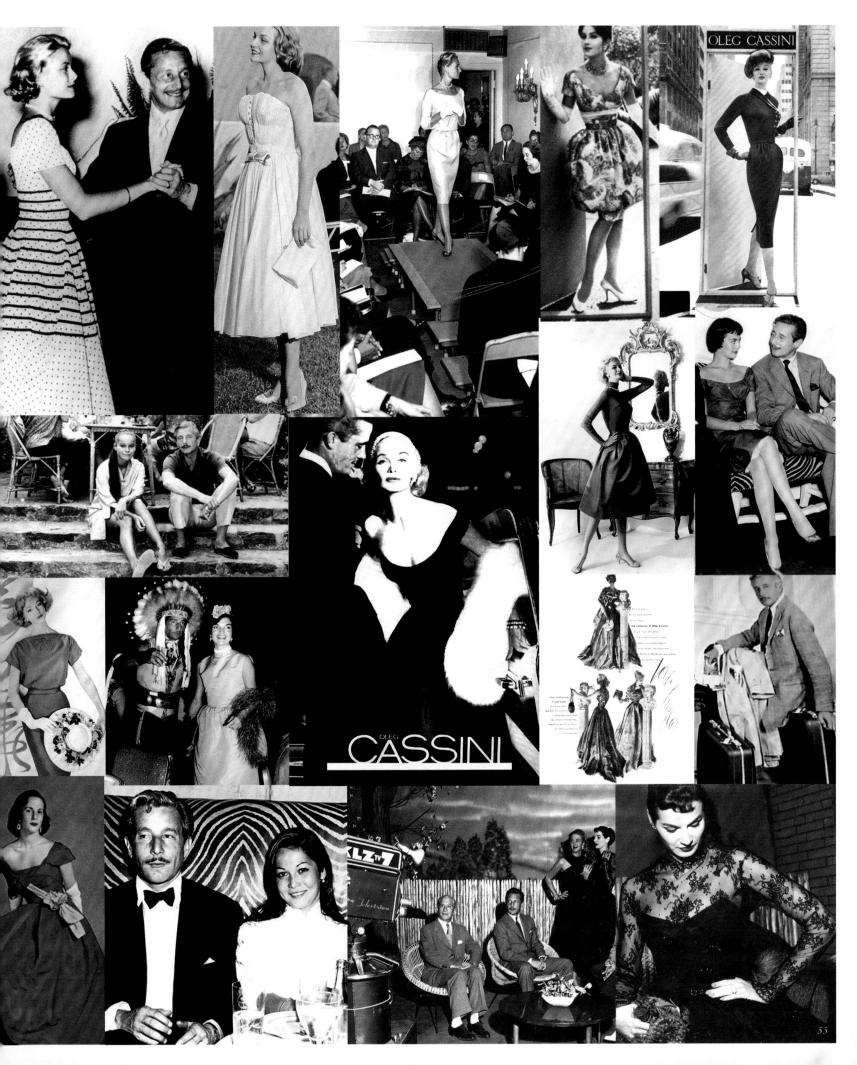

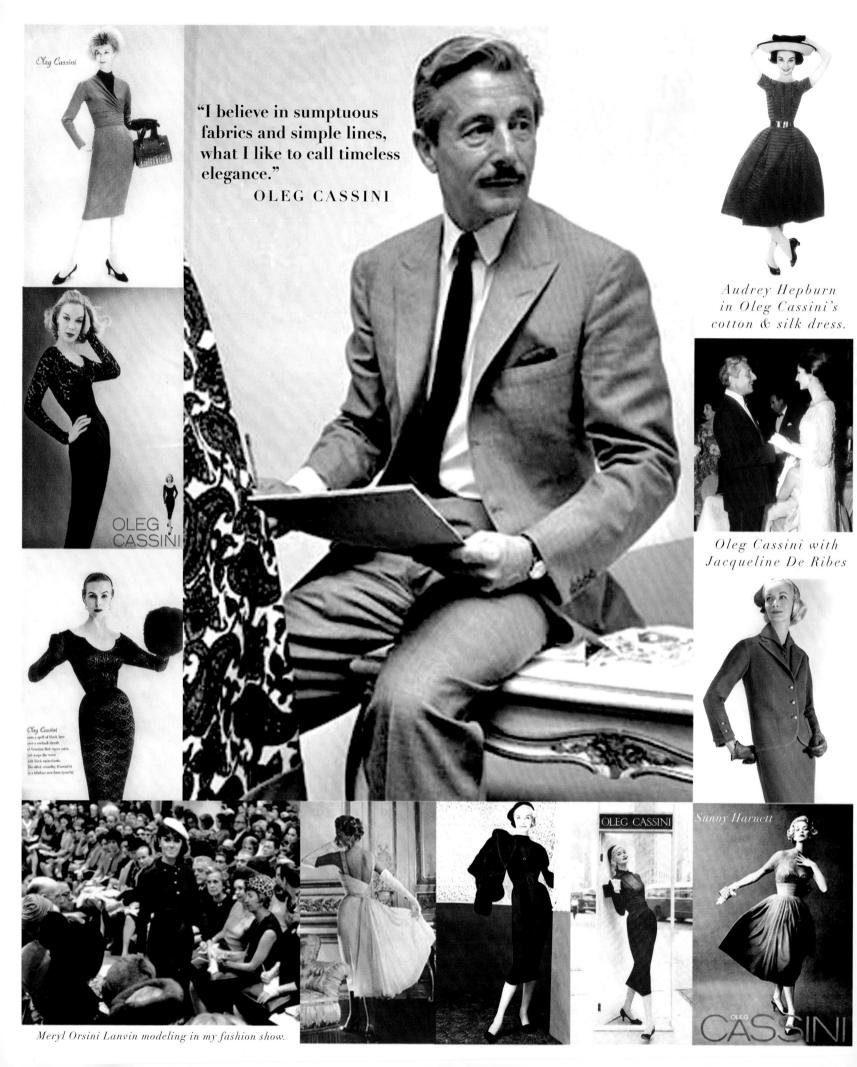

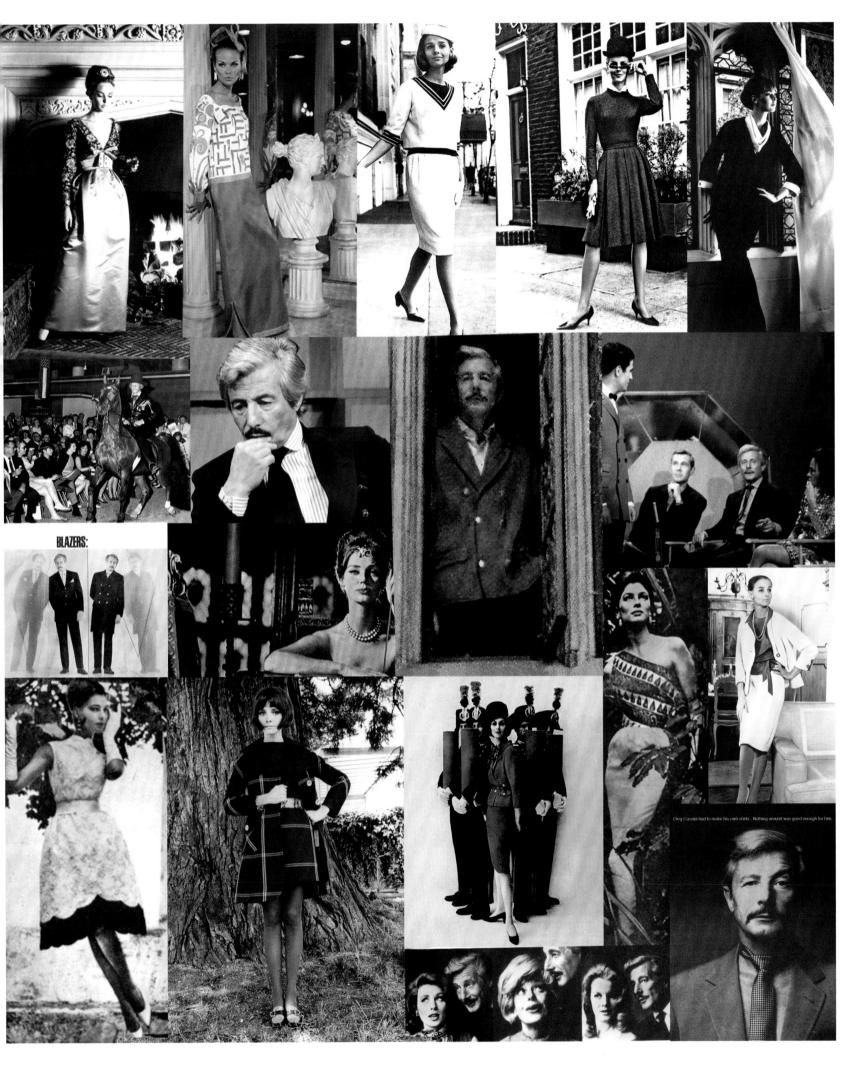

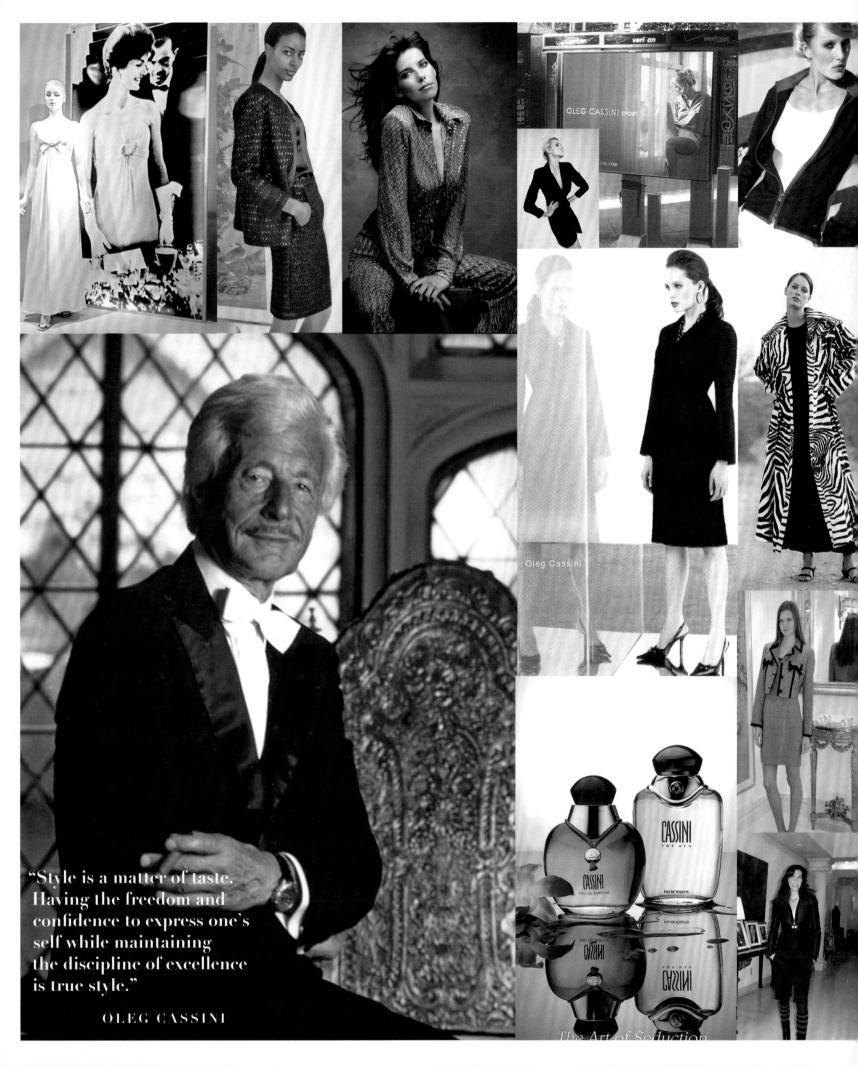

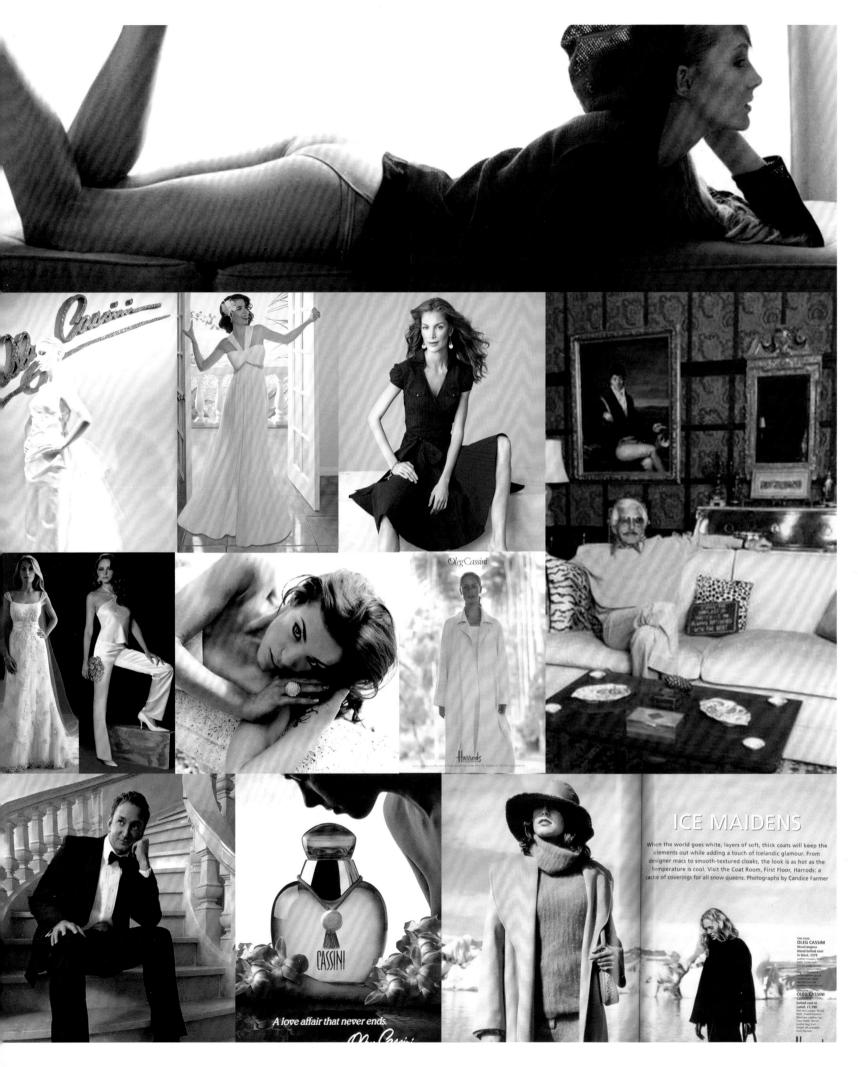

"Olegance knows only one name."

Oleg Cassini

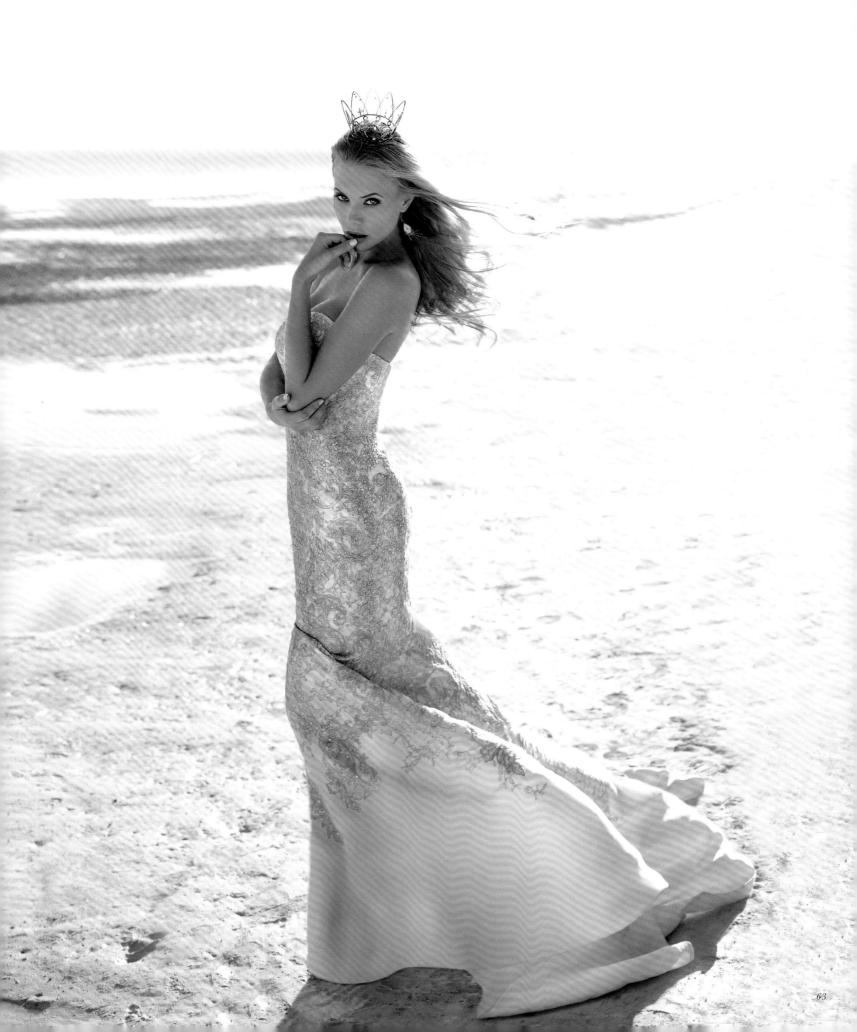

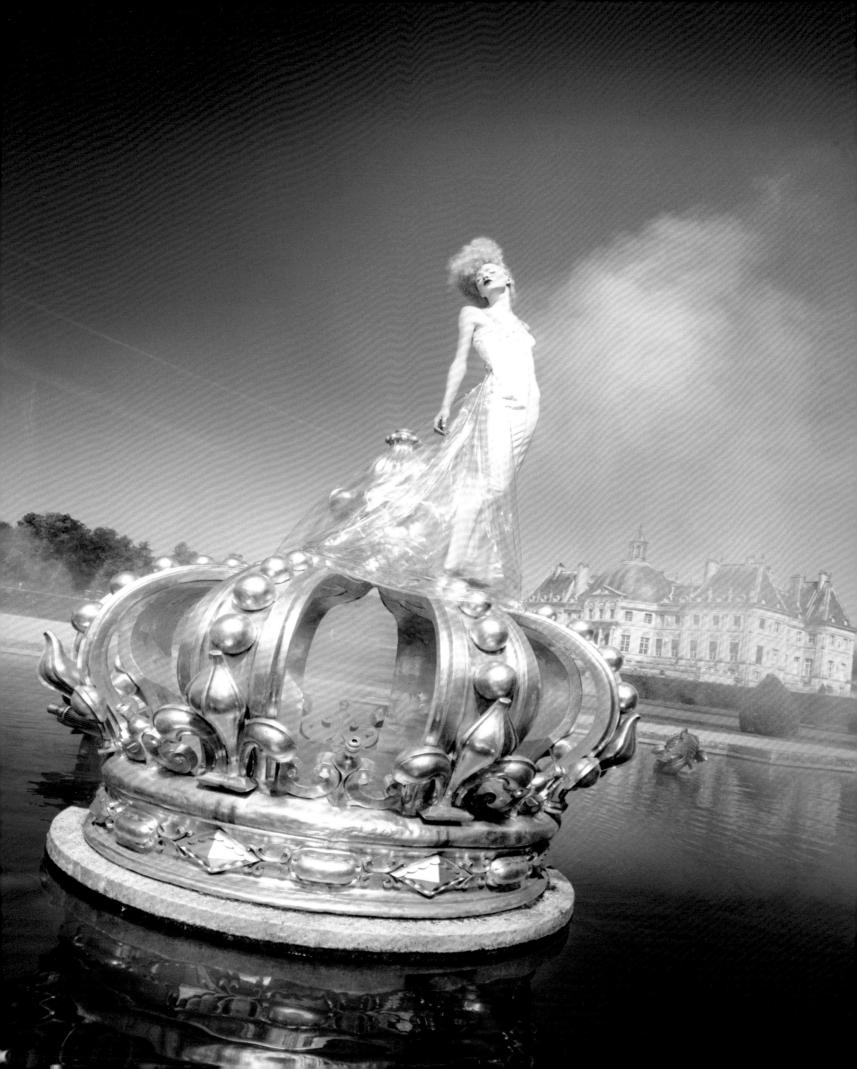

Noyal
Neddings

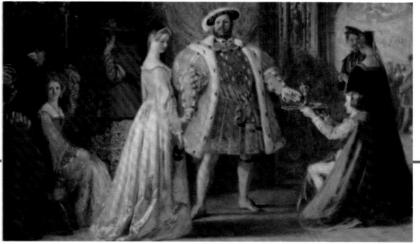

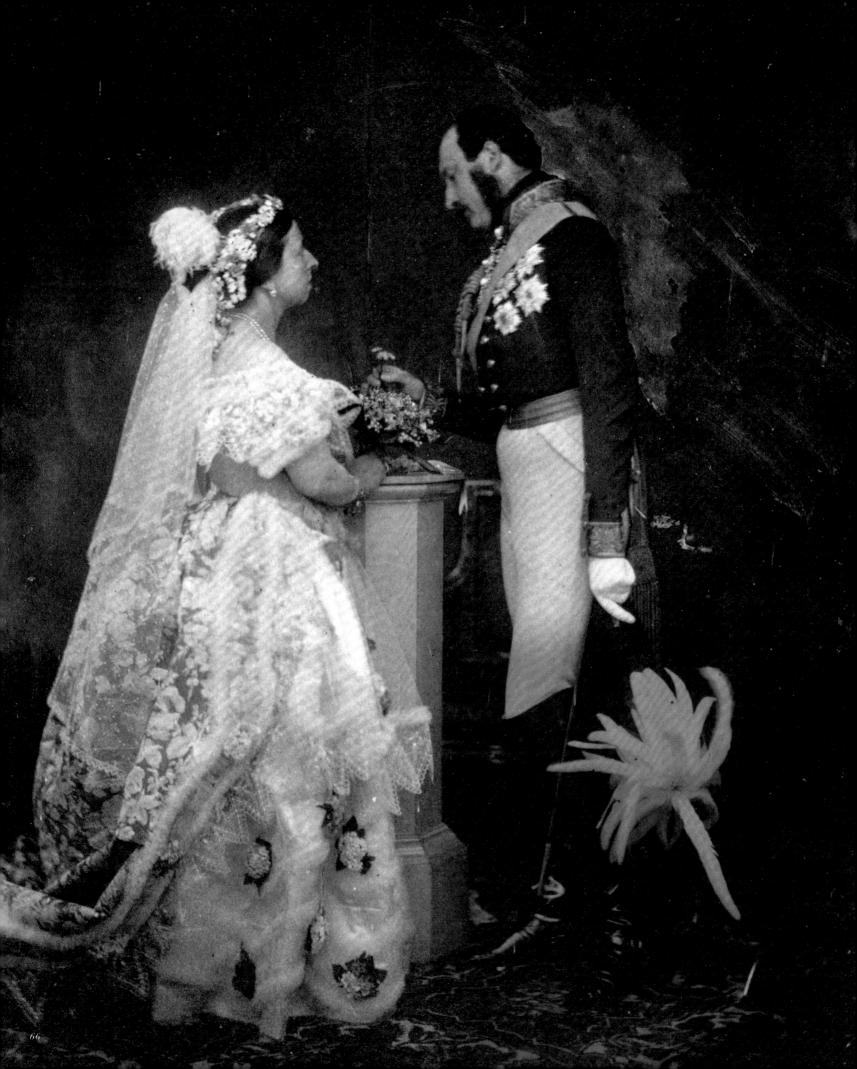

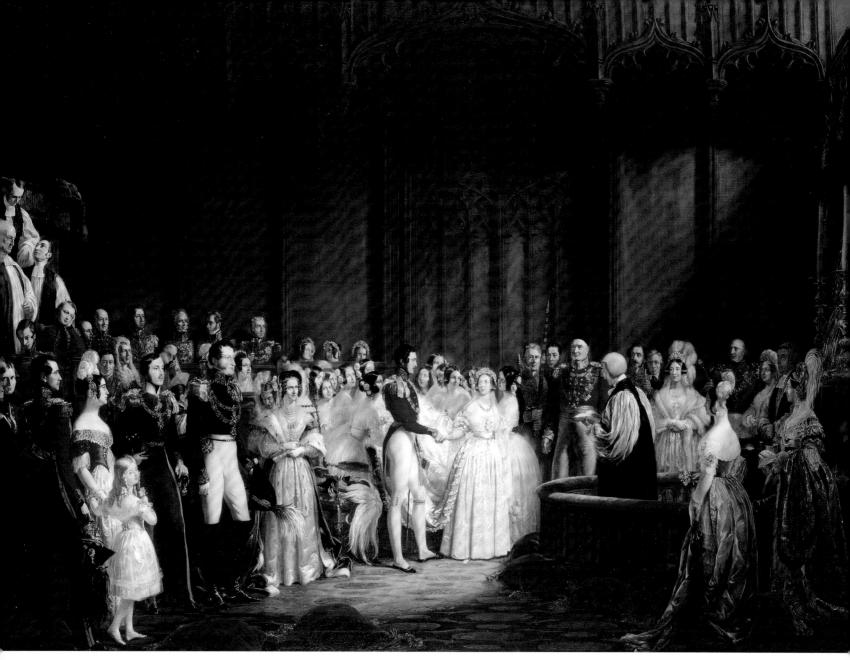

The Wedding of Queen Victoria, & Prince Albert February 10, 1840 The Chapel Royal, St. James Palace

Queen Victoria's gown is referenced as the royal wedding dress that popularized the color white. The choice of white goes back to Roman and Grecian times, representing purity. Victoria wore white for her wedding to her first cousin, Albert, Duke of Saxe-Coburg & Gotha in 1840. Her white satin ball gown with lace overlay skirt and 18 foot train was adorned with fresh, fragrant orange blossoms, which she also wore in her hair. The very happy union of Victoria and Albert produced nine children, and almost every European Monarch is a direct descendant of this marriage. Like Louis XIV, of France, 'The Sun King,' Victoria reigned for over six decades.

In the mid 19th century, white wedding dresses, veils and orange blossoms became the style. The significance of wearing white was an extravagant gesture, and created the need for a special, one time only, symbolic and treasured keepsake that the wedding dress has become. It is said that the Moors first introduced the orange tree into Spain, and passed to France, then to England, and from there to America, where orange blossoms were worn at a White House wedding by Mary Hellen, who married the son of President John Quincy Adams in 1828. Anne of Brittany and Empress Eugénie, wife of Napoleon III, also are credited with enhancing the popularity of the white wedding dress tradition.

LEFT In 1854, photography had just come in as a new art form and Victoria and Albert recreated their wedding in a photograph made 14 years after their actual ceremony. Courtesy of The Royal Collection H.M. Queen Elizabeth II.

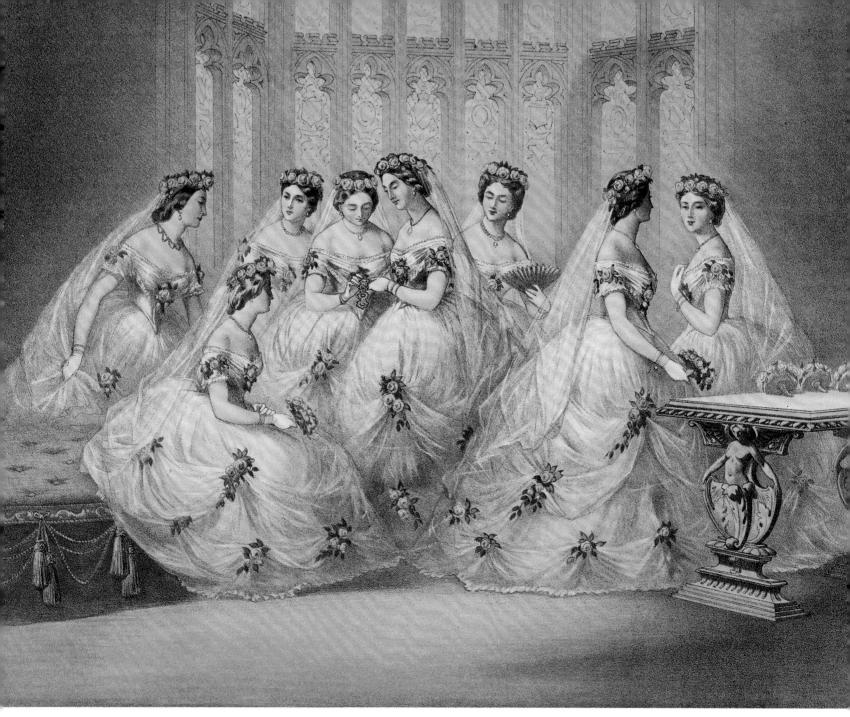

RIGHT Princess Alexandra of Denmark, 18, marries Queen Victoria's eldest son, Edward, Prince of Wales (King Edward VII). ABOVE AND RIGHT Bridesmaids gathered at the wedding, wearing fresh flowers in their hair, and on their gowns.

The New York Times reported: "All were in dresses of great splendor, but without trains. The display of jewels was prodigious. Diamonds blazed on every fair bosom and hand. The corsage of the wife of the Right Hon. Benjamin Disraeli was liberally spotted with jewels. The dress of Disraeli was also literally plastered with gold embroidery and lace. The dress of the Princess was of ample but ordinary dimensions. The material was white tulle over white silk richly decked with orange blossoms. A wreath of orange blossoms encircled her head. Her coiffure was arranged à la Chinoise. For her ornament she wore a superb parure of pearls and diamonds presented by the Prince bridegroom. The train was of great length and was of white silk. As the Princess passed the Queen she made a deep obeisance. To the Prince she dropped a curtsy of exquisite grace, to which the Prince responded by a deep inclination of his head."

The Edwardian Age followed the Victorian Age, and was named for the charming and fun loving Prince Edward. He came to the throne in 1901, at the age of 60, after Victoria's six decade reign. Linked with the French 'Belle Epoque' period, his time is often referred to as a romantic golden age of long sunlit afternoons, garden parties and big hats. Remembered with nostalgia as an "explosion of intellectual and artistic energy," a time of elegance and beauty, it was a prelude to the dark days of the Great War that followed, WWI. Later in life, Prince Edward also socialized with actress Lillie Langtry; Lady Randolph Churchill (Mother of Winston Churchill); actress Sarah Bernhardt; and Alice Keppel, great-grandmother of Camilla Shand Parker Bowles, the Duchess of Cornwall. In 1995, an image of Alice Keppel and her daughter, Violet was placed on a British postage stamp.

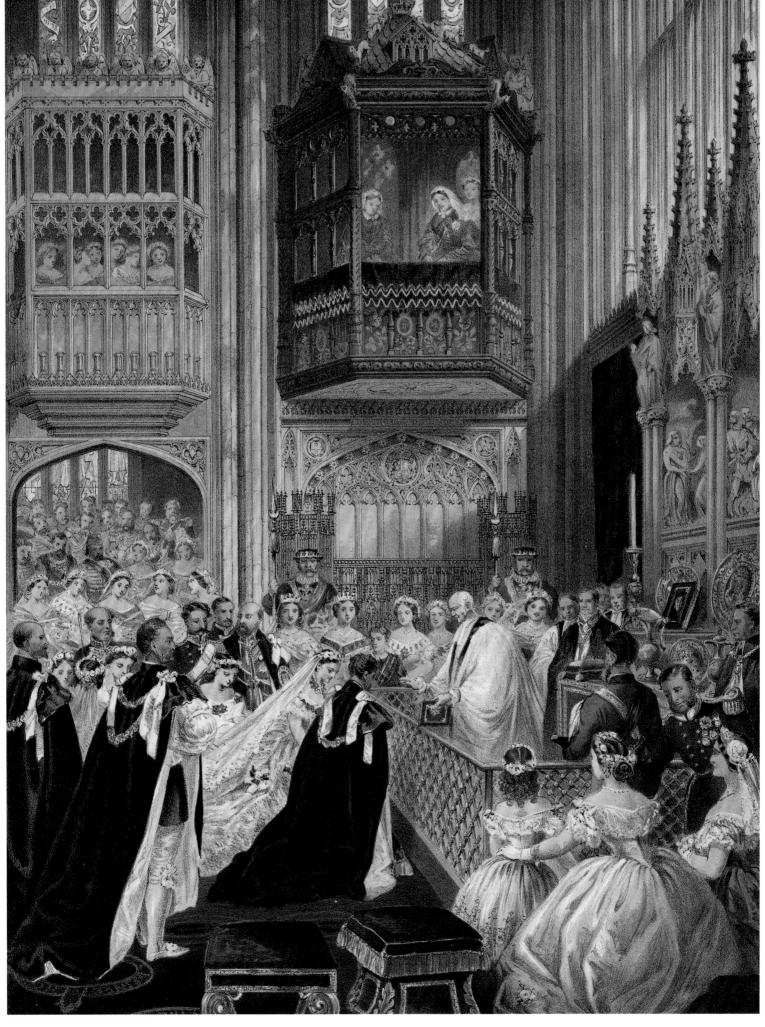

A Royal Wedding, Saint George's Chapel, Windsor Castle-March 10, 1863

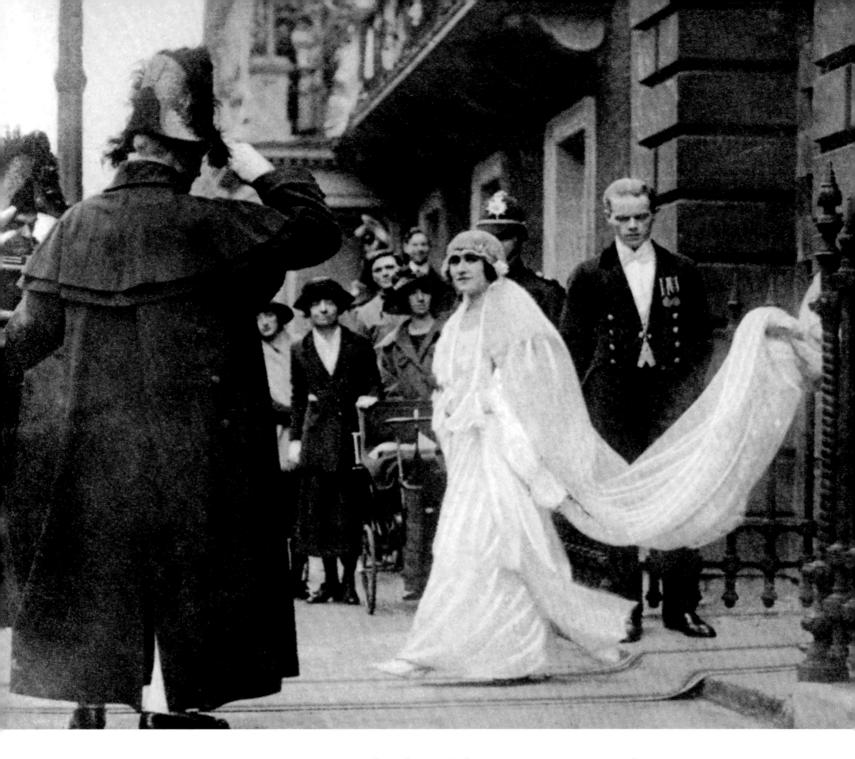

Queen Elizabeth-The Queen Mother

In 1923, Lady Elizabeth Bowes-Lyon married HRH the Duke of York in Westminster Abbey. Her wedding dress was the traditional full length gown with a court train. The dress featured the trendy dropped waist, and she wore a cloche style lace headdress. The look was described as medieval at the time.

Following the abdication of King Edward VIII in 1936, The Duke and Duchess of York succeeded to the throne as King George VI and Queen Elizabeth. The Duchess of York became known as Elizabeth the Queen, and later the Queen Mother, when her daughter, also named Elizabeth was crowned Queen Elizabeth II.

Queen Elizabeth II has reigned for over six decades with Prince Philip by her side.

The Duke & Duchess of Windsor December 10, 1936

Theirs was known as the poignant star-crossed love story of their time.

Over the crackling radio waves, into the chilled air, the King announced the decision to his astonished people in a heartfelt message, saying: "I have now found it impossible to carry the heavy burden of responsibility and to discharge my duties as King as I would wish to do without the help and support of the woman I love."

On December 10, 1936, the King of England, Edward VIII, abdicated his throne, and his brother, the Duke of York, father of Princess Elizabeth, became King in his place.

On June 3, 1937, they married in France, his first marriage, her third. They traveled the world together known to all as the Duke and the Duchess of Windsor.

Wallis chose the memorable blue gown by Mainbocher, a long sleeved, bias cut gown that hugged her lean silhouette. It was complemented by an interesting crown headdress. In her 'Wallis blue gown' she made an exceedingly chic companion to the 'best dressed' of men. Both at their wedding and during their stylish life together, they were the epitome of elegance.

Renowned individually for their sartorial style, the glamorous and alluring Duchess was quoted as having said: "I am not much to look at so I may as well be the best dressed."

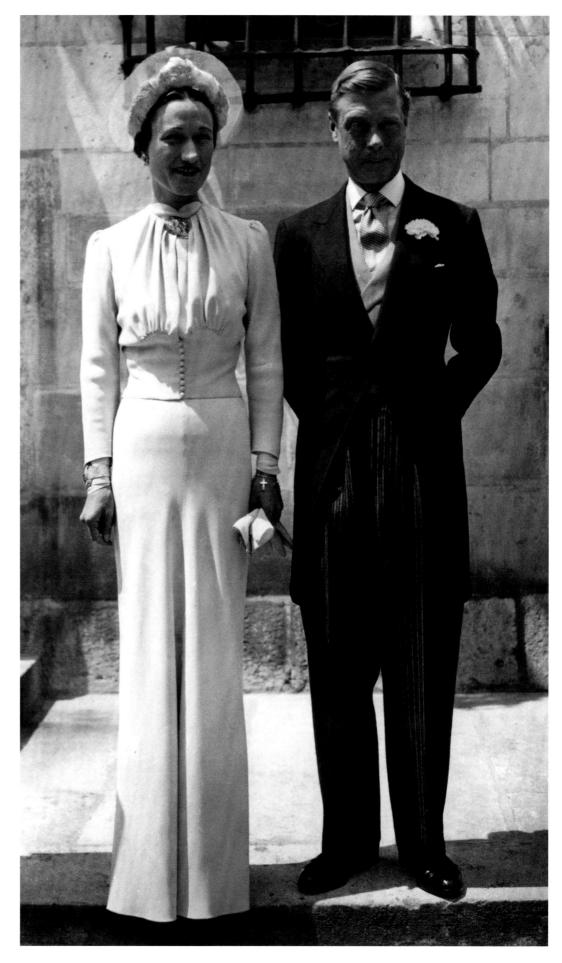

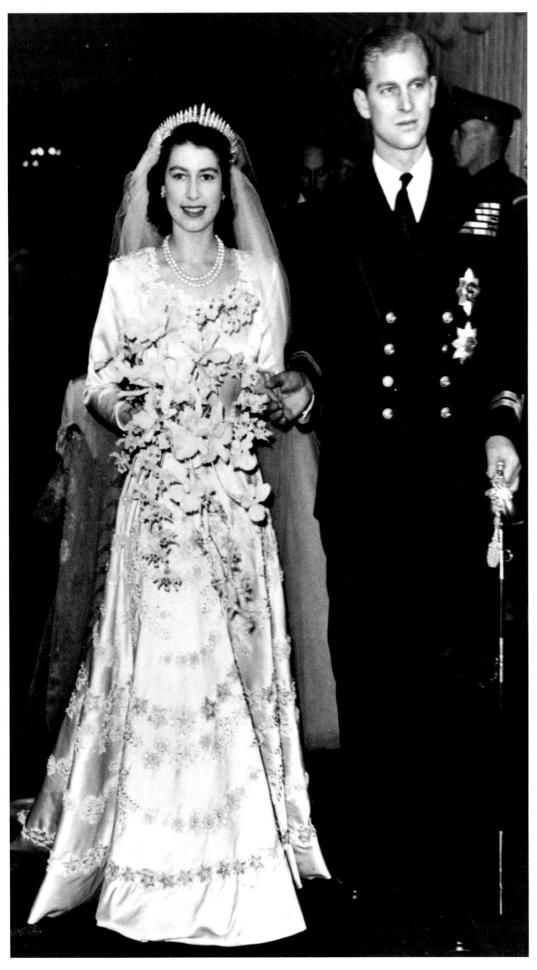

Six years later, Princess Elizabeth would be crowned Queen Elizabeth II.

Princess Elizabeth S Prince Philip November 20, 1947

The Royal couple exchanged vows at Westminster Abbey before the Archbishop of Canterbury on November 20, 1947, and the wedding heralded the end of the dark days of WWII and gave way to the positive thoughts of peacetime. Winston Churchill, England's wartime Prime Minister, famously captured the feelings of the time about the wedding of Crown Princess Elizabeth to Prince Philip Mountbatten, nephew of the deposed King of Greece, as: "A bright ray of colour on the hard road we have to travel."

Being post war, frugality was pervasive, Elizabeth financed her wedding gown with 200 extra clothing stamps, and the main course of the wedding breakfast at Buckingham Palace featured partridge, a meat not subject to rationing.

Princess Elizabeth's long sleeved gown was ivory duchesse satin, with a sweetheart neckline trimmed with lace, and created by Norman Hartnell. The gown was embellished with 10,000 pearls, and had a record setting train of 15 feet of silk tulle, and was said to have been inspired by a Botticelli painting.

The pearl earrings were a present from Queen Mary (something old). Elizabeth's double strand pearl necklace, a gift from her parents (something new) and the diamond tiara, a loan from her mother, the Queen (something borrowed).

The bridal bouquet of orchids and myrtle was cut from the bushes used for the bouquets of all Royal Brides since 1850.

Winston Churchill, a wedding guest, stated: "If they had scoured the globe, they could not have found anyone so suited to the part."

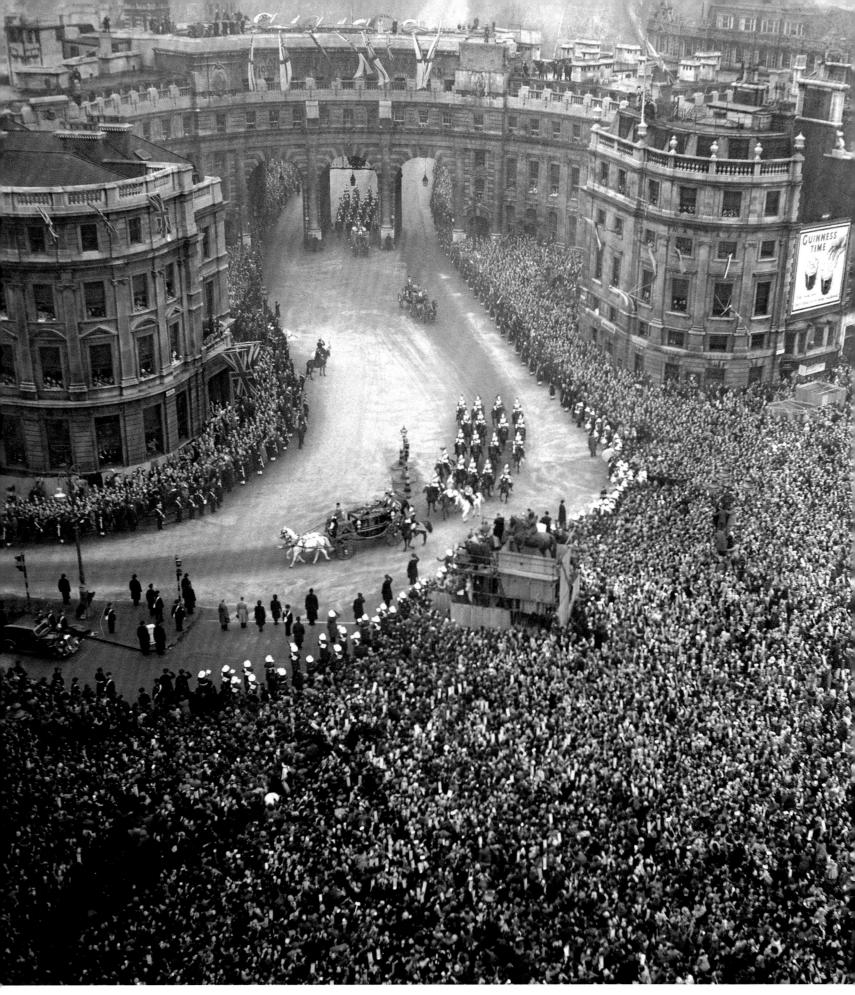

London, November 20, 1947: The Royal Wedding of Princess Elizabeth and Prince Philip. The Irish State Coach making the turn at Trafalgar Square towards Whitehall.

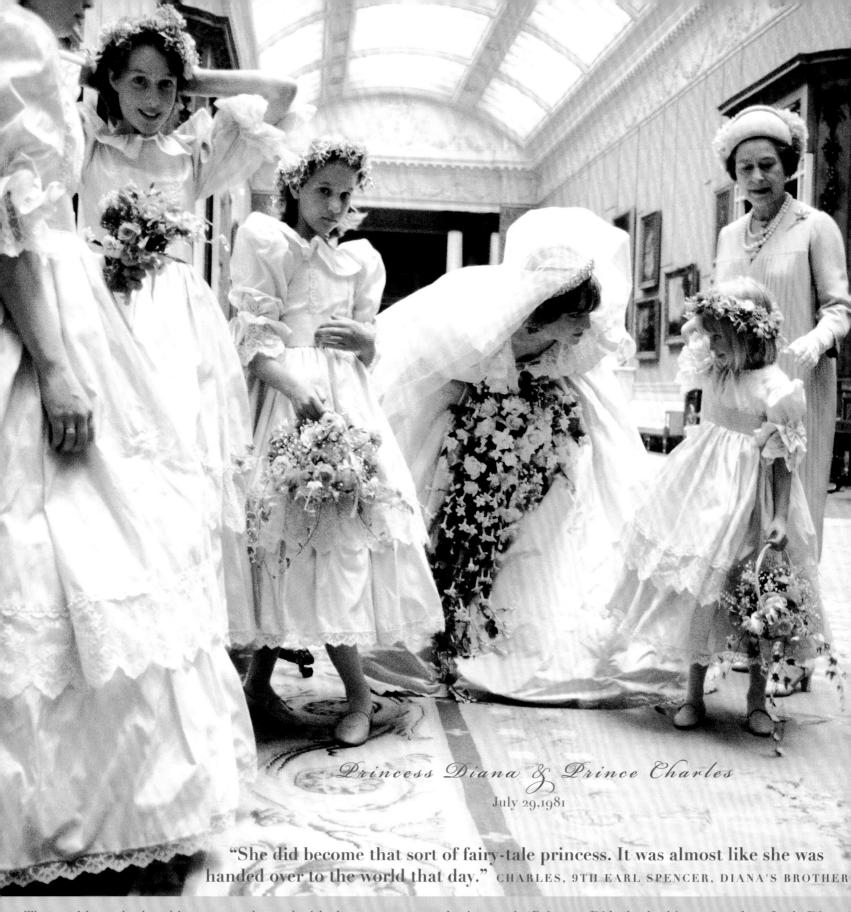

The world watched and became enchanted with the statuesque and aristocratic 'Princess Di,' who had just turned 20. Lady Diana Spencer, chose the team of David and Elizabeth Emanuel to design her memorable wedding gown. The extravagant sleeves, tied with bows and the fantastic 25 ft. long train, combined to give a truly majestic feeling to the gown. The beautiful young and coltish, long legged Princess Diana, with her model height of 5'10", the Royal Wedding trappings, the television moment by moment coverage all made the Wedding Day spectacular and iconic. Silk taffeta, opulent sleeve treatments, bows, lace and embellishments became a major fashion impression and widely encouraged the romantic 'Princess Bride' look. Mariah Carey, pop star, famously stated that she was inspired by Diana's gown for her own wedding to music impresario, Tommy Mottola. *Photo: Lord Patrick Litchfield*

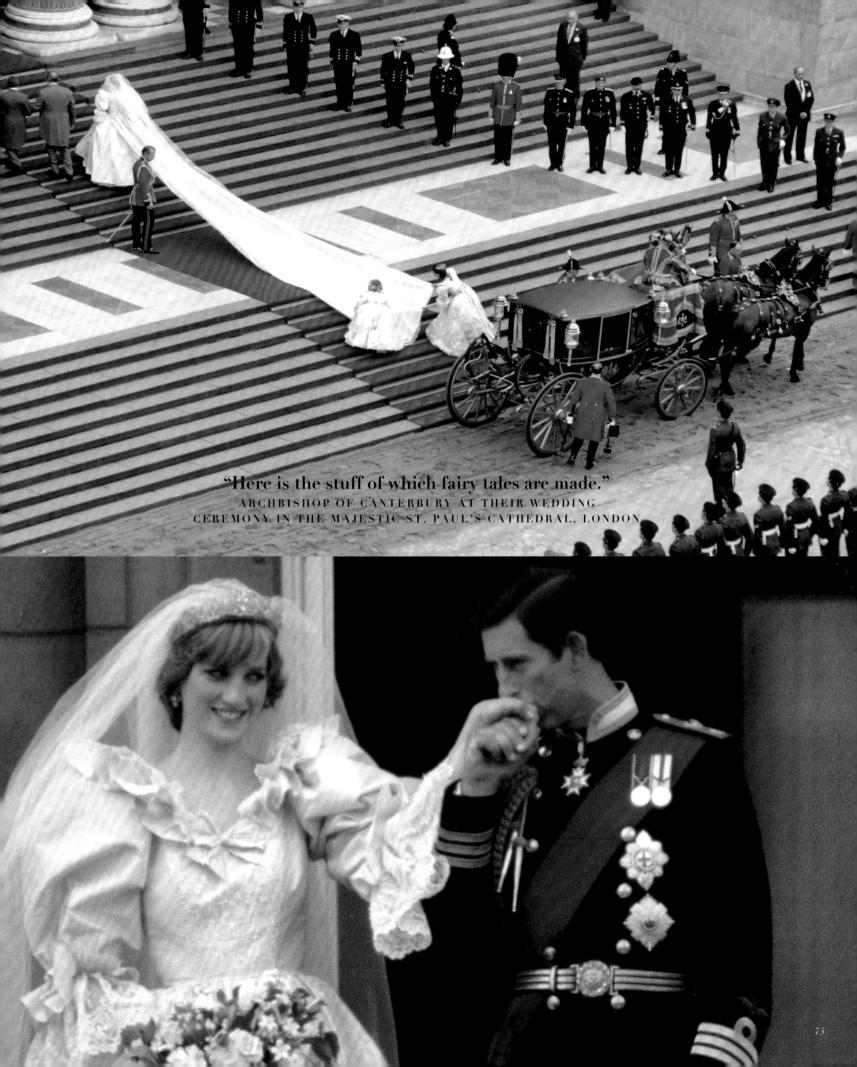

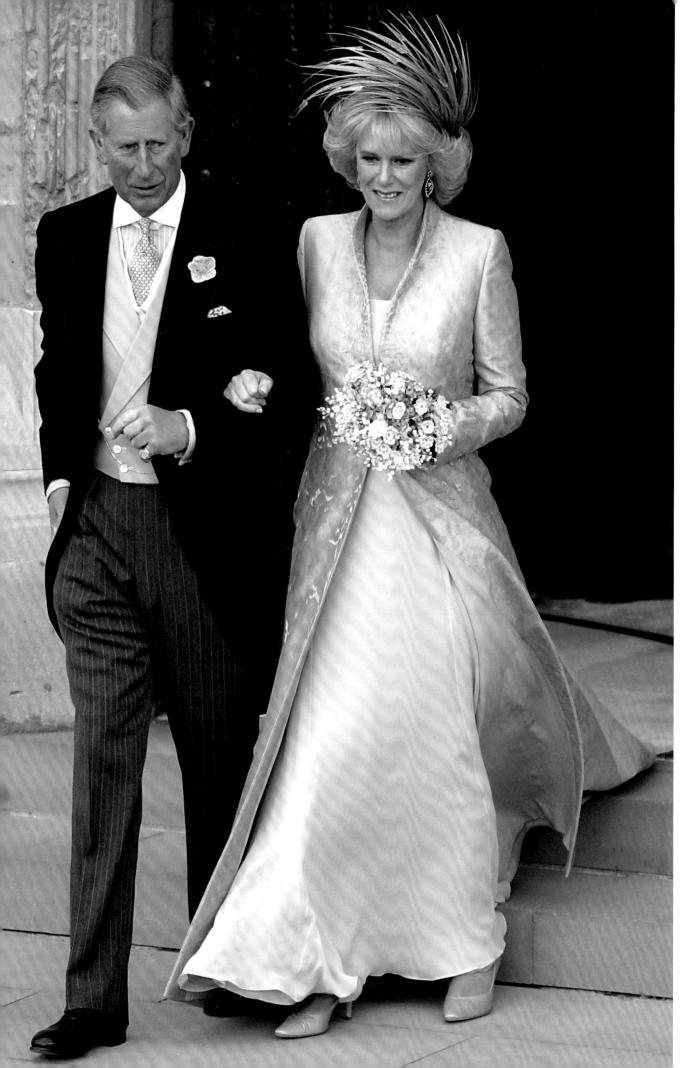

Charles & Camilla April 9, 2005 St. George's Chapel Windsor Castle

It has been said that Camilla Shand's opening comment to Prince Charles when they met while both were in their early twenties, Summer 1971, was: "You know Sir, my great grandmother, Alice Keppel, was a close friend of your great, great, grandfather, King Edward VII."

However, it has also been said that her comment, referring to his polo pony was: "That's a fine animal you have there, Sir."

Prince Charles & Camilla, the Duchess of Cornwall April 9, 2005

For the civil marriage service to Prince Charles, Camilla, the Duchess of Cornwall, wore an ivory dress and coat by Robinson Valentine with matching Philip Treacy hat.

For the prayer service at the St. George's Chapel, Windsor Castle, and the reception that followed, Camilla wore a porcelain blue floor length coat embroidered with gold over a matching blue gown with a stunning gold leaf spray, worn like a crown in her hair.

Color as a keynote has had great symbolism for wedding dresses. The various shadings of white are a favorite choice, and white has traditionally symbolized innocence, as well as blue, which has also symbolized fidelity and love.

"If the bride wears blue, the husband will be true."

RIGHT A proposed sketch for the Duchess appearing in *People* magazine prior to the wedding as a design concept, featuring a pearl embroidered illusion bodice.

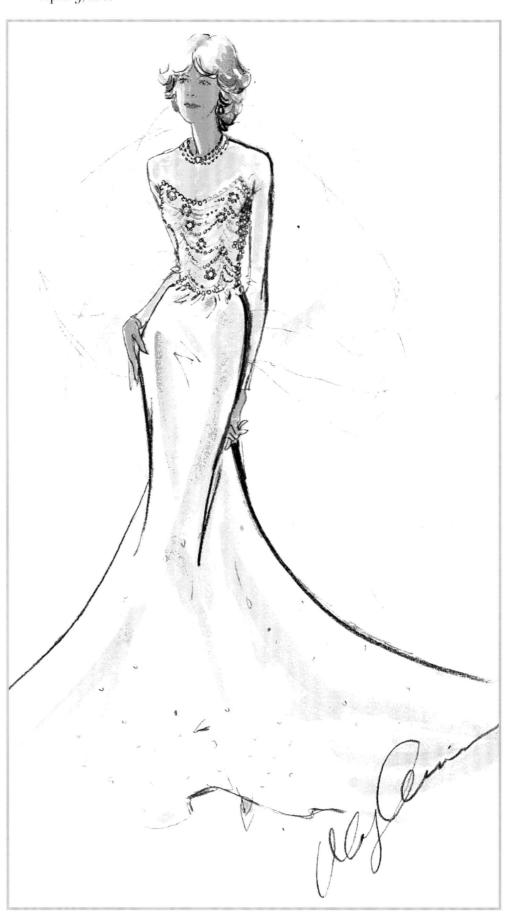

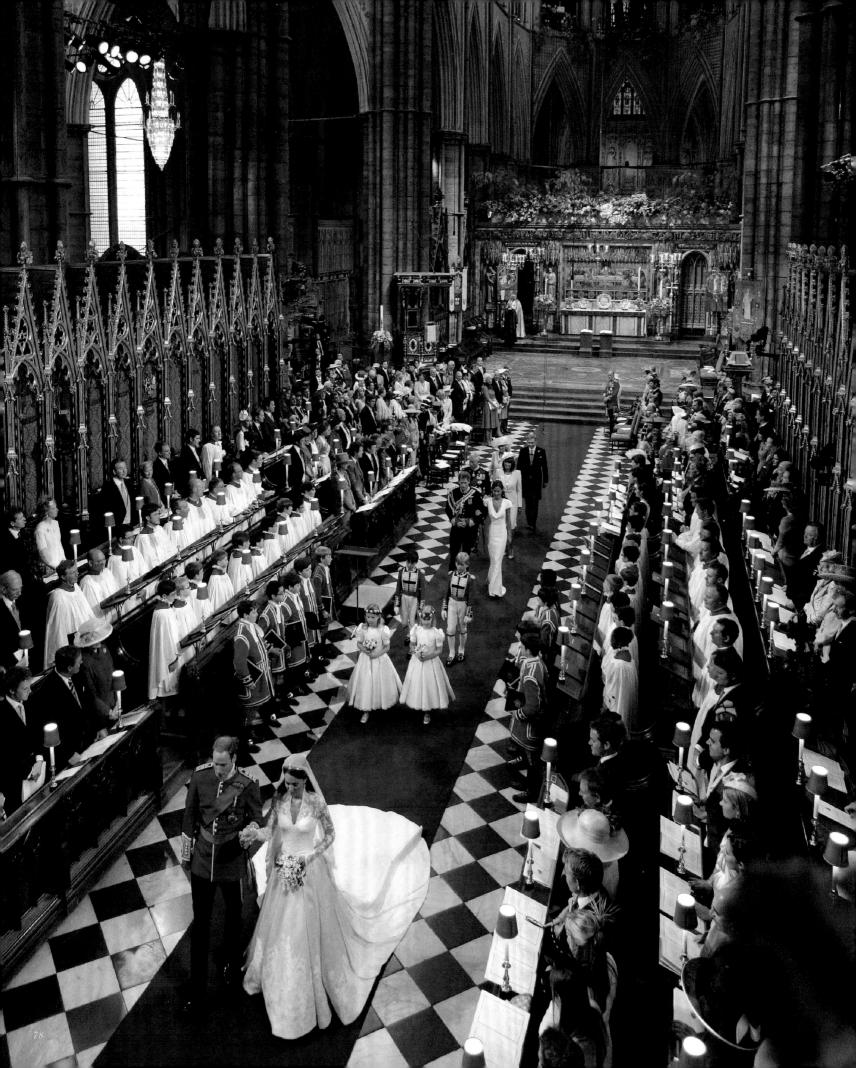

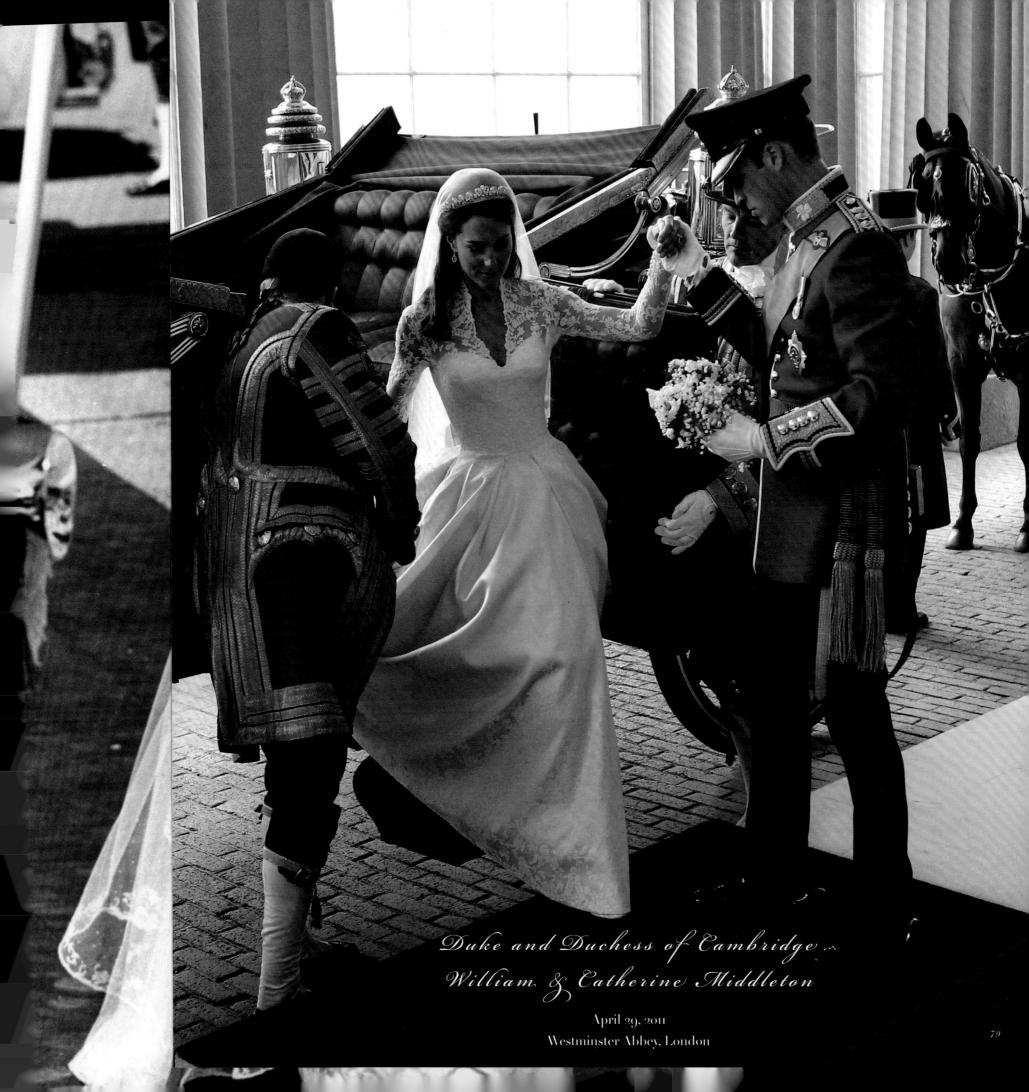

Princes Phili Jur Monte le Trince et le ont l'honneur de r leurfille, Son Alte. Caroline avec A dans la plus stricte en la Chapelle du Monsieur et Ma Monsieur Mich Légion d'Honne et Madame Tie de vous faire pa Philippe Tuno Son Altesse Se Caroline de La Bénédiction Excellence Monseig dans la plus strict en la Chapelle s Prince Albert & "La Vaucouleur". A 14 , Rui Le Clos des Oliviers". Princess Charlene Wittstock July 2, 2011 Monaco

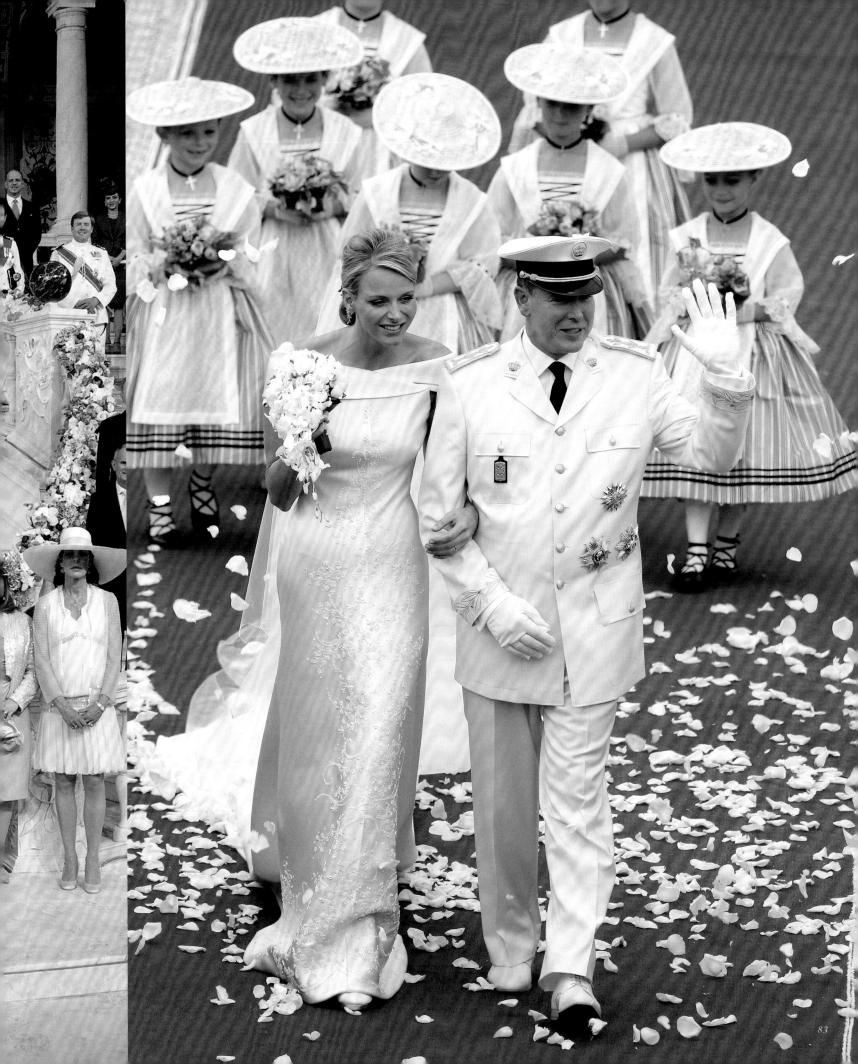

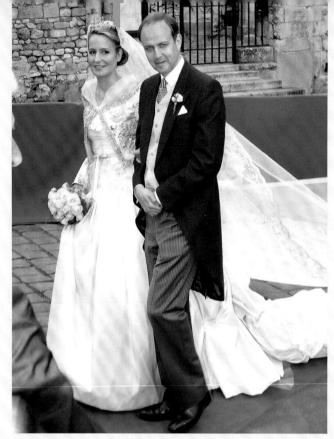

Prince Jean & Philomena May 4, 2009

Prince Jean Carl Pierre Marie d'Orléans, Dauphin of France, Duke of Vendôme and his Spanish wife Philomena of Tornos and Steinhart wed at a religious ceremony at the gothic 12th century cathedral, Notre Dame de Senlis. The wedding party then moved on to a reception in the Château de Chantilly, the historic former home of King Luis Felipe of Orleans, an ancestor of the groom.

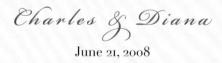

Prince Charles-Philippe Marie Louis d'Orleans of France, Duke of Anjou, married Diana Alveres 11th Duchess of Cadaval at the Evora Cathedral in Portugal.

The engagement dinner at Le Cirque, NYC, featured Oleg Cassini crystal diamond paperweights as wedding gifts for all.

Pippa Middleton & James Matthews May 20, 2017

Pippa Middleton married James Matthews in what has been called the society wedding of the year, in front of royalty, family and friends in Englefield near Redding, in Berkshire. The couple walked hand-inhand along the church path led by a group of young page boys and bridesmaids, including Prince George and Princess Charlotte.

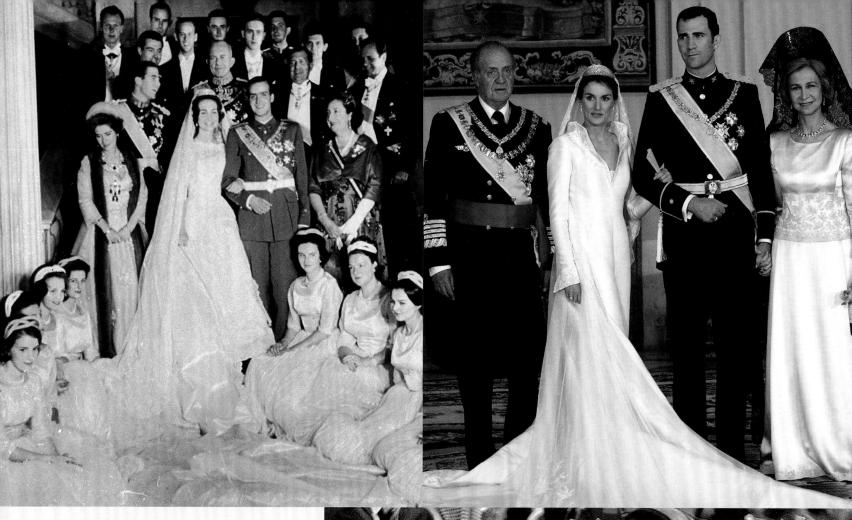

Sophie & Juan Carlos

The King and Queen of Spain May 1, 1962

ABOVE Prince Juan Carlos of Spain and Princess Sofia of Greece and party at their wedding.

Felipe & Letizia

May 22, 2004

ABOVE, RIGHT The wedding of the Prince and Princess of Asturias with his parents, the Spanish King and Queen, Juan Carlos and Sofia, in Almudena Cathedral in Madrid, Spain.

RIGHT The flower children's outfits were inspired by the paintings of the great Spanish painter Goya.

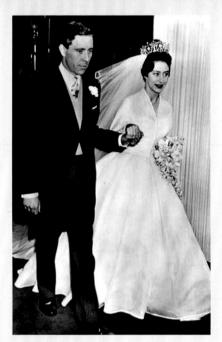

Princess Margaret & Antony Armstrong Jones

May 6, 1960

Princess Margaret, the Sister of Queen Elizabeth II at Westminster Abbey.

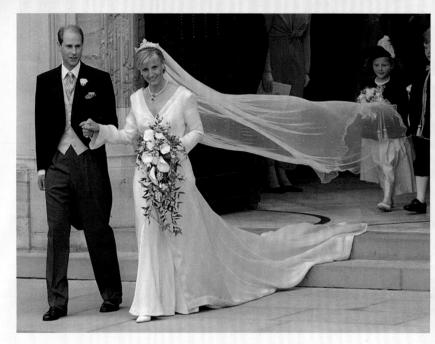

Edward & Sophie

June 19, 1999

The wedding of Prince Edward, Earl of Wessex and Sophie Rhys-Jones took place at St George's Chapel at Windsor Castle.

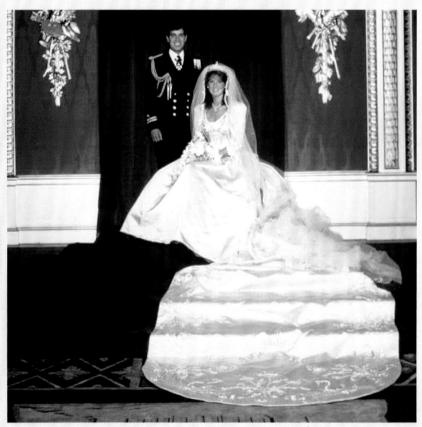

Prince Andrew & Sarah Ferguson July 23, 1986

The wedding of Prince Andrew, Duke of York, and Sarah Ferguson at Westminster Abbey in London, England.

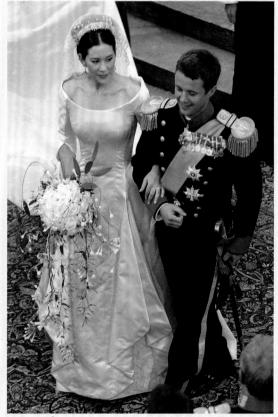

Danish Crown Prince Frederik & Mary Donaldson

May 14, 2004

"From today you are a real Princess who has got both the Prince and all the kingdom."

BISHOP ERIK SVENDSEN (in his sermon)

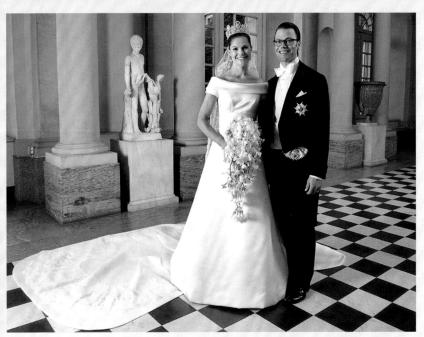

Victoria, Crown Princess of Sweden Crown Prince Haakon & Mette-Marit & Daniel Westling

August 25, 2001

June 2010 Stockholm, Sweden

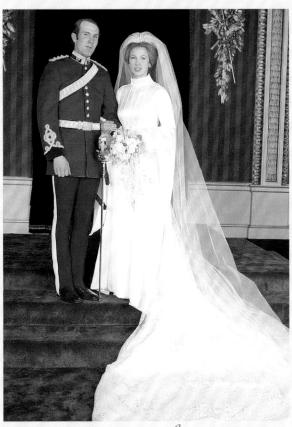

Ann & Mark Phillips

November 14, 1973

The wedding of Princess Anne and Mark Phillips took place at Westminster Abbey in London.

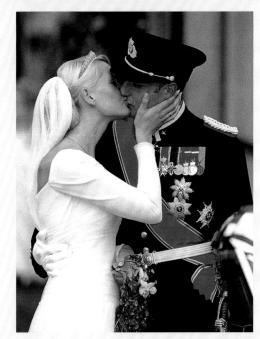

Oslo, Norway

Crown Prince Haakon the Norwegian heir to the throne and Crown Princess Mette-Marit on their wedding day.

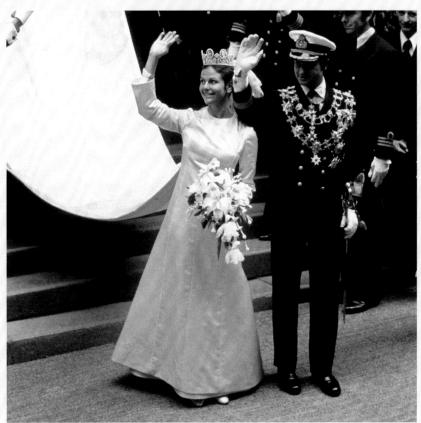

Carl Gustaf & Silvia Sommerlath

June 1976 Sweden

King Carl Gustaf, of Sweden and German-born Silvia Sommerlath met at the Munich Olympics in 1972. Abba dedicated their hit song Dancing Queen to Queen Silvia.

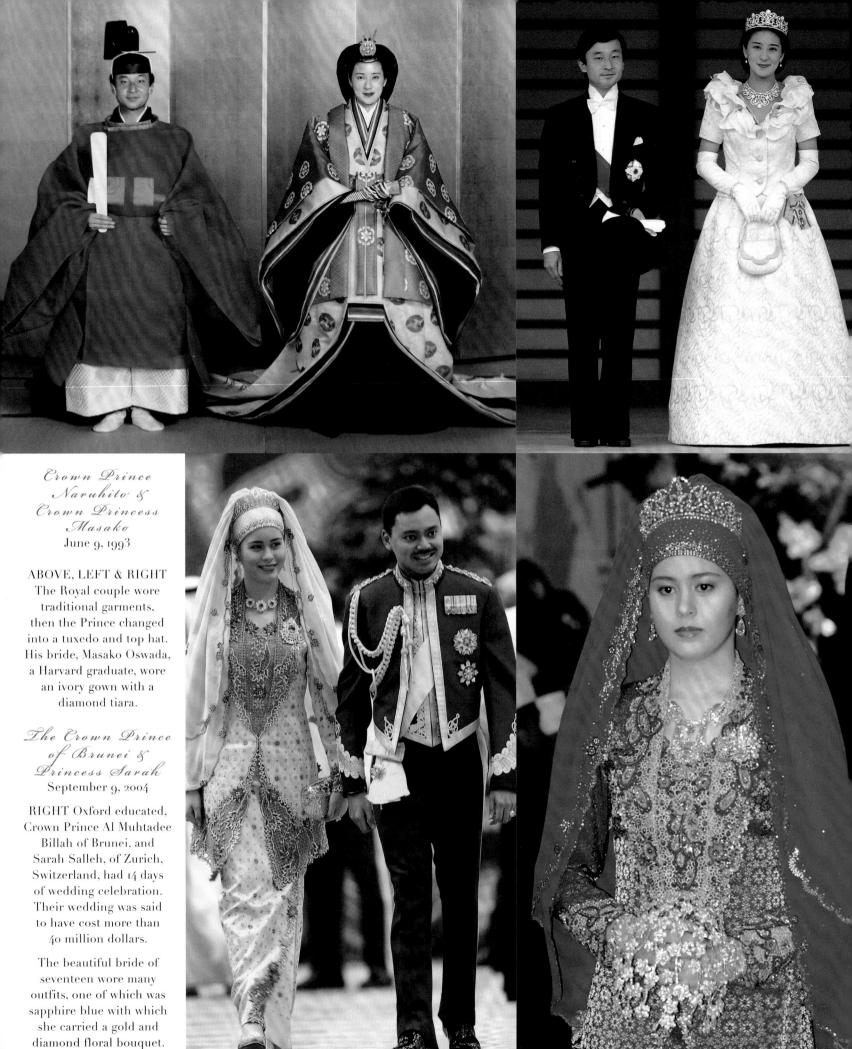

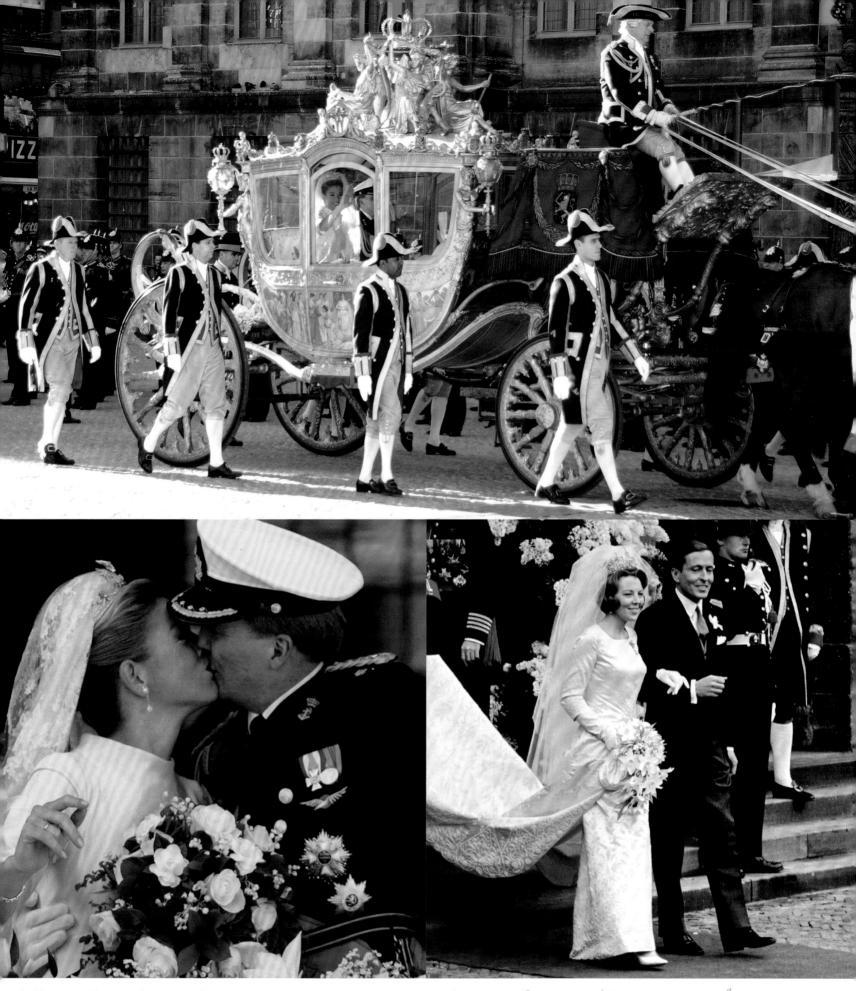

Willem - Alexander & Máxima. February 2, 2002, Amsterdam Crown Prince Willem-Alexander of the Netherlands married Argentine born Máxima Zorreguieta. They rode in the Royal golden coach (top).

Princess Beatrix & Claus von Amsberg March 10, 1966

Beatrix, Willem-Alexander's mother, became Queen of the Netherlands and German born Claus became known as her Prince Consort.

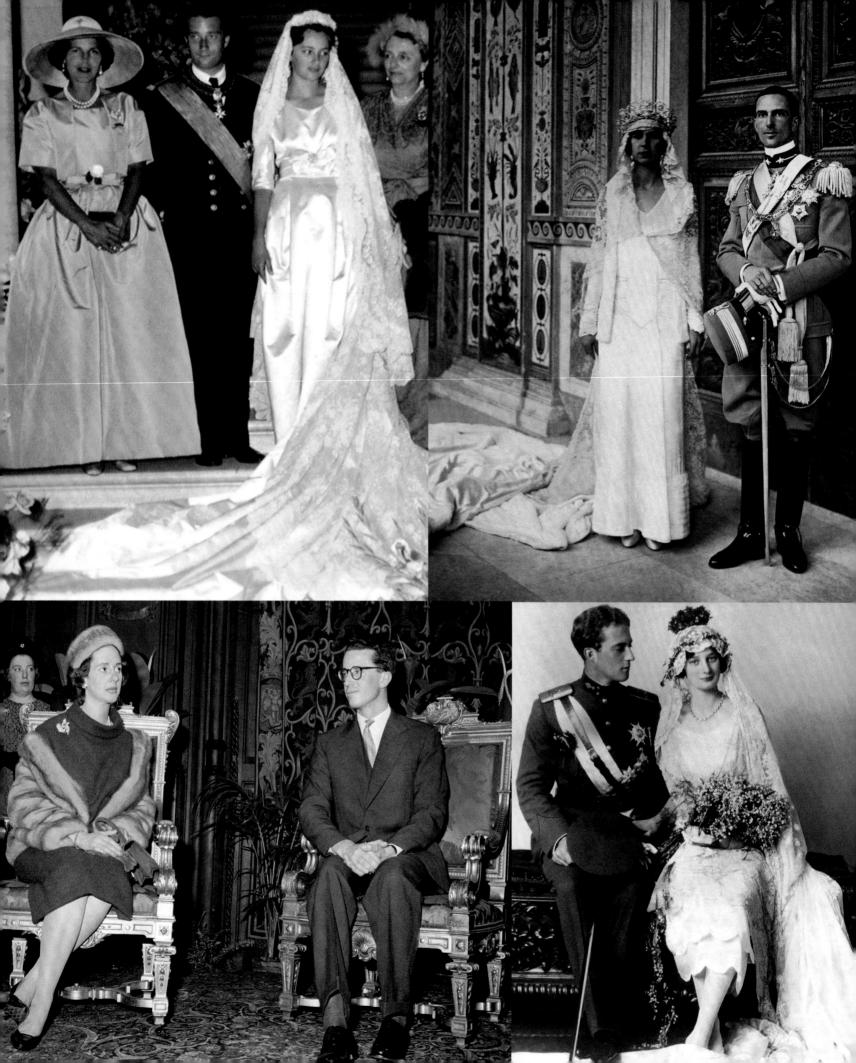

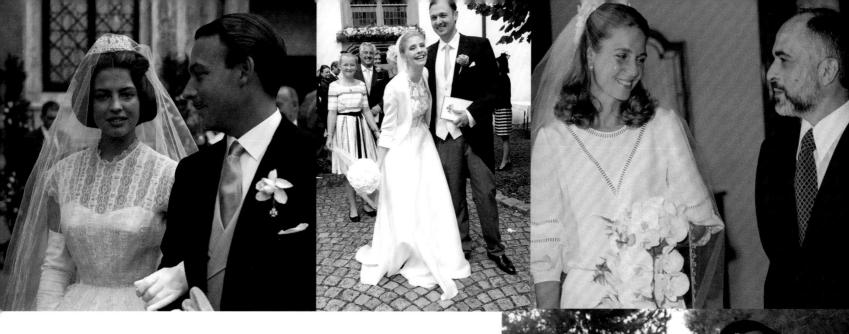

THIS PAGE

ABOVE Fifteen year old Princess Virginia (Ira) von Fürstenberg, dubbed, "the school girl bride" and her prince, Alfonso von Hohenlohe-Langenburg, in Venice on September 30, 1955.

Ira is the daughter of Clara Agnelli & Prince Tasillo von Fürstenberg, niece of Gianni Agnelli, sister of Egon, sister-in-law (to be) of Diane.

ABOVE, CENTER Prince Maximilian of Sayn-Wittgenstein-Berleburg and Franziska Balzer The German prince and Franziska wed in a beautiful ceremony in Bad Laasphe, Germany in August 9, 2016.

ABOVE, RIGHT Lisa Najeeb Halaby, an American architect, became the fourth wife of King Hussein on June 15, 1978, in Amman. Her first name was changed from Lisa to Noor, an Arabic word meaning "light." Queen Noor and King Hussein had four children.

MIDDLE RIGHT King Abdullah II of Jordan, then Prince Abdullah of Jordan, and Rania al-Yassin were married on June 10, 1993 at Zahran Palace in Amman, Jordan.

LOWER RIGHT Prince Karim Aga Khan & The Begum Sarah in Paris on October 31, 1969.

LEFT PAGE

TOP, LEFT Prince Albert of Belgium (now King) and Princess Paola (now Queen) wed on July 2, 1959. Princess Maria Pia di Savoia was Maid of Honor.

TOP, RIGHT Princess Marie José & King Umberto II of Italy in Rome on January 8, 1930.

BOTTOM, LEFT Queen Fabiola de Mora y Aragón & King Baudouin I of Belgium in Brussels on December 15, 1960.

BOTTOM, RIGHT Belgium King Leopold III & Queen Astrid in Stockholm on November 4, 1926.

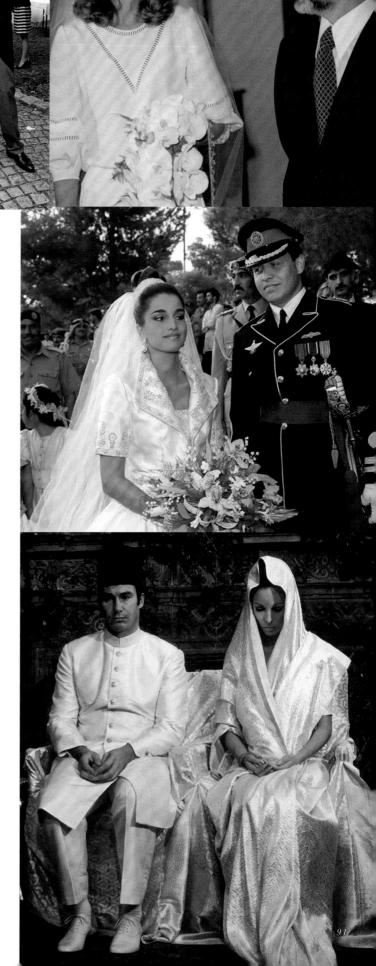

The best Wedding in the World will be mine . . . My dress is perfect . . . Love is in the air today. Zogether we will say our vows, and seal our bond with a kiss . . . Unforgettable..

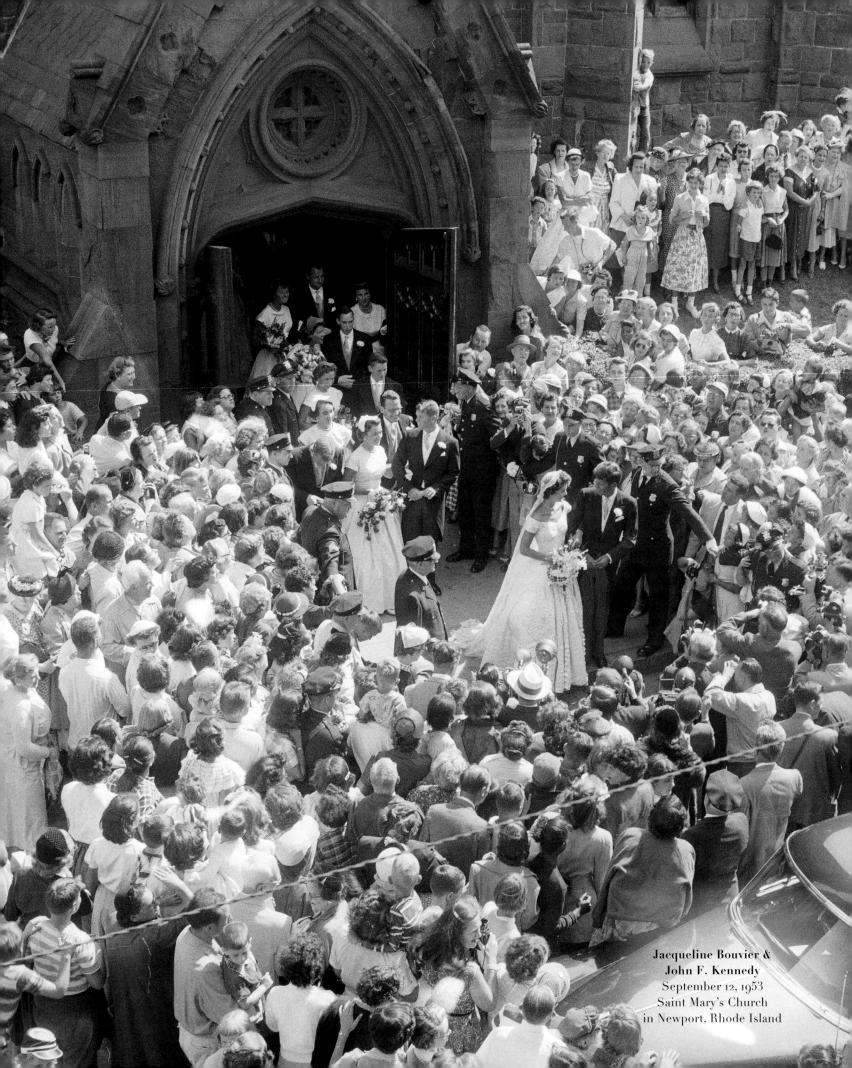

The best weddings in the world

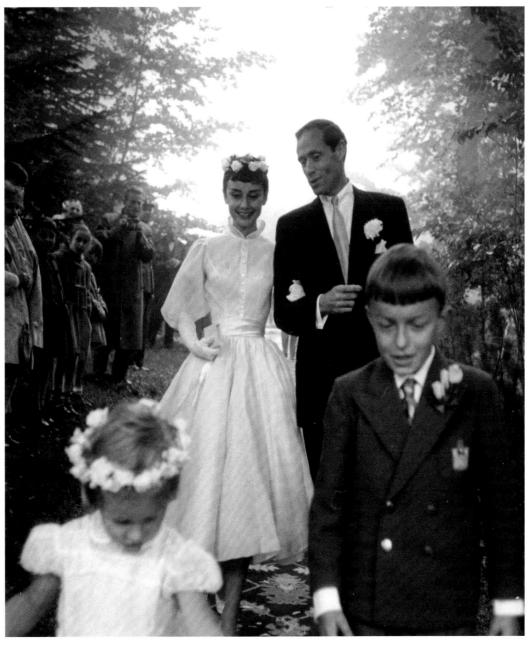

Audrey Hepburn & Mel Ferrer September 25, 1954 Burgenstock, Switzerland

It was a very good year for iconic beauties . . .

Audrey, a Taurus

Jackie, a Leo

Grace, a Scorpio

Born the same year:

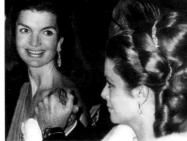

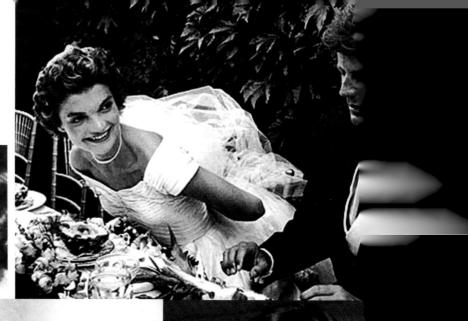

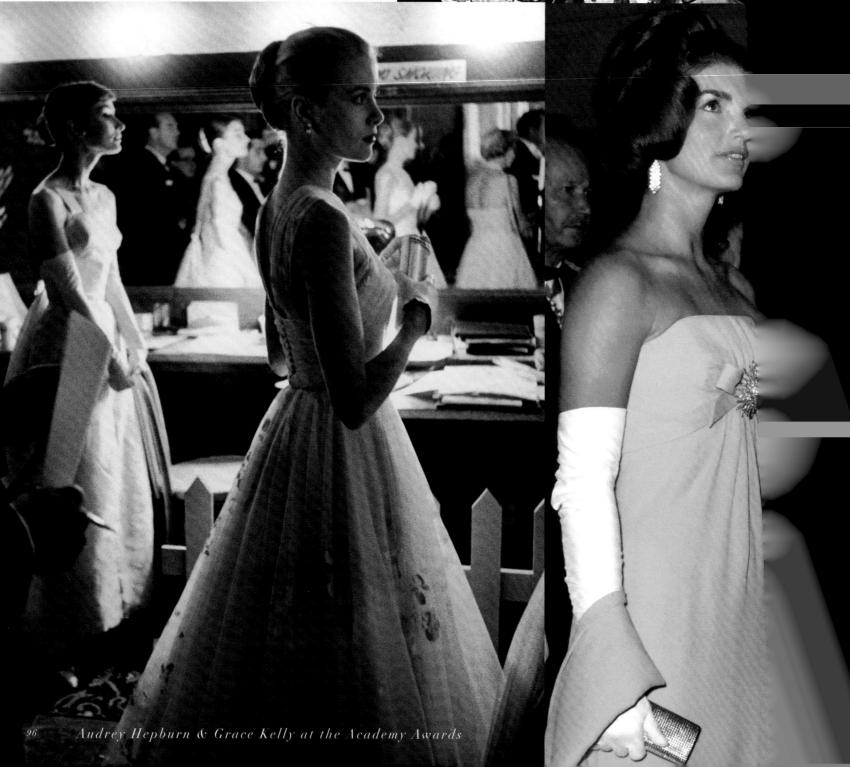

Clark Gable & Joan Crawford

Starring in the 1934 film Forsaking All Others. While they never married each other off the screen this legendary couple, appeared in eight films together.

Orson Welles & Rita Hayworth

September 7, 1943 Santa Monica, California

This marriage was coined the 'beauty and the brain.'

Rita Hayworth & Prince Aly Khan

May 27, 1949 Chateau de l'Horizon, France

Rita dressed by Jacques Fath.

Gina Lollobrigida in the 1961 film

Come September with Rock Hudson.

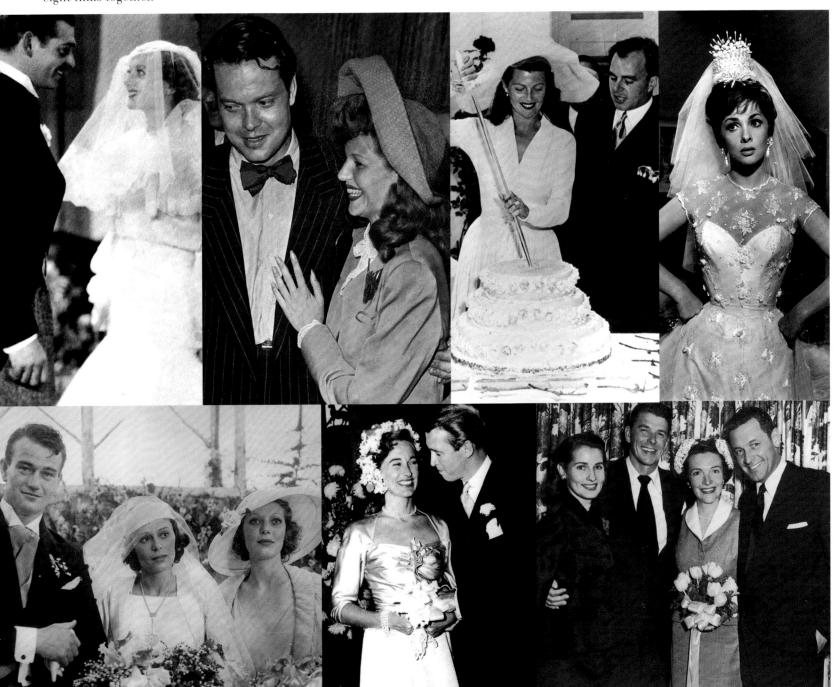

John Wayne & Josephine Saenz July 5, 1933

The wedding took place at the home of Loretta Young who was the Maid of Honor.

Gloria McLean & Jimmy Stewart

August 9, 1949 Brentwood, California

Gloria wore a satin dress with a sweetheart neckline.

Ronald Reagan & Nancy Davis March 4, 1952

Bill and Ardis Holden hosted the Reagan's wedding at the Holden's home in Toluca Lake, California. Ronald Reagan served two terms as our 40th President.

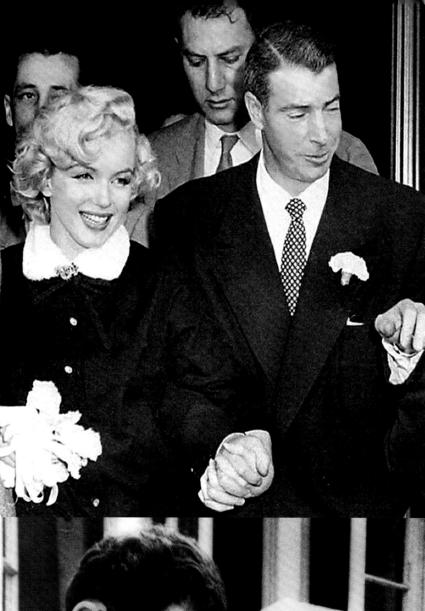

Marilyn Monroe & Joe DiMaggio, her Yankee Slugger January 14, 1954 San Francisco, California

James Dougherty & Marilyn Monroe
On June 19, 1942, 16 year old,
Norma Jeane wore a lace gown
to her first wedding.

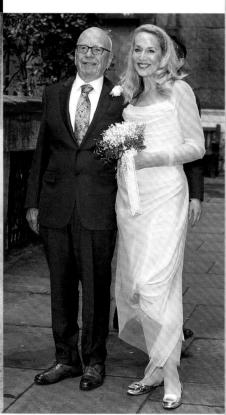

Arthur Miller & Marilyn Monroe June 29, 1956 Roxbury, Connecticut

Marilyn's third wedding with iconic American writer Arthur Miller.

Jerry Hall & Rupert Murdoch March 5, 2016

Jerry in a Vivienne Westwood gown, at St Bride's Church, Fleet Street.

OPPOSITE

TOP LEFT Kathryn Grant & Bing Crosby October 24, 1957 Las Vegas, Nevada

TOP RIGHT **Mia Farrow & Frank Sinatra** July 19, 1966 Las Vegas, Nevada

Mia wore a "Jackie" inspired dress with bow and jacket.

BOTTOM LEFT Hillary Rodham & Bill Clinton October 11, 1975 Fayetteville, Arkansas

> BOTTOM FAR LEFT Barack Obama & Michelle Robinson October 3, 1992

Married at Trinity United Church in Chicago.

CENTER
Donald J. Trump &
Melania Knauss
Jan. 22, 2005
Palm Beach, Florida

BOTTOM CENTER Judy Garland & Vincente Minnelli June 18, 1945

The wedding took place at the home of Judy's mother in Los Angeles. She wore a gray jersey dress.

BOTTOM RIGHT Julie Andrews & Tony Walton May 10, 1959 Weybridge, Surrey

Shown holding her father's hand while on her way to wed her childhood sweetheart.

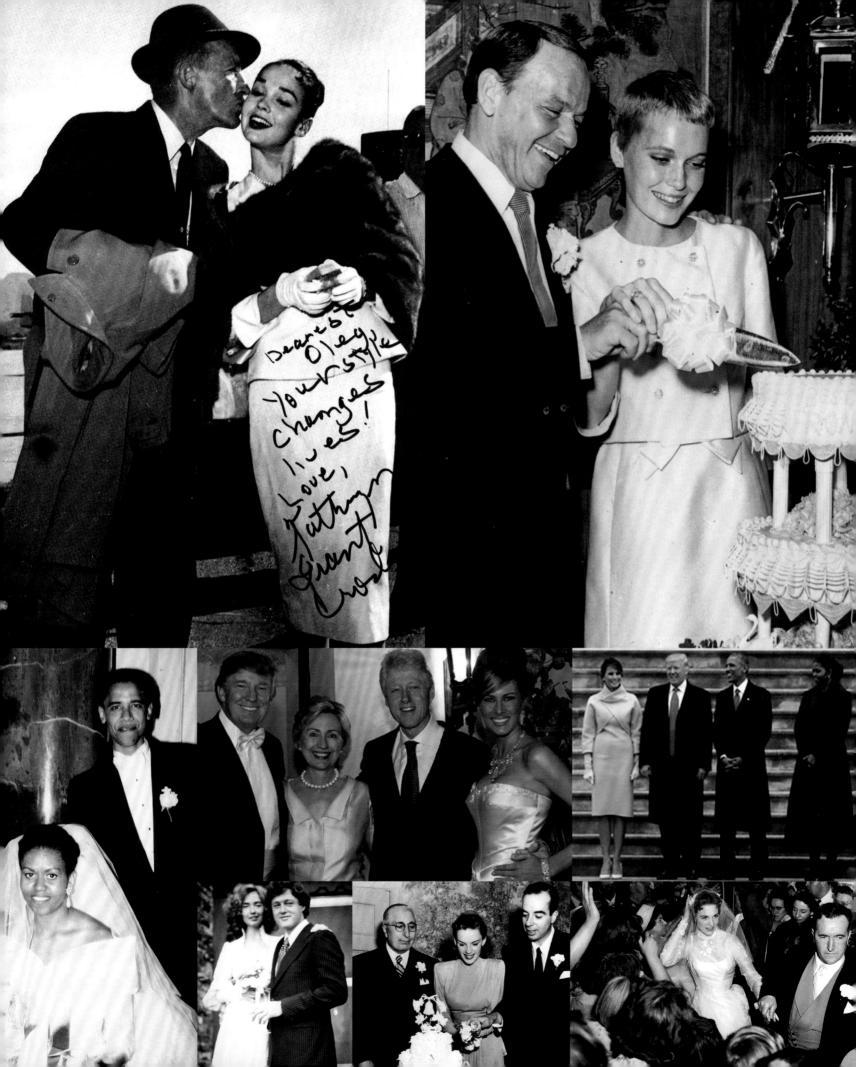

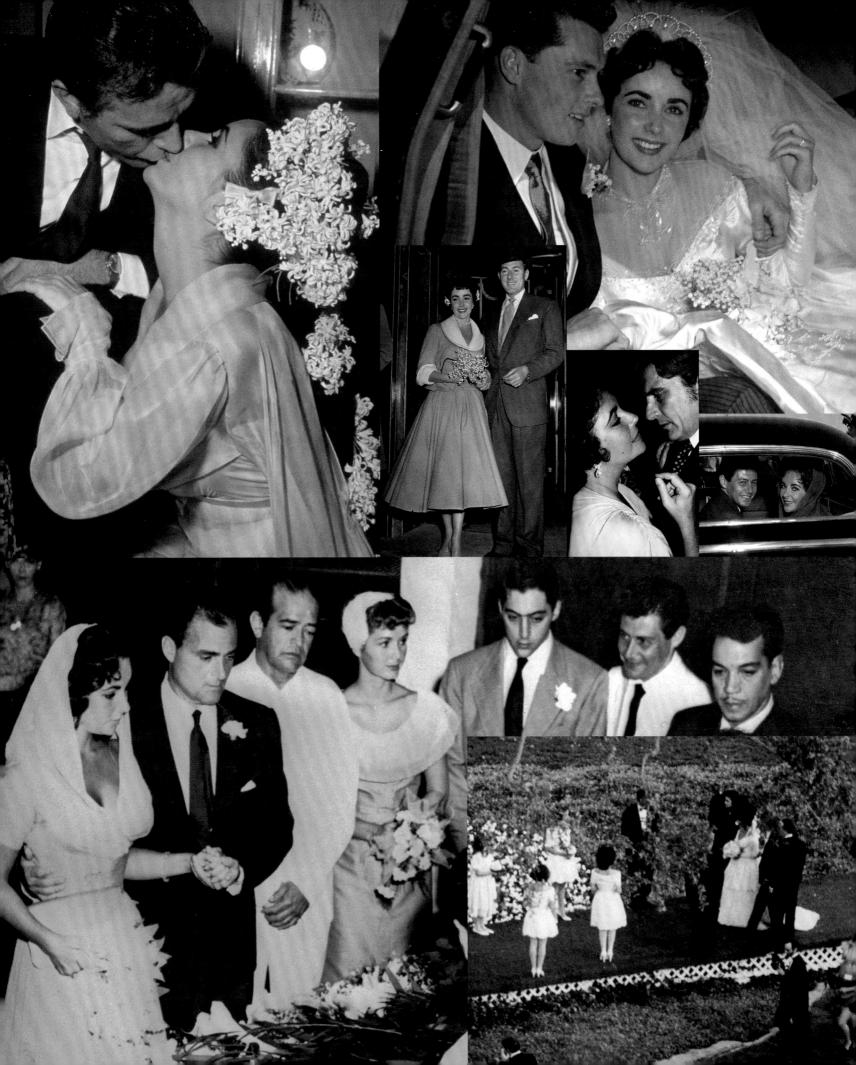

OPPOSITE

Elizabeth Taylor & Nicky Hilton May 6, 1950

Nicky was the hotel heir and great-uncle of Paris Hilton. Elizabeth's wedding gown was designed by Helen Rose.

> Elizabeth Taylor & Michael Wilding February 21, 1952

Elizabeth wore a tea-length dress with portrait collar.

Elizabeth Taylor & Mike Todd
February 2, 1957

Todd was a stage & film producer. Elizabeth wore a gown designed by Helen Rose.

> Elizabeth Taylor & Eddie Fisher May 12, 1959

Elizabeth Taylor & Richard Burton March 15, 1964 Montreal, Canada

The dress was designed by Irene Sharaff. Elizabeth and Richard would remarry on October 10, 1975.

Elizabeth Taylor & Senator John Warner December 4, 1976

Elizabeth Taylor & Larry Fortensky October 6, 1990

At Neverland Ranch with Michael Jackson. The dress was designed by Valentino.

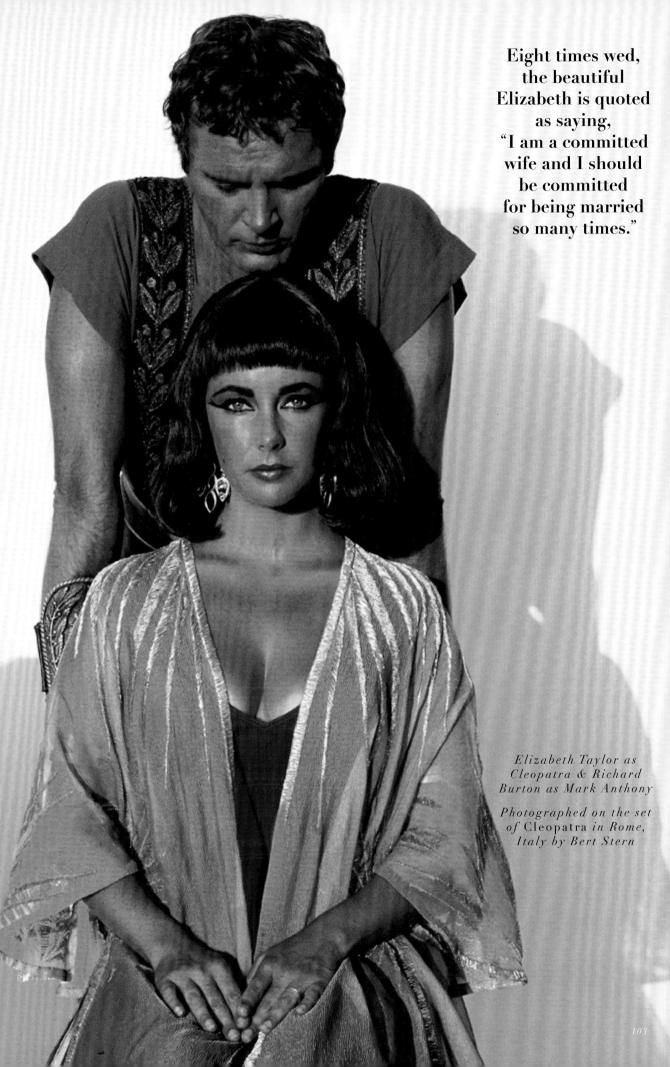

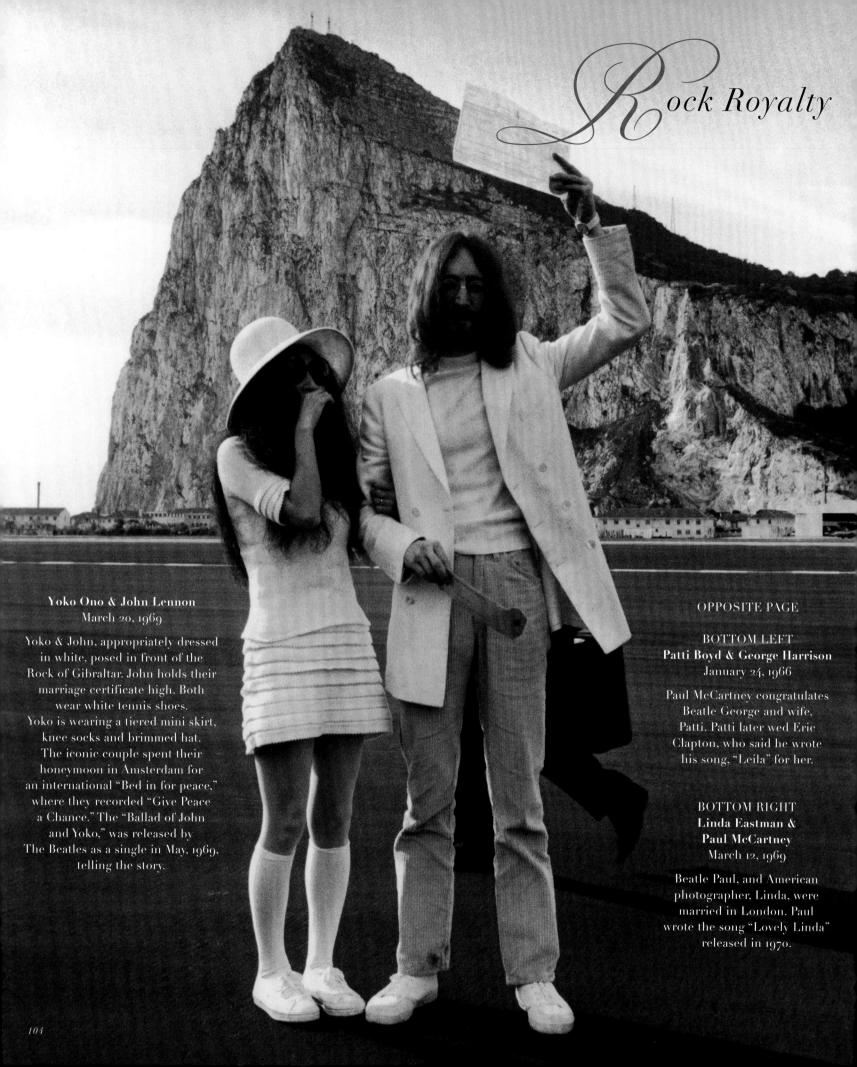

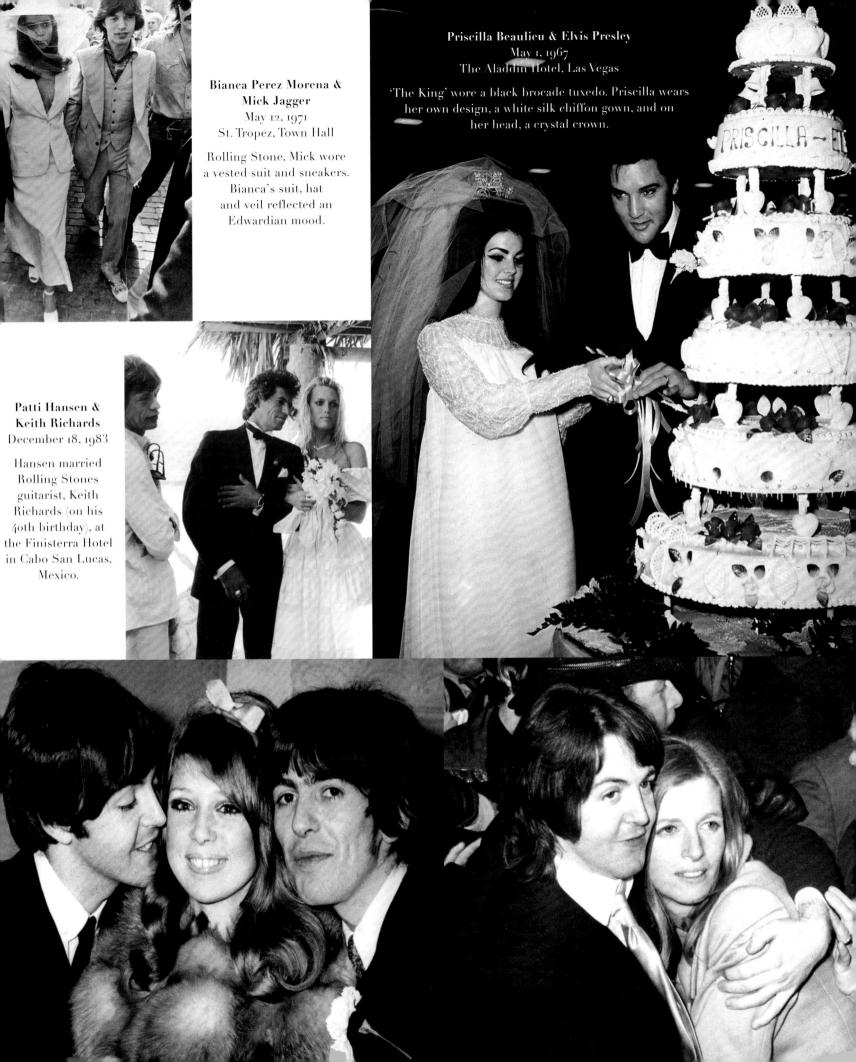

Gianni and I were fri

I knew Gianni Agnel Pucci since we were con the beach at Forte Italy. Fiat was Giann and he liked to be cal 'avvocato' (lawyer).

Slim and elegant, Gia gesture was distinctive immensely well dress dangerously, roaring haute corniche to Ca 100 miles per hour fr La Leopolda, former home of King Leopol

I would spend weeks with Gianni and the beautiful, Marella.

At La Leopolda, I wo my own guest pavillic the main house with swimming pool and I in attendance.

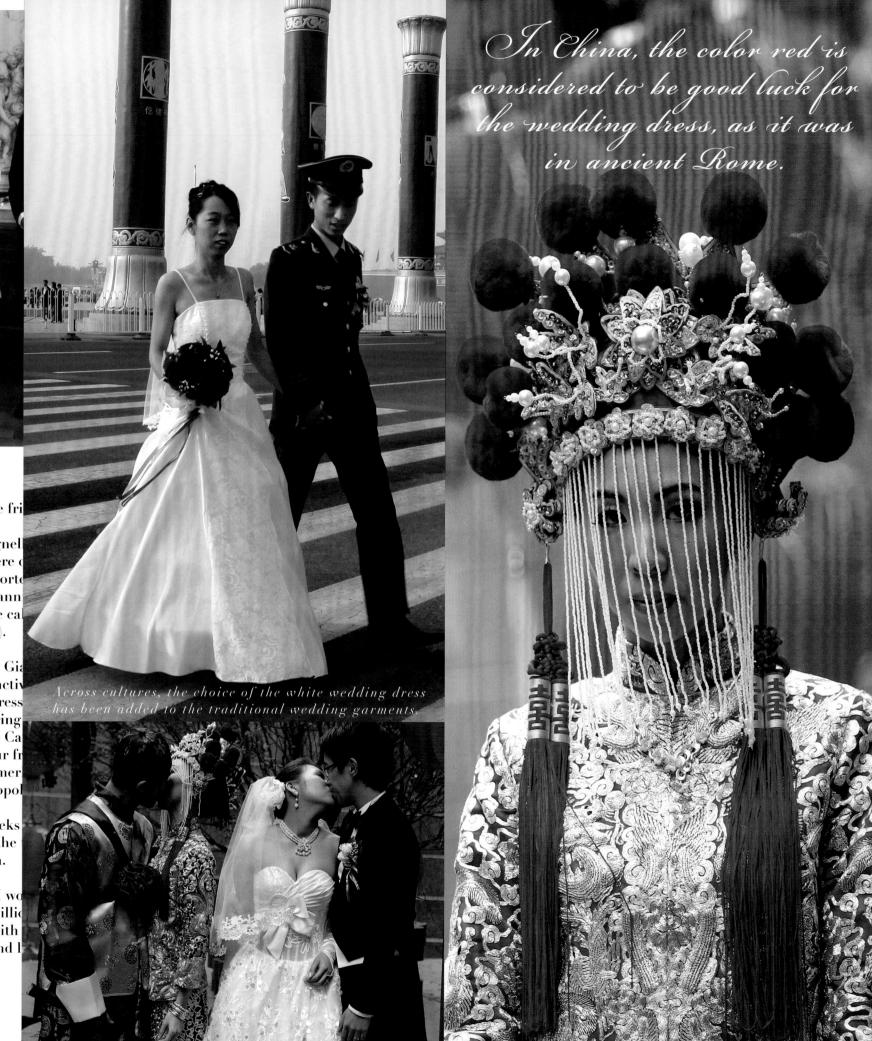

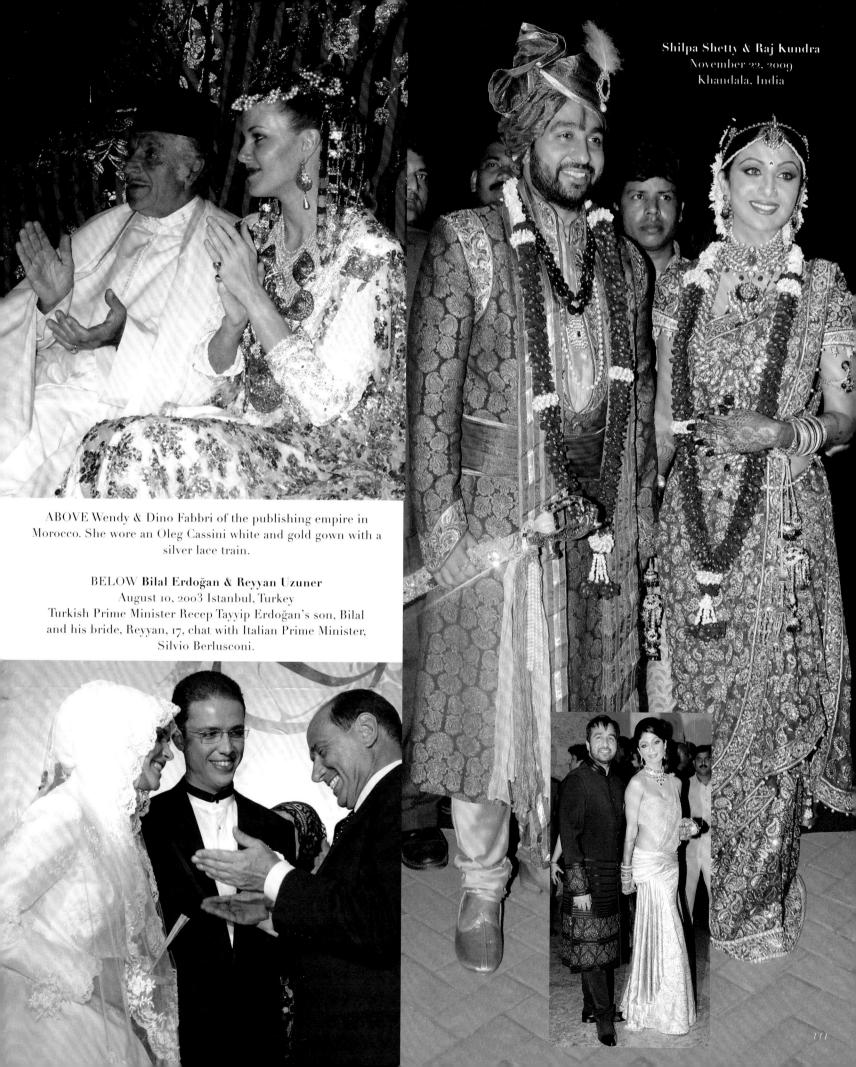

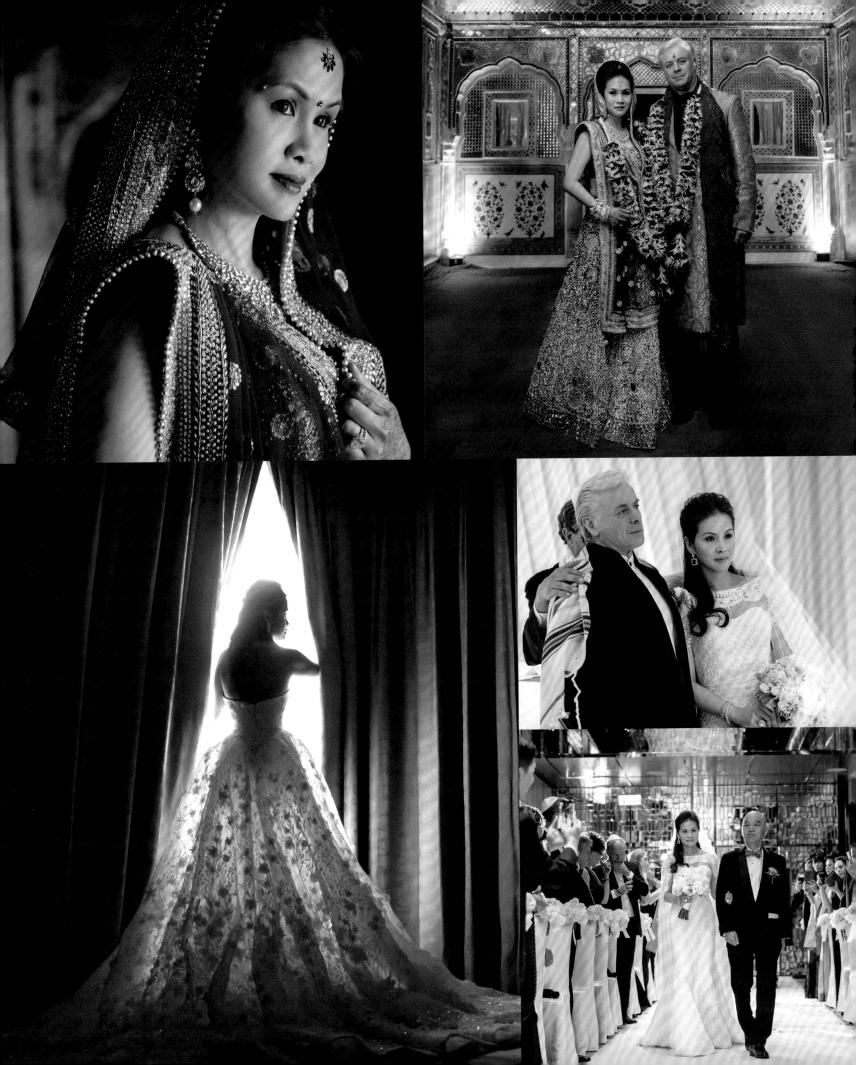

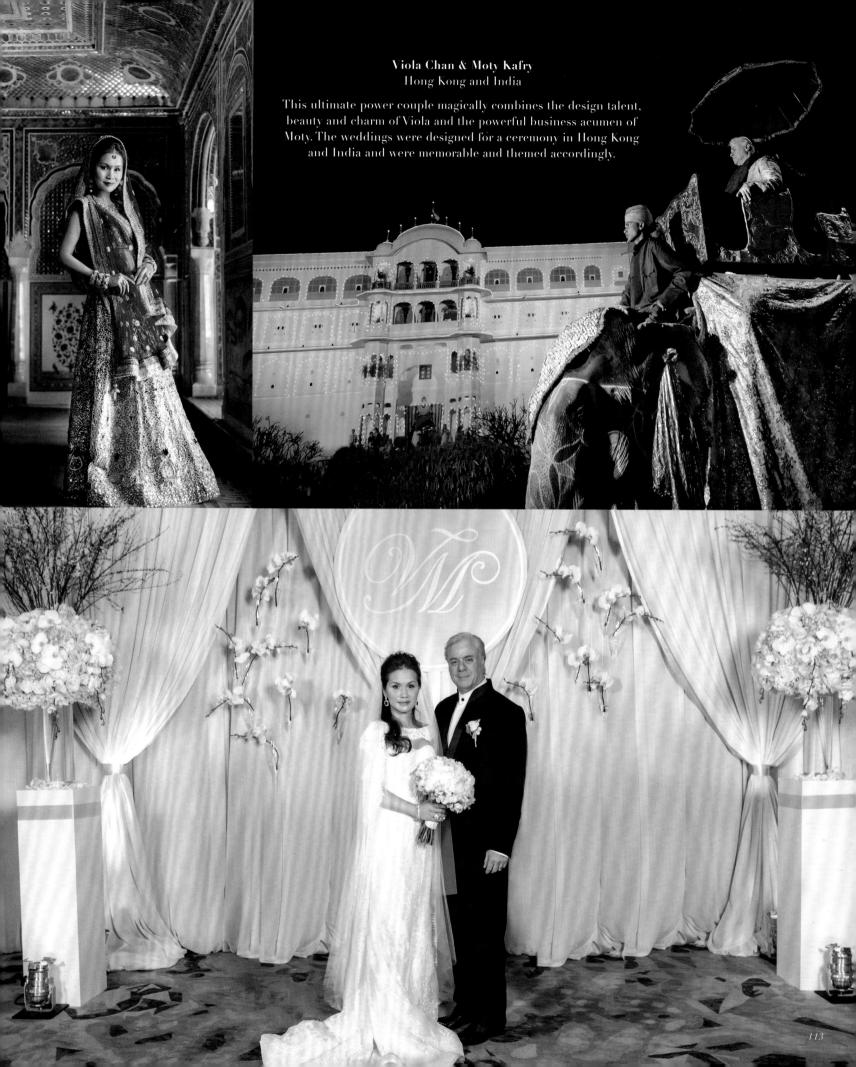

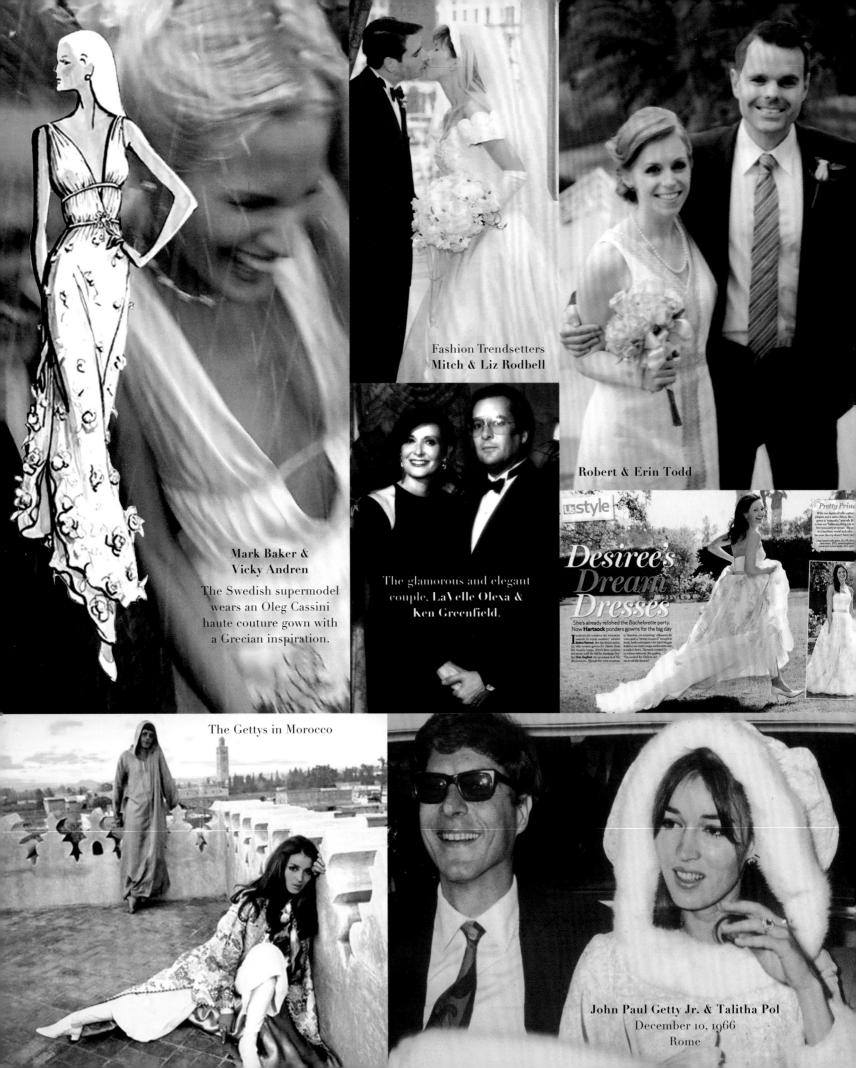

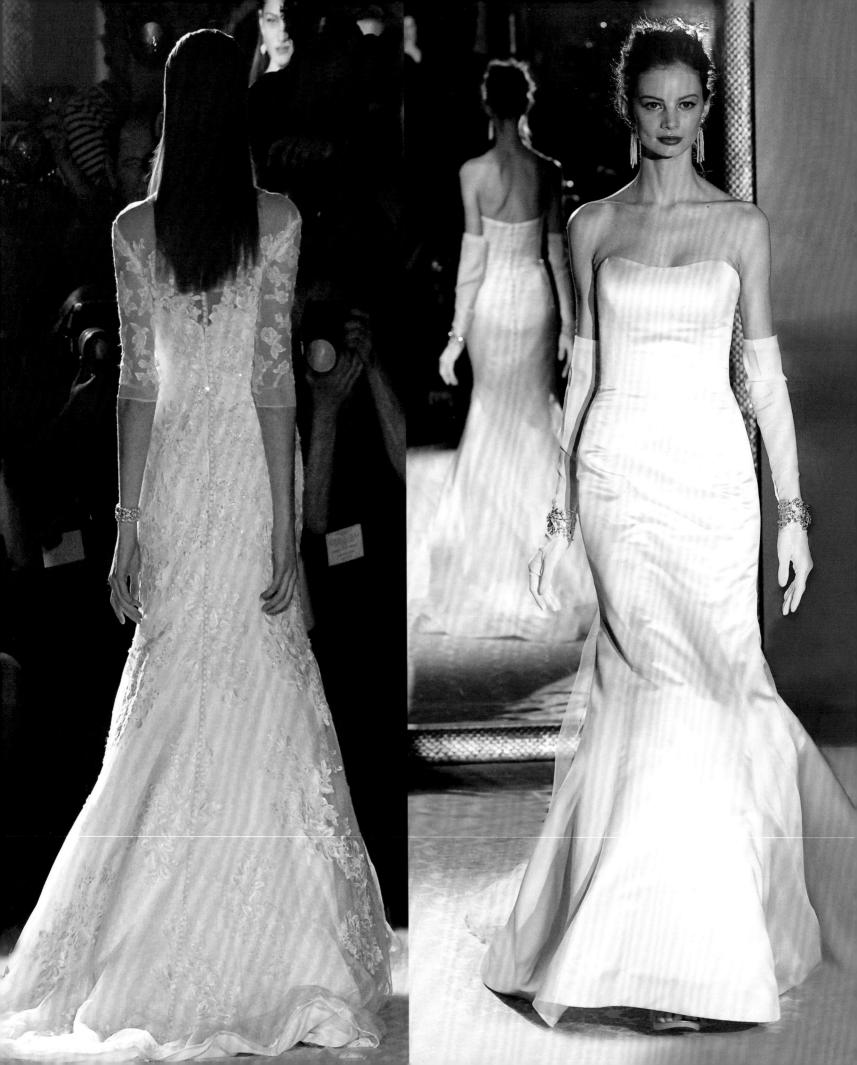

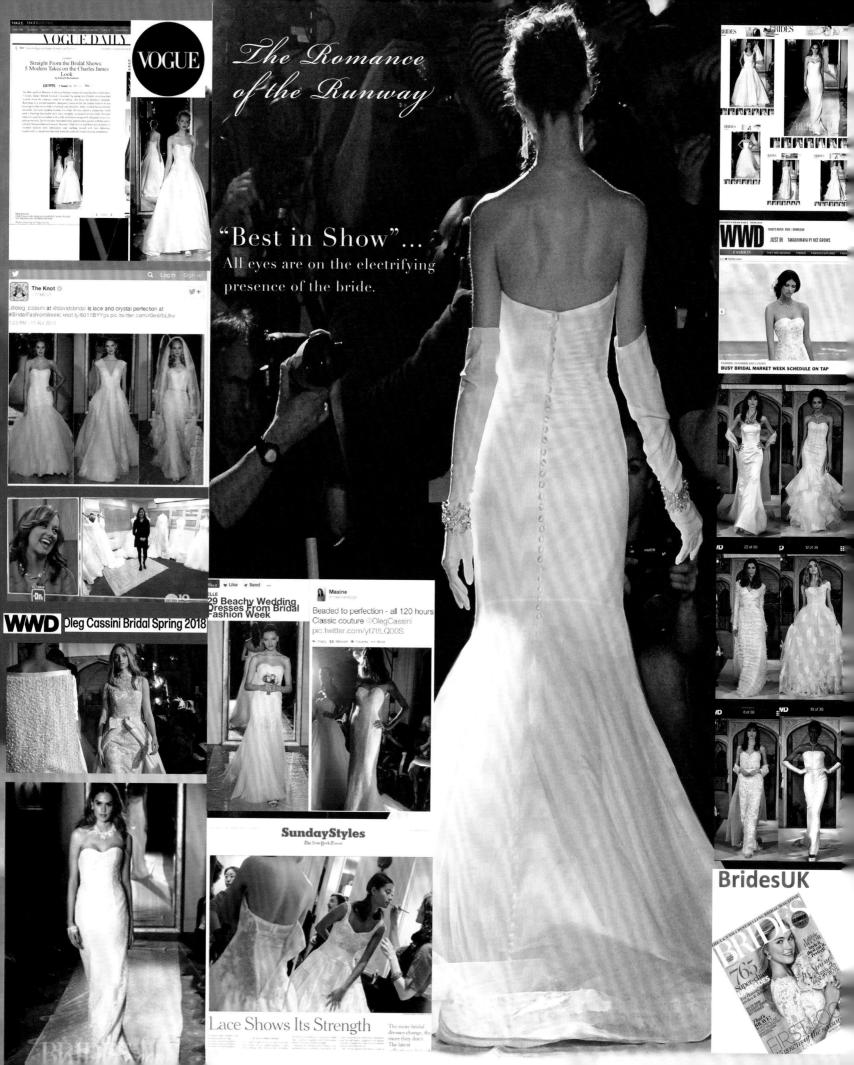

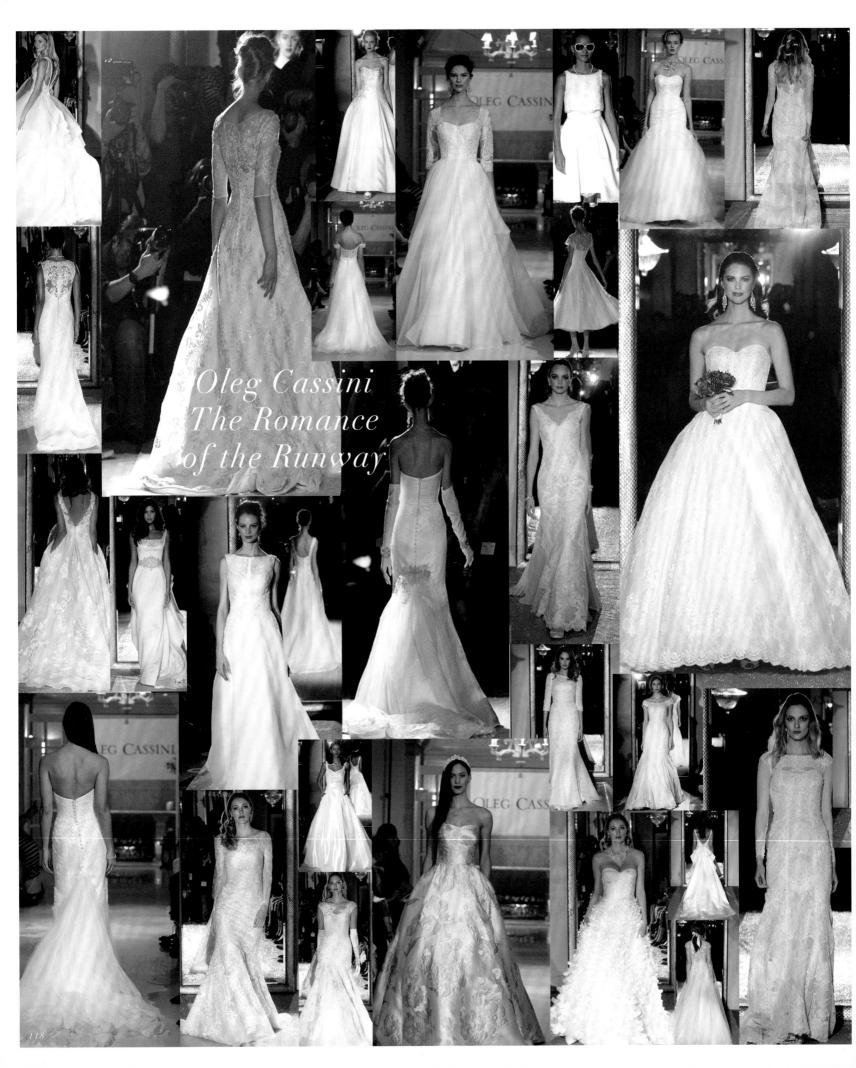

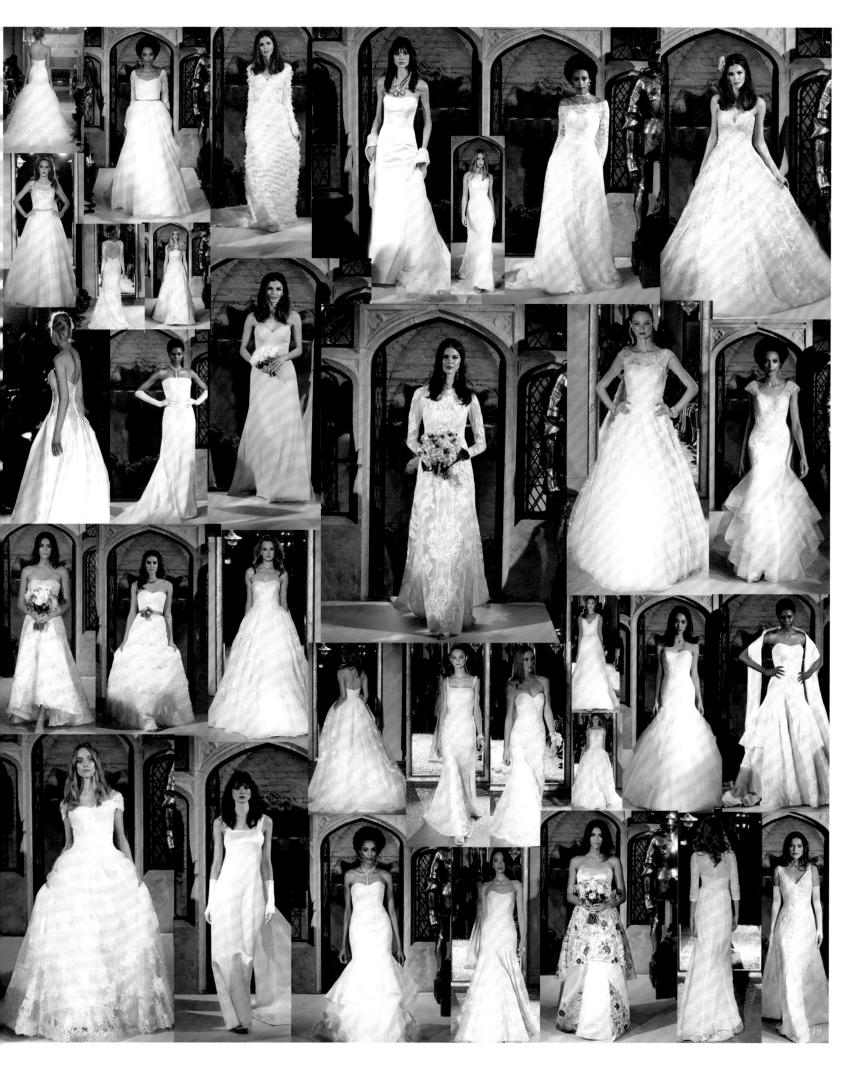

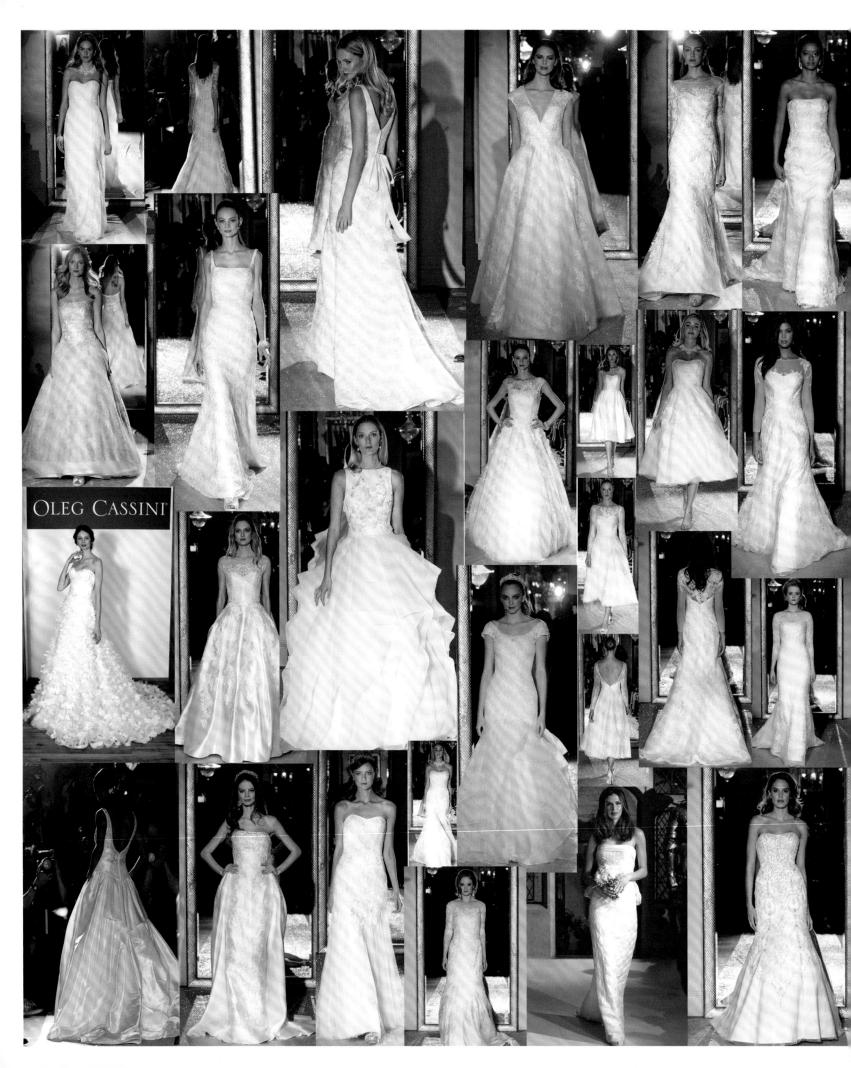

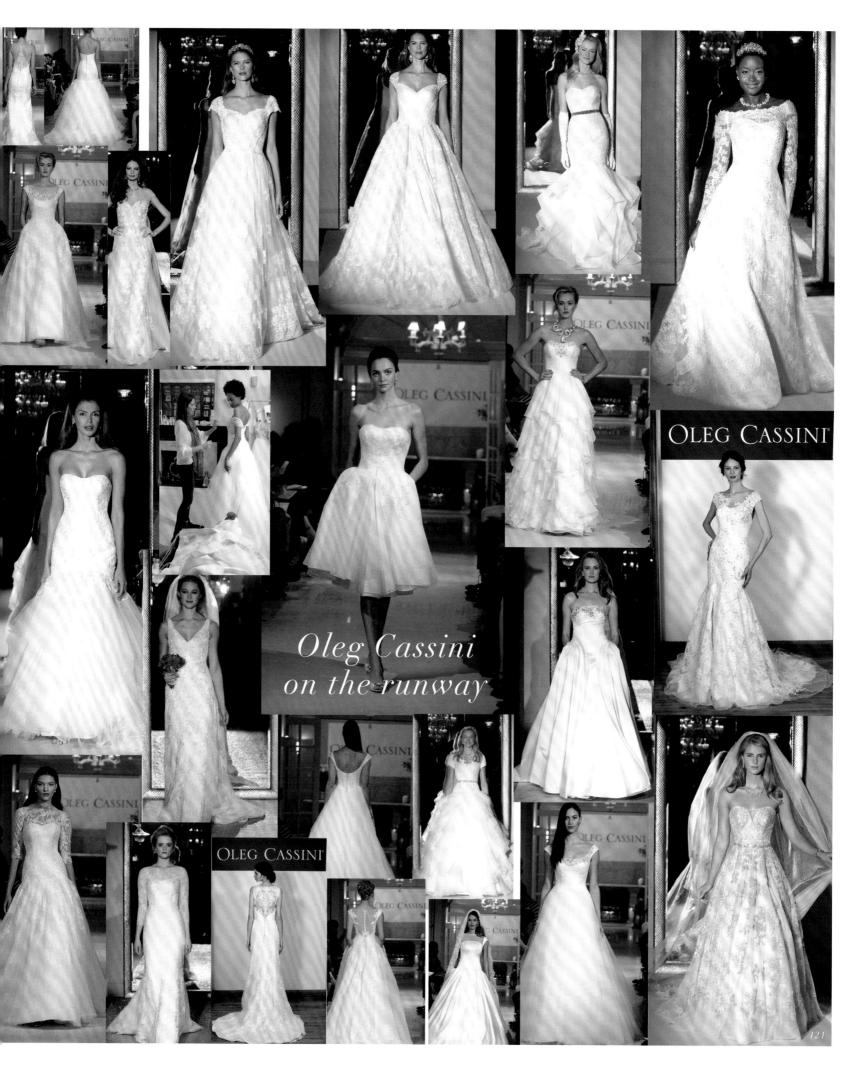

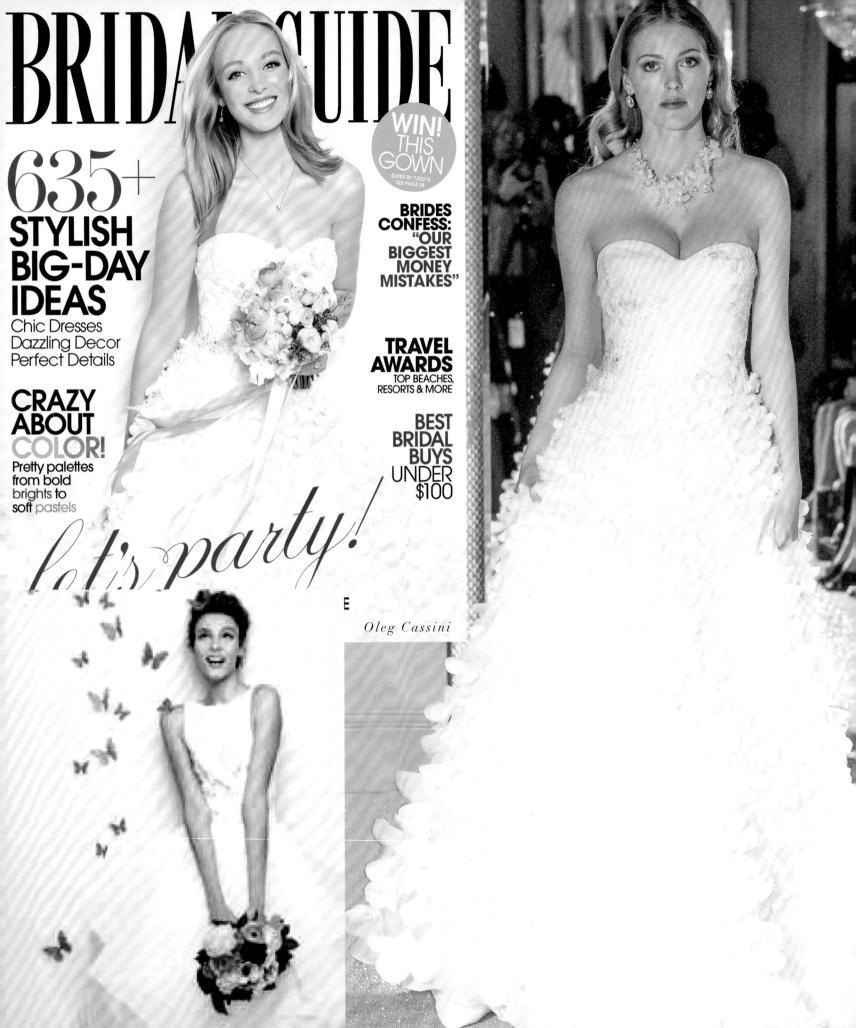

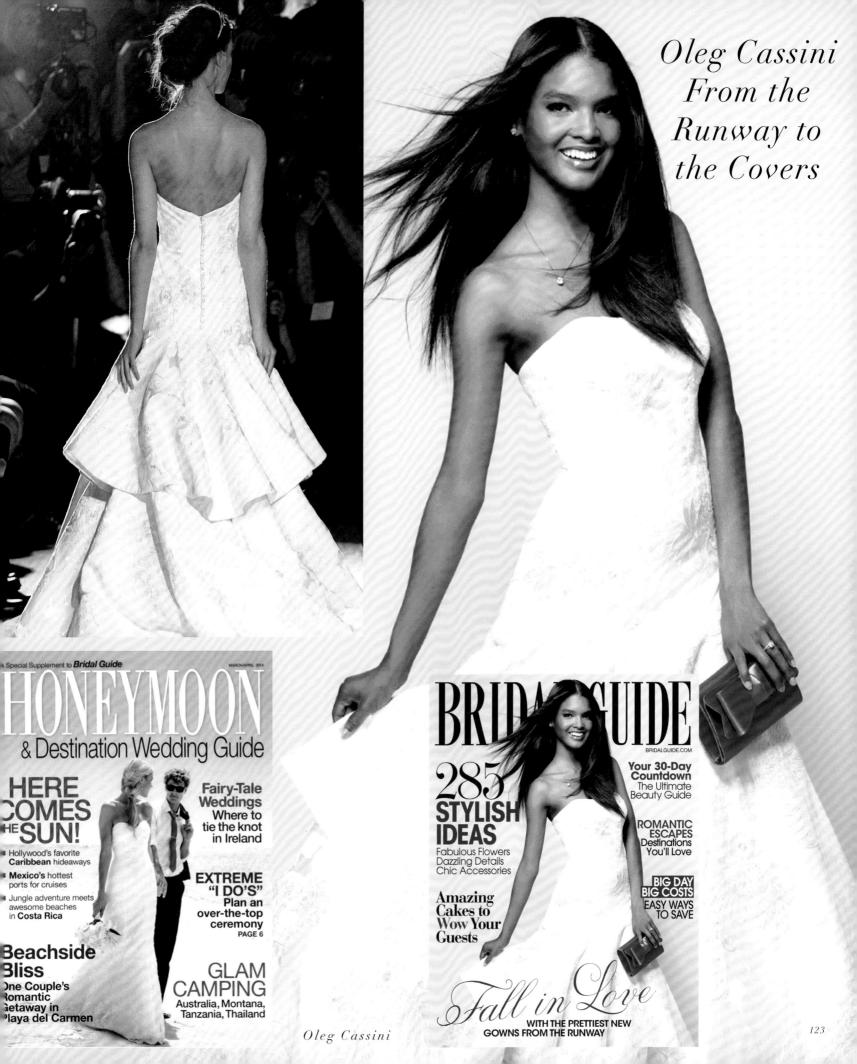

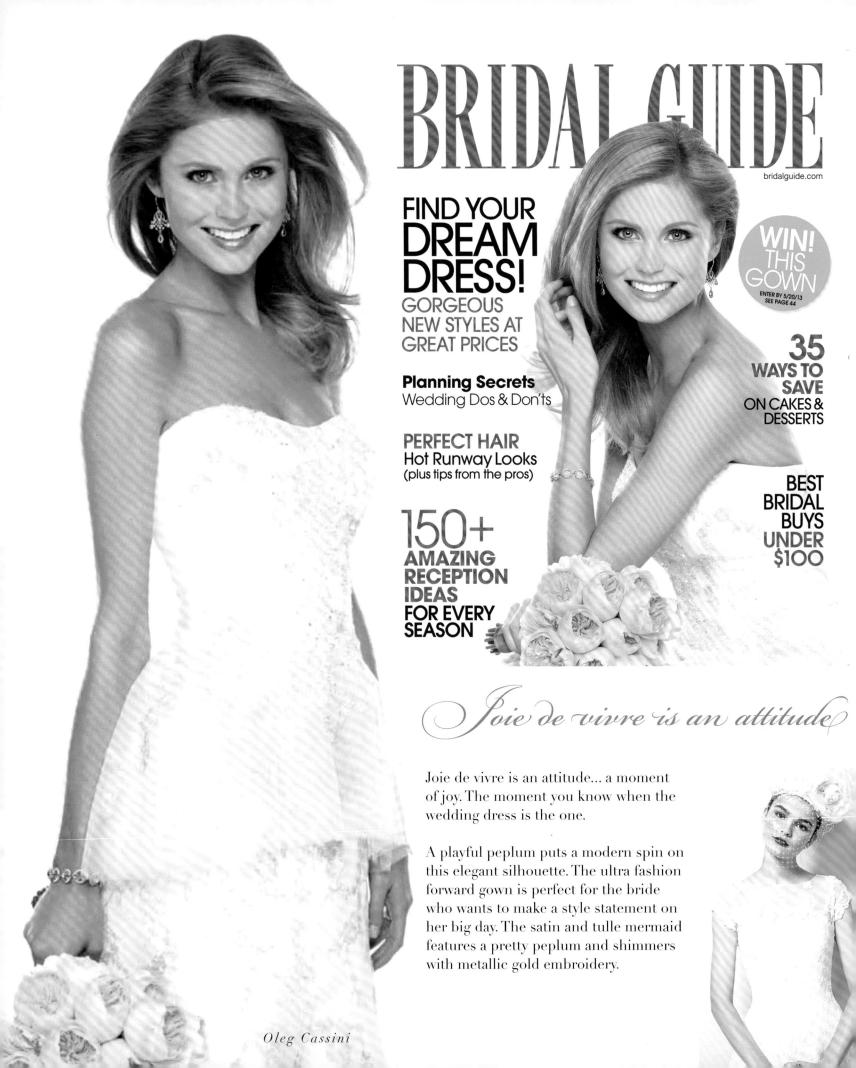

Oleg Cassini Princess Brides

Shimmery, beaded details add an ultra-sweet and elegant touch to this romantic ball gown. Dazzle your guests in this sumptuous, lace gown. With more than 60 yards of lady-like lace,10,000 hand applied beads and sequins, demure cap sleeves and a basque waist, this dress is a sophisticated bride's fairy-tale dream come true.

CLASSIC CARIBBEAN RESORTS

BAHAMAS, PUERTO RICO, ST. LUCIA, DOMINICAN REPUBLIC

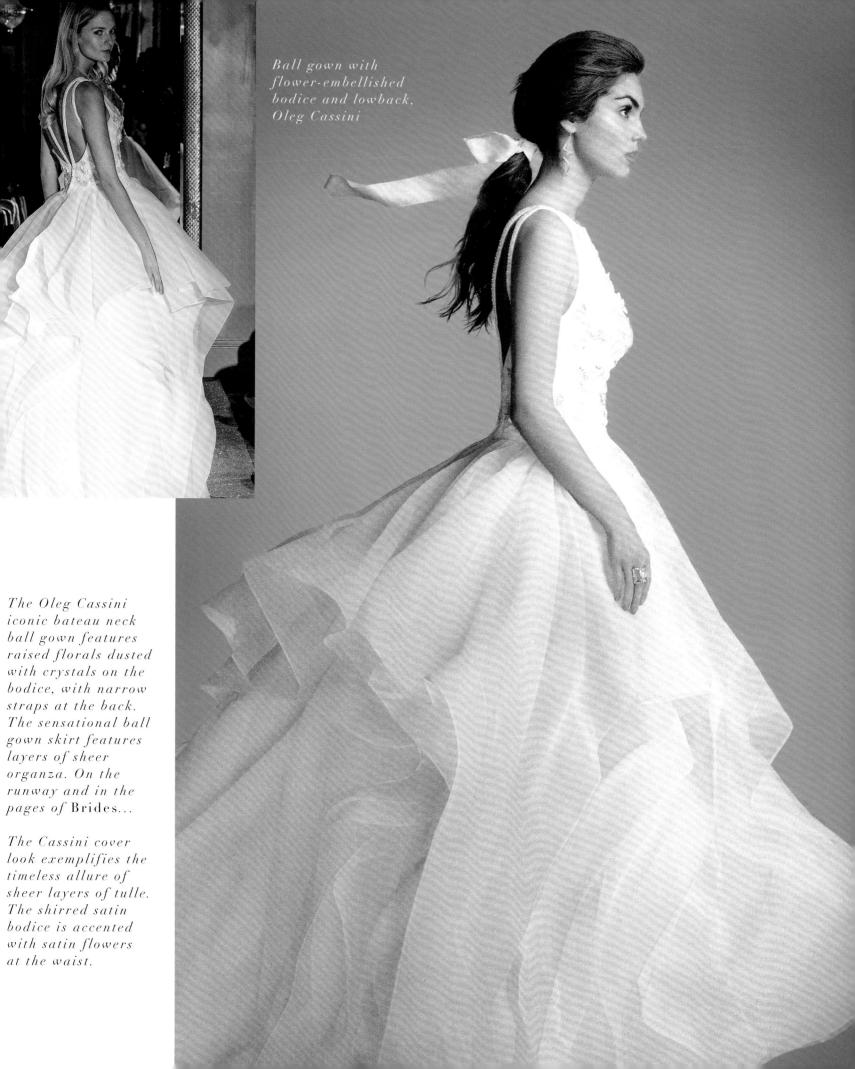

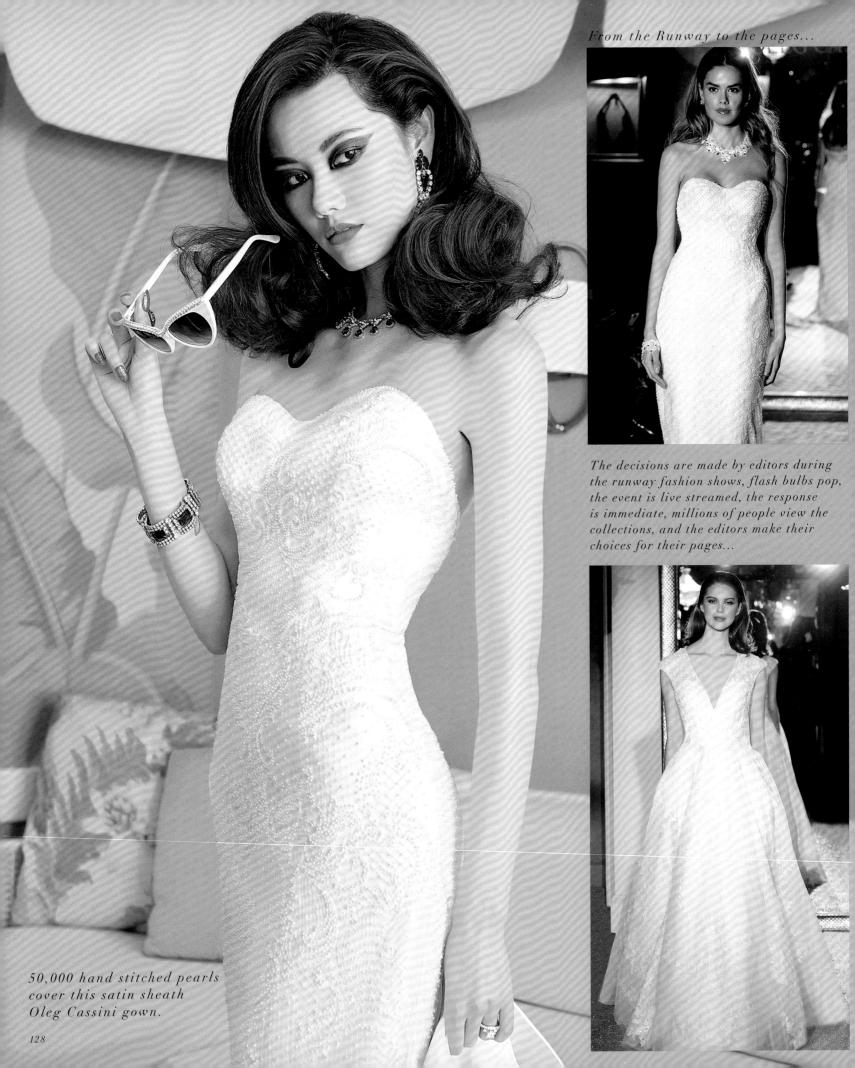

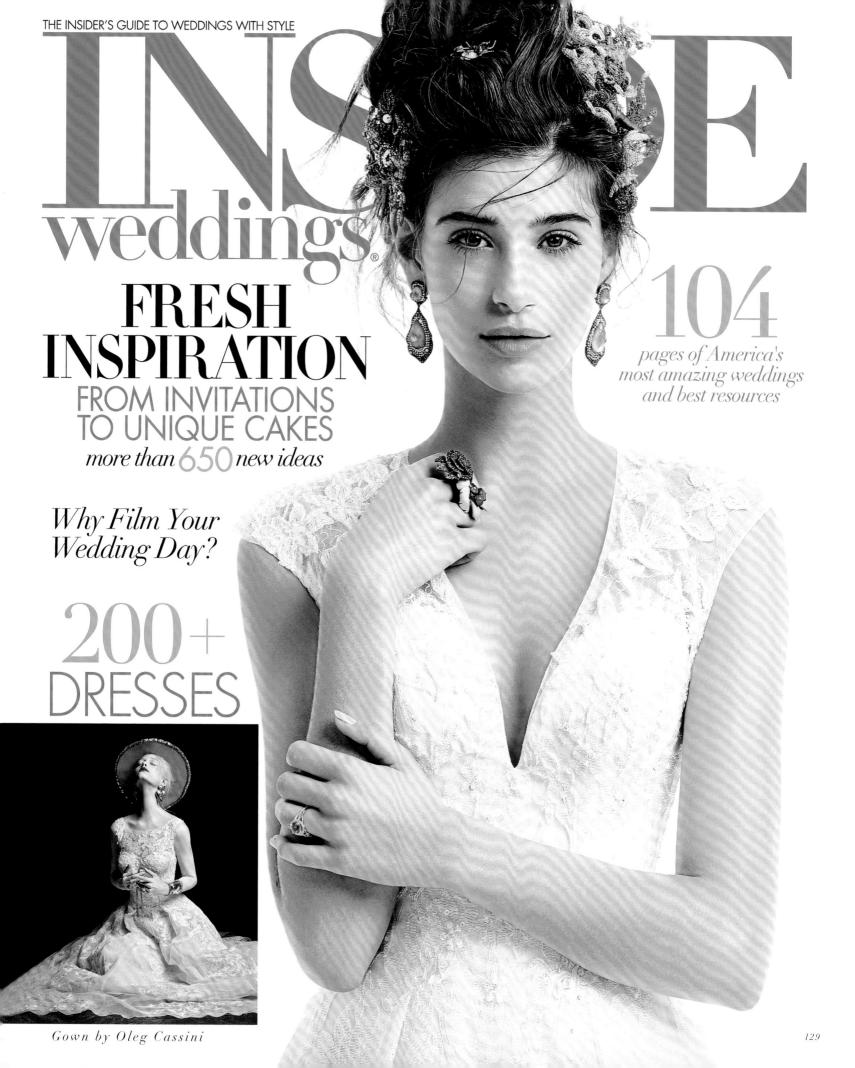

Drecious Metals

Gold & platinum threads are intertwined to create a magnificent damask fabric, crafted into this dramatic ball gown. The narrowed bodice evolves into the extravagant ball gown skirt. Couture details abound, inseam pockets and tiny damask covered buttons all down the back of the floor length gown to the edge of its wide circle hem.

The Fantastics . . .

The romance and fantasy of the 18th Century royal court gown is envisioned in this 21st Century creation. The richly embroidered narrowed center column is accented with side panniers of smooth ivory satin, making a magical and regal fashion statement from Oleg Cassini.

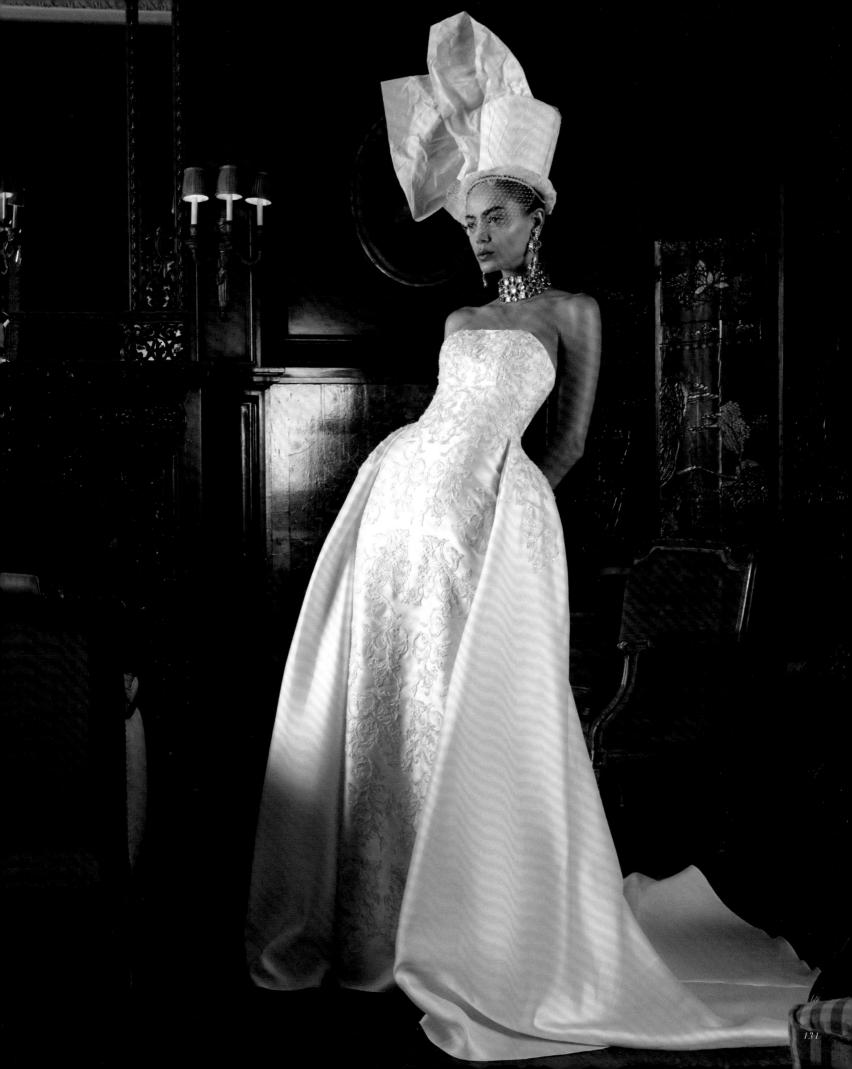

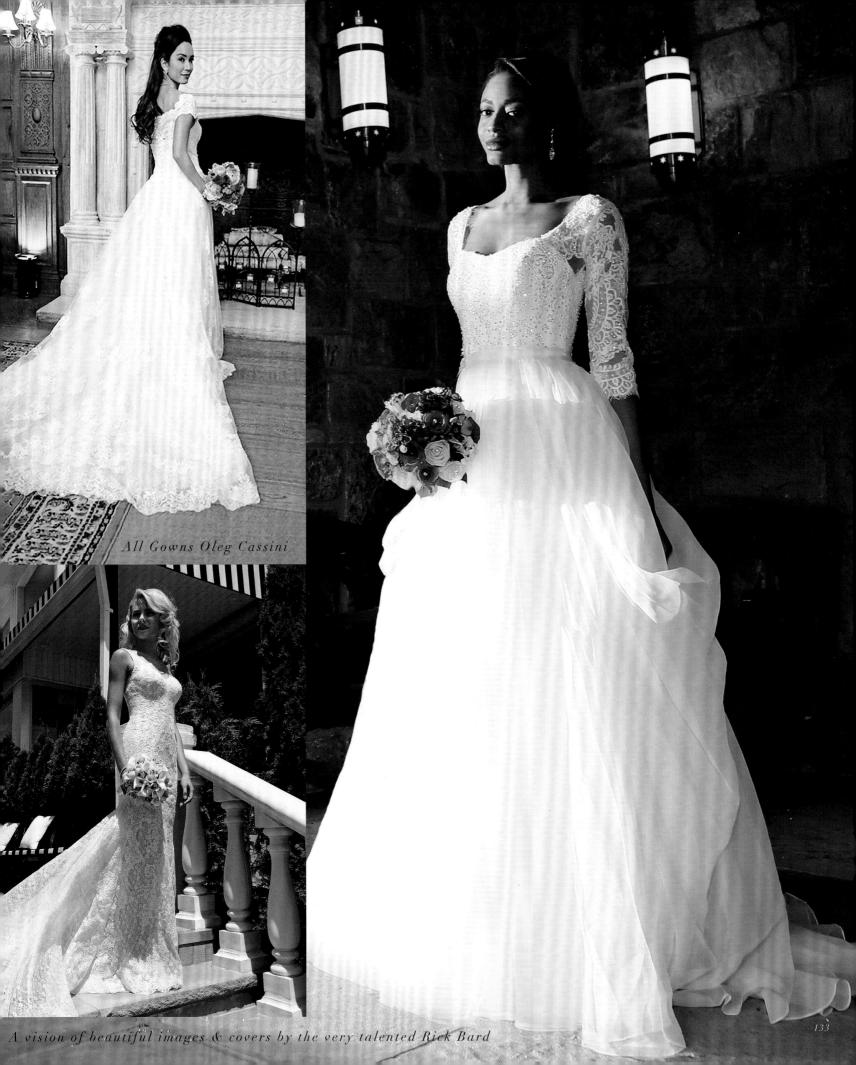

Oleg Cassini Gown

T&C WEDDINGS

Princess CUT MONACO July 2, 2011 OLEG CASSINI

THEY KISSED
A LOT OF
FROGS BEFORE
FINDING
THEIR PRINCES.
THE DRESS
SHOPPING
PROCESS
NEEDN'T BE
AS LABORIOUS.

By Sarah Bray

GRACE PERIOD Princess Charlene, a former Olympic swimmer, wore Armani Privé. The draped silk duchesse satin neckline flattered her strong shoulders.

CHARLENE WITTSTOCK & PRINCE ALBERT II OF MONACO

Classic blooms, such as peonies, lilies, and d Oleg Cassini gown

TOWNANDCOUNTRYMAG.COM

ABOVE Sheer illusion tulle is gathered across the Sweetheart neckline. The opulent ball gown skirt has layers of lace and illusion covered with gold filigree motifs of embroidered flowers.

RIGHT The sheath gown with rounded circle train features a sweetheart curved back with covered buttons. Three dimensional flowers are hand stitched on the sheer illusion overlay. Photographed on the Serengeti plains by the talented team of Town & Country.

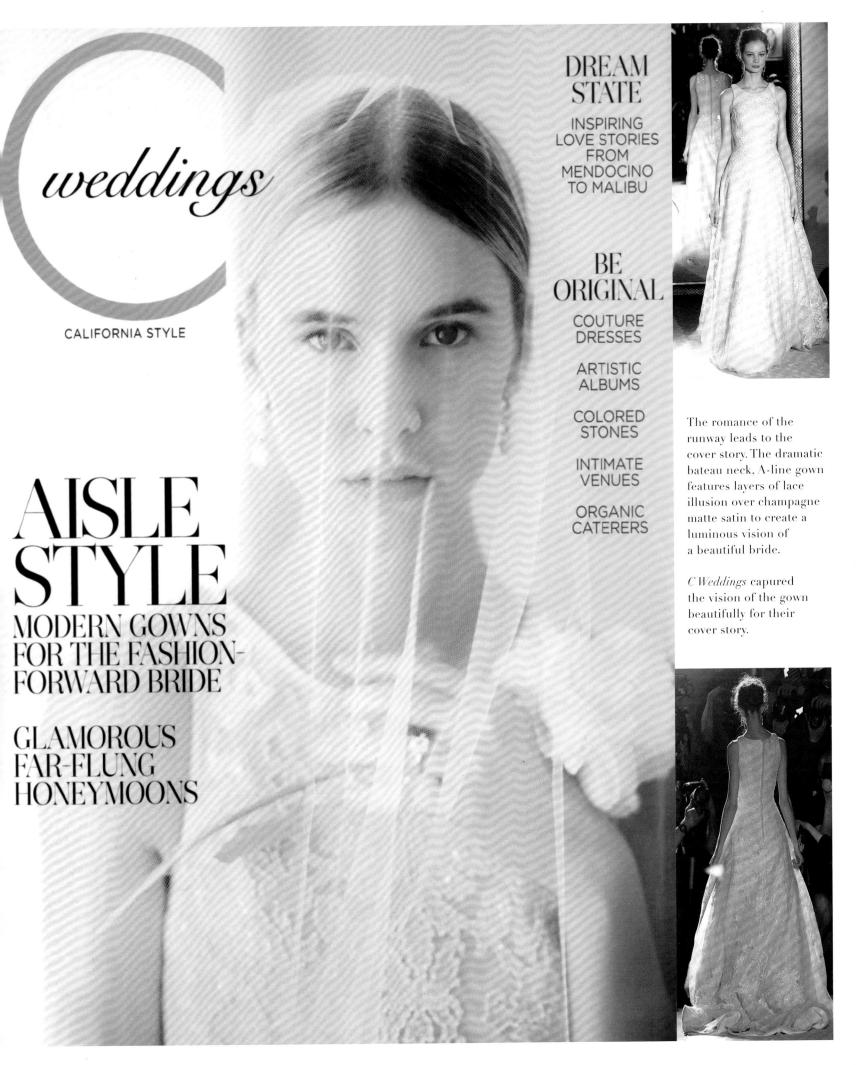

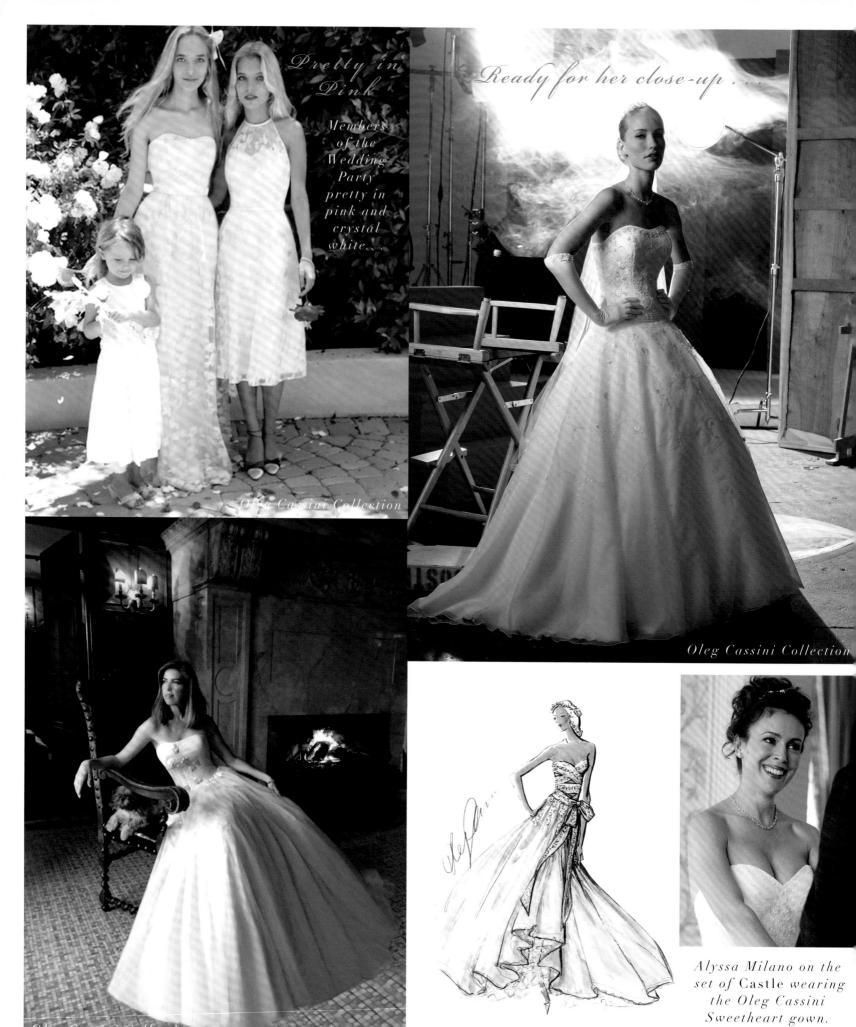

In Hollywood, Malin Akerman photographed by Jeff Forney, is wearing a white chiffon Cassini strapless gown with a sweetheart neckline trimmed in black chiffon flowers frosted with jet crystals.

The Oleg Cassini Bridesmaid's Collection . . .

Satin is teamed with layers of tulle in the rich and vibrant shade of wine highlighted at the narrowed waist with sparkling crystals.

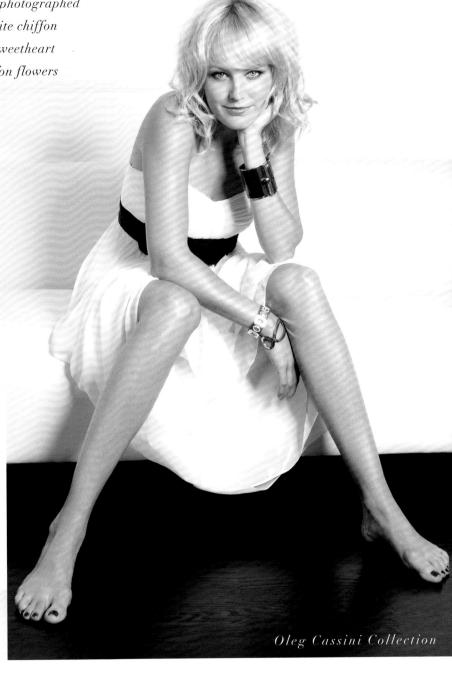

The Sweetheart Neckline

If symbols can be portents of the future, what better choice can a bride make for her dress's neckline than a sweetheart? So called because it resembles the top of a heart, the meaning imbued in the name of this very popular and flattering style only enhances its appeal. A sweetheart neckline is most often used with a strapless bodice, though it can be paired with sleeves, to add intrigue to more conservative styles, such as on the sweetheart gown that Queen Elizabeth wore to her 1947 wedding to Prince Philip.

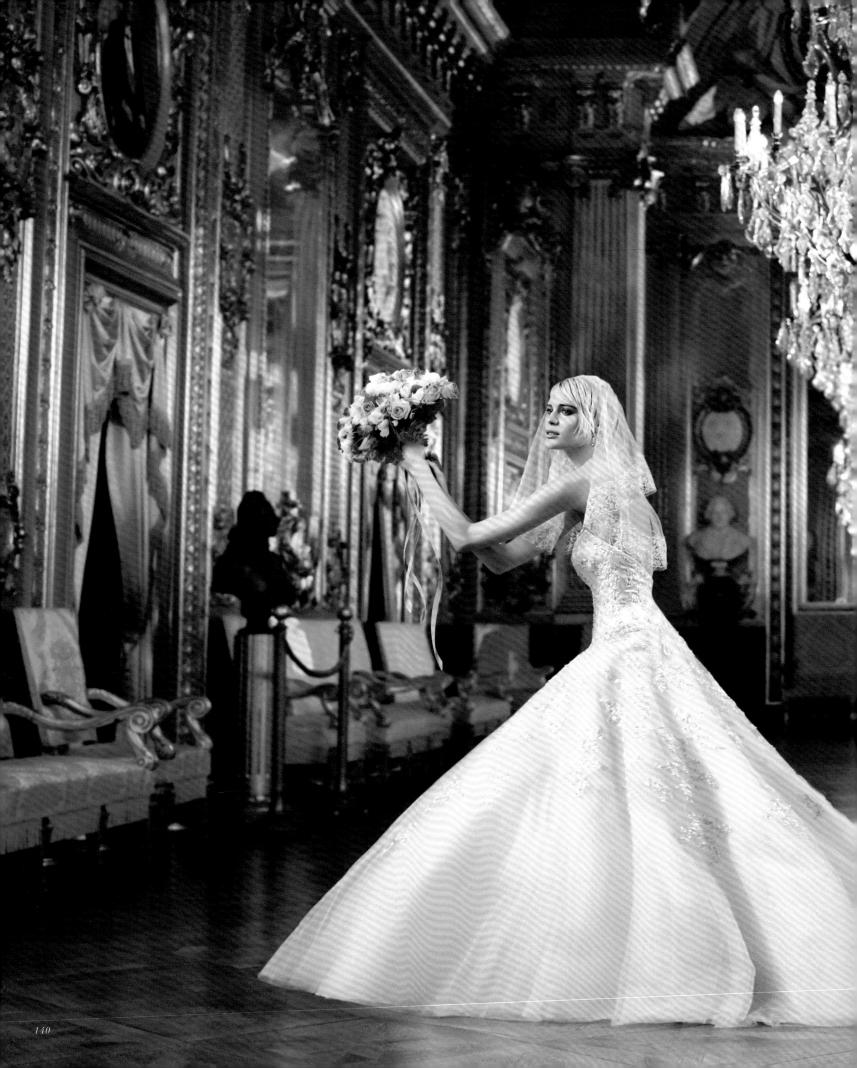

The Ball Gown is enhanced with an illusion bodice with floral motifs that are embellished with polished crystals and pearls . . . The mix is traditional yet with a twist . . . This style of gown is also very popular with young Debutantes . . .

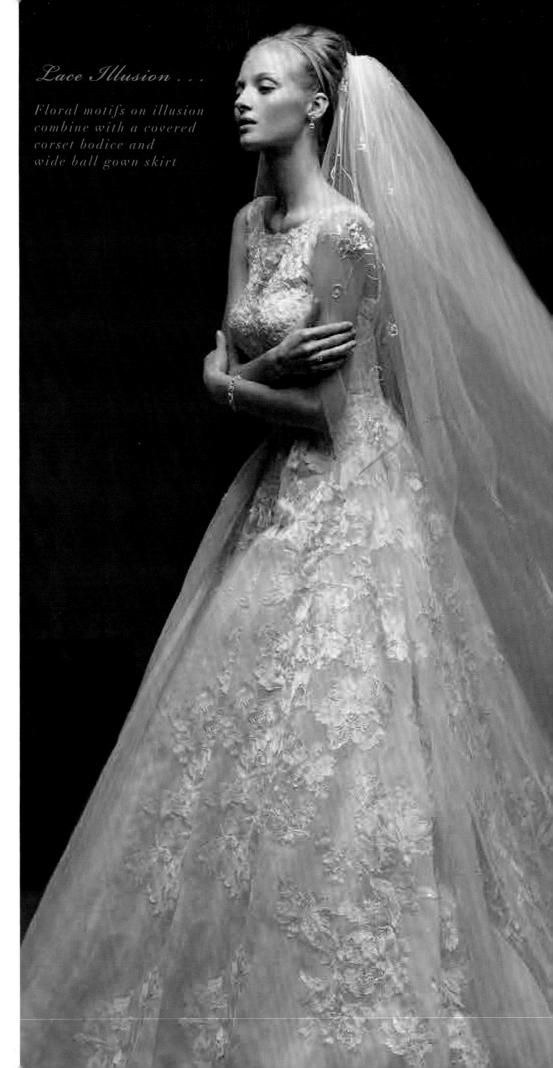

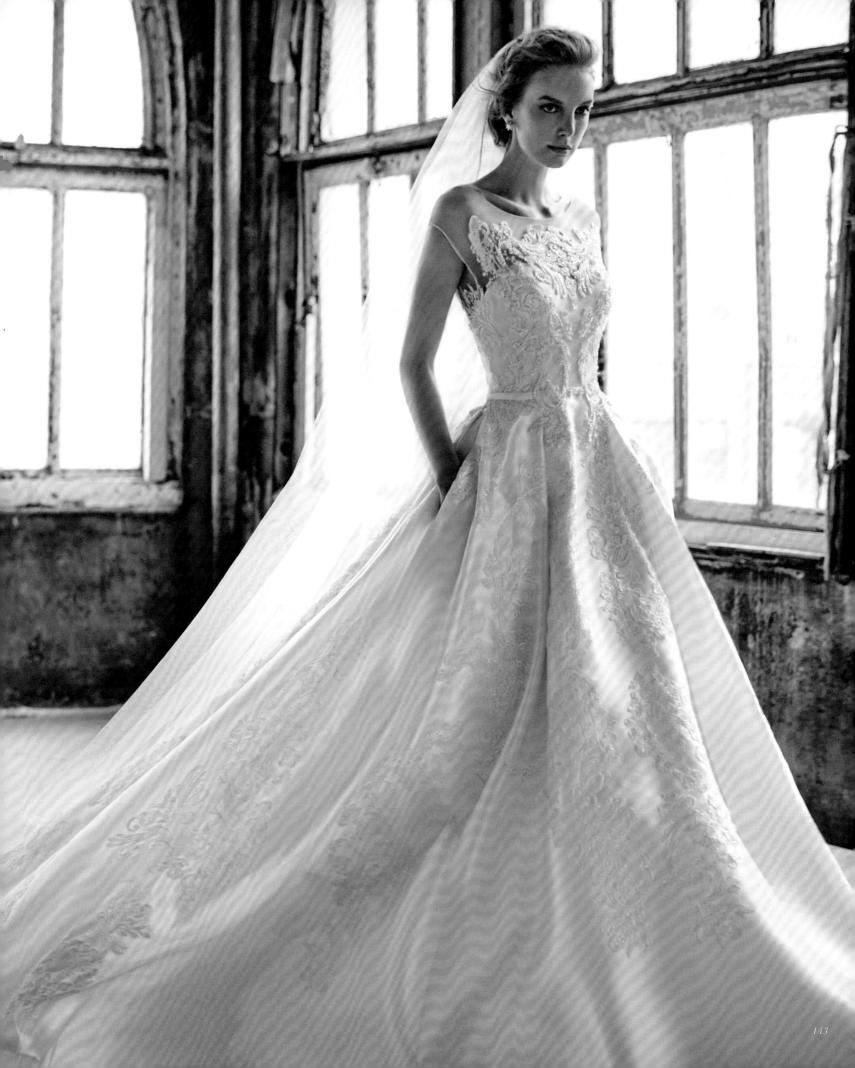

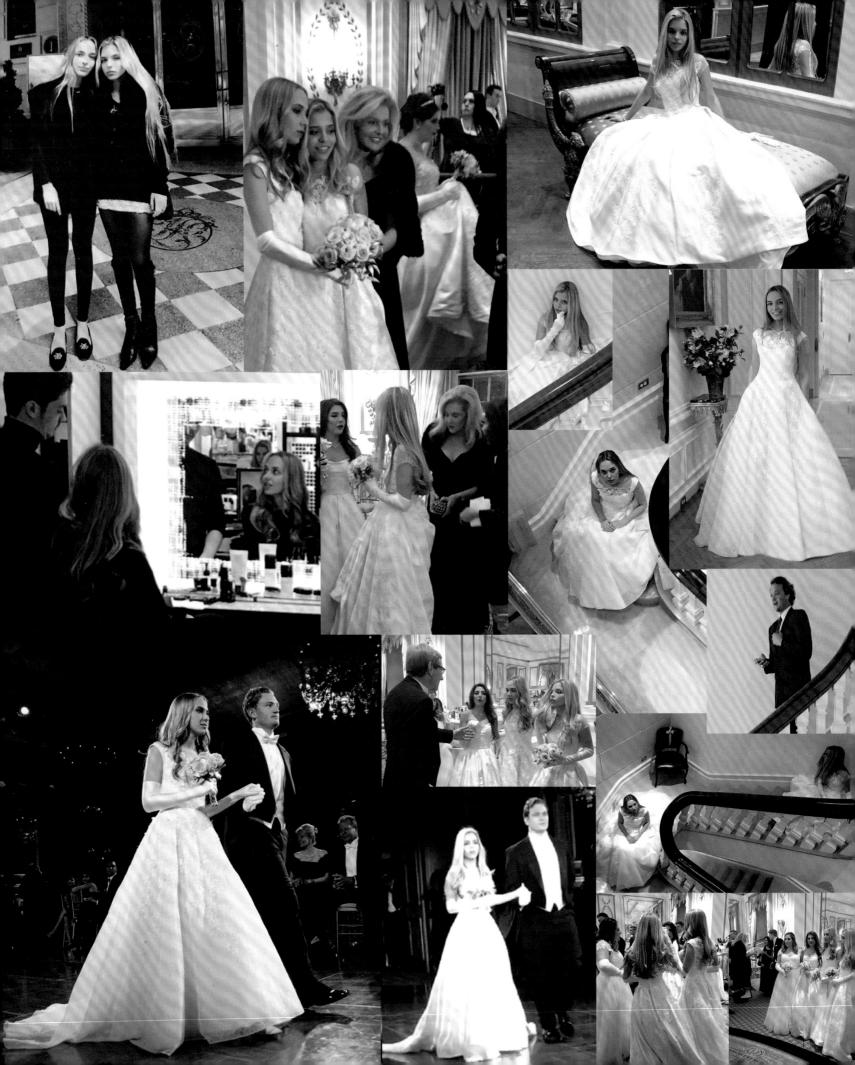

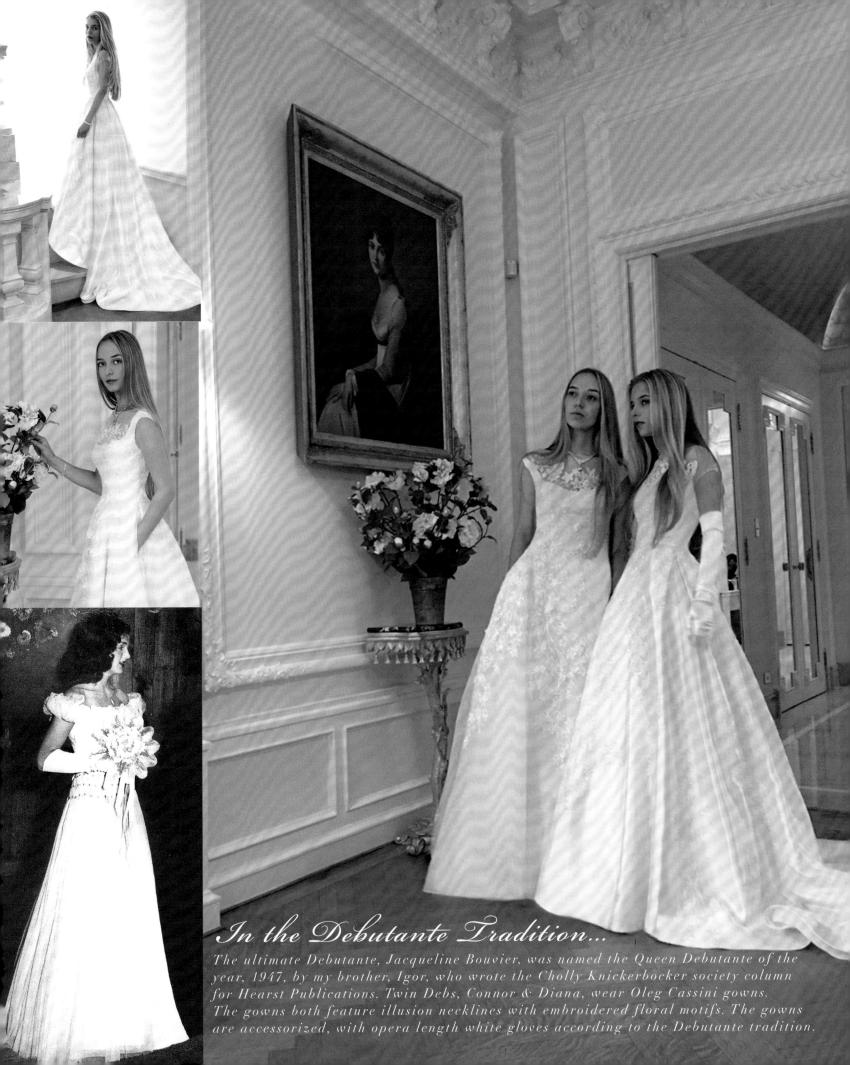

The costume the bride chooses for her wedding is unique and special to her. Since this is the moment that surpasses all others, what the bride chooses to wear as adornment is key to the entire event.

For one of the most significant royal weddings of all time, the bride, Queen Victoria, wore a white wedding dress. She chose white silk with a Honiton lace overlay for her gown and train, trimmed with fresh orange blossoms. Her bridesmaids were dressed in similar white gowns. She also had her bridesmaids carry her long train, setting another tradition, which along with the traditional wearing of white has continued from the 19th century into the 21st. Today the Maid of Honor traditionally helps to arrange the train, if needed, and holds the floral bouquet during the ceremony.

White comes in many tonal shades, and becomes the perfect palette for embroidery and embellishments of crystals, pearls, and lace over satin and ethereal tulle. Color has been used as an accent to white very successfully, and although white is assumed to be the color for a wedding dress, blue preceded white as a symbol of romance, and fidelity. Shades of golden yellow trimmed with gold became an important color choice for brides in the 18th century. Today's wedding is a ceremony that celebrates the joy of romance, yet through the centuries, wars have been fought because of marriages.

Royal marriages set traditions for brides, as the celebrities of their day and most royal marriages were of political importance since they involved kingdoms and future dynasties.

Symbols of wealth were displayed on the outer garments, which were encrusted with precious stones stitched with silver and gold on opulent fabrics. The overall impression of these royal robes was one of power, prosperity, beauty, and above all, optimism.

The bride is a vision in traditional white lace embroidered with crystal and pearl beading on white satin and tulle.

She wears a lace mantilla and carries a bouquet of white orchids. The orchid, with its rare and delicate beauty is historically known as a symbol of wealth, love, beauty, and luxury. In ancient Greece, the orchid was thought to represent virility and strength.

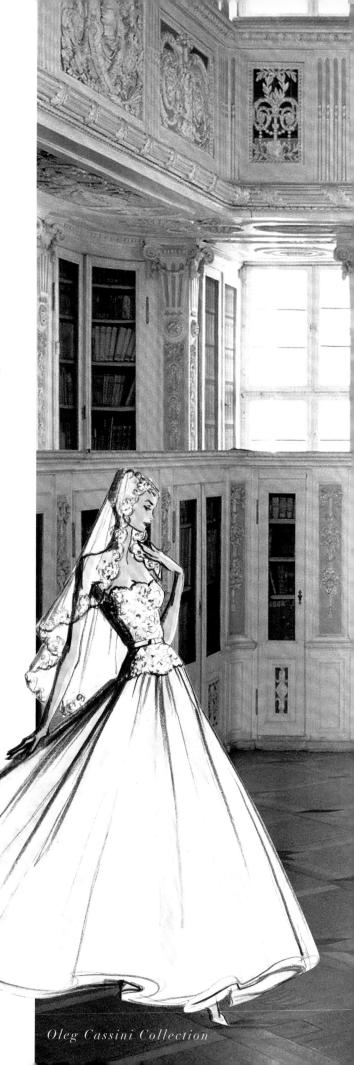

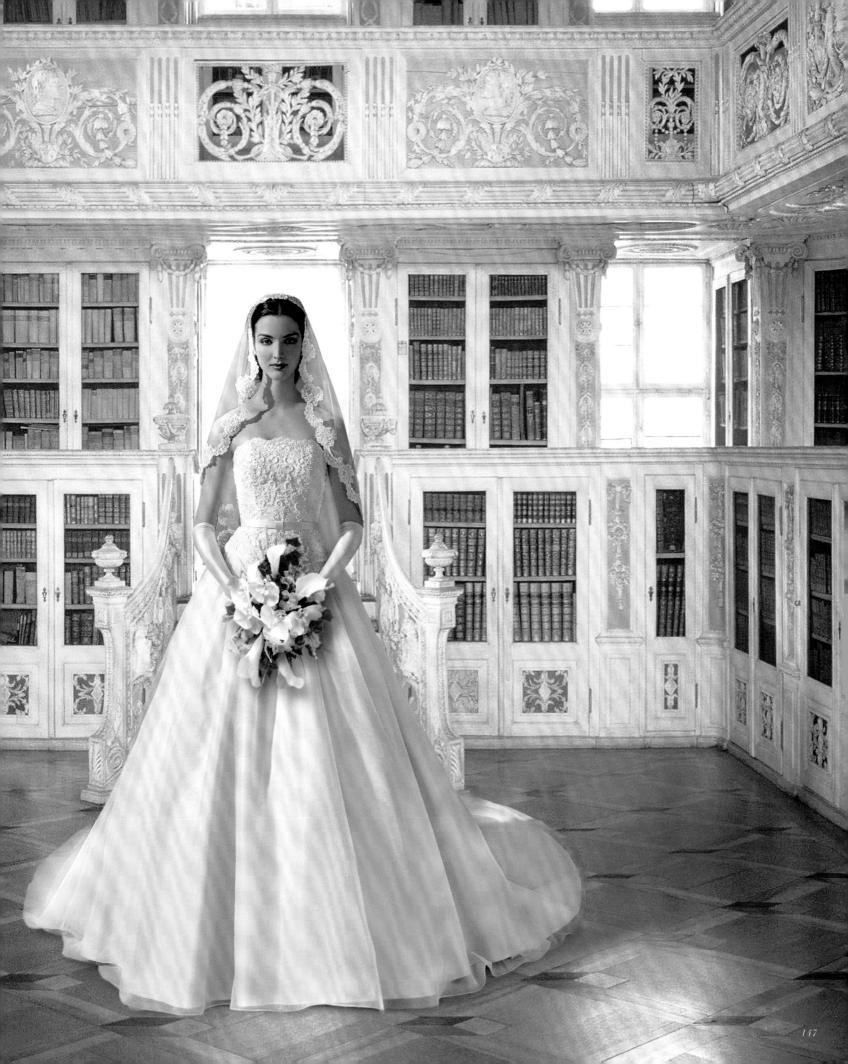

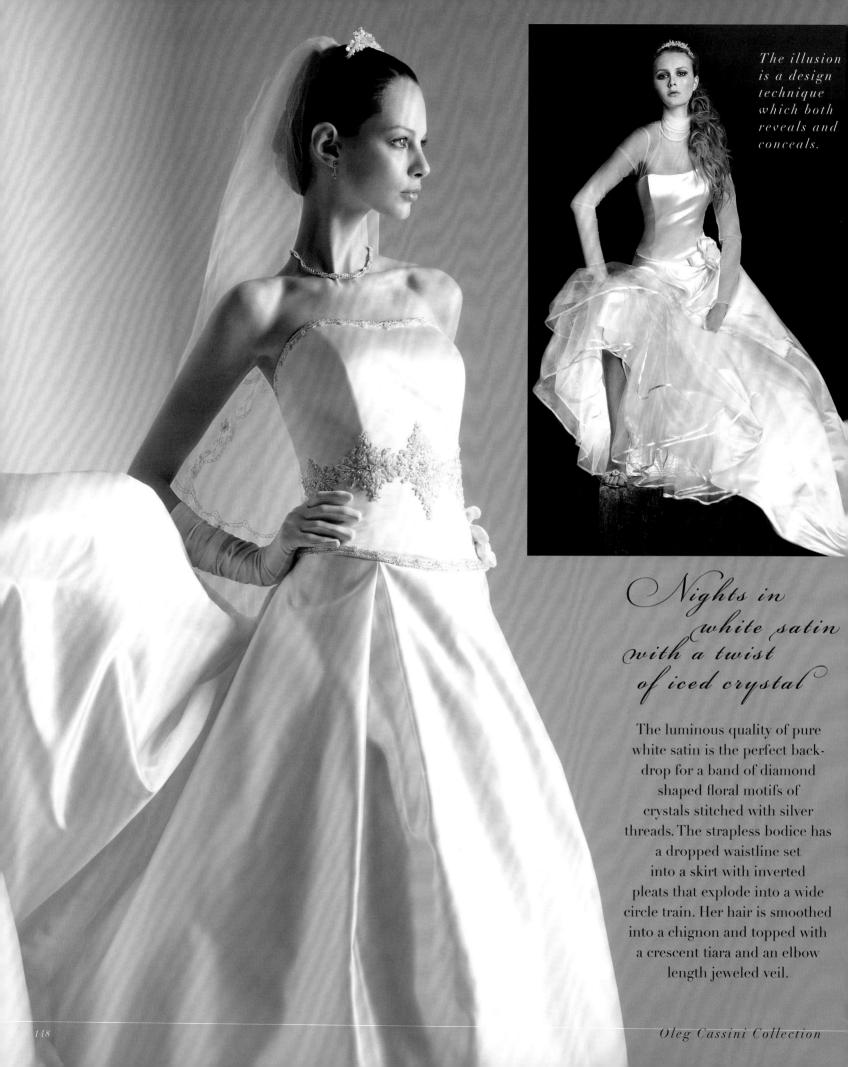

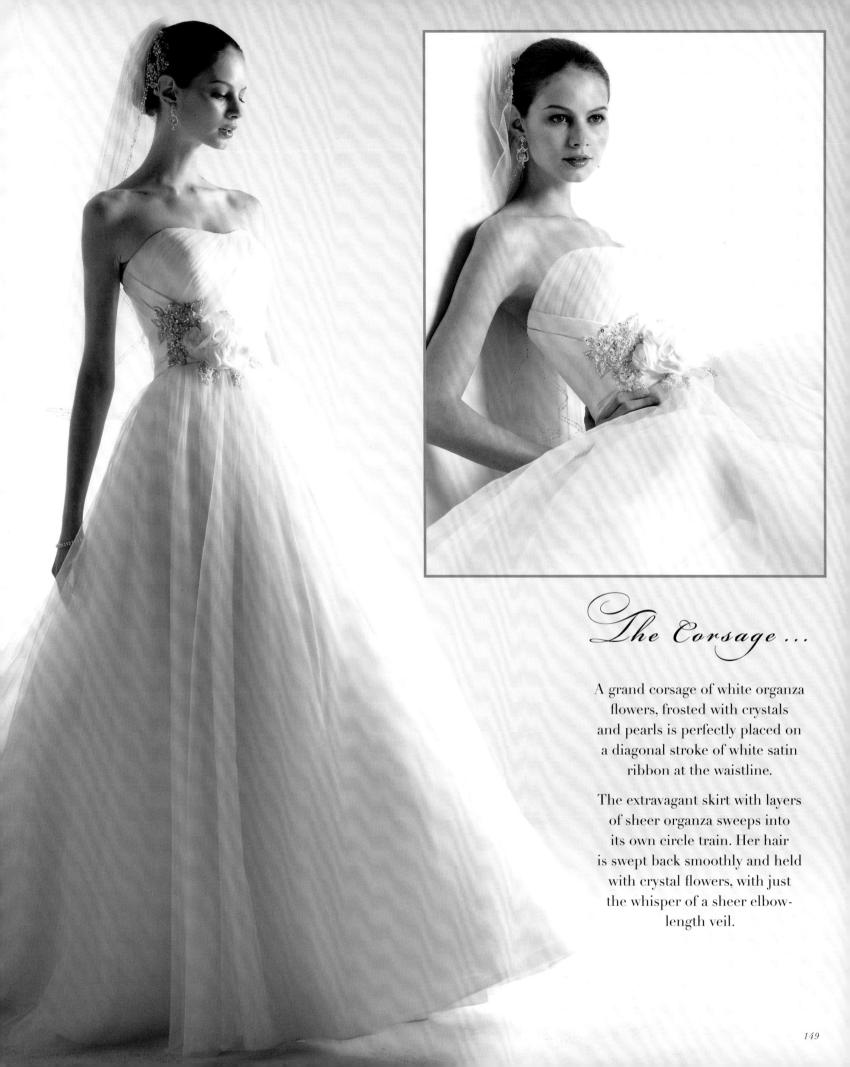

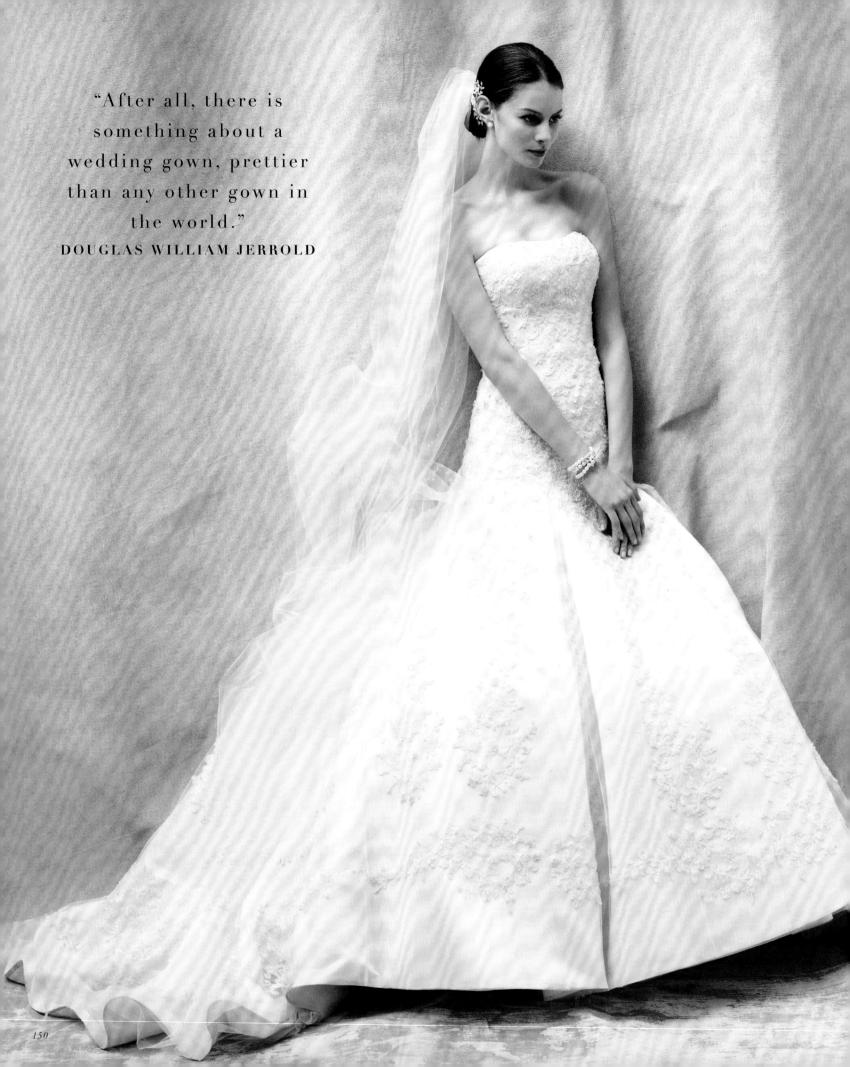

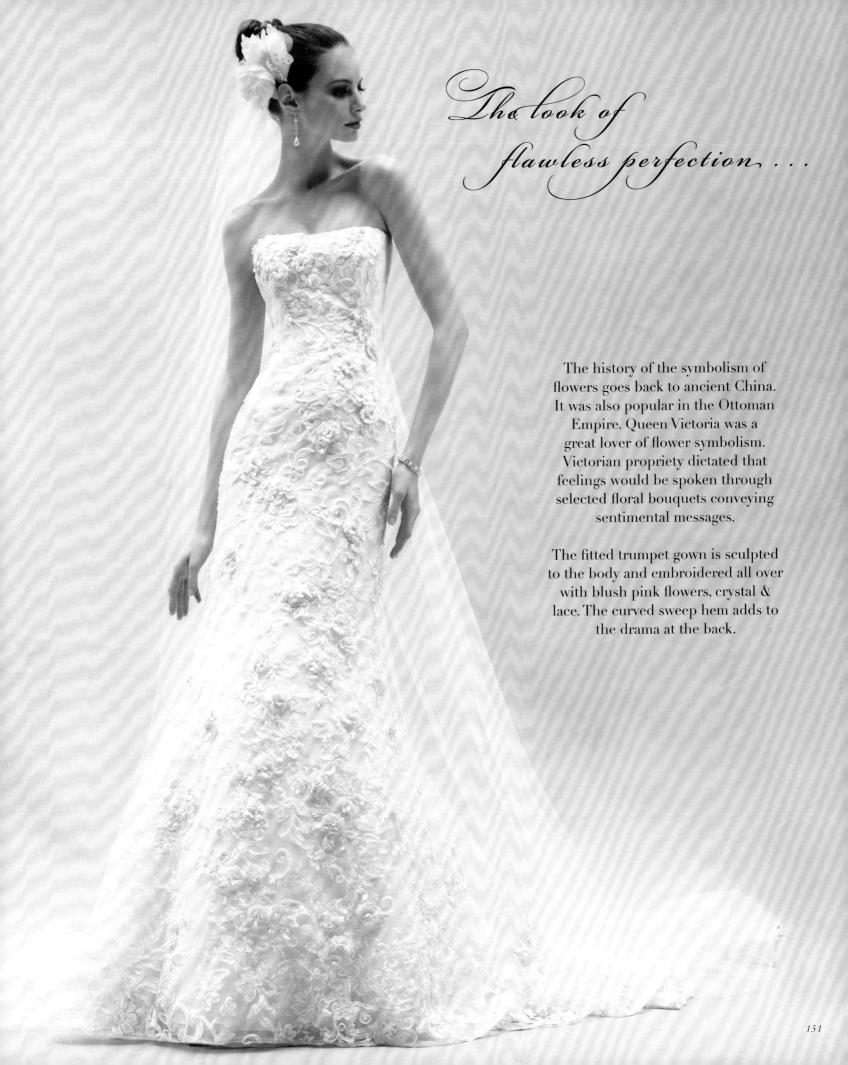

A hint of a whisper of pink palaces and dreams that can come true

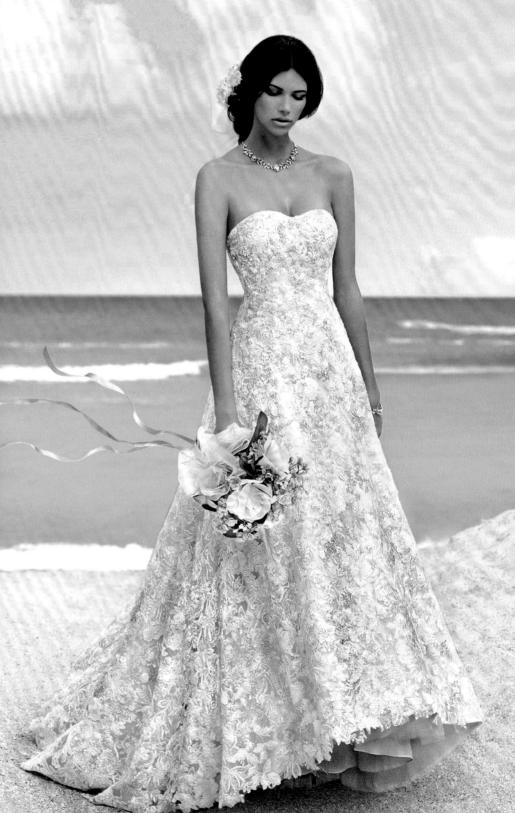

ABOVE Vivien Leigh as Scarlet O'Hara in Gone with the Wind (top) serves as inspiration for Sarah Jessica Parker's pink Dior gown in the film Sex and the City (bottom).

RIGHT Photo by Patrick Demarchelier / Vogue ©Condé Nast Publications

OPPOSITE Oleg Cassini Gown.

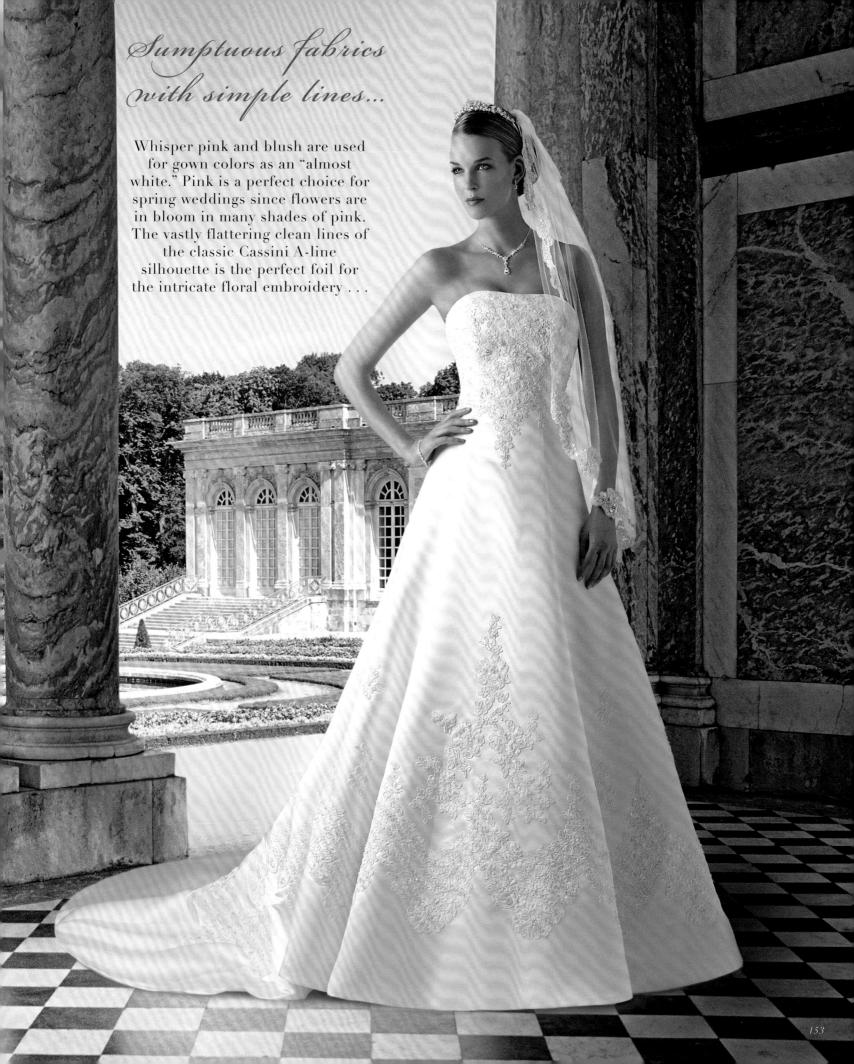

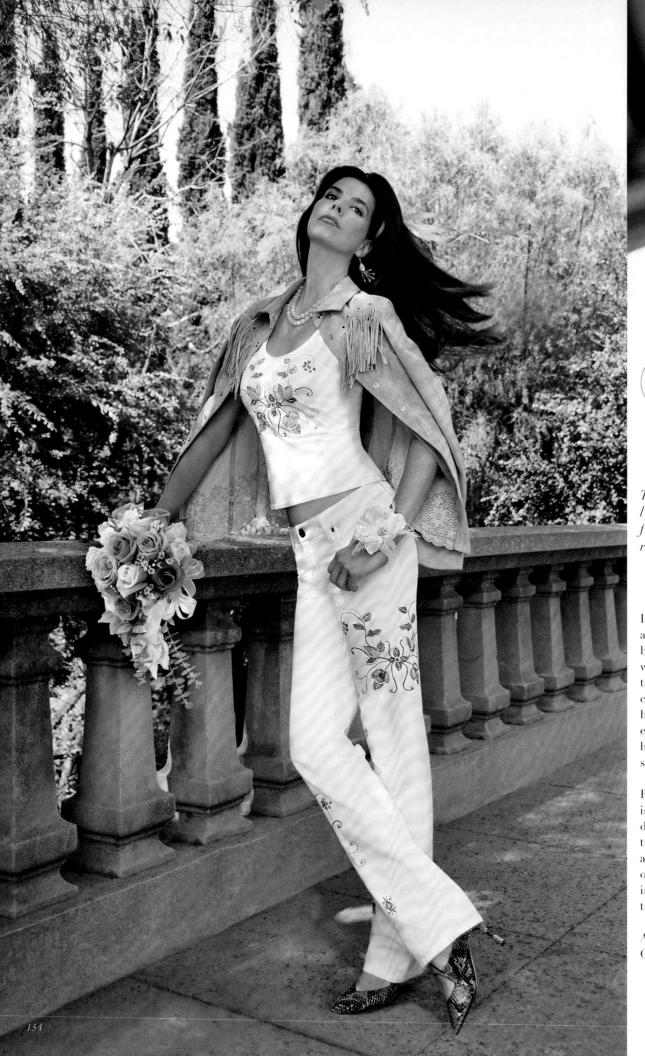

The mood is light and lovely, like a slim crystal flute filled with sparkling rosé champagne.

LEFT The fun and unexpected . . . a memorable statement, a look both creative and vibrant. Pair white Cassini jeans and matching tank, embroidered with the vivid colors of the Oleg Cassini Kavita beaded pattern. The memorable ensemble is topped with a softly hued pink fringed jacket with stenciled floral motifs . . .

RIGHT The formal and fabulous is the Oleg Cassini trumpet gown done in embroidered layers of tulle and organza. Polished crystals and tiny pearls are hand-stitched on to the fabric to create shimmering layers of skirt flaring out below the narrowed body of the gown.

ABOVE Casa Cassini Crystal Flute Oleg Cassini Crystal Collection

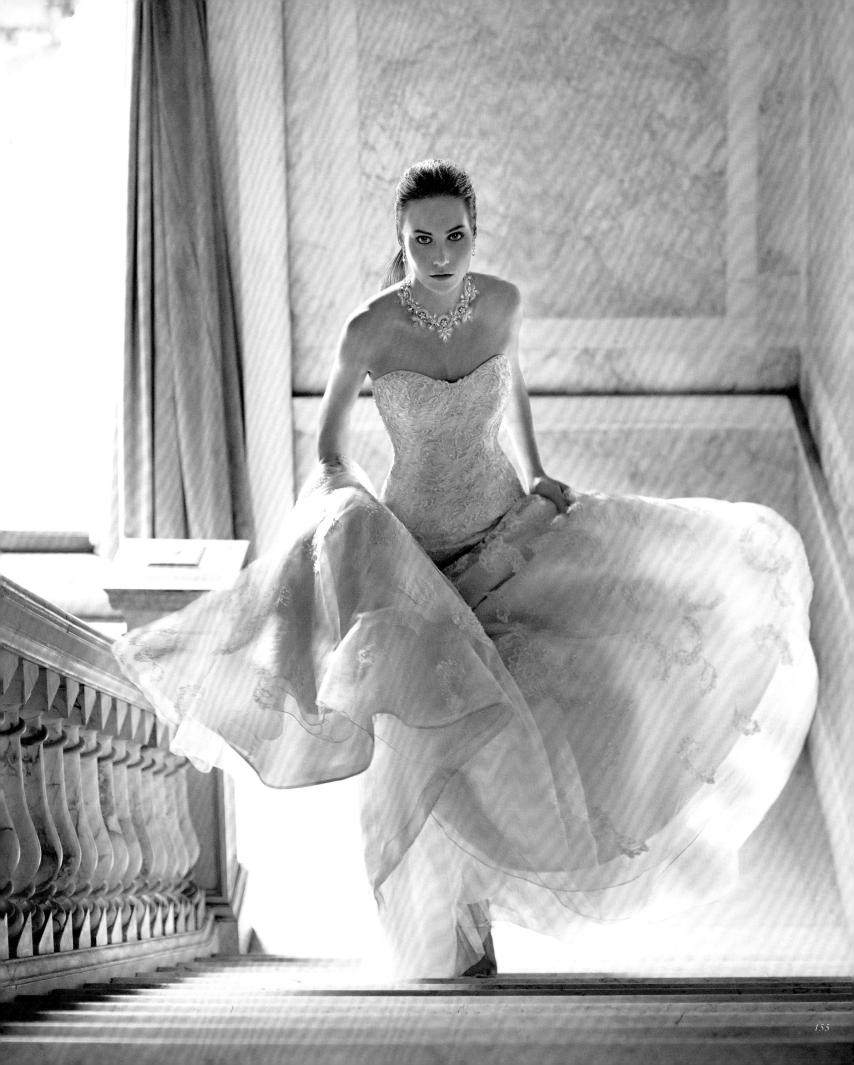

Known as the art of design through the eye of a needle and thread, embroidery has evolved through the centuries as a technique to express design details and messages of opulence on fabric.

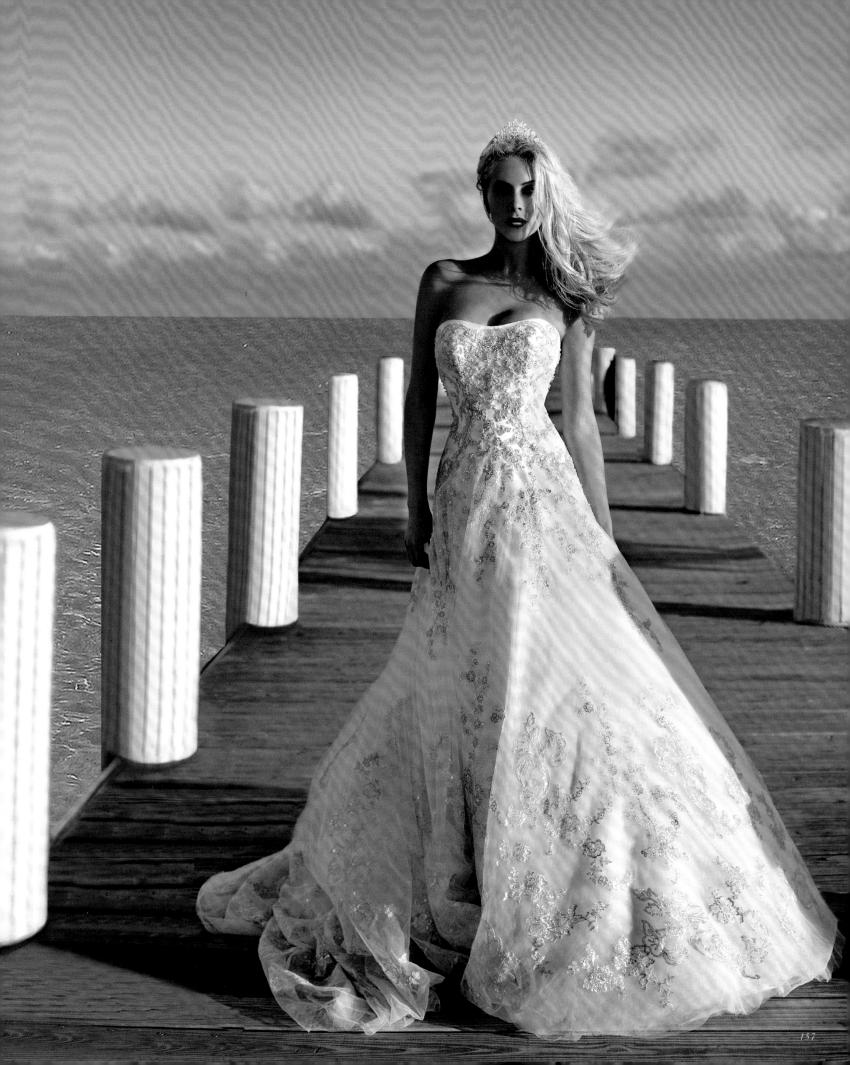

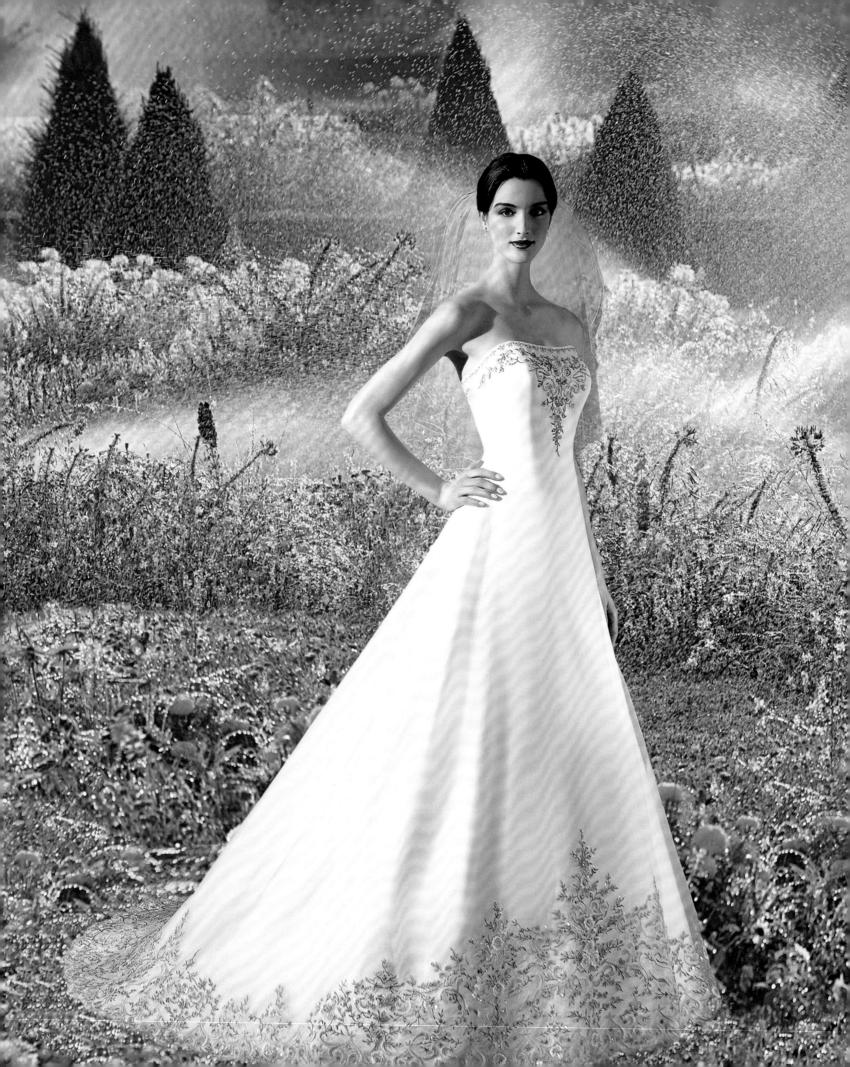

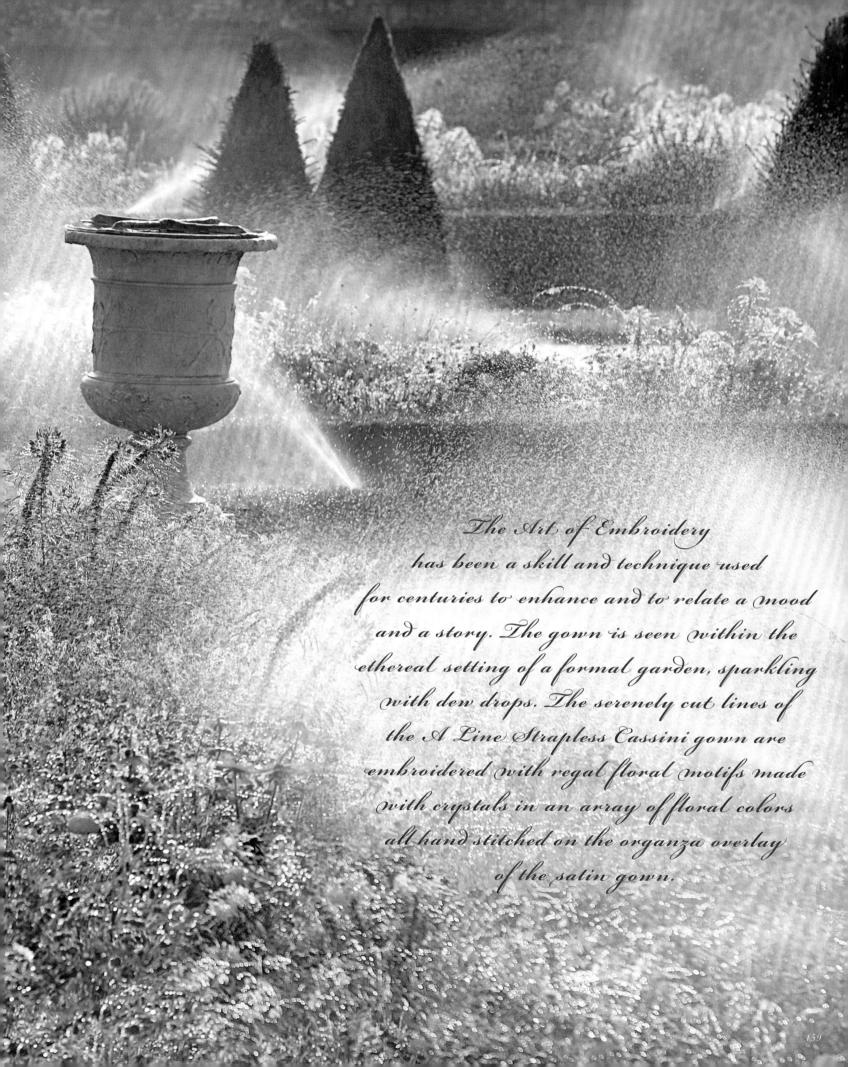

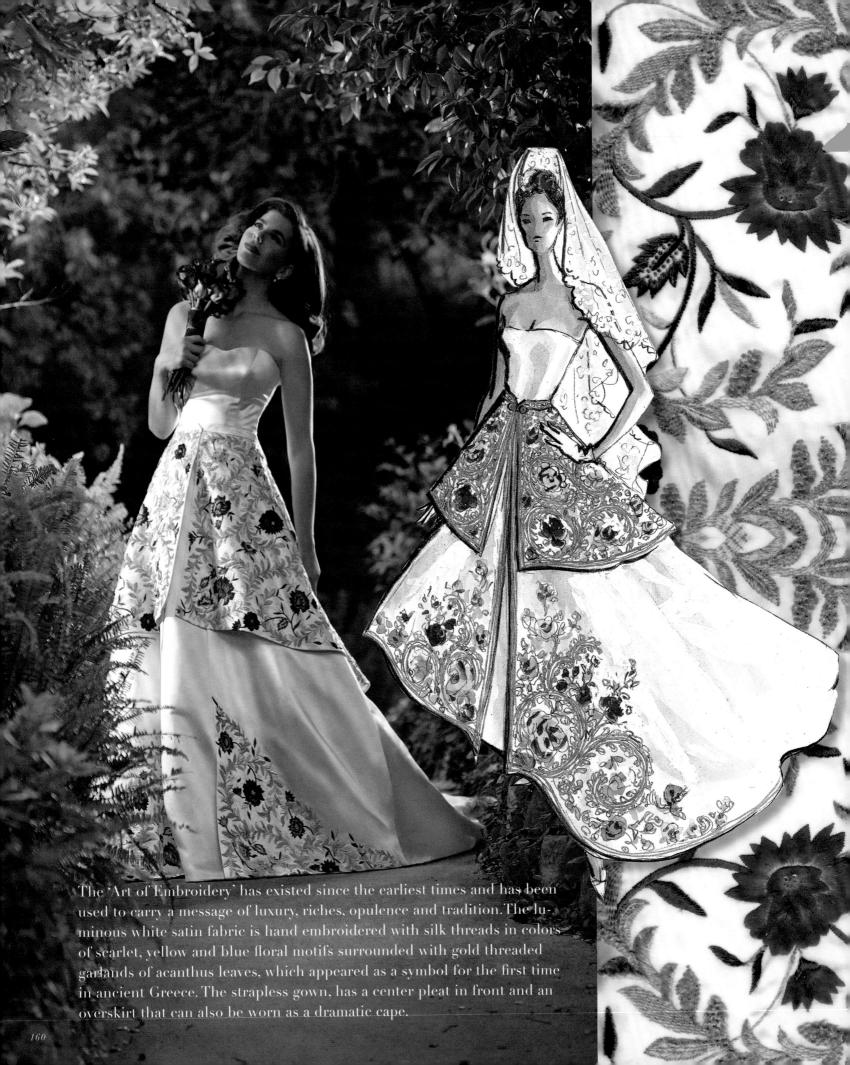

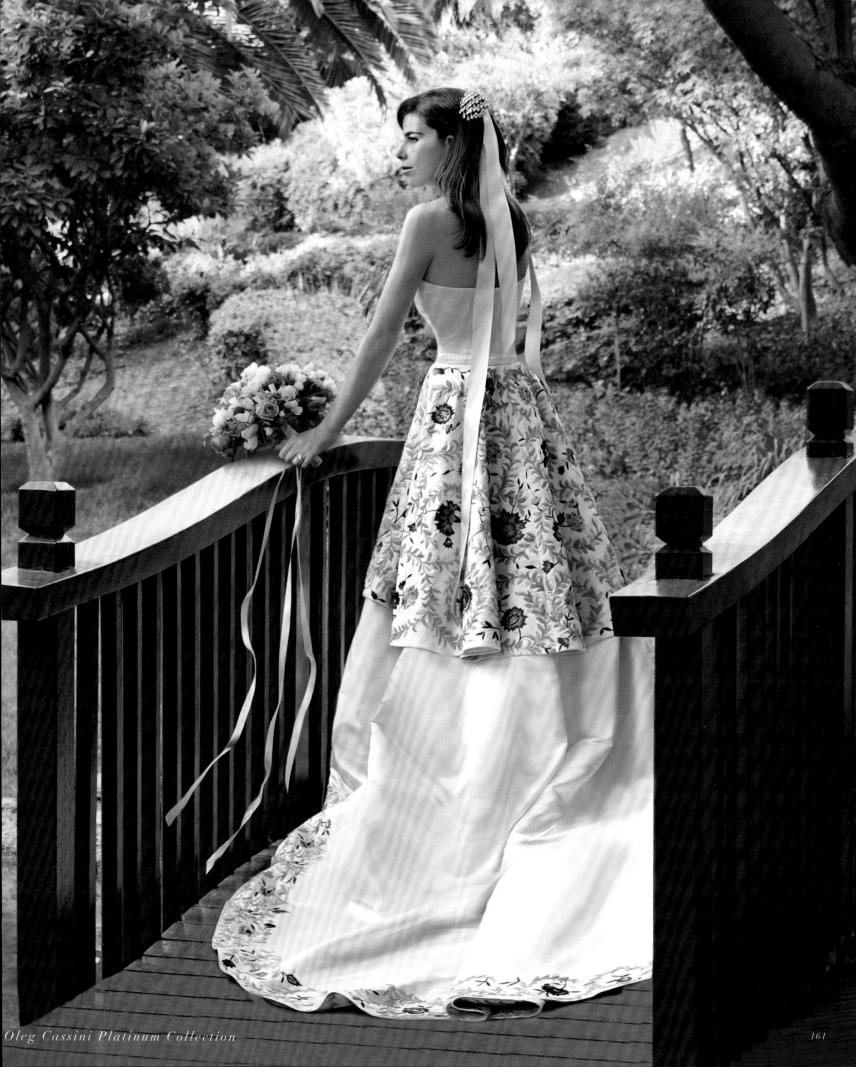

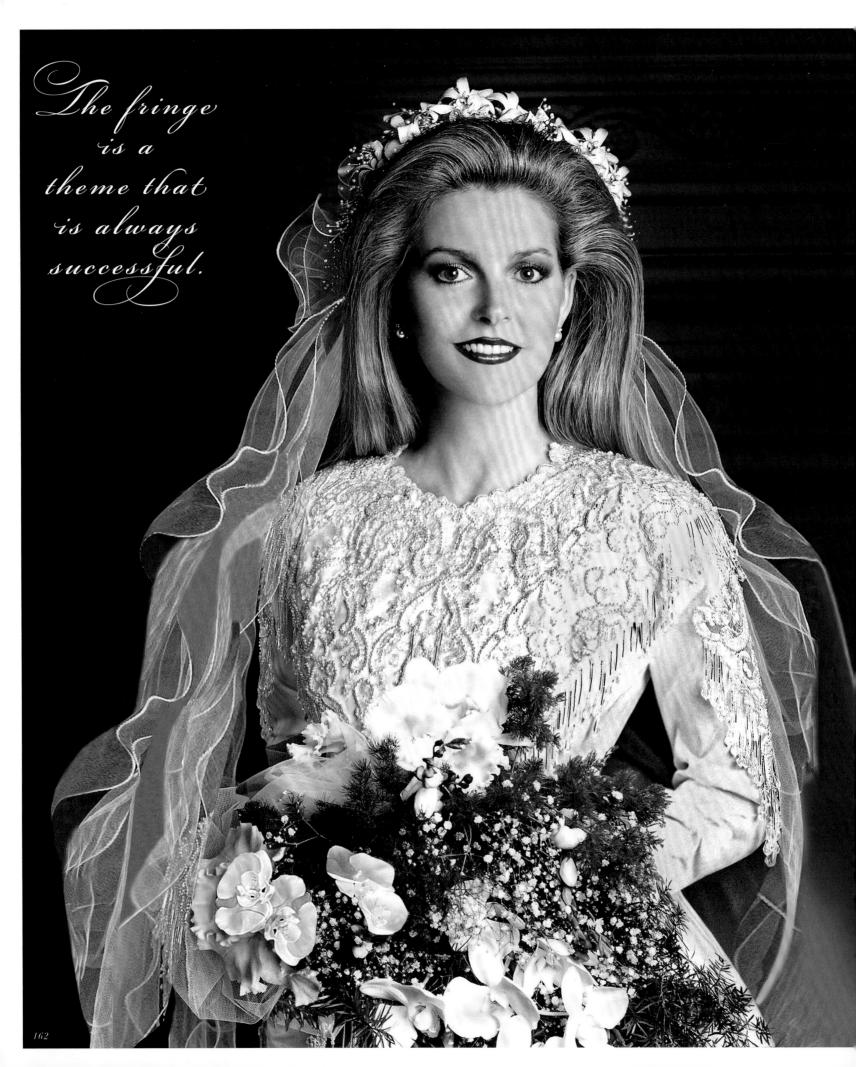

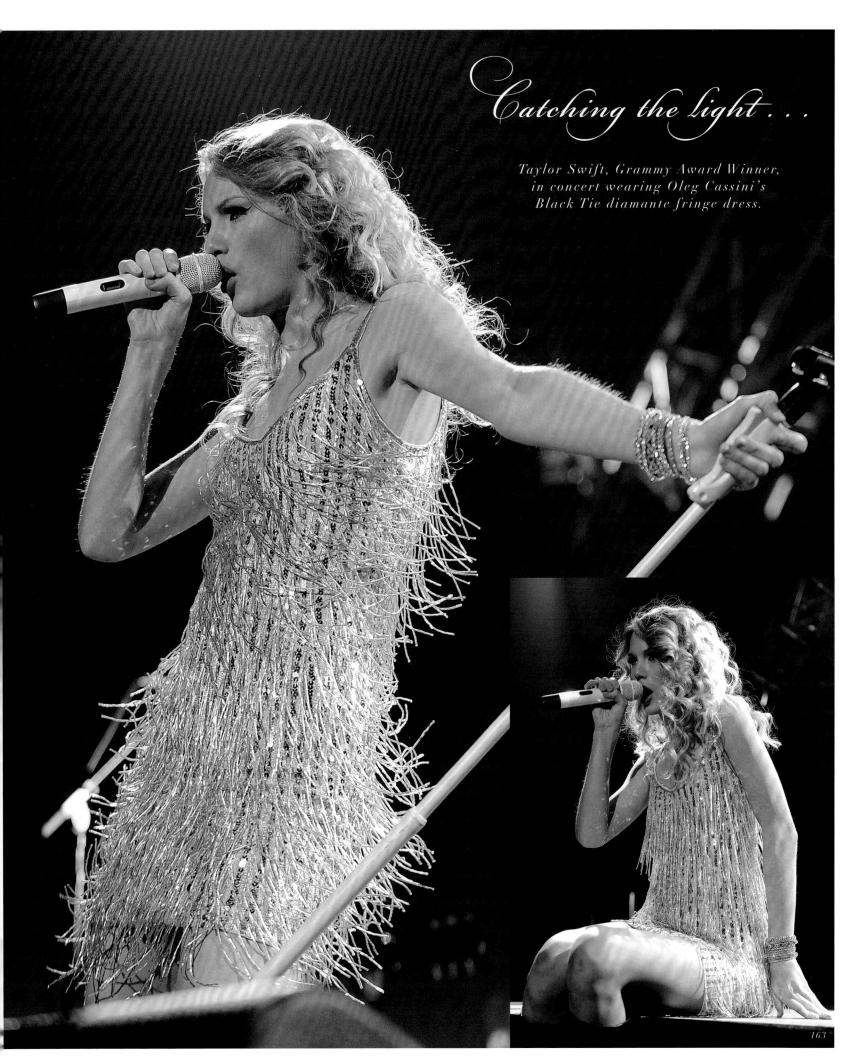

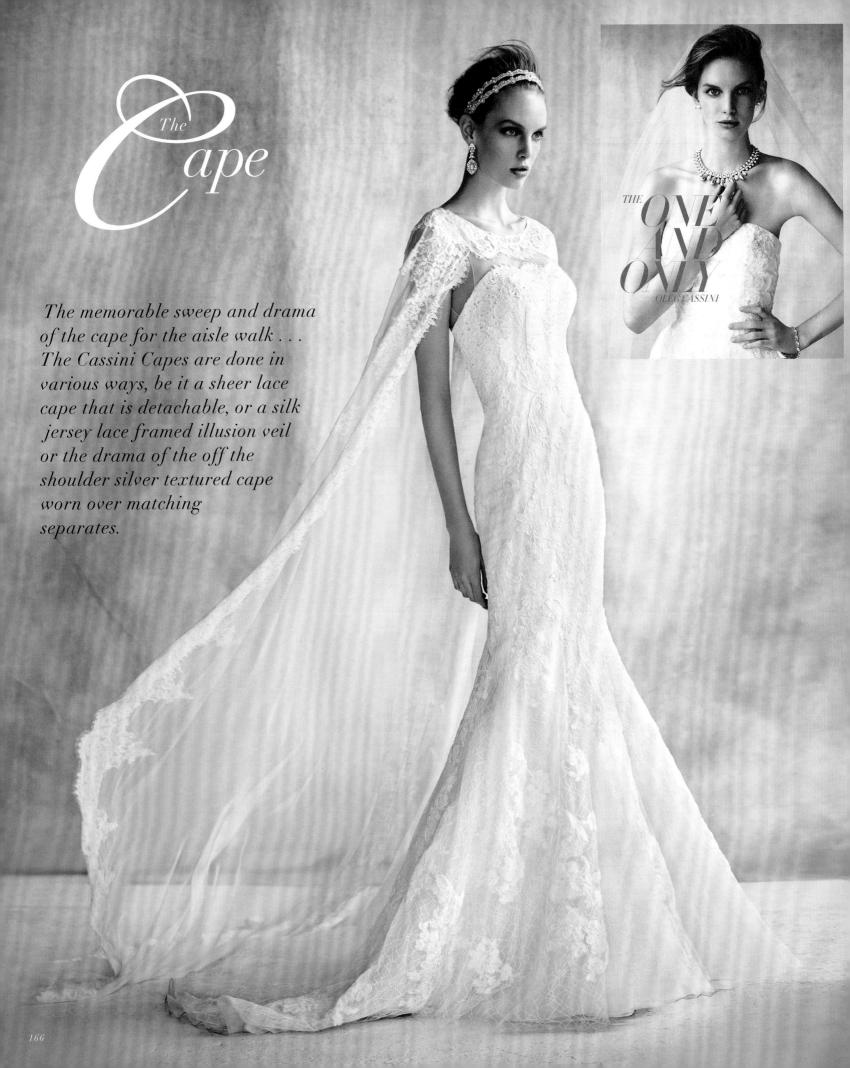

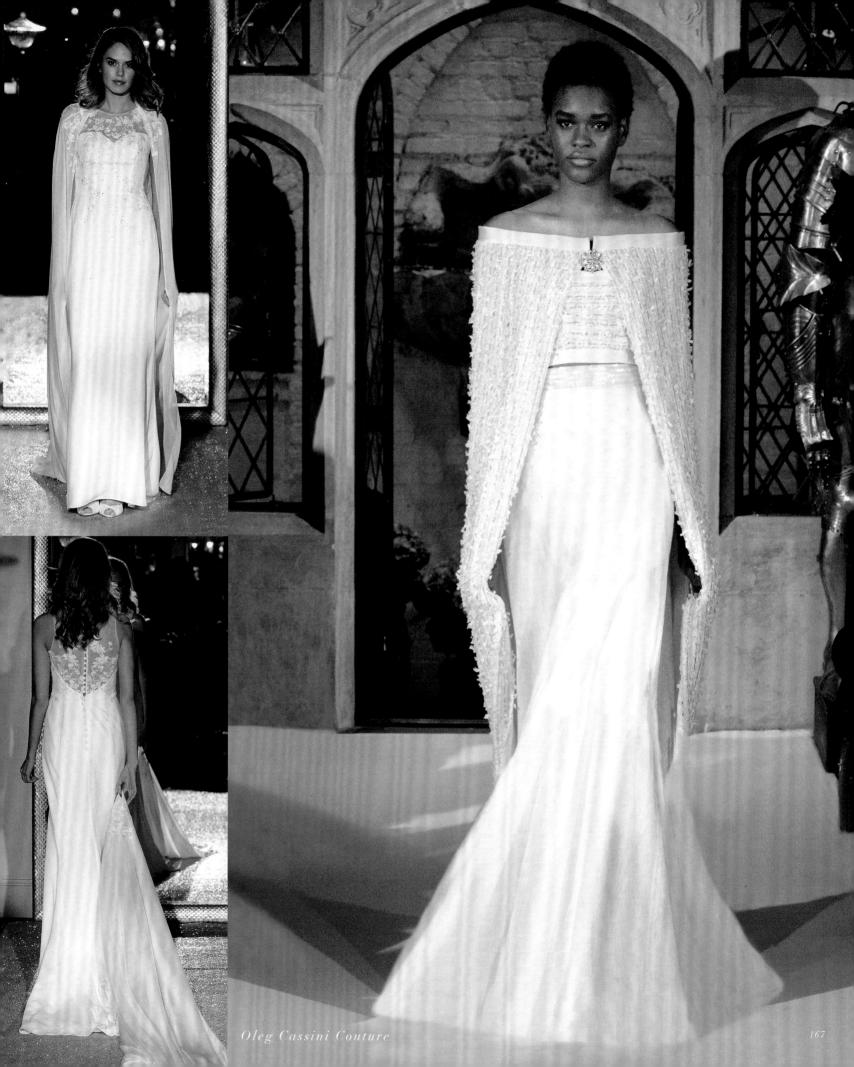

Belle of the Ball

Like a magnificent still life portrait, a ball gown recalls the glamour of royalty.

Its silhouette is débutante in mood, and fun to wear. Both grand yet modest, it achieves a regal impression with a flattering silhouette.

It is most often designed with a strapless, very fitted bodice giving a dramatic contrast to the fullness of the skirt.

The ball gown lends a creative palette for details. The bodice of opalescent sequins reflects prisms of light, a marvelous combination with the softness of the matte finish tulle skirt.

The embroidered bodice is a design technique to highlight the top of the gown, and can be done with embroidery and jewels.

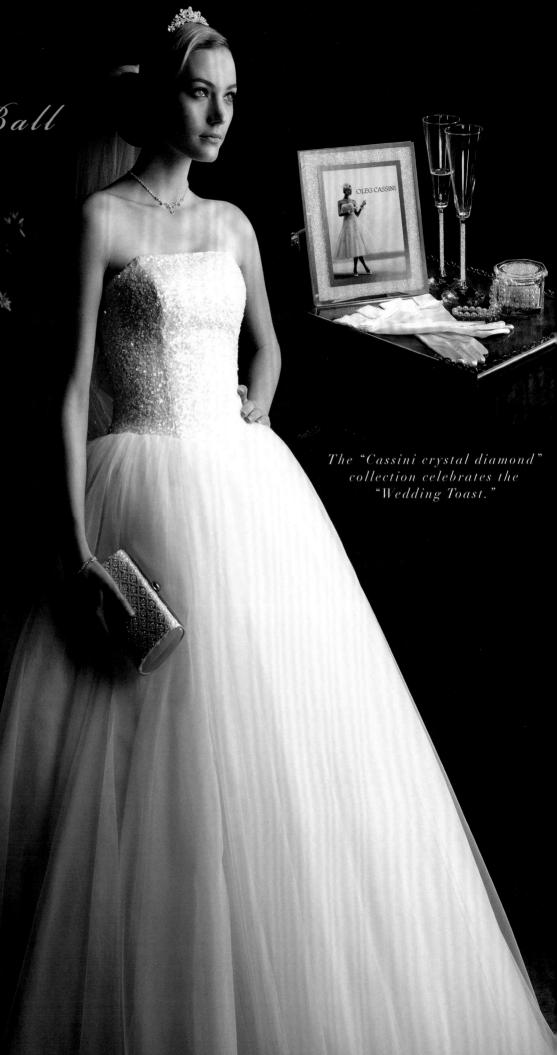

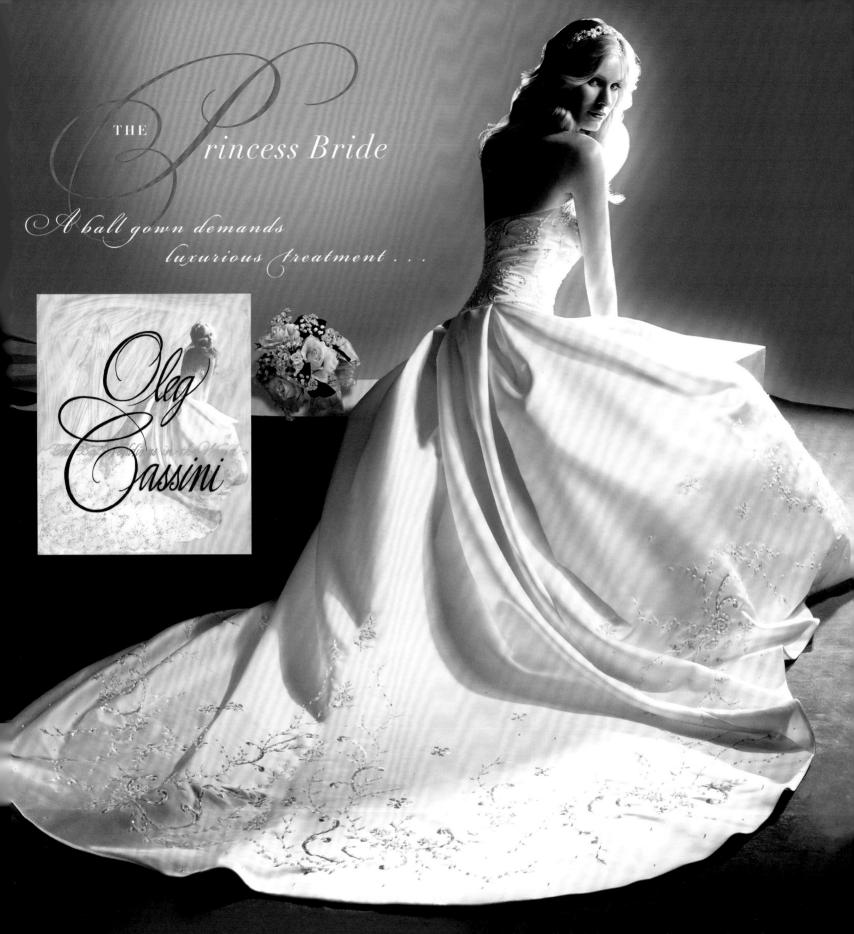

As a term, the Princess Bride is perfect for the bride taking center stage, evoking all the glamour and expectation of a young débutante. The silhouette is storybook, enhancing the romance of a narrow waist and the drama of a very full skirt.

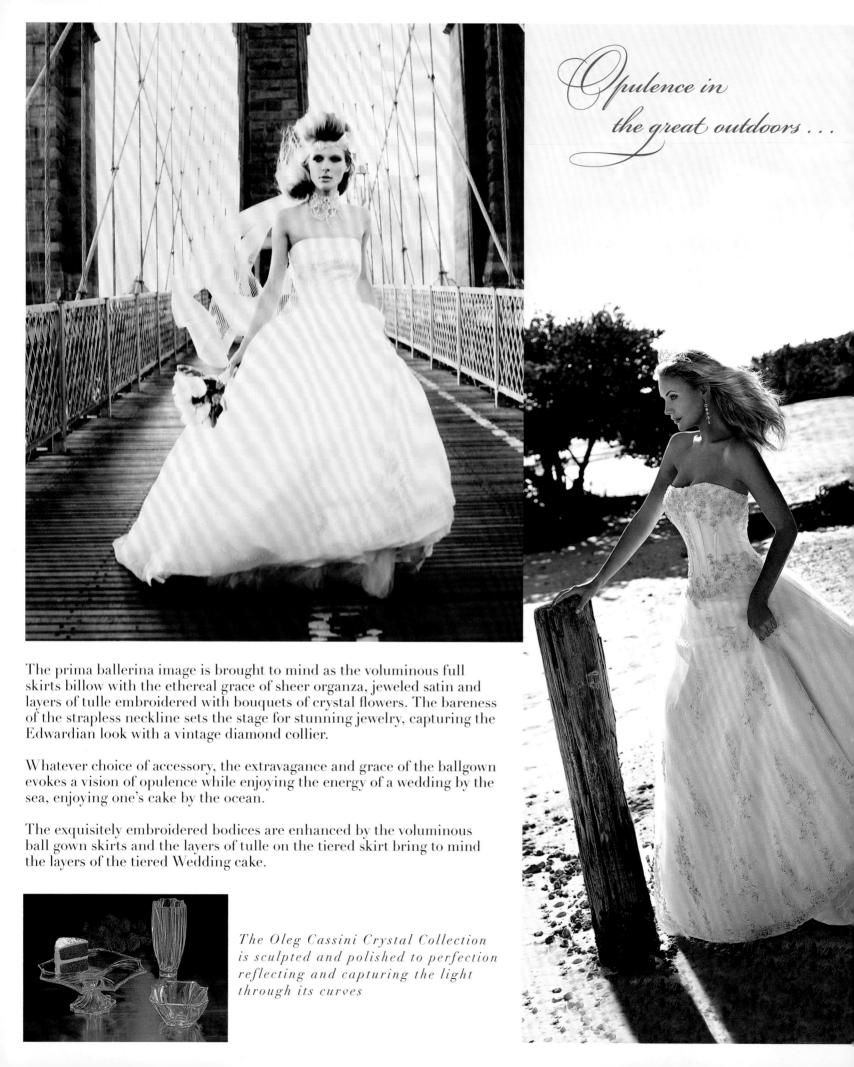

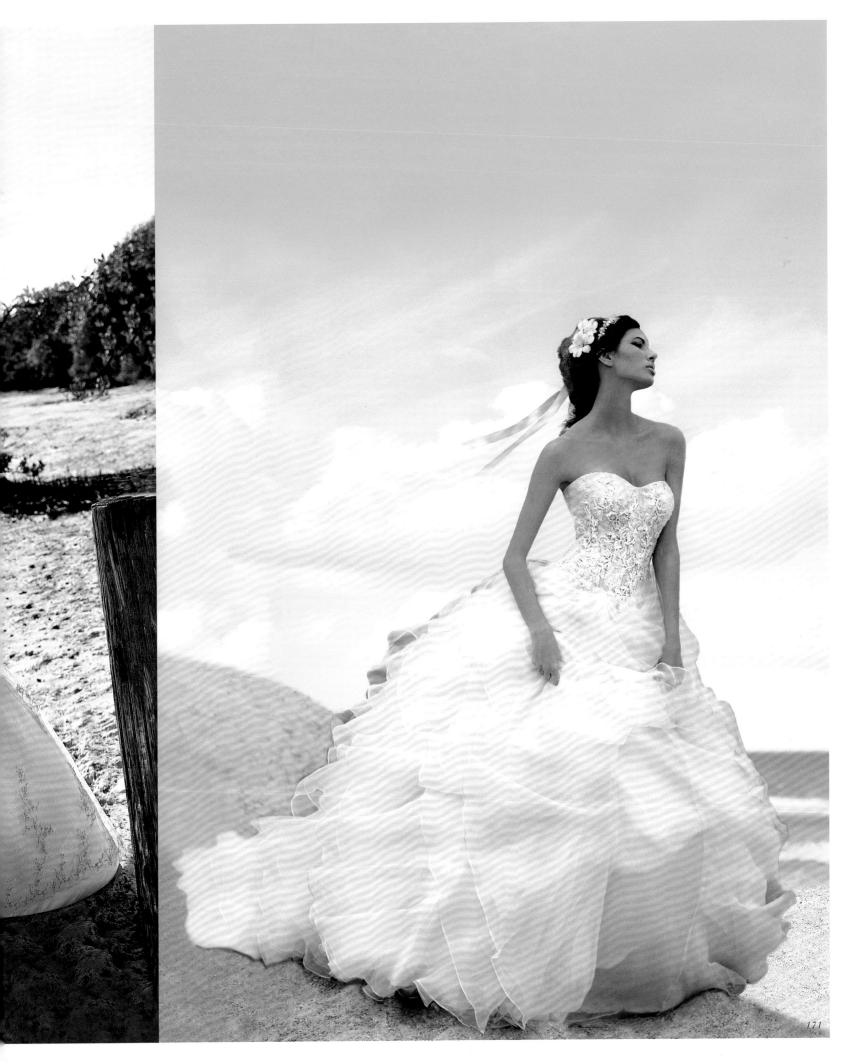

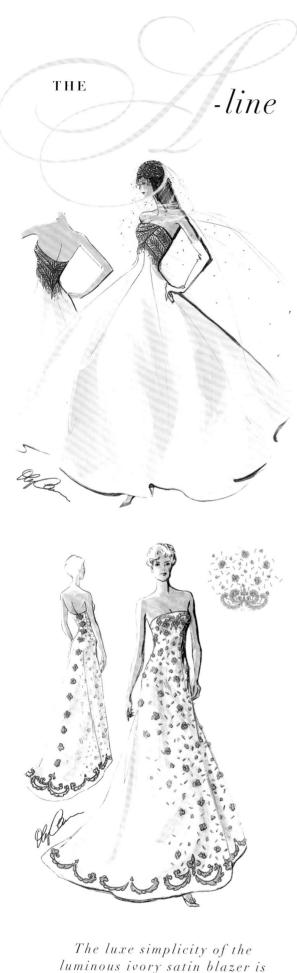

luminous ivory satin blazer is worn with the $\overset{\circ}{A}$ Line satin gown, completing the look ...

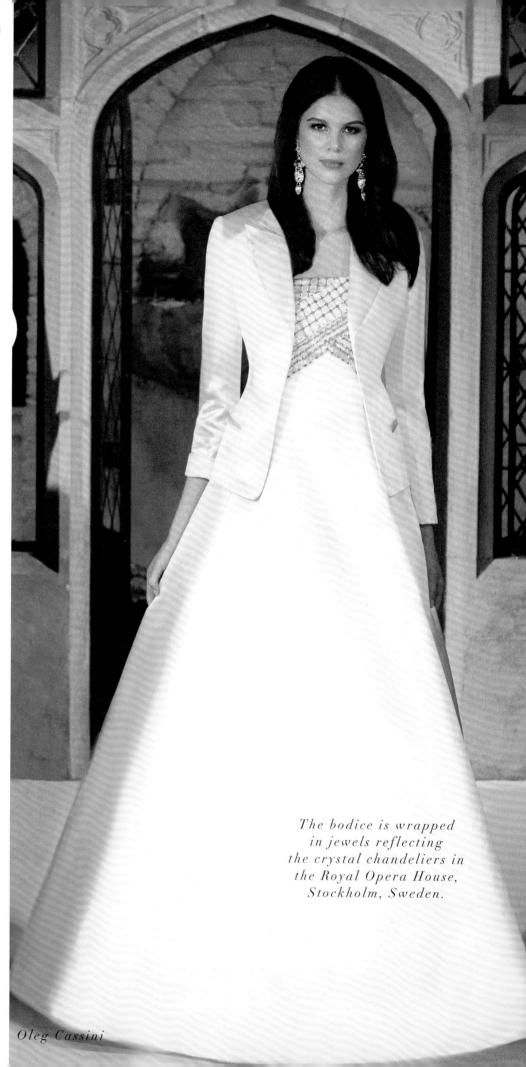

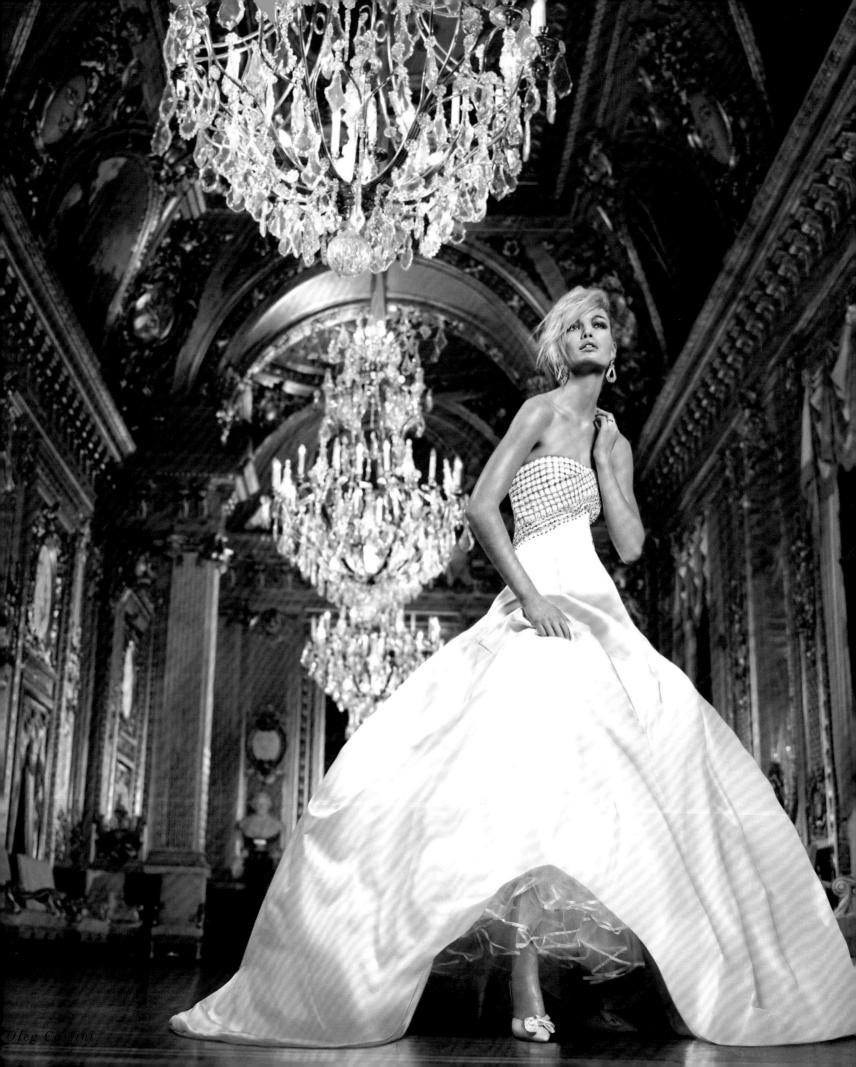

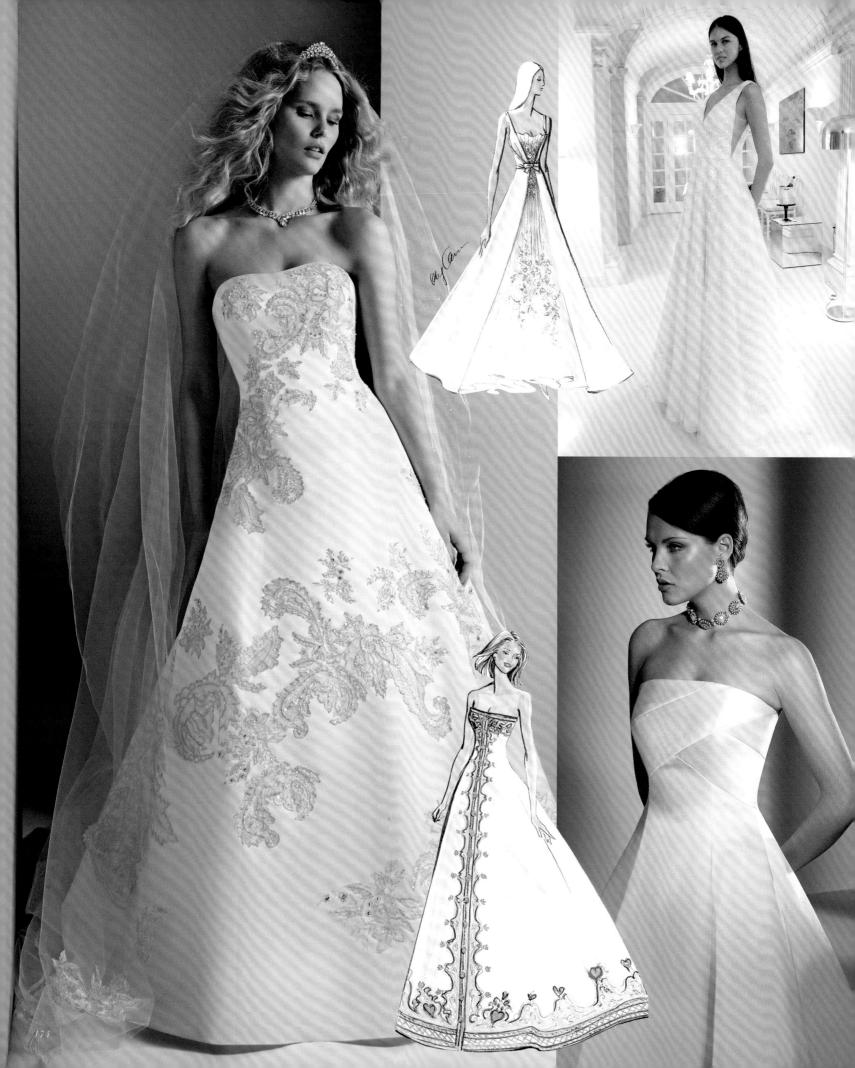

'-line silhouette

Cassini A-line silhouette ched international iconic us when Jackie wore her g Cassini dresses, coats and ns. Since then, this silhouette become a favorite choice of les for their wedding dress.

• A-line shape never fails to extaste, and subtle style. It n elegant and flattering ouette.

A-line dress can be stunningly ple in shimmering satin, with lings of taffeta, or dressed with overlays of lace, organza, fon, and embellished with eled embroidery.

multitude of choices, coupled a the A-line's unconditionally oming line from bodice to aline makes this silhouette able for all, an excellent canvas which to paint a unique vision each bride. The possibilities of A-line silhouette are endless, the only requirement is a lush gination.

The dropped waistline encircled by a crystal belt evokes the magic and romance of Camelot.

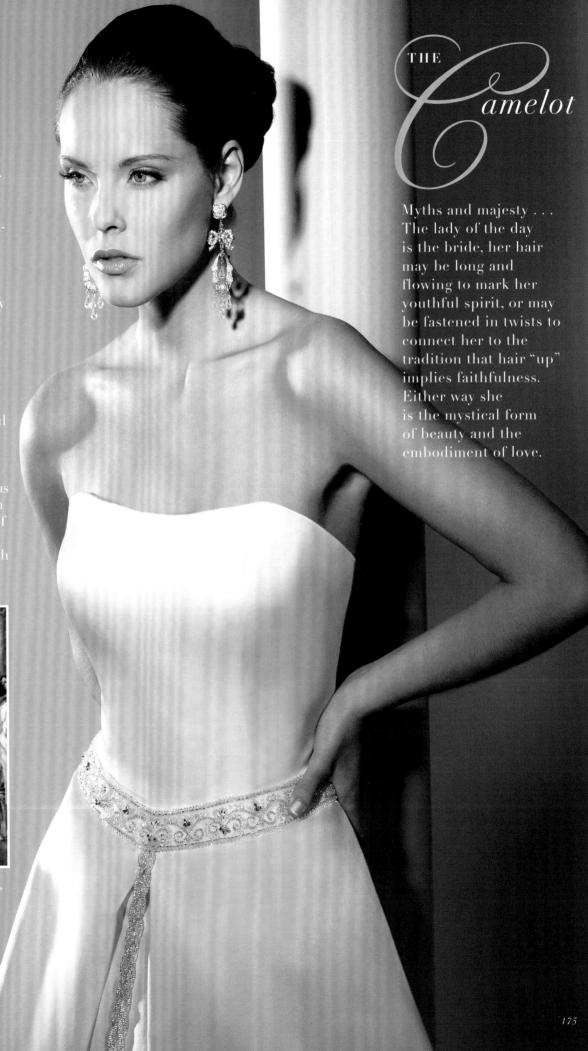

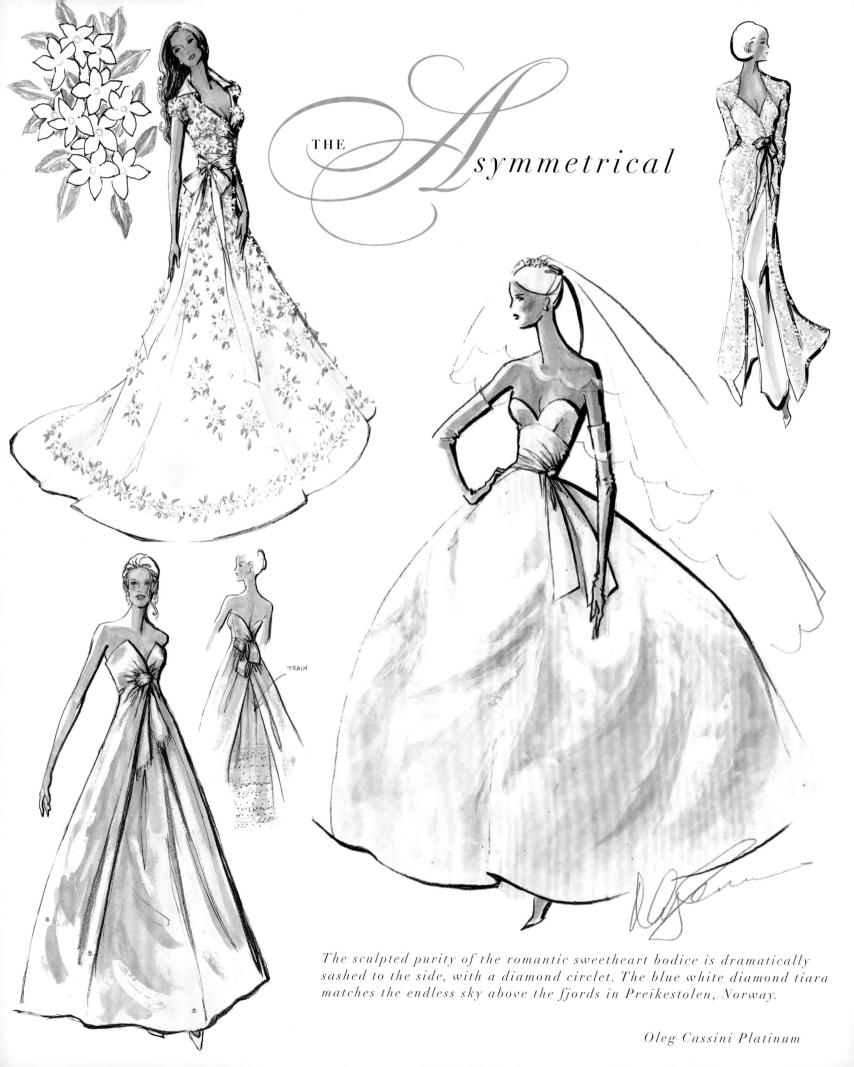

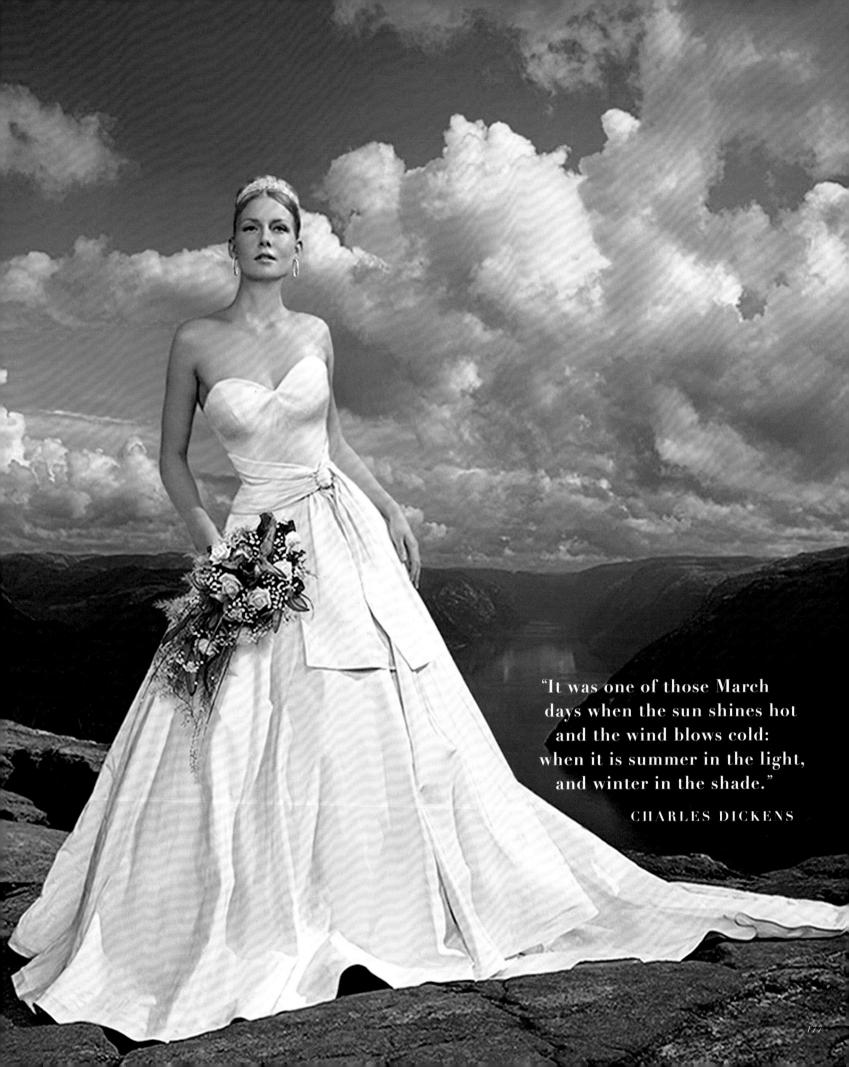

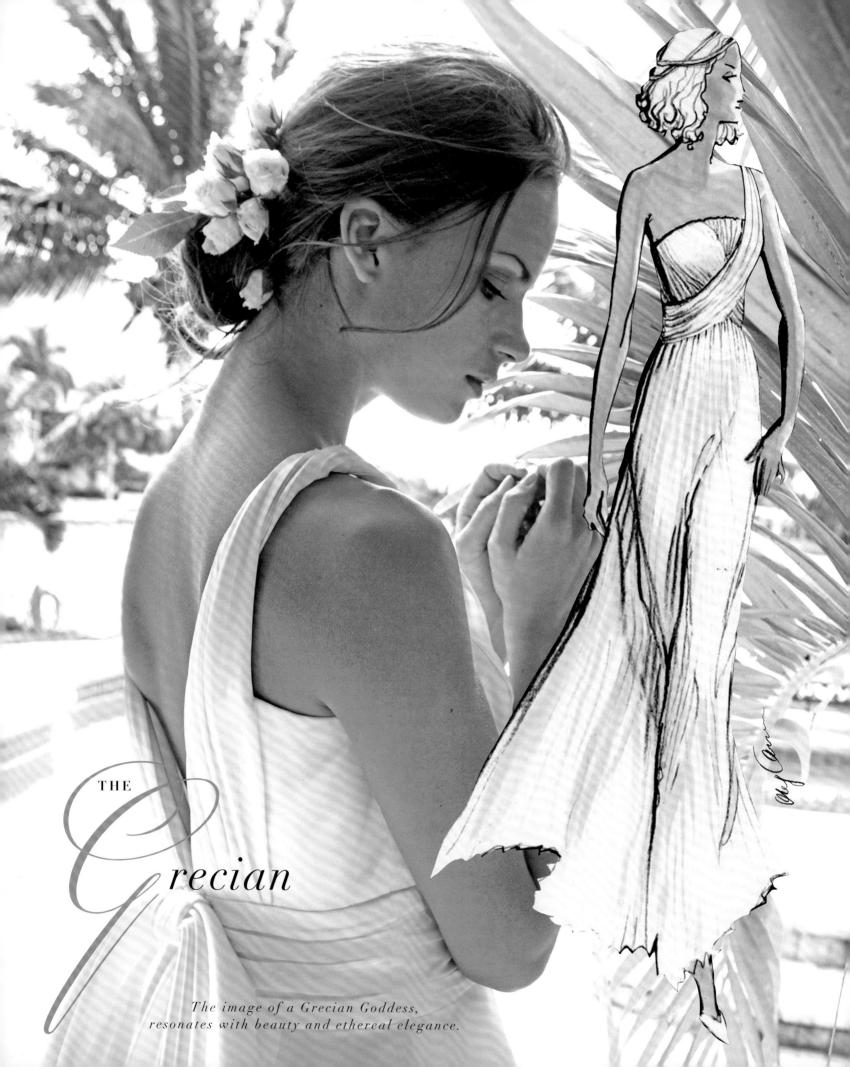

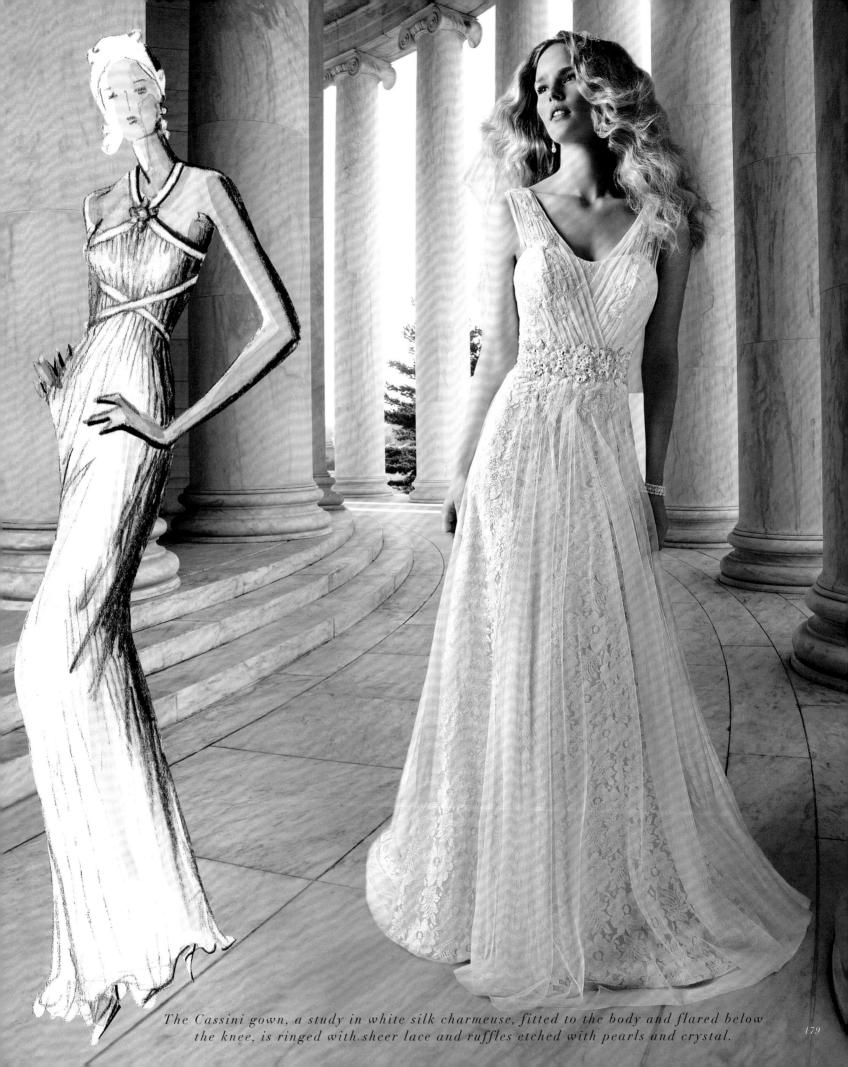

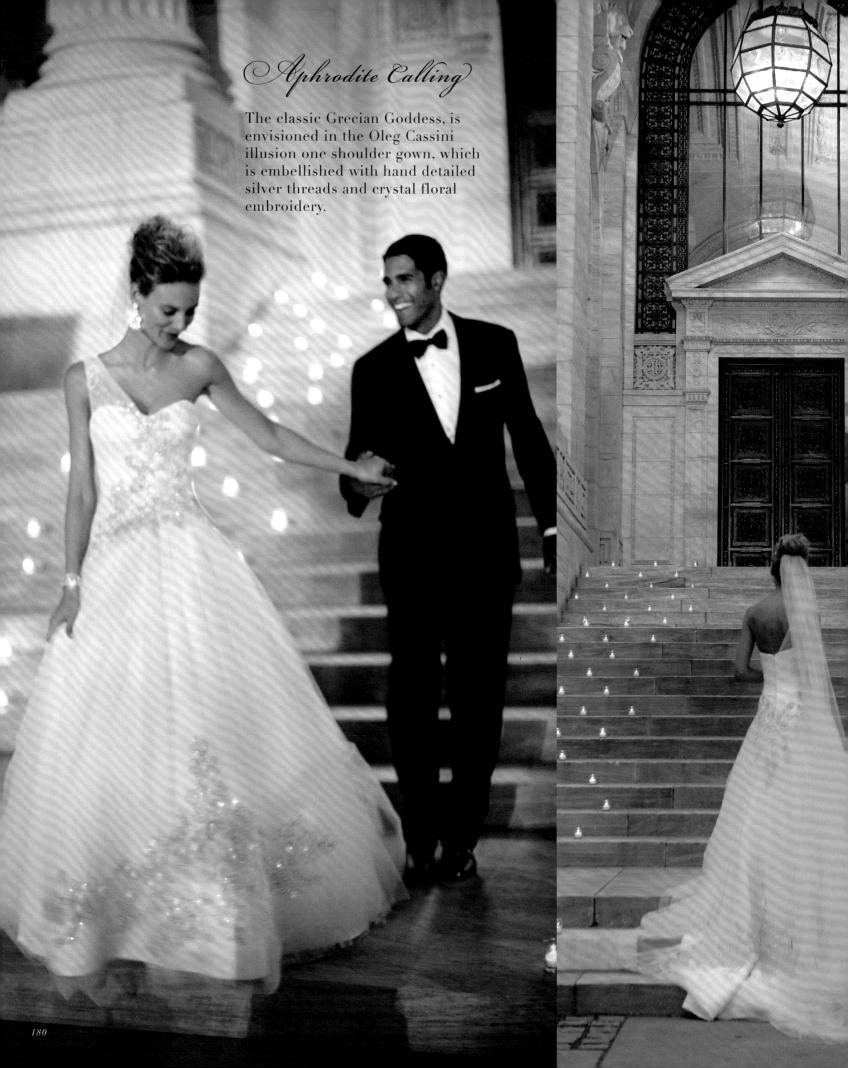

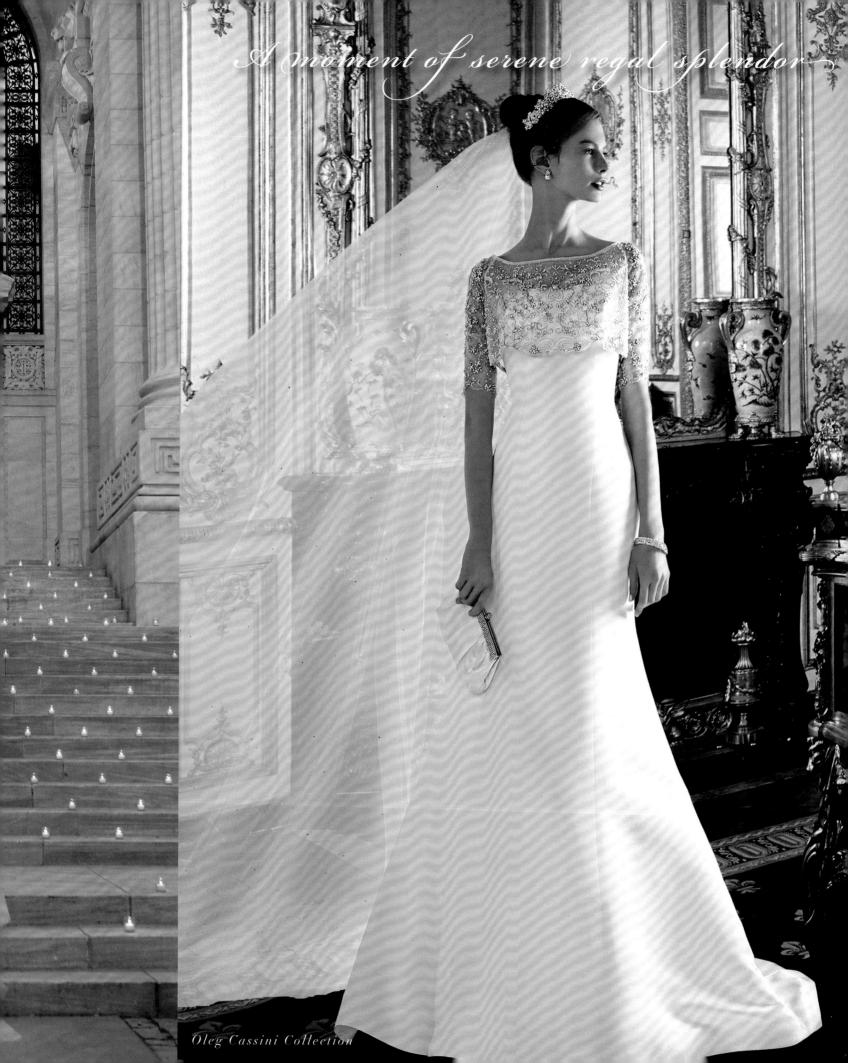

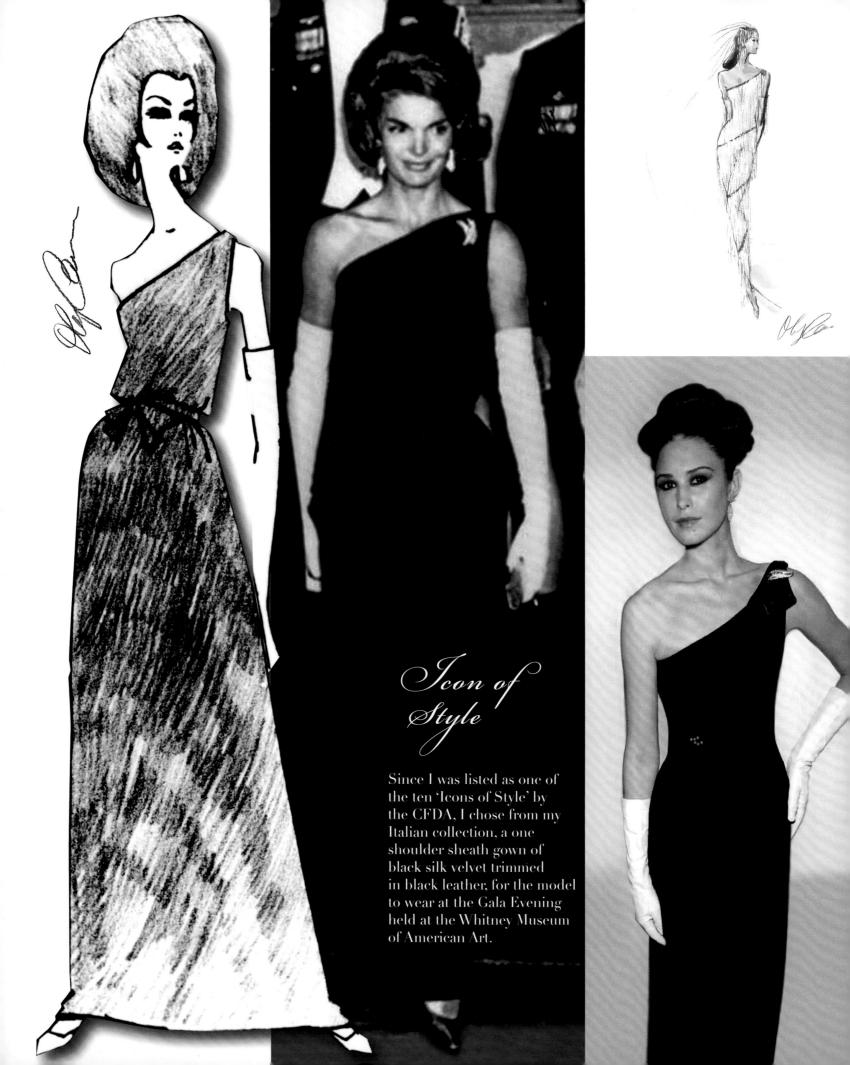

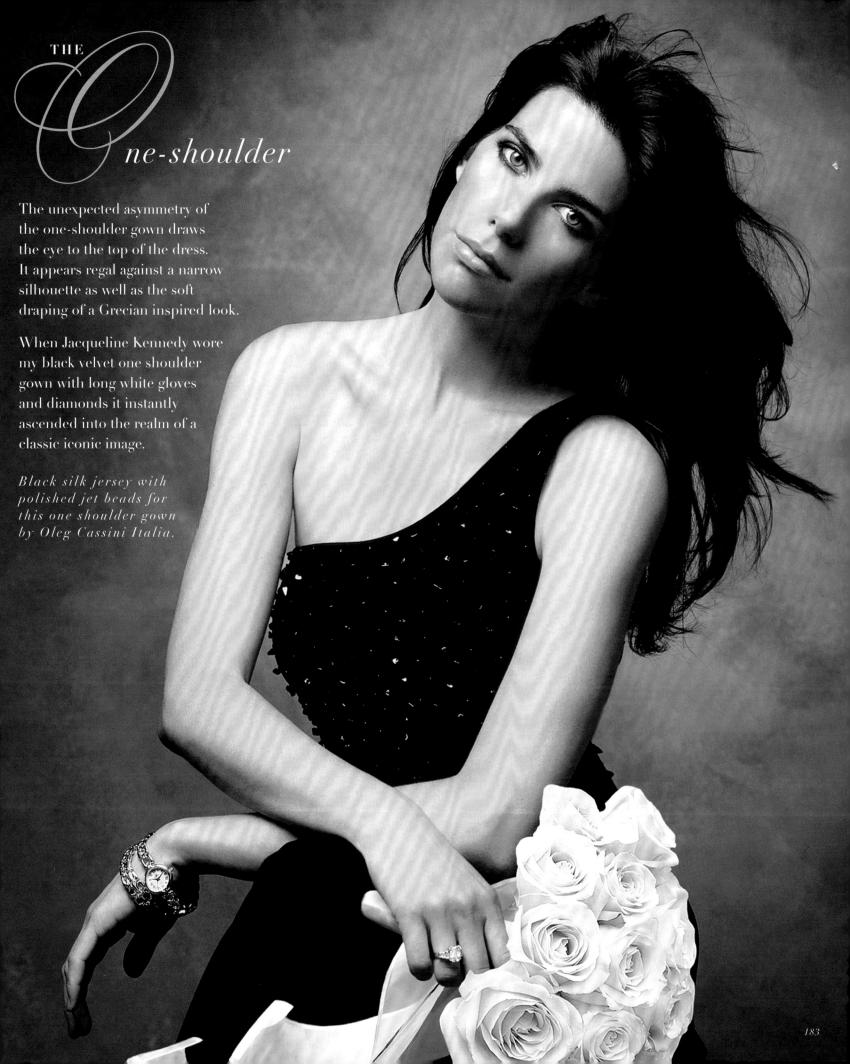

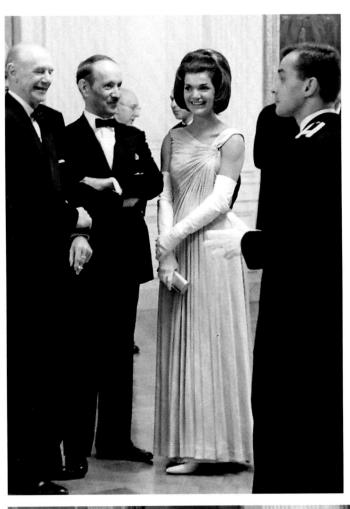

"I think this is
the most
extraordinary
collection of
talent, of human
knowledge, ever
gathered at
The White House,
with the possible
exception
of when
Thomas Jefferson
dined alone."
J.F.K.

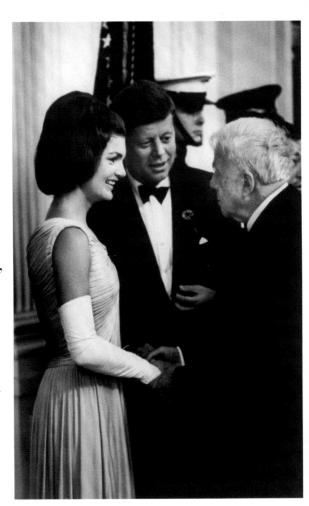

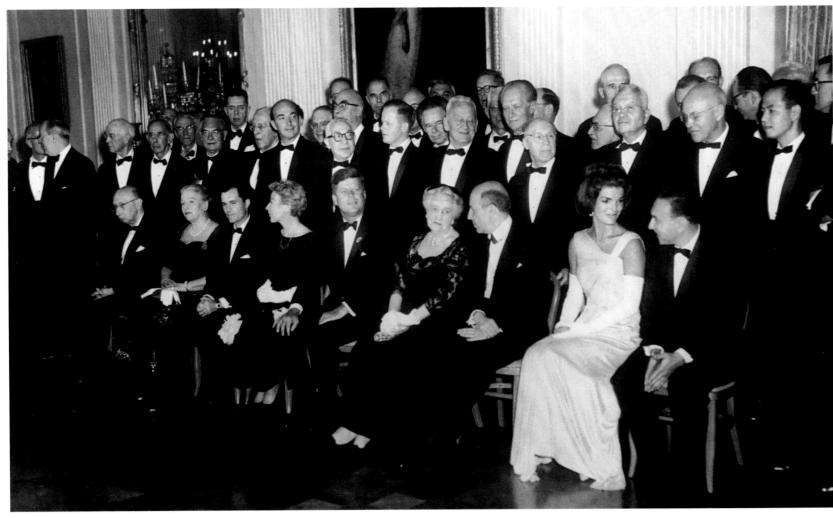

At The White House dinner for Nobel Prize Laureates, President Kennedy made a memorable toast to the group.

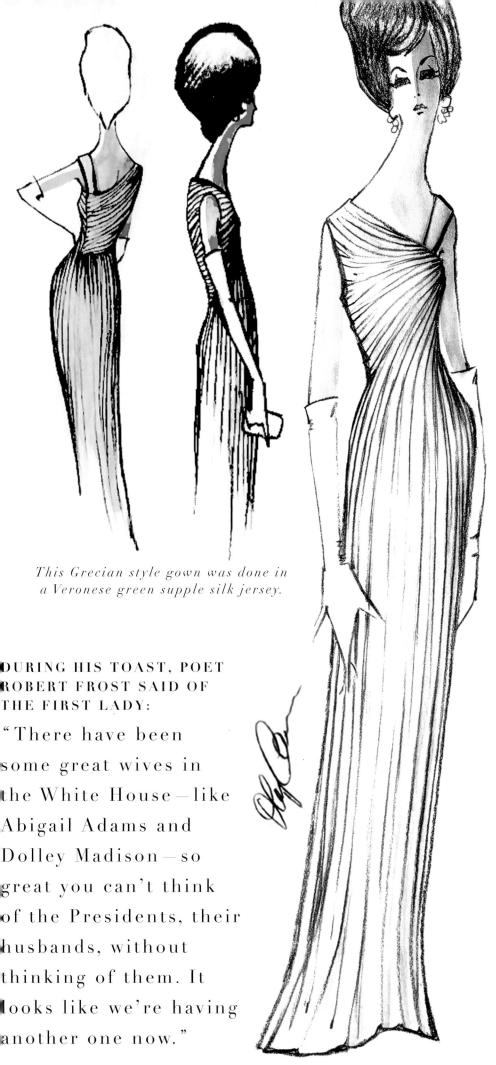

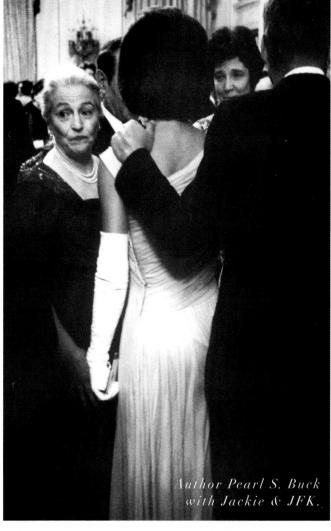

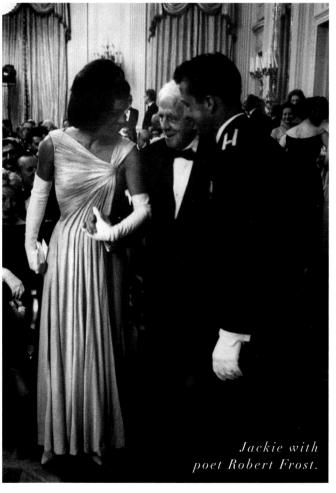

Recalling Napoleonic era royalty, the Empire is a silhouette dignified by its history, yet is stylistically free and unconstrained. First seen on the figures of goddesses in Greek and Roman antiquities, the Empire is a timeless look.

Although it is a shape with the weight of history behind it, the Empire has the stylistic ease and versatility to be utterly romantic. The defining feature of the Empire is its raised waistline, which rests just under the bust and can extend to the ribs, from which the skirt of the gown flows in a single vertical line to the hem. Lighter fabrics are particularly lovely and the extended length of the gown accentuates the luxurious draping of fabric choices like chiffon, jersey, silk, organza, velvet.

The Empire first became popular in the late 18th century and reached the height of its popularity in France during the early 19th century. The trend began with Pauline Bonaparte, sister of Napoleon, yet the silhouette is usually associated with the image of Napoleon's Empress, Josephine. Evoking the grandeur of a Royal wedding, the magnificent portrait by David of the Coronation shows both Josephine and her court wearing richly trimmed Empire gowns.

Regal and romantic, a bride in an Empire gown calls on rich historical tradition and is totally memorable.

Gown by Oleg Cassini

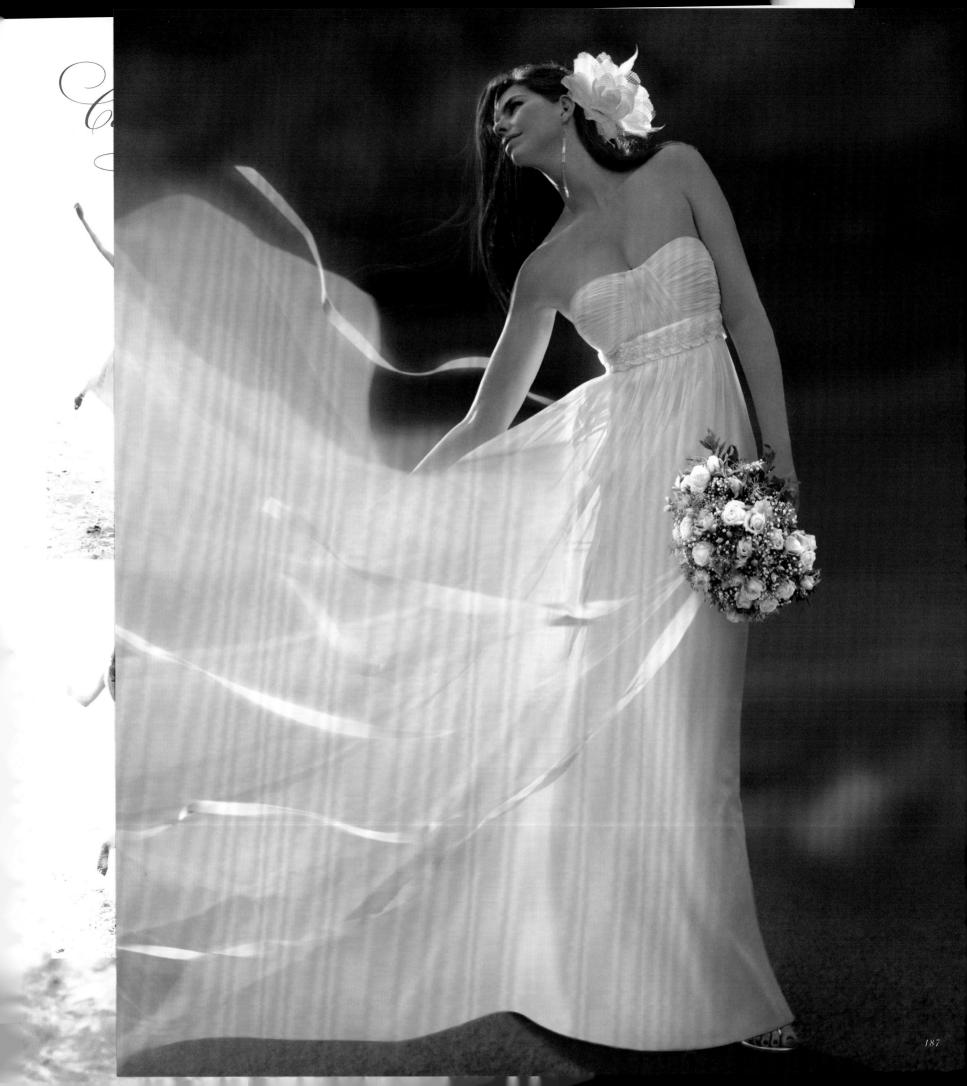

"Any tim spen is w TORQU

The ear dame' l Boilly, fee 1785. I chronicle amongs and

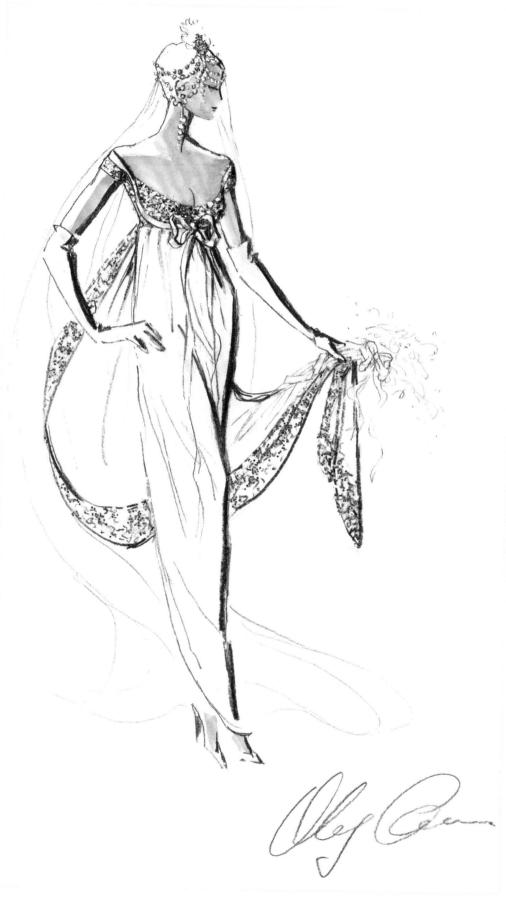

Empress Josephine, wife of Napoleon popularized the Empire silhouette in the early 19th century.

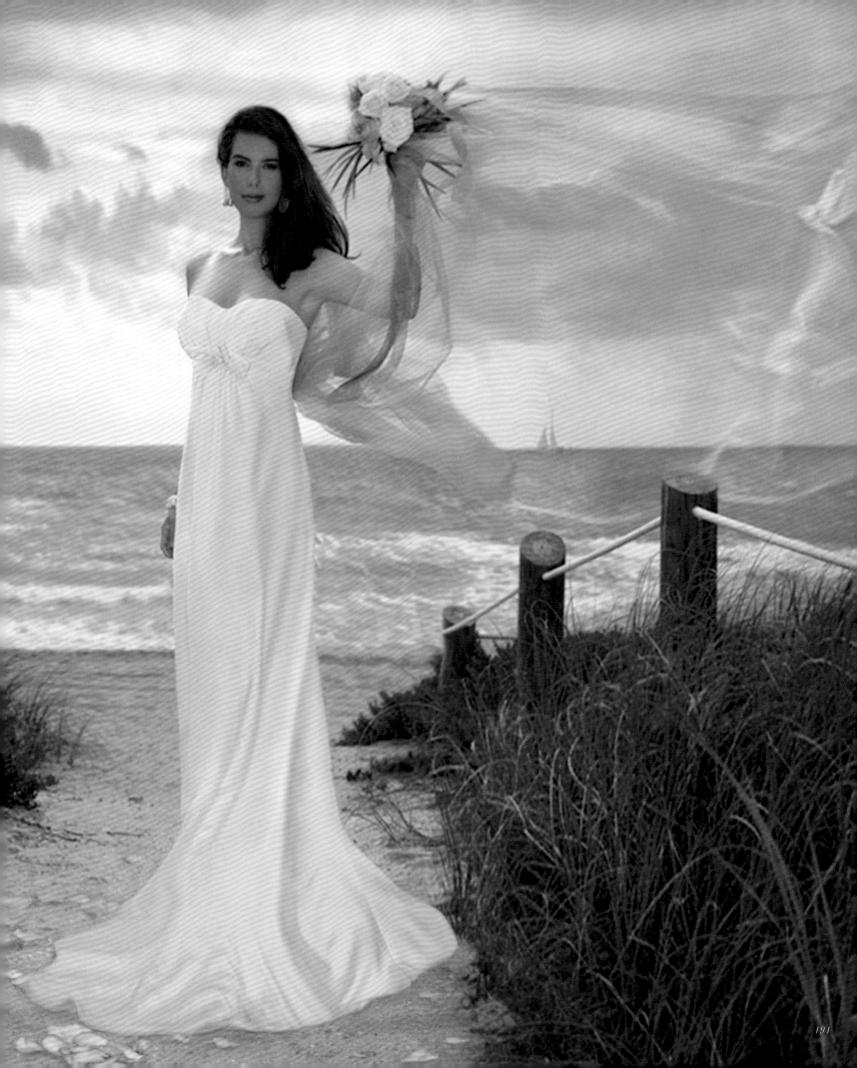

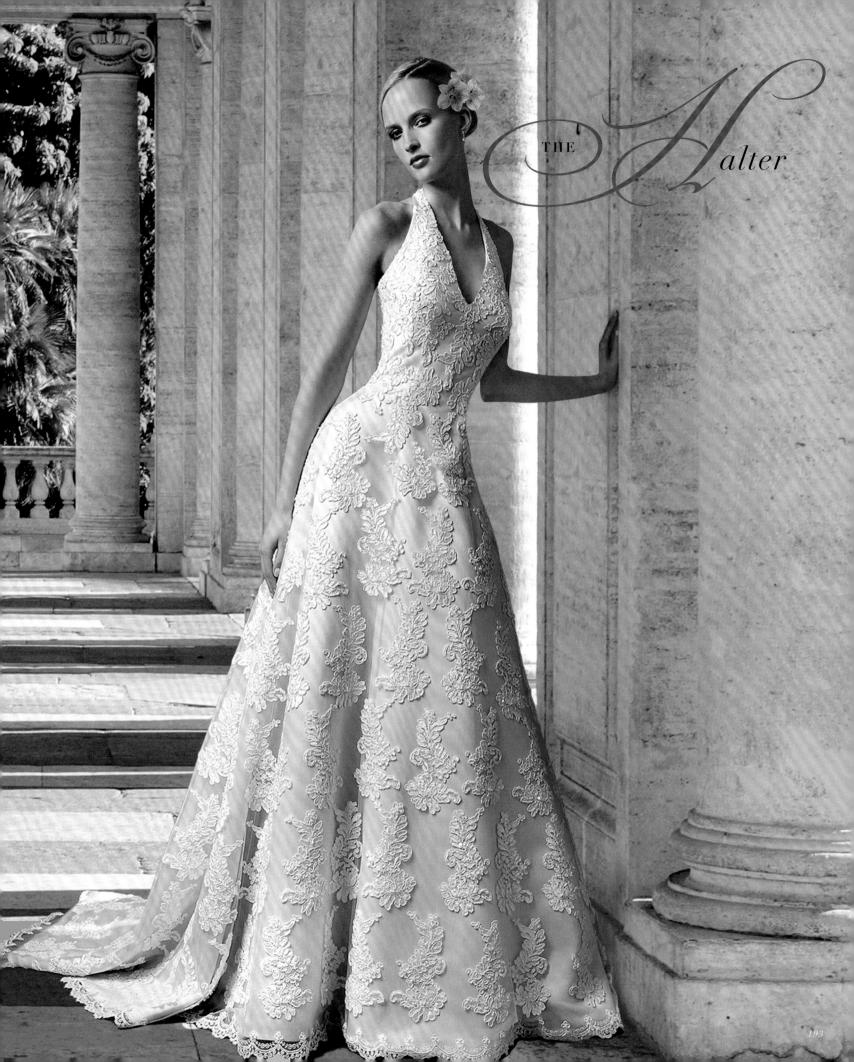

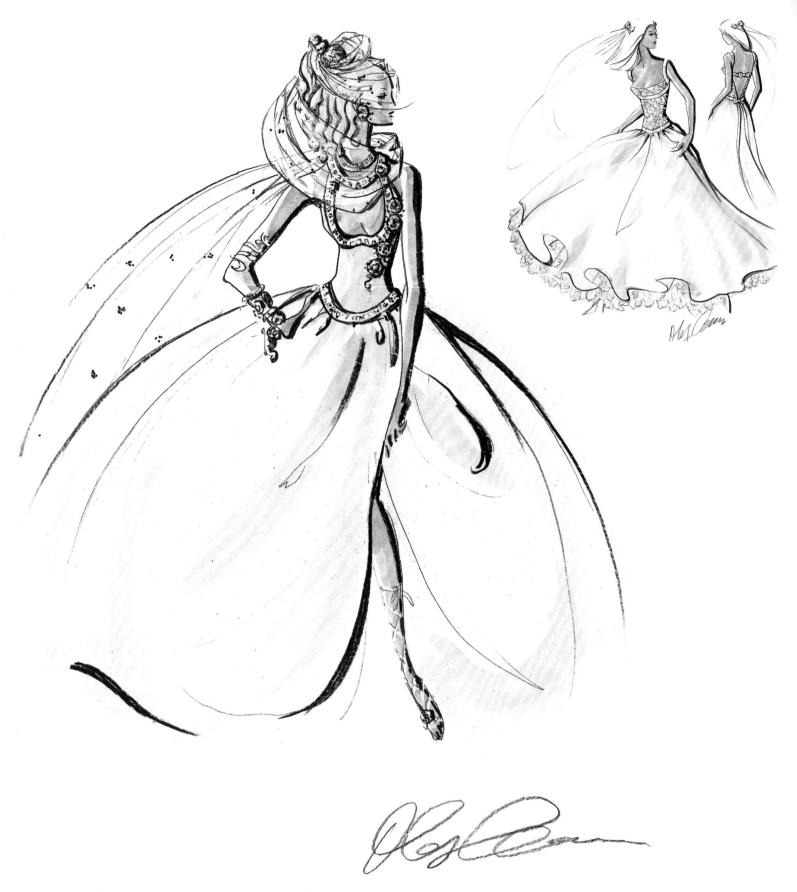

The rounded scoop neckline of the halter gown reveals an unexpected voluptuousness above the drama of the lavishly embroidered and corseted midriff. The fabric is a shimmering pure white satin richly detailed with polished crystals and silver trim. Playful as well as provocative, the halter is a shape that goes with any silhouette, from the full skirt of a ball gown to a breezy, free flowing toga, to a form fitting sheath. The halter is bare on the back and sides and fastened around the neck, and draws attention to its own distinctive shape as well as the shoulders, back and decollétage that it showcases.

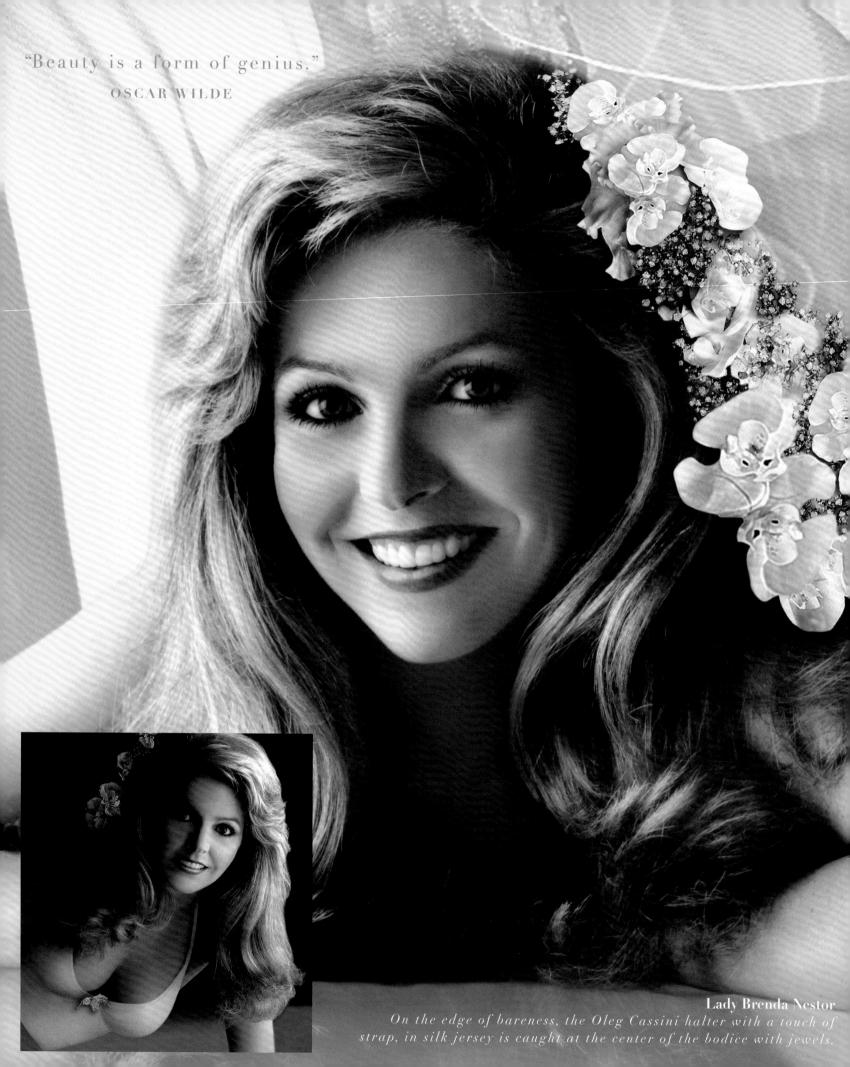

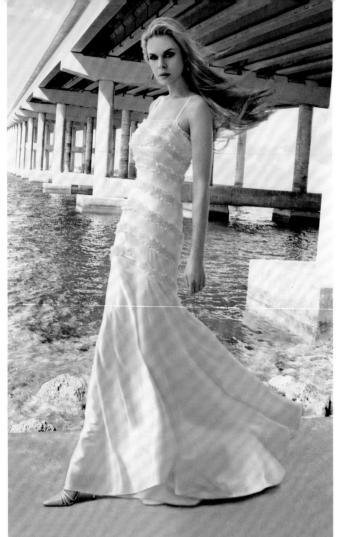

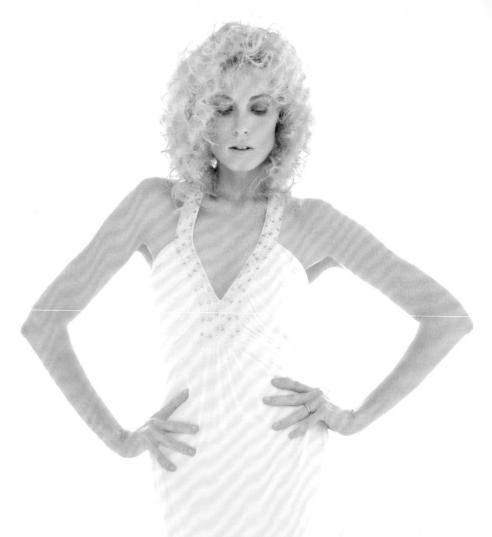

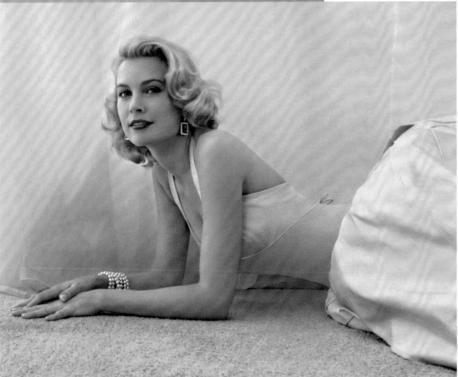

Grace Kelly in the Oleg Cassini Halter Dress

The Oleg Cassini halter gown is a clinging column of white silk jersey with a deep V neck of satin ribbon trimmed with polished crystals and pearls. Wrapping the neckline and bodice with satin mixed with lace and organza is a flattering design technique and works very well with the bare halter silhouette.

Gown by Oleg Cassini Photo by Antoine Verglas

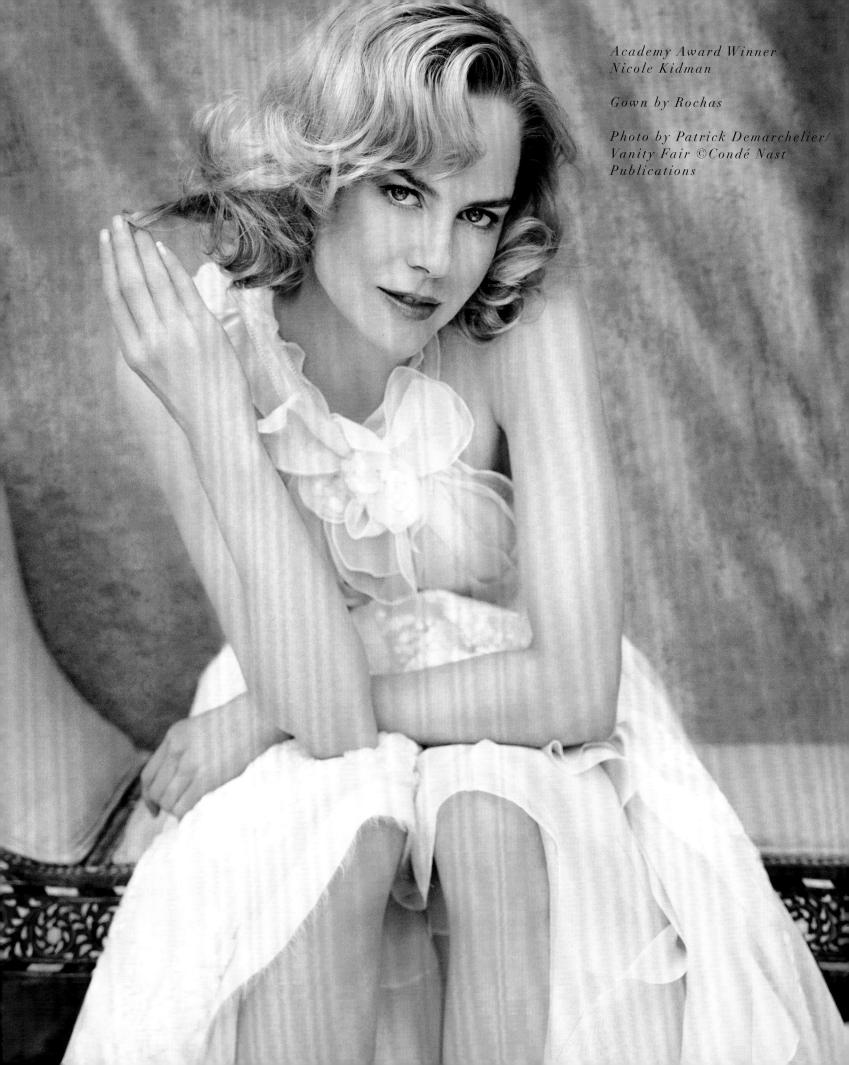

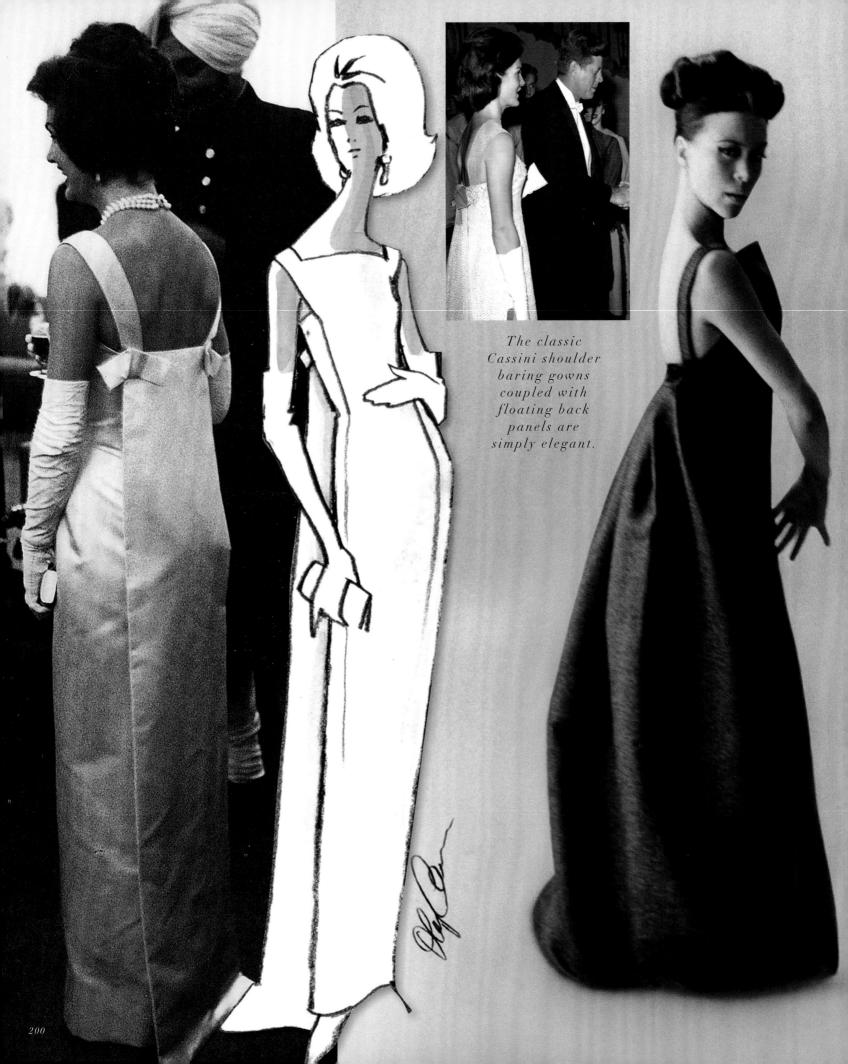

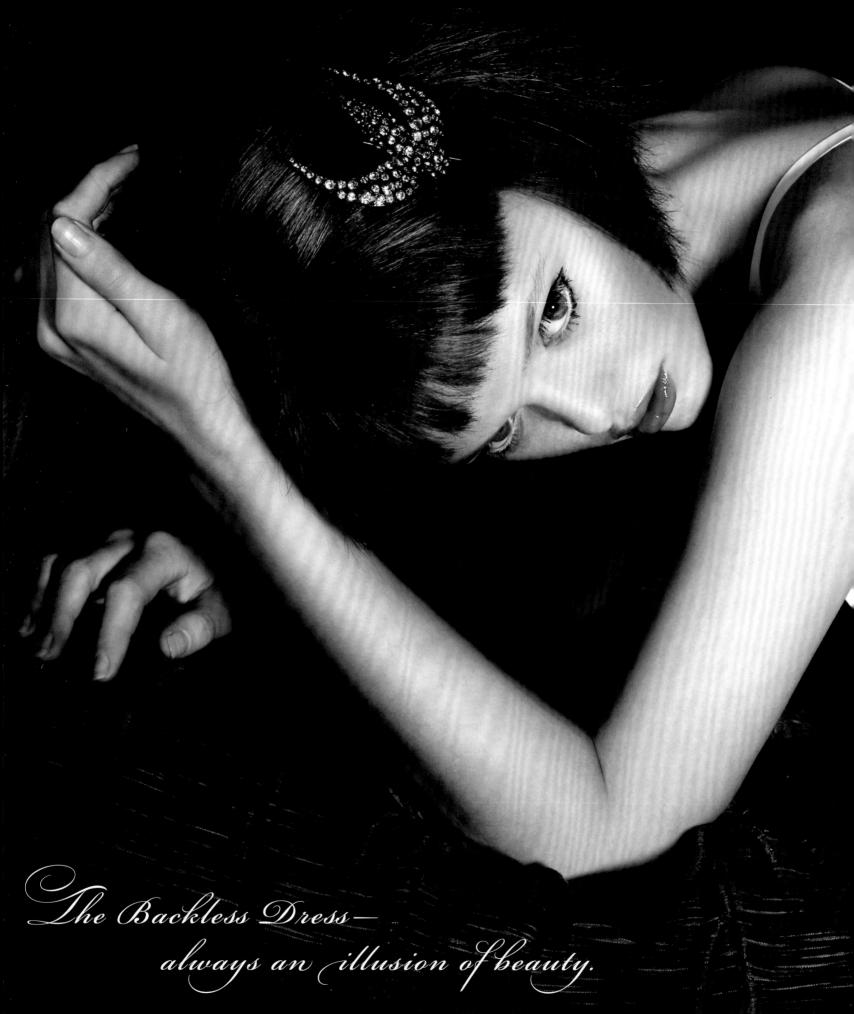

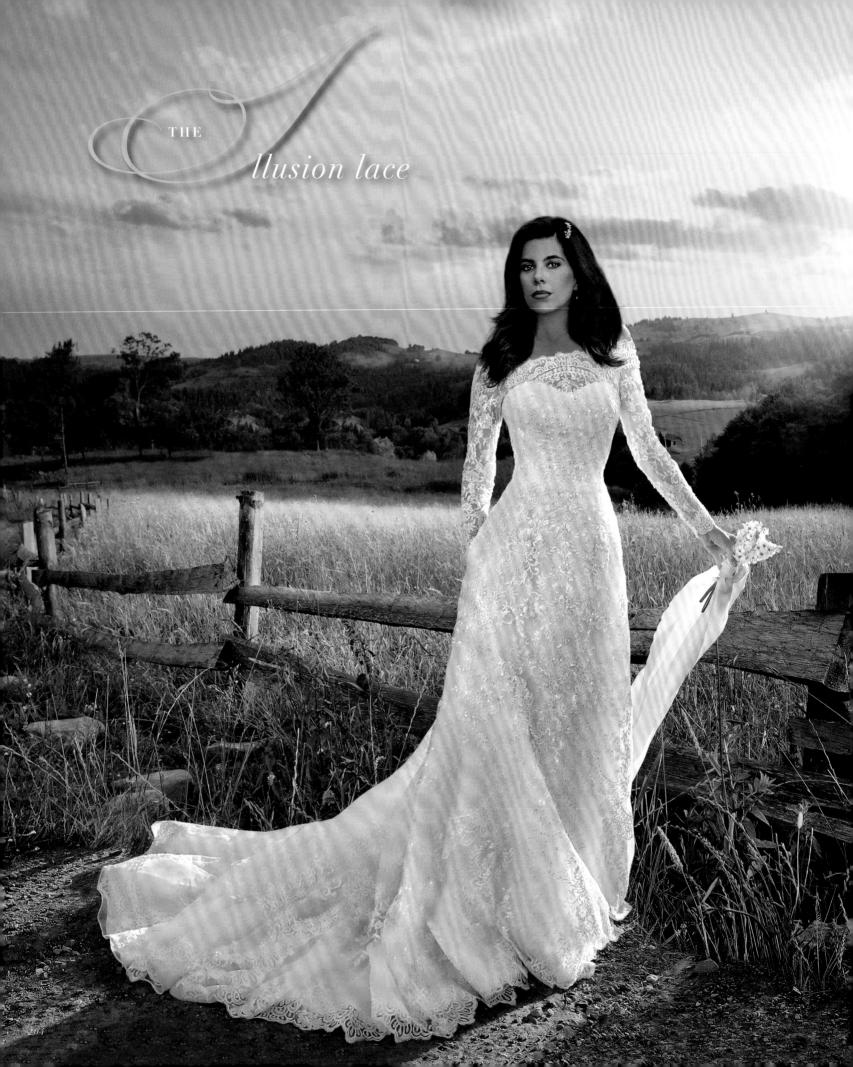

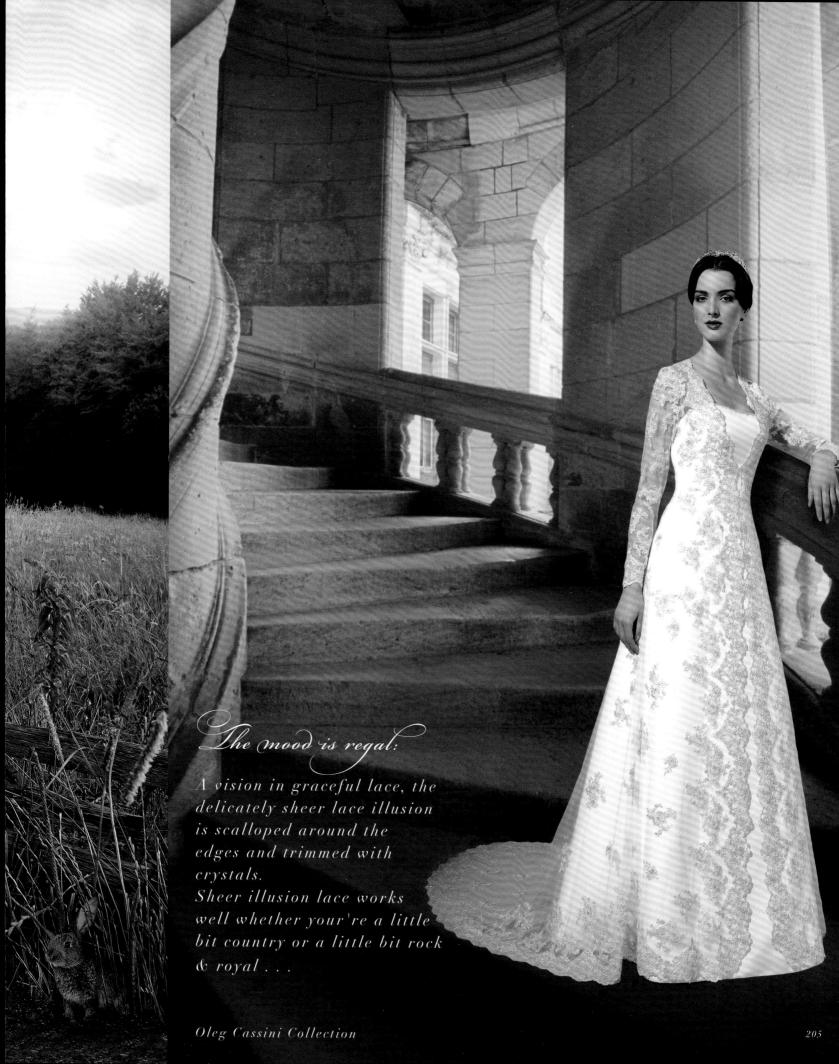

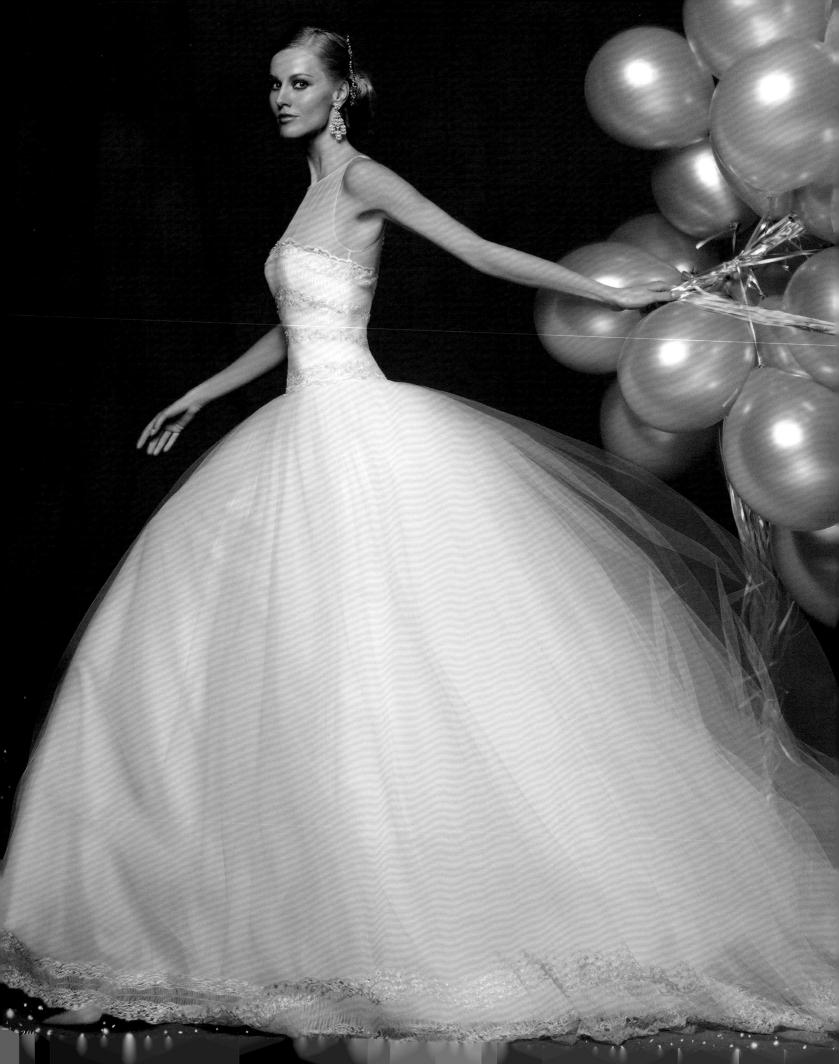

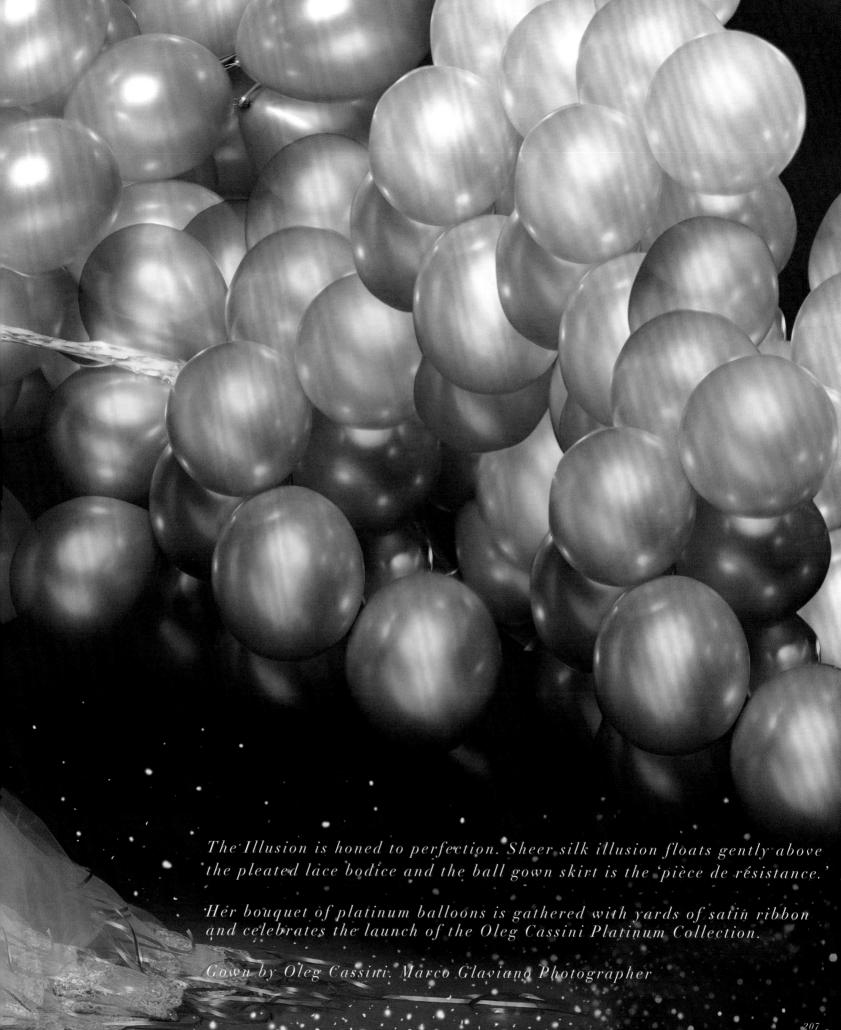

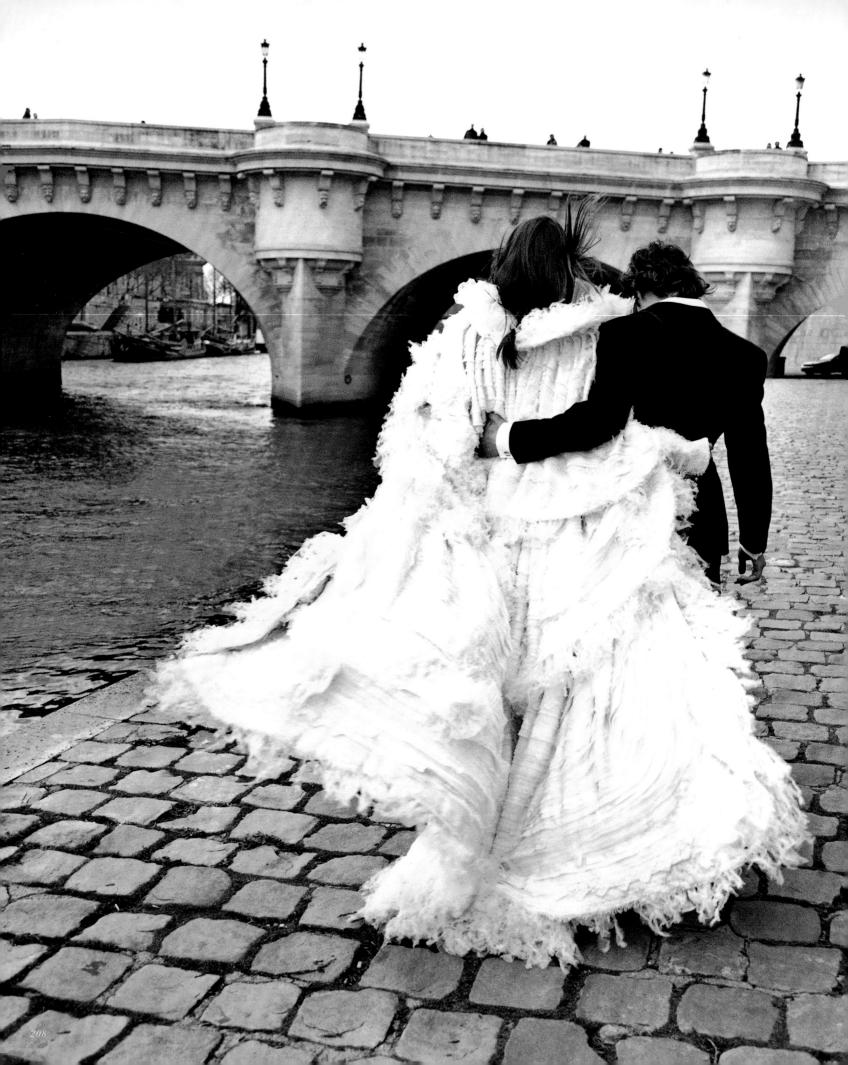

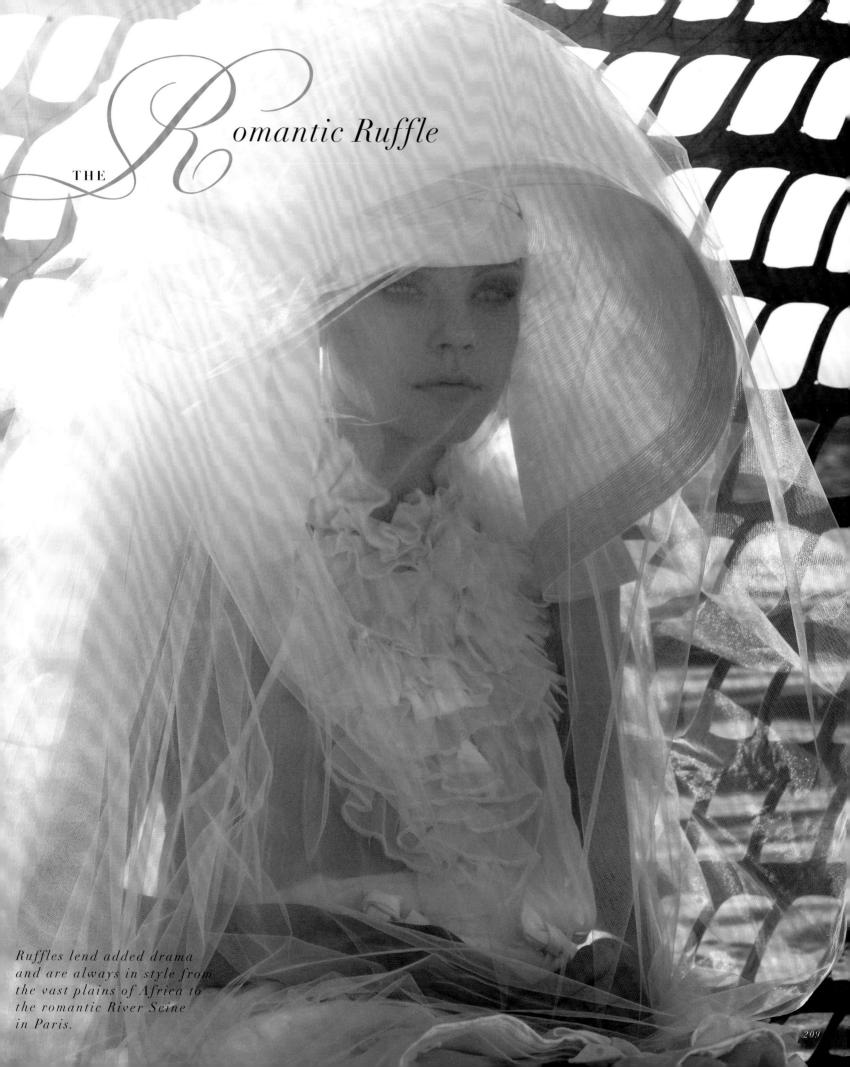

Actress Keira Knightley wears a shirtwaist look of lawn cotton softened by a ruffled train. The mood is American Western in feeling, shot on the African plain. The term 'lawn' derives from a city in France, Laon, which produced large quantities of the lawn fabric. This is similar to the term 'denim' which derives from Nîmes in France.

East) meets Mest

A wedding in the country evokes
the image of a young Russian Countess
wearing romantic ruffles
of white lawn cotton

THIS PAGE Photo by William Cadge

OPPOSITE
Photo by Arthur Elgort /
Vogue © Condé Nast Publications

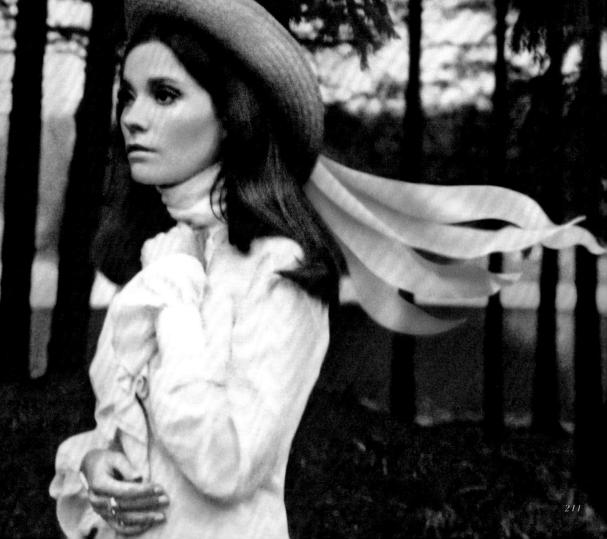

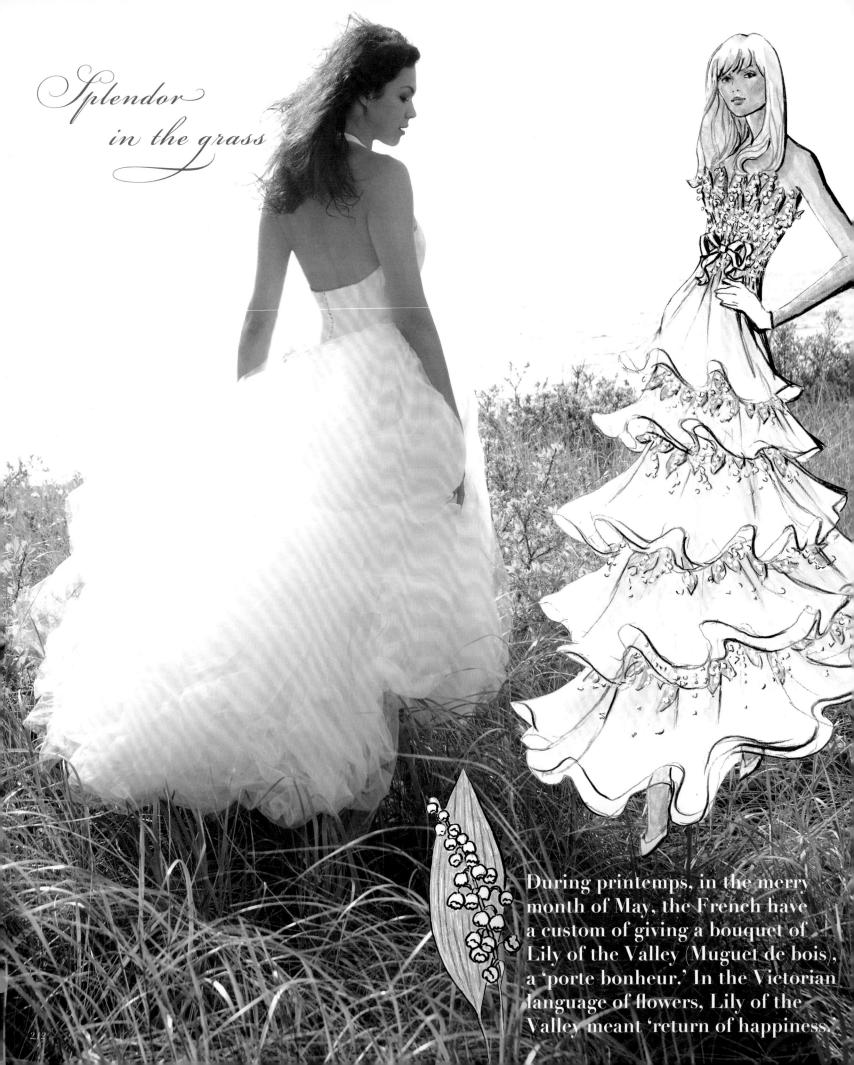

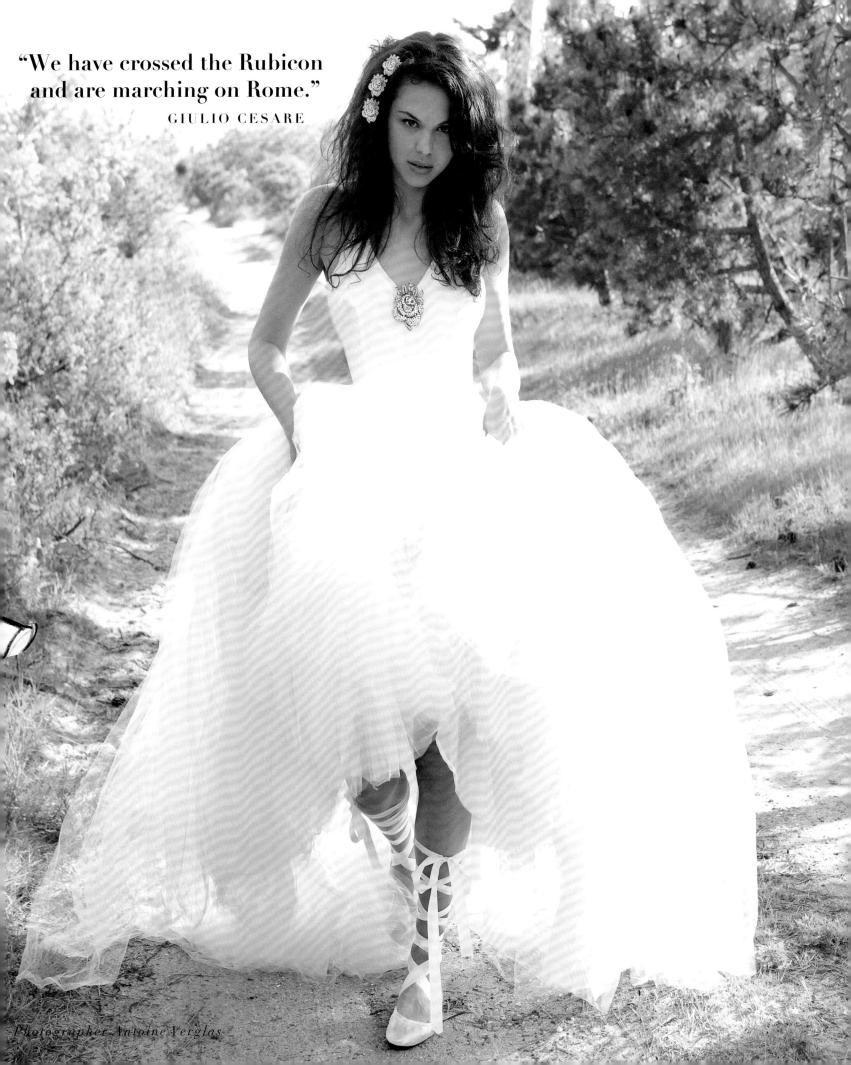

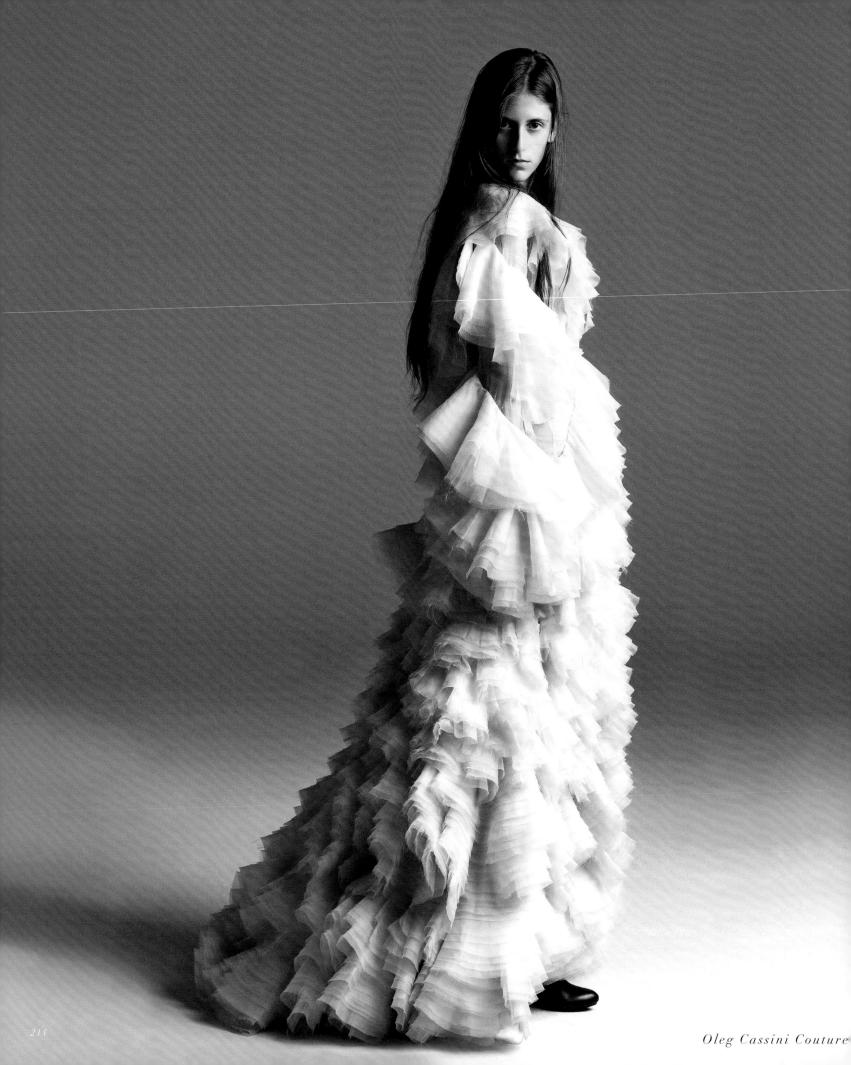

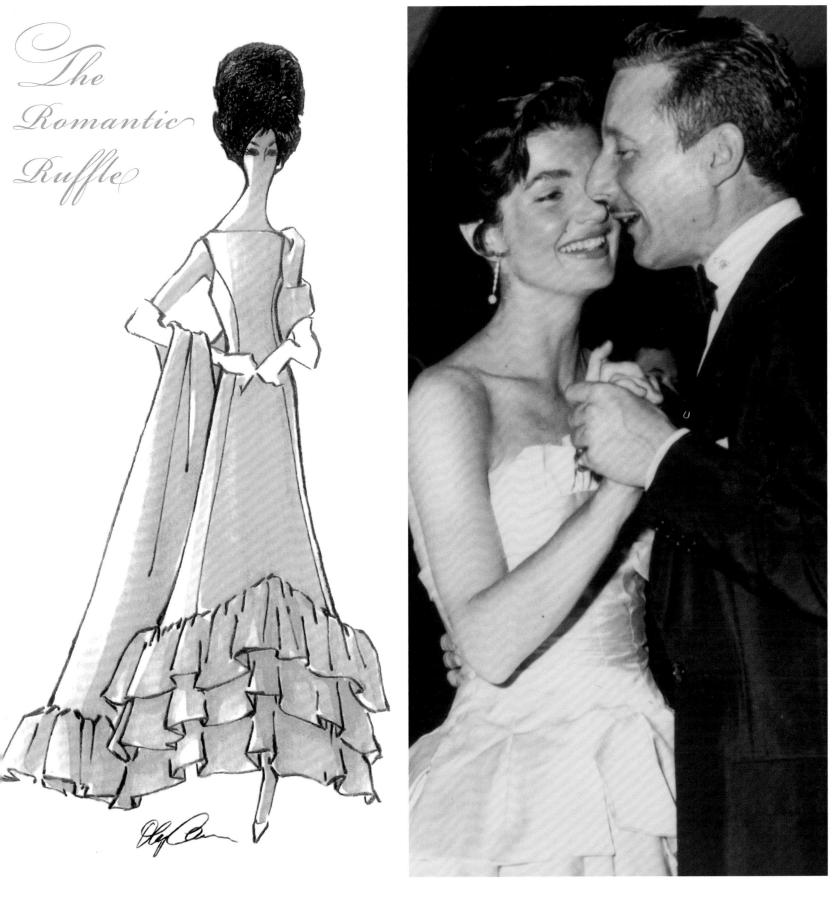

In addition to the appealing vision and movement they create, romantic ruffled tiers on the wedding dress bring to mind the tiered cake. The visual allusion to this matrimonial symbol adds another dimension to the overall look. Tiers, whether they be light, subtle layers of fabric, or frothy ruffles, add glamour and volume to the dress. Ruffles shimmer playfully and add an accent of flair and an element of excitement.

Ruffles were an important design element for Jackie. To paraphrase Oscar Wilde, "her tastes were very simple, she only liked the very best."

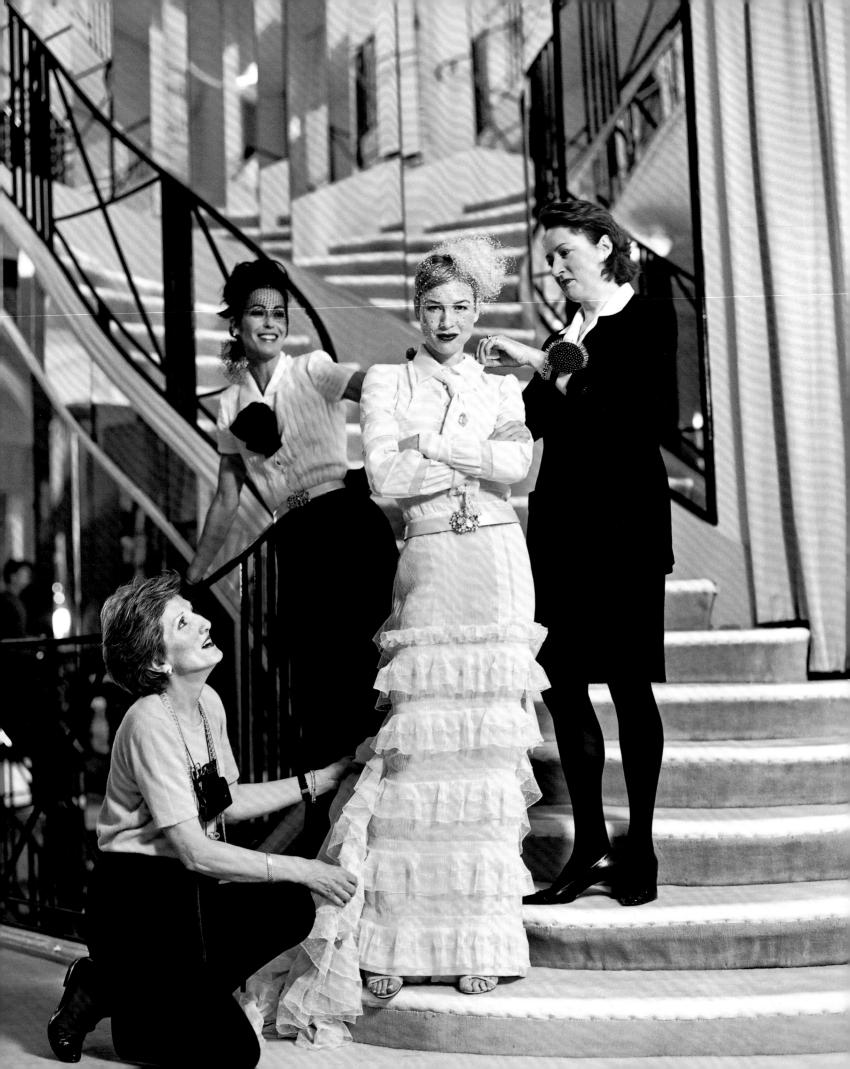

The stage is set (... THIS PAGE Cassini Crystal stems are filled with rosé. Charmeuse silk is tiered and centered with signature bows, topped with a black velvet hat. Photo by Mattias Edwall OPPOSITE Academy Award Winning Actress Renée Zellweger, on the stairway at Chanel, being wrapped in the ruffled tiers of a wedding dress. Photo by Arthur Elgort / Vogue ©Condé Nast Publications Oleg Cassini gown

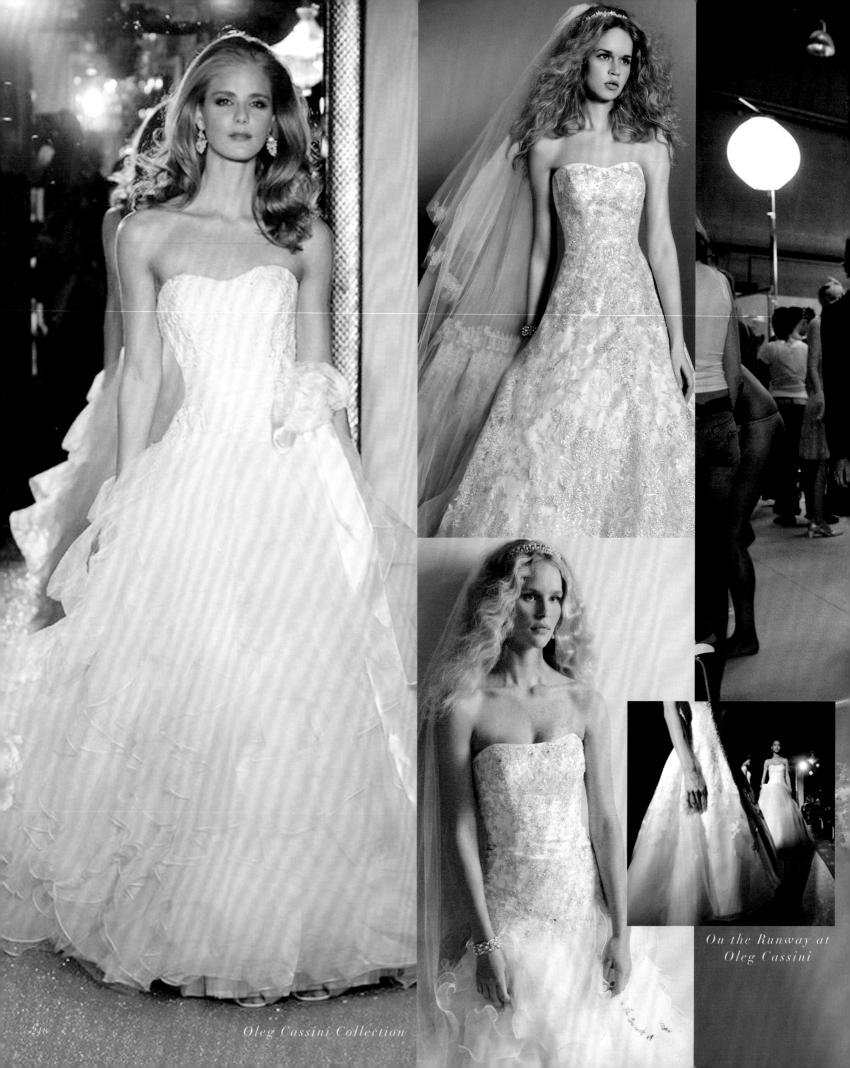

Ruffleson the

Behind the scenes at Chanel, the bride

Photo by Robert Fairer

Oleg Cassini Collection

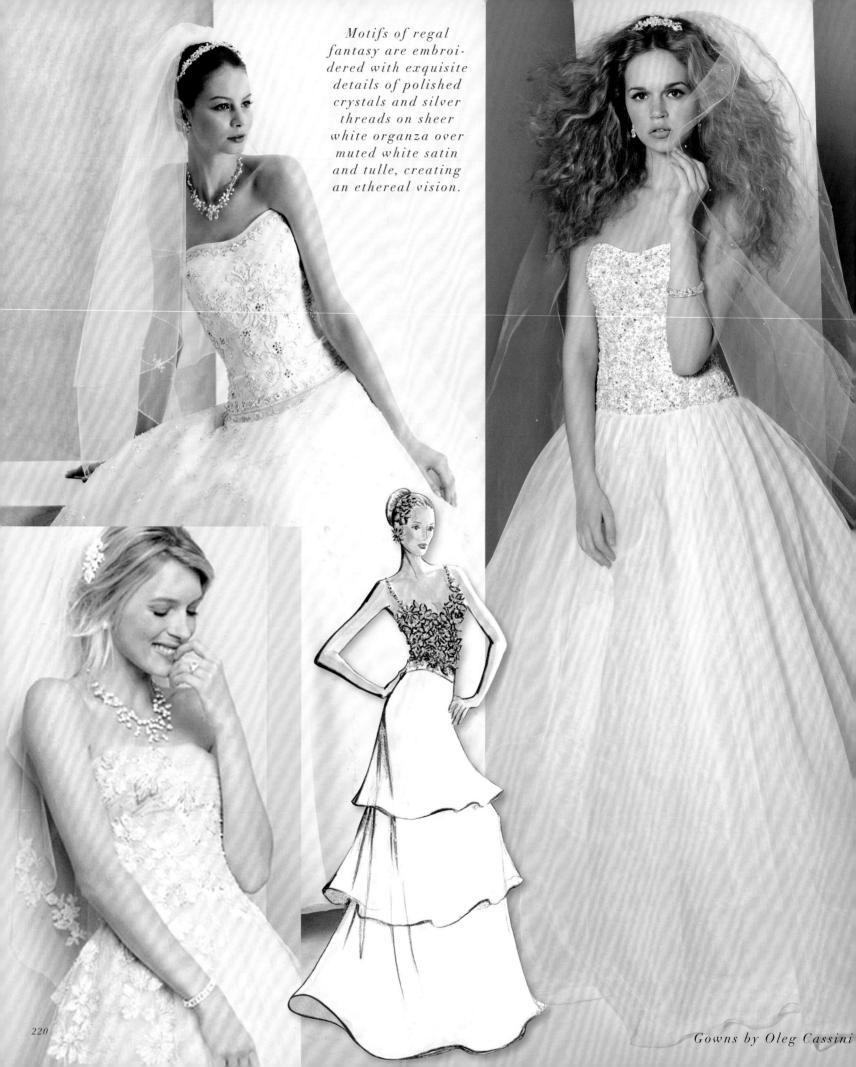

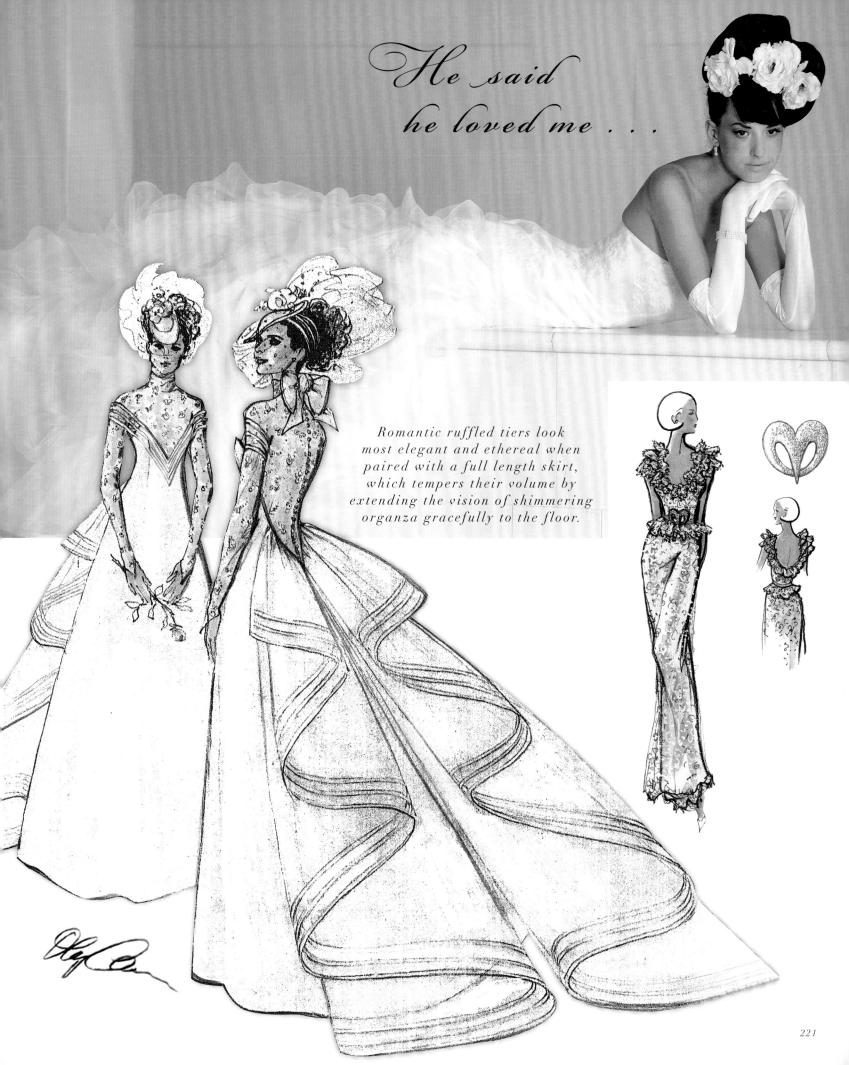

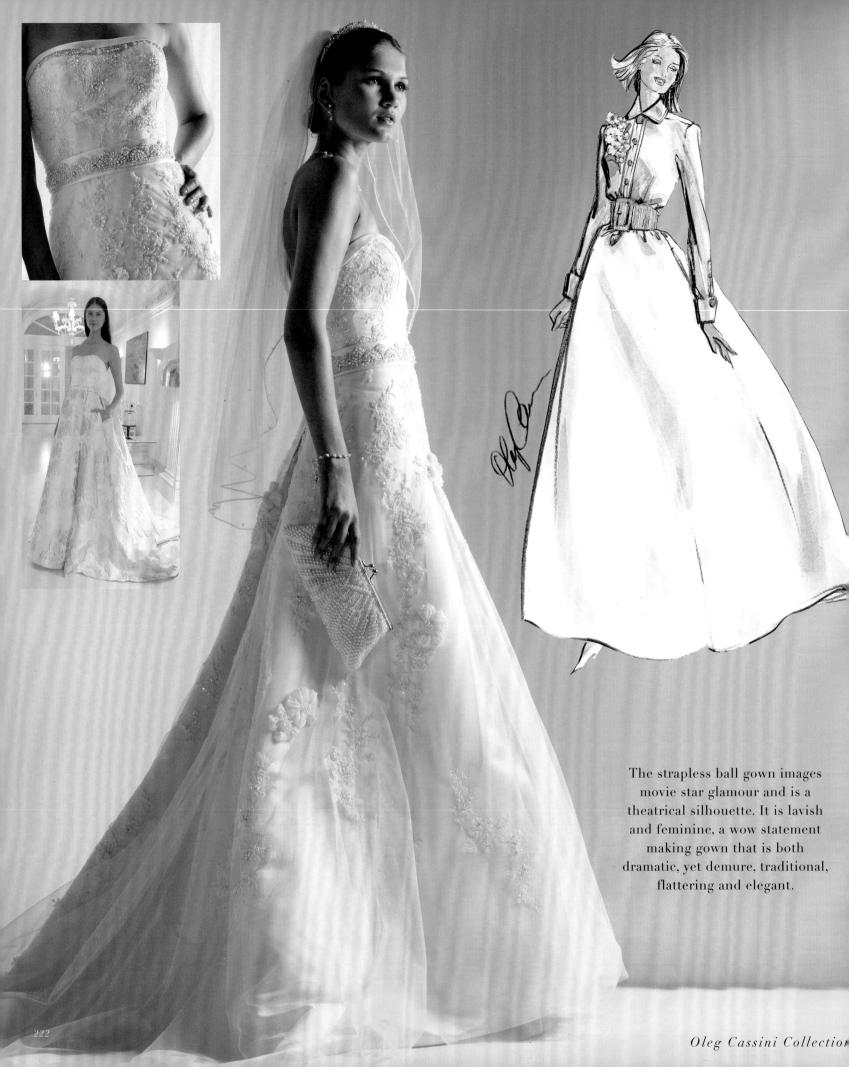

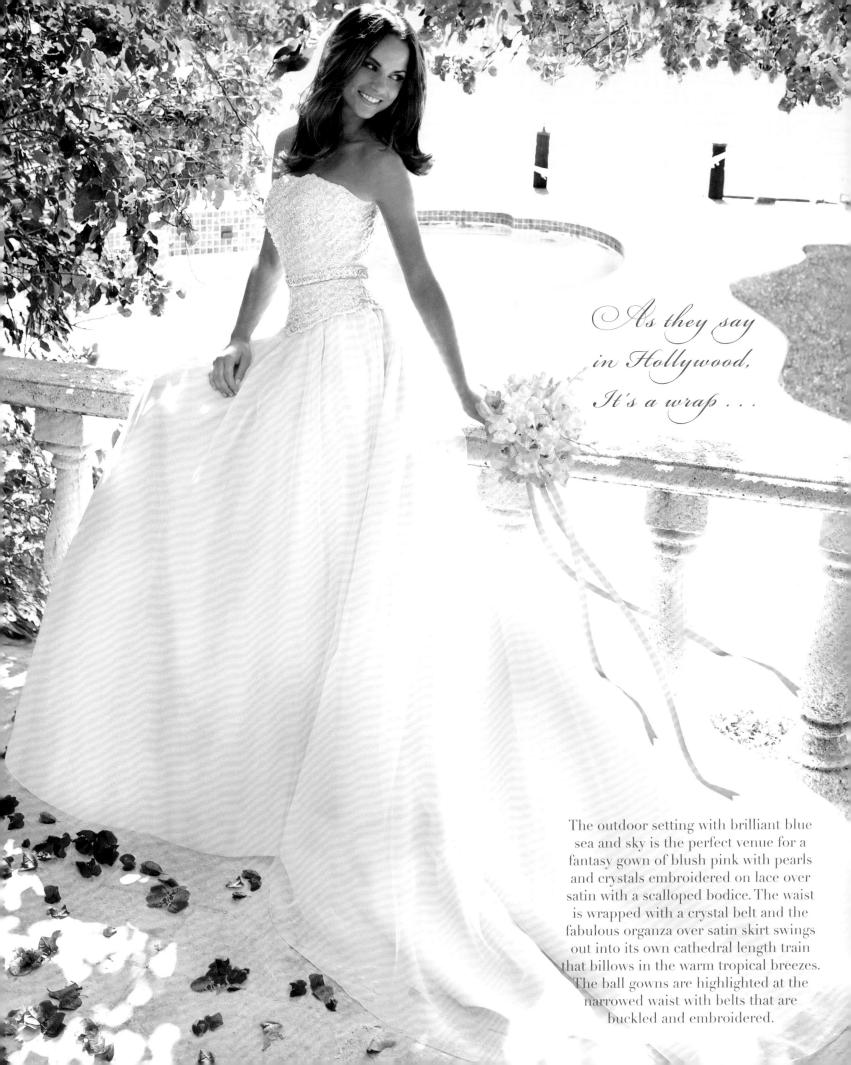

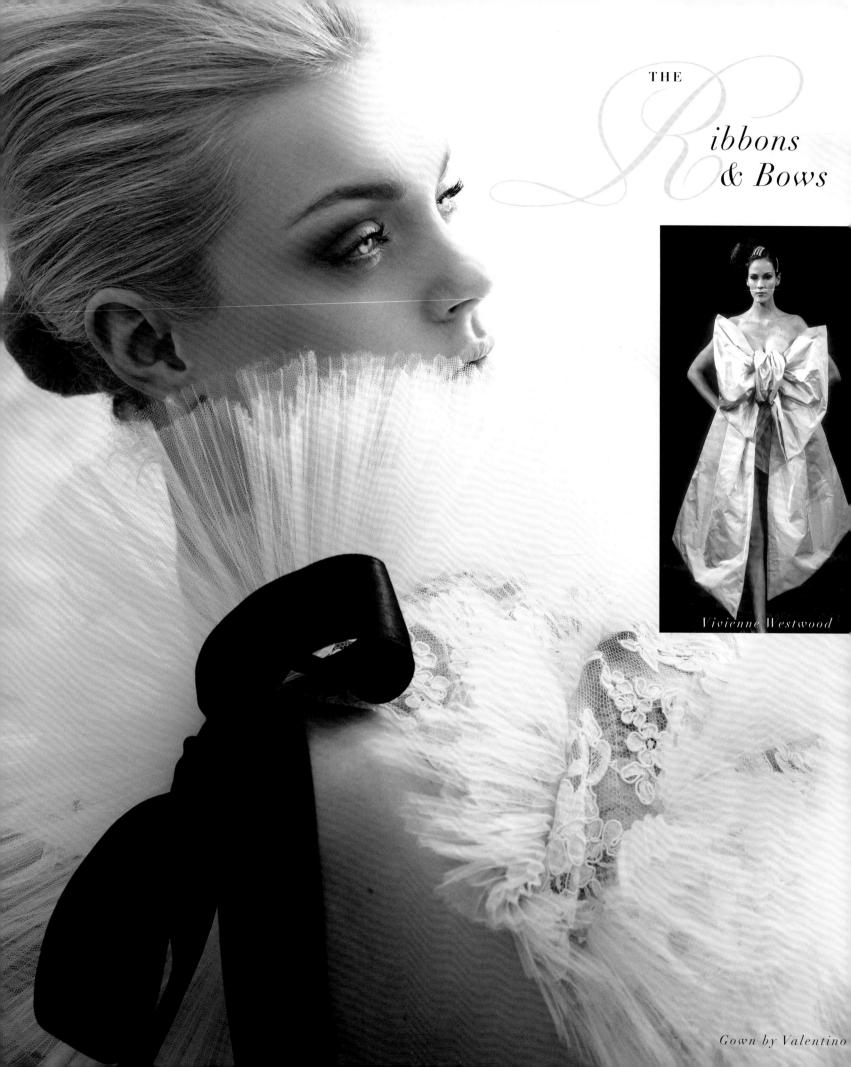

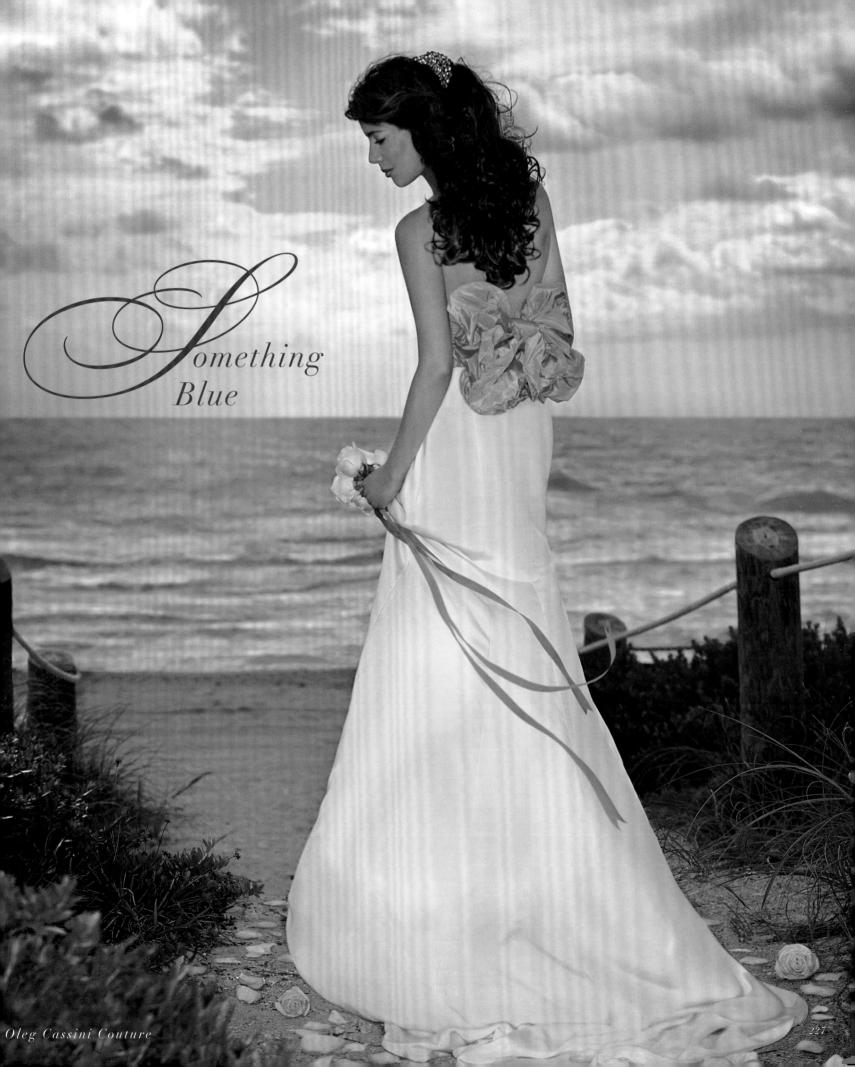

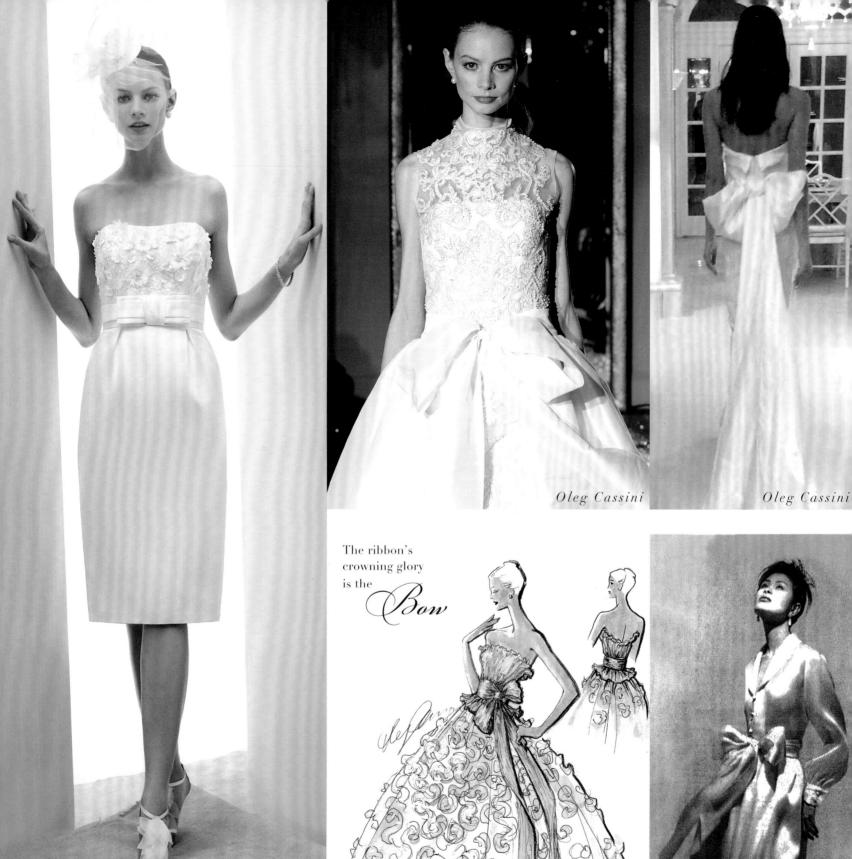

There is nothing more adorable than the dance length Oleg Cassini 'Jackie' Dress. Pure white satin is gathered at the waist with a bold center bow. The curved strapless bodice embroidered with three dimensional flowers is embellished with clusters of pearls and polished crystals. The look is topped with a flower fascinator wrapped in sheer tulle sprinkled with crystals.

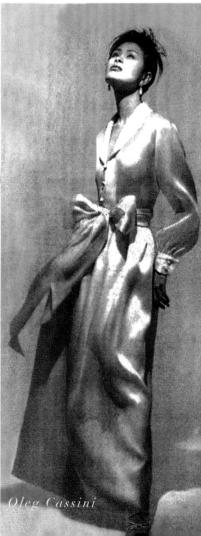

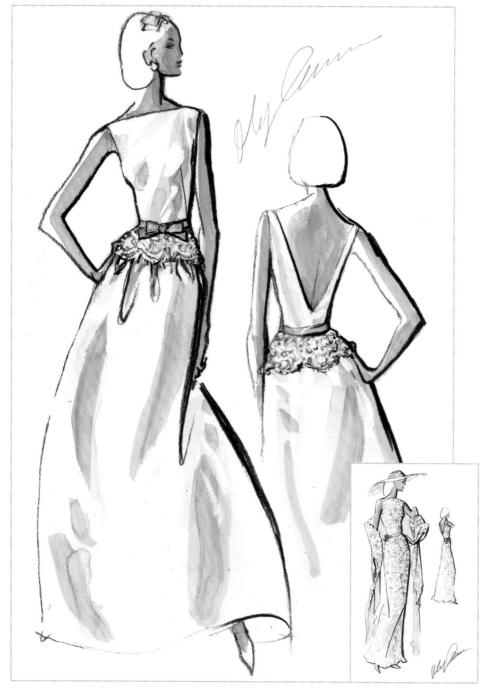

The Bateau Neck & Bow

Popularized by the iconic image of First Lady Jacqueline Kennedy wearing Oleg Cassini gowns, with signature bows and bateau necks, the drama of the smooth sophistication of her necklines was at the back, with deep Vs and scooped backs. Stretching gracefully from one shoulder to the other with a subtle, delicate dip, the bateau ('boatneck'), is a neckline that proudly covers with surprising allure. The secret is the natural accentuation of the collarbone and neck, an area that is appealing on almost all women, and is a perfect setting for jewels and necklaces. It's a shape that is flattering, drawing attention to the sleeker, slimmer, neck and collarbone areas. This shape of neckline is often associated with sailors; it is said that it was favored for its wide neck, which made it easier to pull off after going overboard. The bateau works well with bell skirts or the classic sheath embroidered all over with beaded fringes and jewels.

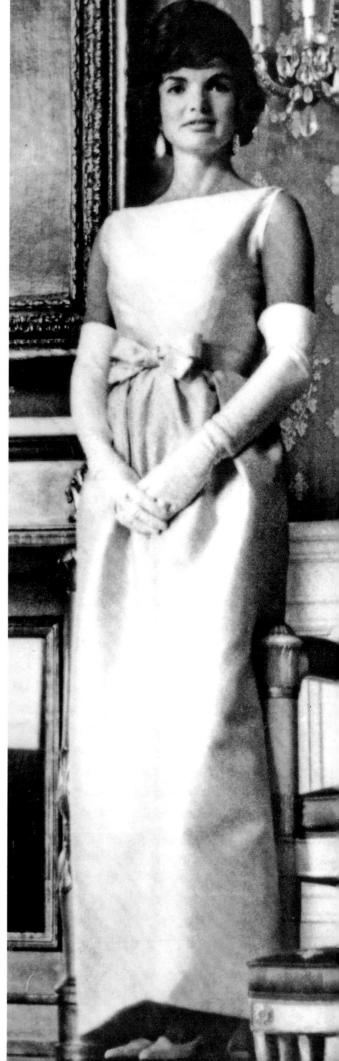

"Beauty and style and harmony and grace depend on simplicity." PLATO A time honored classic, The 'Ribbon Dress' reflects the light in a spectacular fashion. Satin ribbons worked in circles around the dress are embroidered with pearls and polished crystals on scalloped lace, making Caroline Castigliano is known for her understated elegance. a perfect link of matte and shine. Oleg Cassini

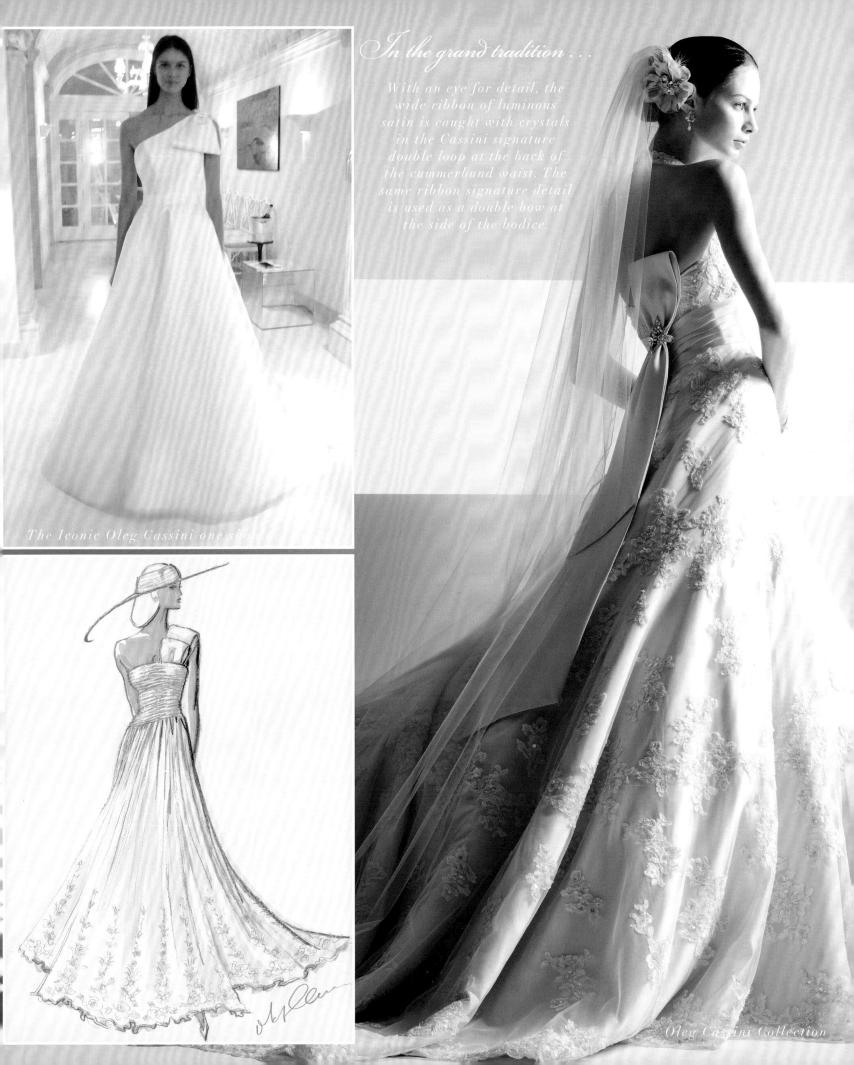

Beauty and the Beach ...)amera) Oleg Cassini Collection

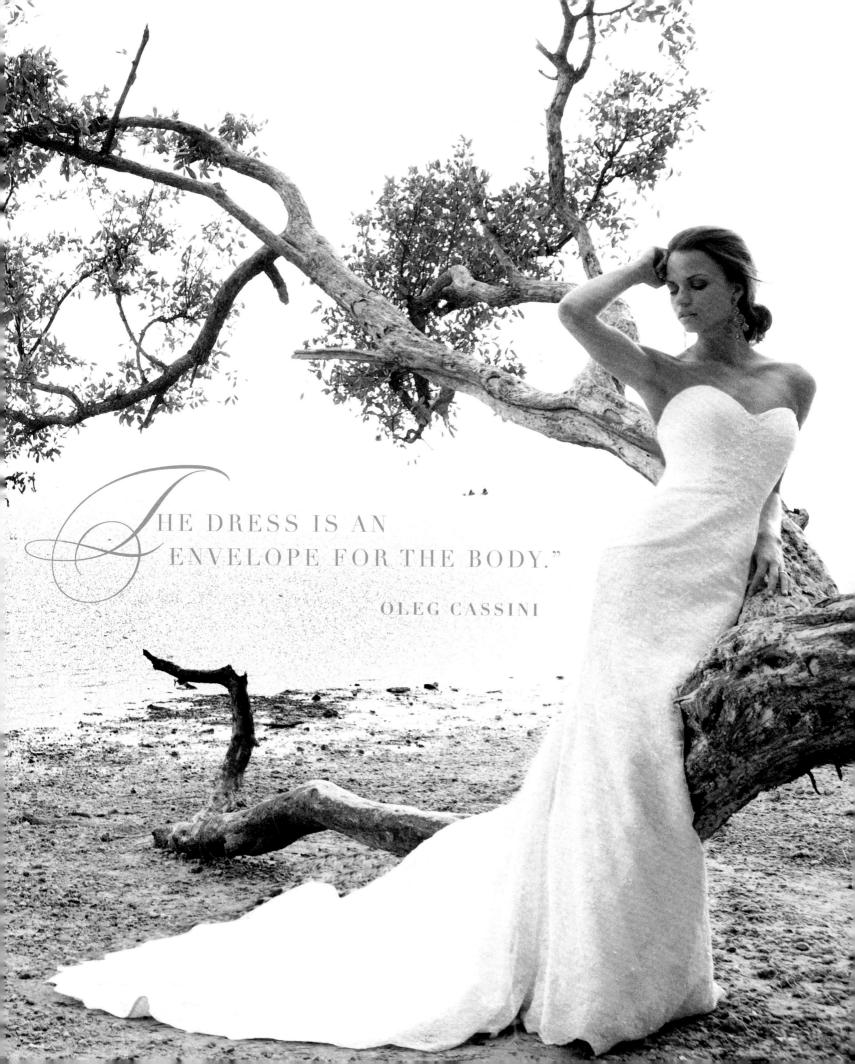

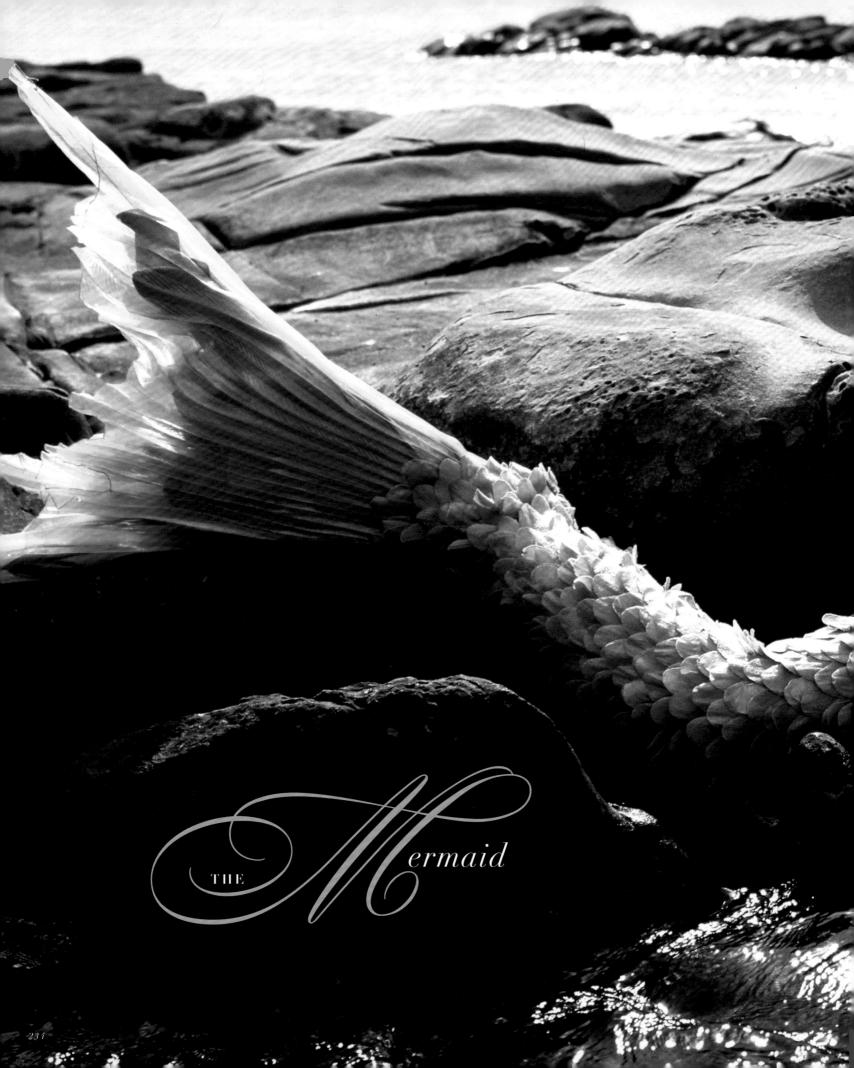

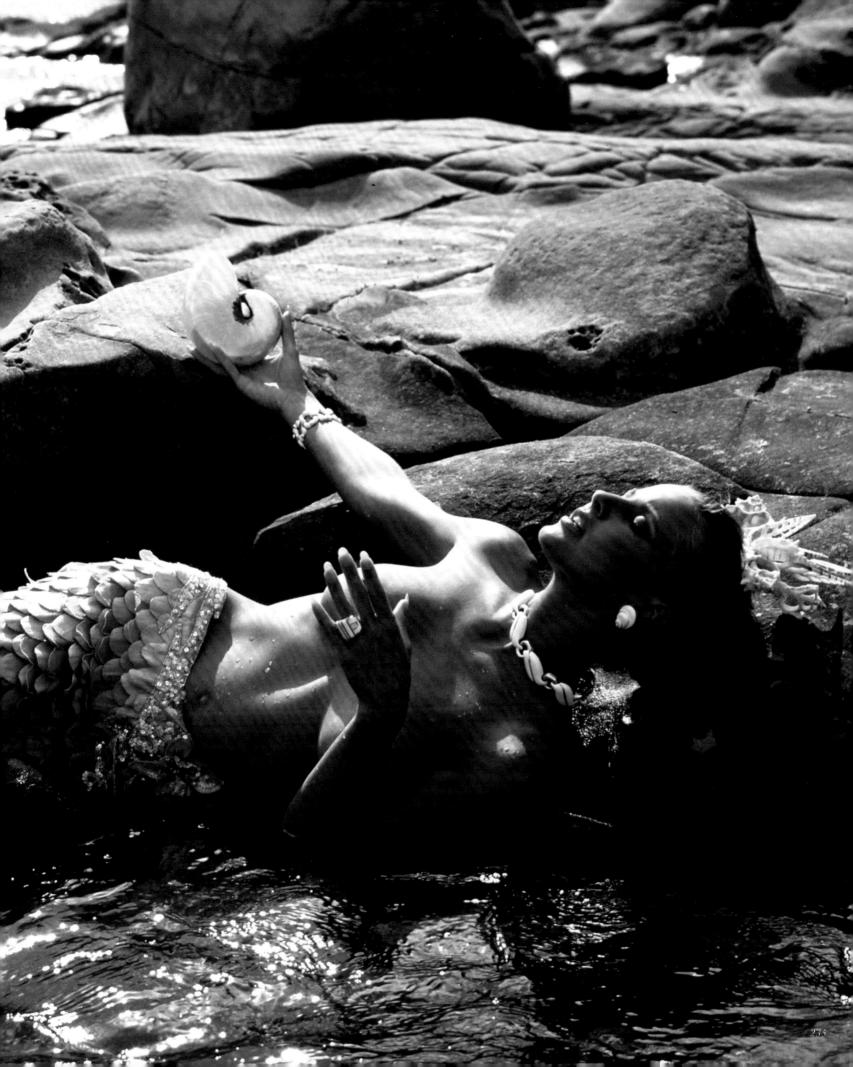

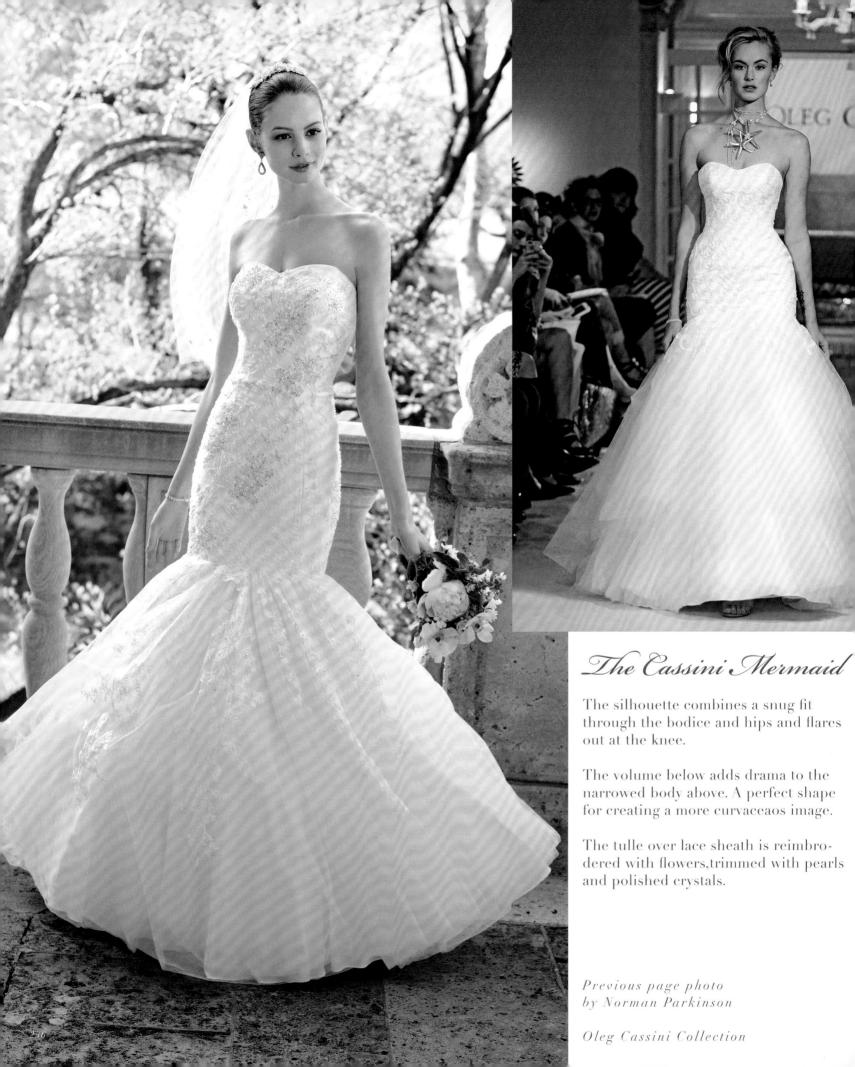

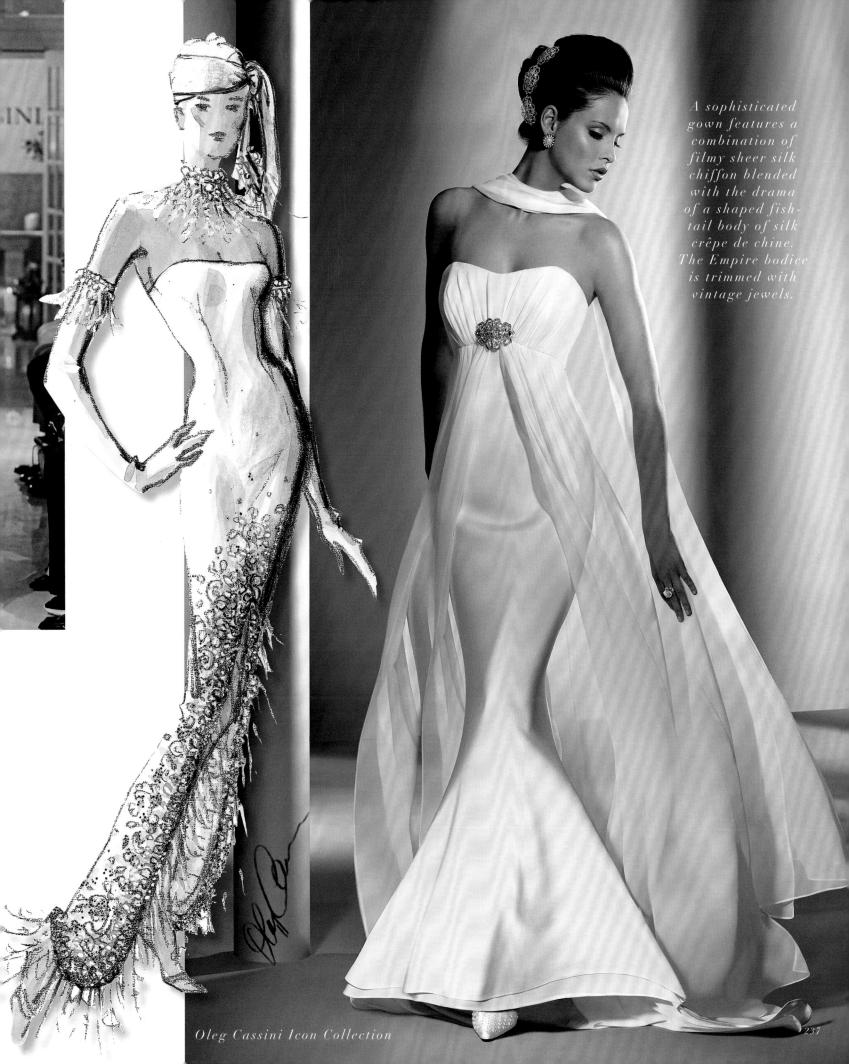

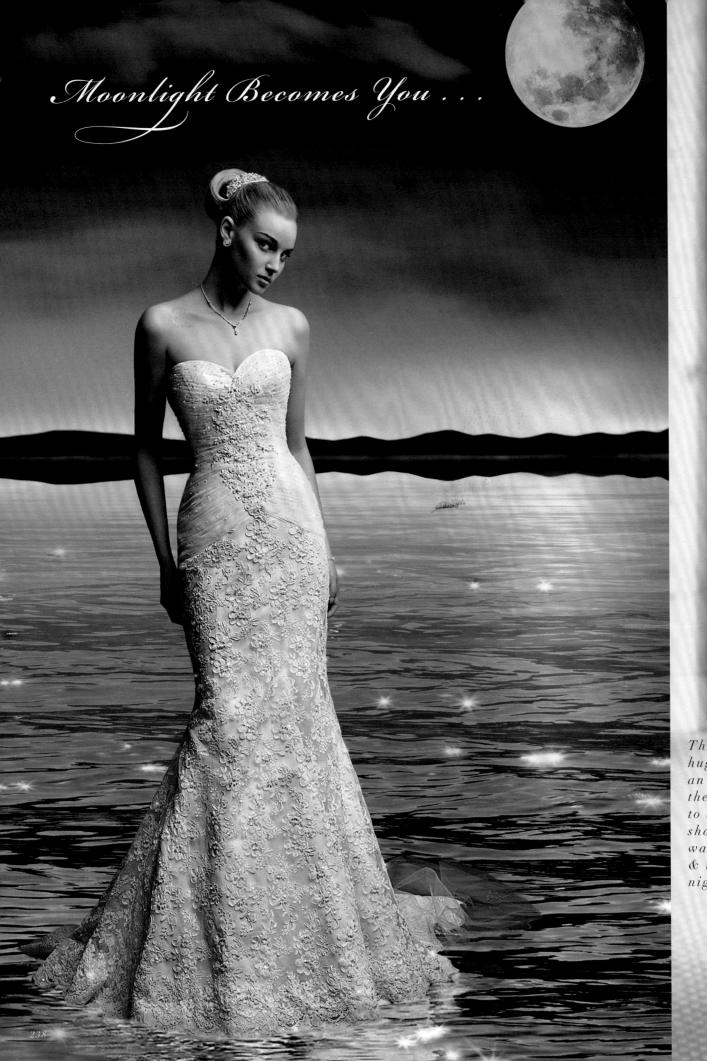

The wedding dress hugs the body, like an envelope, and then gently flares to a graceful trumpet shape for a perfect walk down the aisle & then to dance the night away . . .

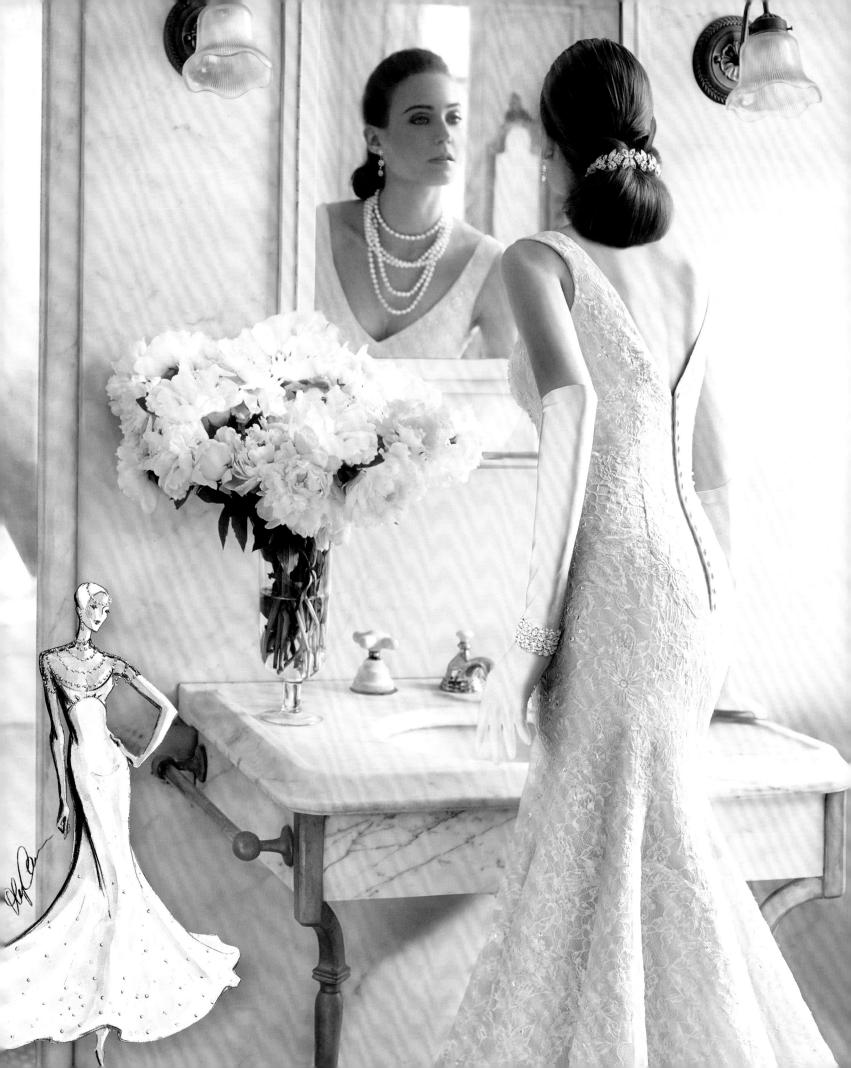

The 'Sheath' is a term I used to reference the fit of a gown to the sheath of a sword. This is one of the most dramatic of silhouette choices.

The embroidered lace gown has a scalloped neckline caught with 'spaghetti' straps.

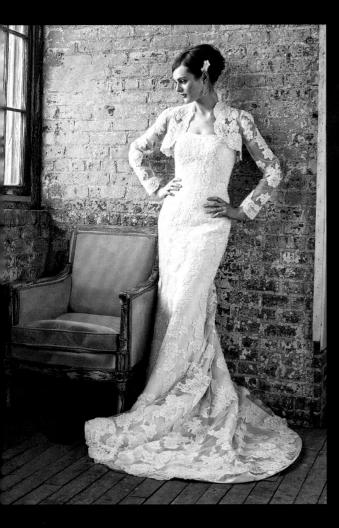

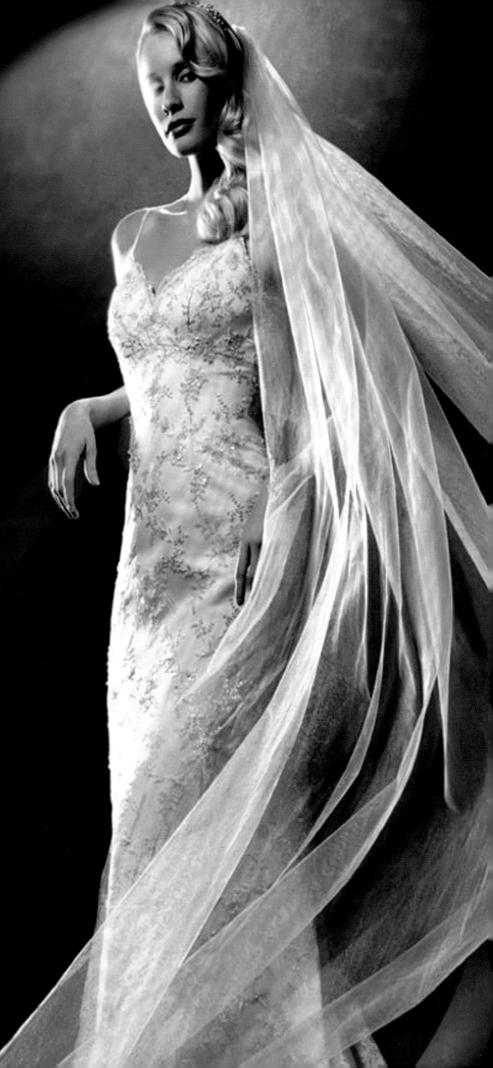

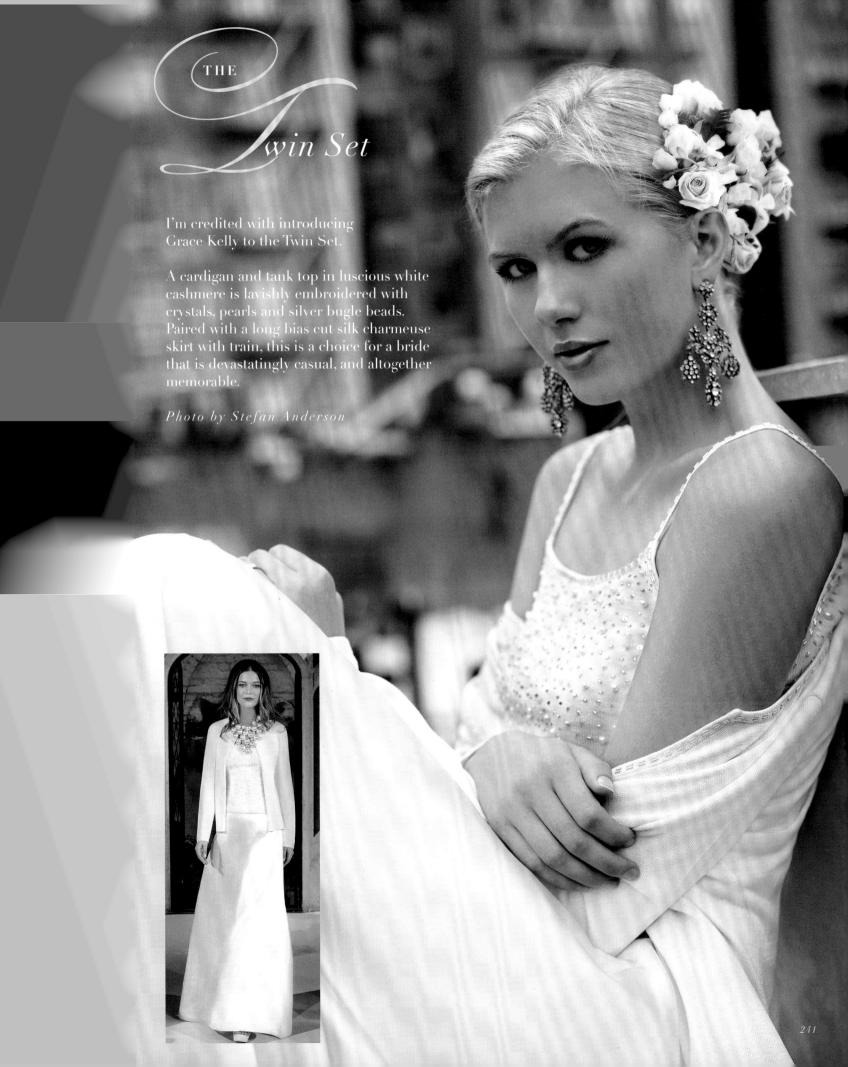

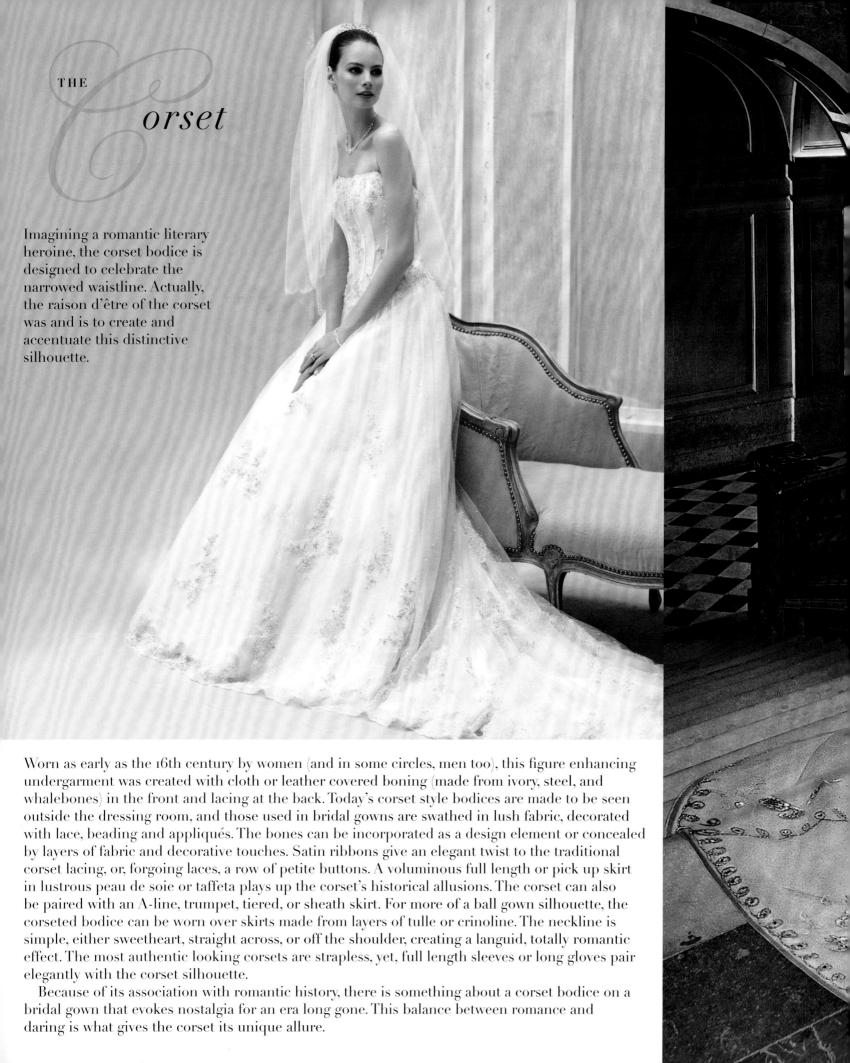

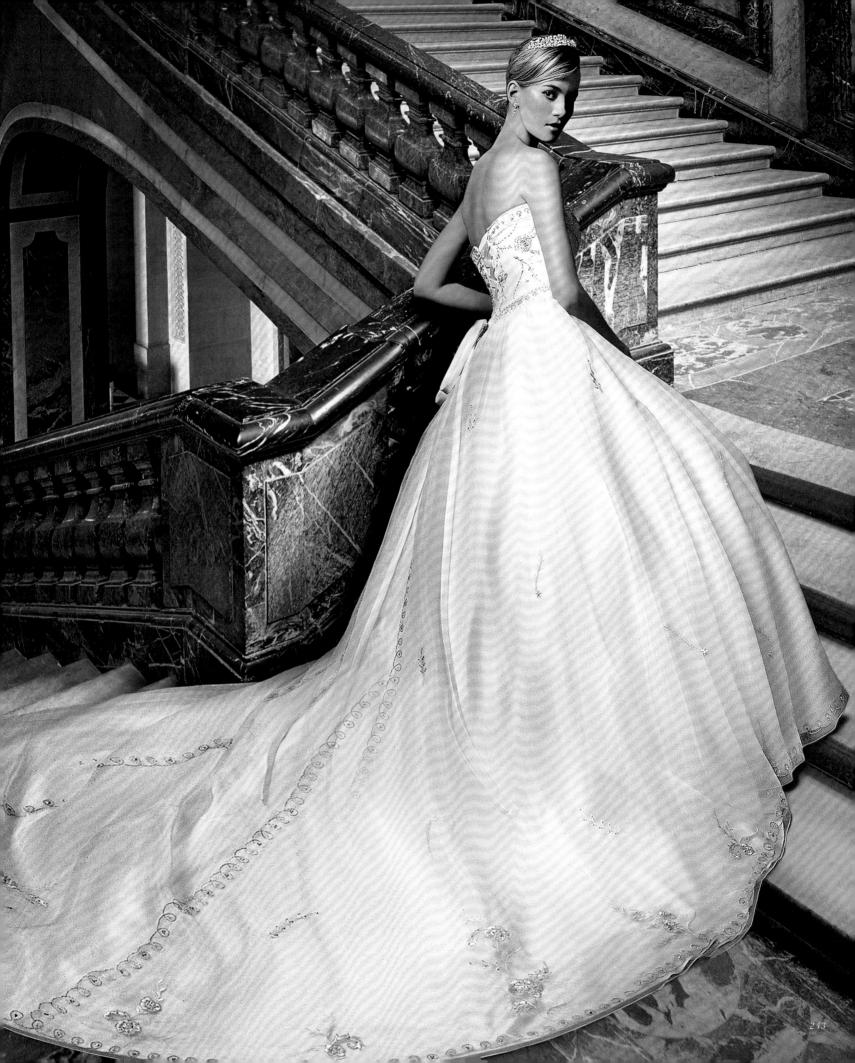

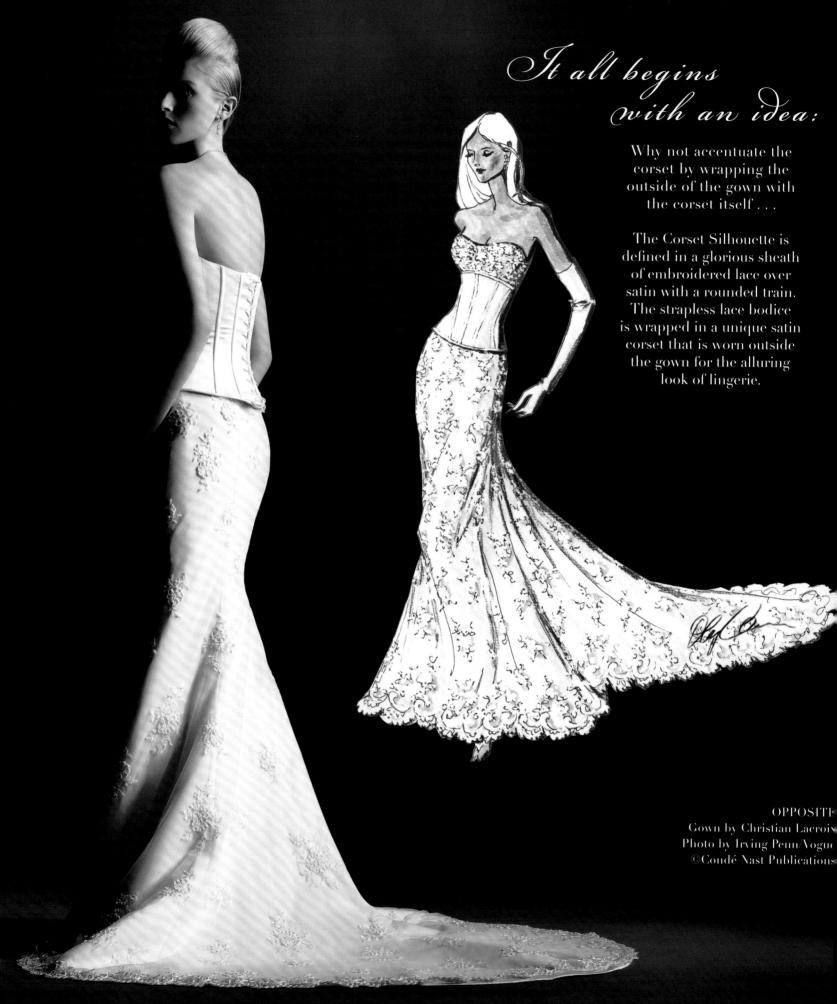

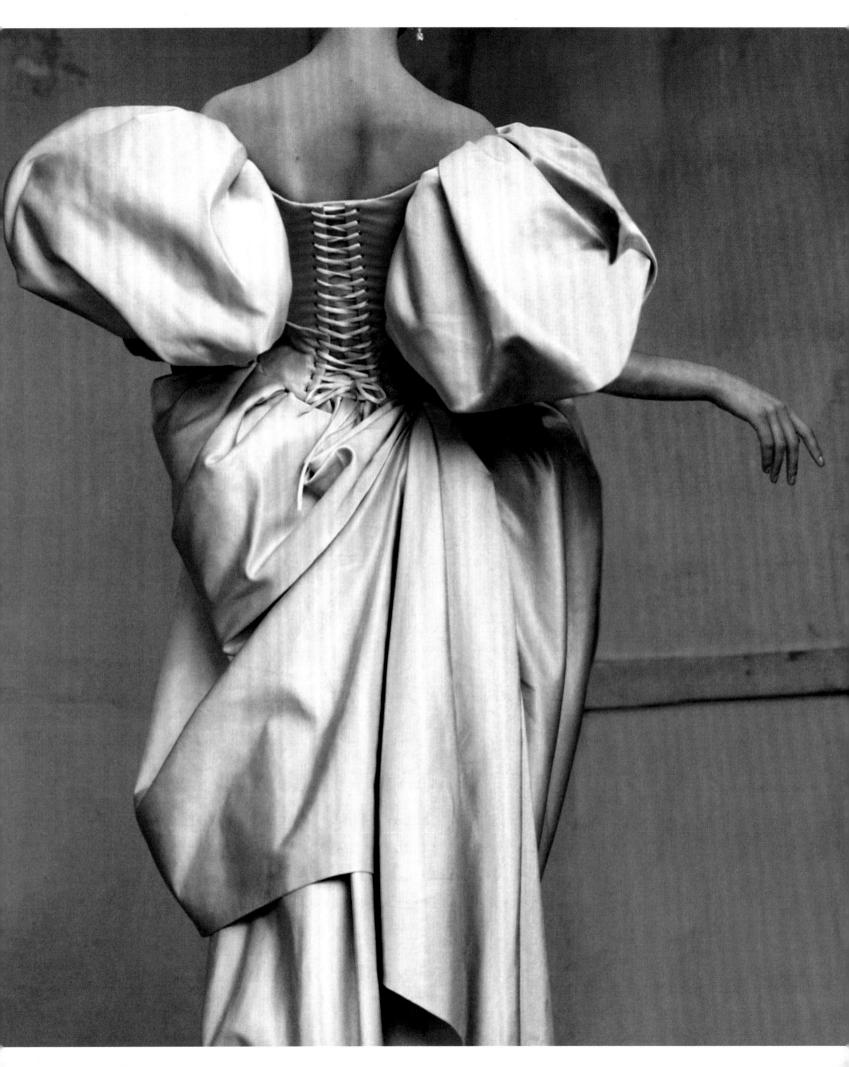

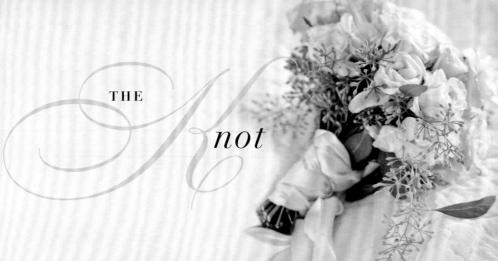

A wedding is a ceremonial occasion with its origins in centuries of tradition. The costume of the bride is the pivotal image that sets the theme for the event itself. Traditions evolve out of legend and it is fascinating to explore the many derivatives of the 'taken for granted' sayings associated with weddings. Many ancient beliefs and practices have evolved into modern customs linked with history that have become part of the tapestry that is 'The Wedding.' The wedding band worn on the fourth finger of the left hand derived from the belief that there is a love vein that runs directly from the heart to the ring finger. A diamond is seen as the fire of love, that would never cool, for its brilliance and durability.

"Something old" symbolizes the link with the bride's family and the past. "Something new," means optimism and hope for their new life ahead. "Something borrowed," is usually an item from a happily married member of the family or a friend, whose good fortune in marriage is to carry on to the new bride. The borrowed item is also to remind the bride that she can depend on her friends and family. "Something blue," has been connected to weddings for centuries. In ancient Rome, brides wore blue to symbolize love, modesty, and fidelity. Before the late 19th century, blue was a popular color for wedding gowns, "Marry in blue, lover be true." A silver sixpence in the bride's shoe represents wealth and financial security. It dates back to a Scottish custom of a groom putting a silver coin under his left foot for good luck. These days, a dime or a copper penny is substituted.

The Legend of St. Katherine, circa 1225, used the Middle English 'cnotte' ie: 'knot,' night, to mean the tie or bond of wedlock. 'To tie the knot,' as an expression, has come to mean, getting married. Knots have a place in the folklore of many cultures and usually symbolize unbreakable pledges. It has been widely suggested that the origin of this expression derives from the nets of knotted string which supported beds prior to the introduction of the metal bed frame. The theory goes that, in order to make a marriage bed secure, one needed to "tie the knot." Historically, the knot is symbolic of a lasting unity. The bride would also arrive at the altar with an untied shoe, and the groom would tie the lace. Knots were tied in the bridal bouquet as part of the ceremony with a fabric or silken cord. The love knot is a symbol used on garments and jewelry, and, in Italy, a knotted ribbon is tied over the entrance to the reception, and frosted pastries tied in knots are served.

The design of the gown symbolizes the tying of the knot custom, representing the bonds of marriage. The waist is wrapped in a satin sash which dramatically extends to a floor length train.

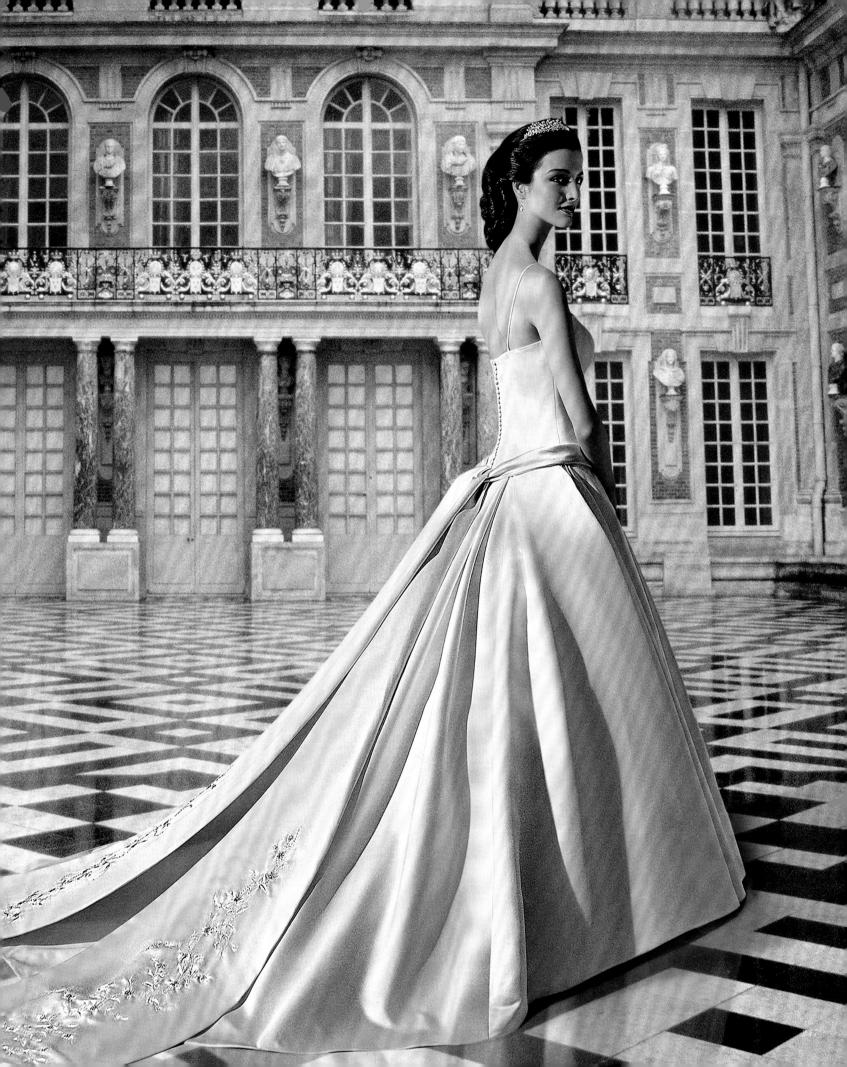

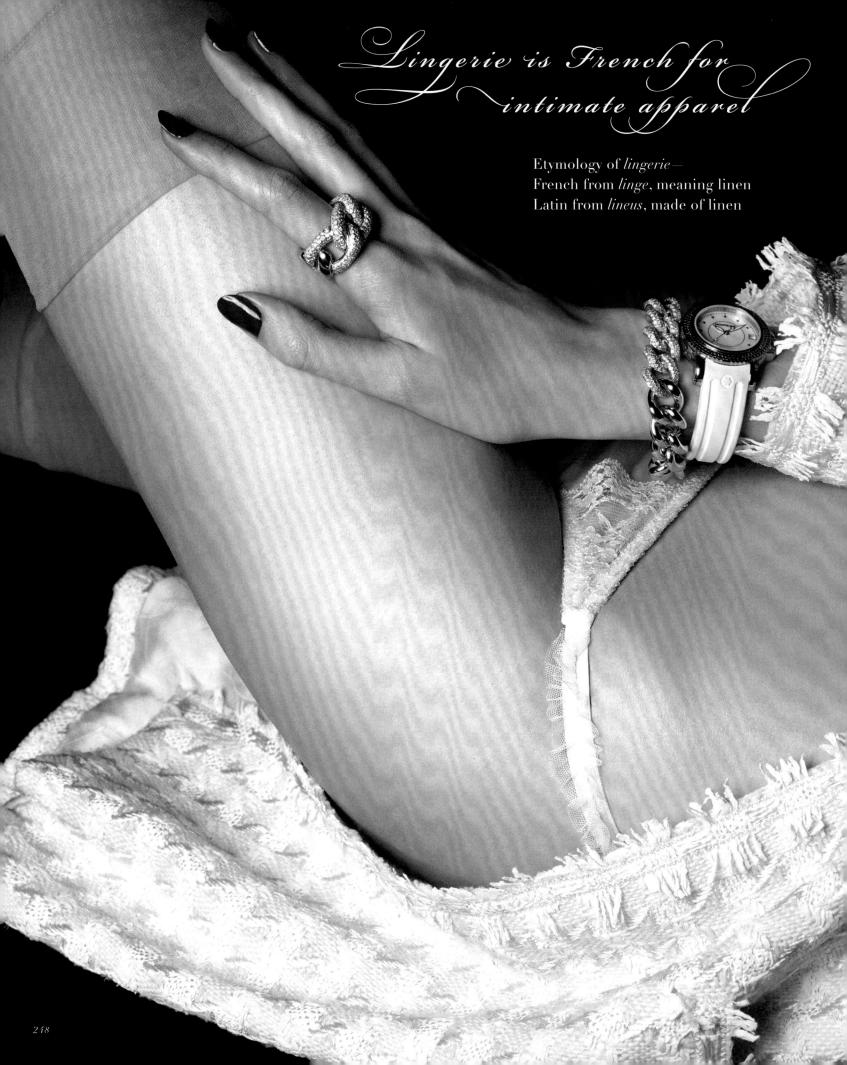

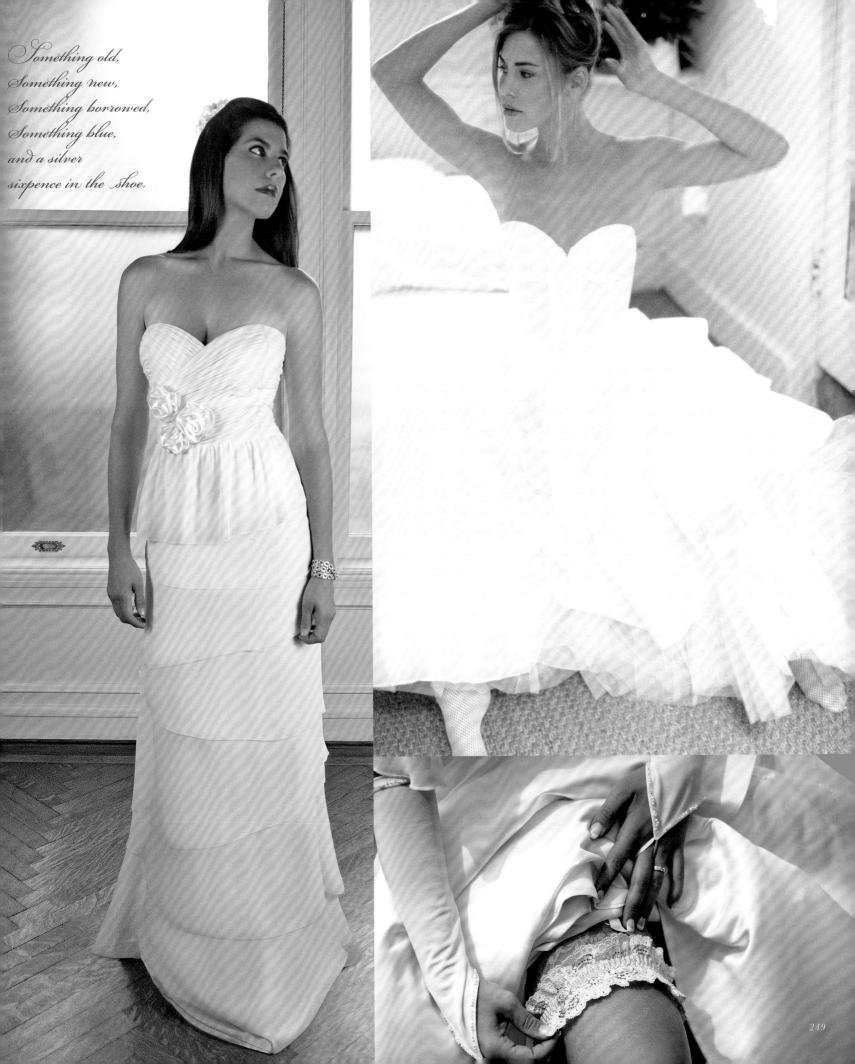

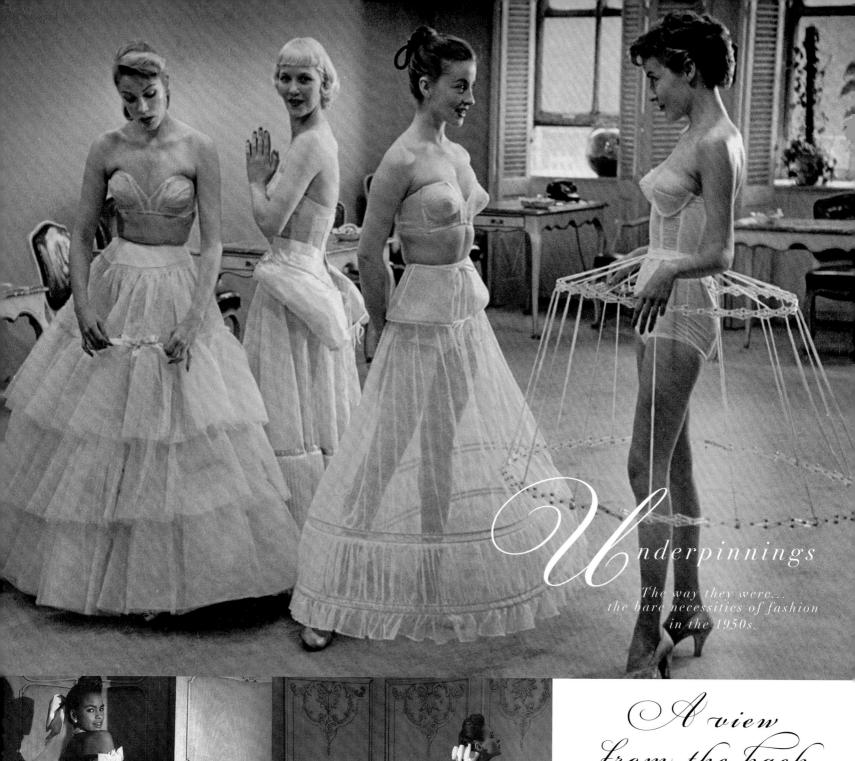

101

Aview From the back

A decoration on the back of the dress such as a bow or silk flowers is a way to add even more eye catching allure. Traditionally most brides stand with their back to their guests during much of the ceremony, and this side of the dress enjoys its time in the spotlight.

Shot in the Cassini building, Photographed by Horst © Condé Nast Publications

THE Justle

Making an entrance, the bustle is back . . .

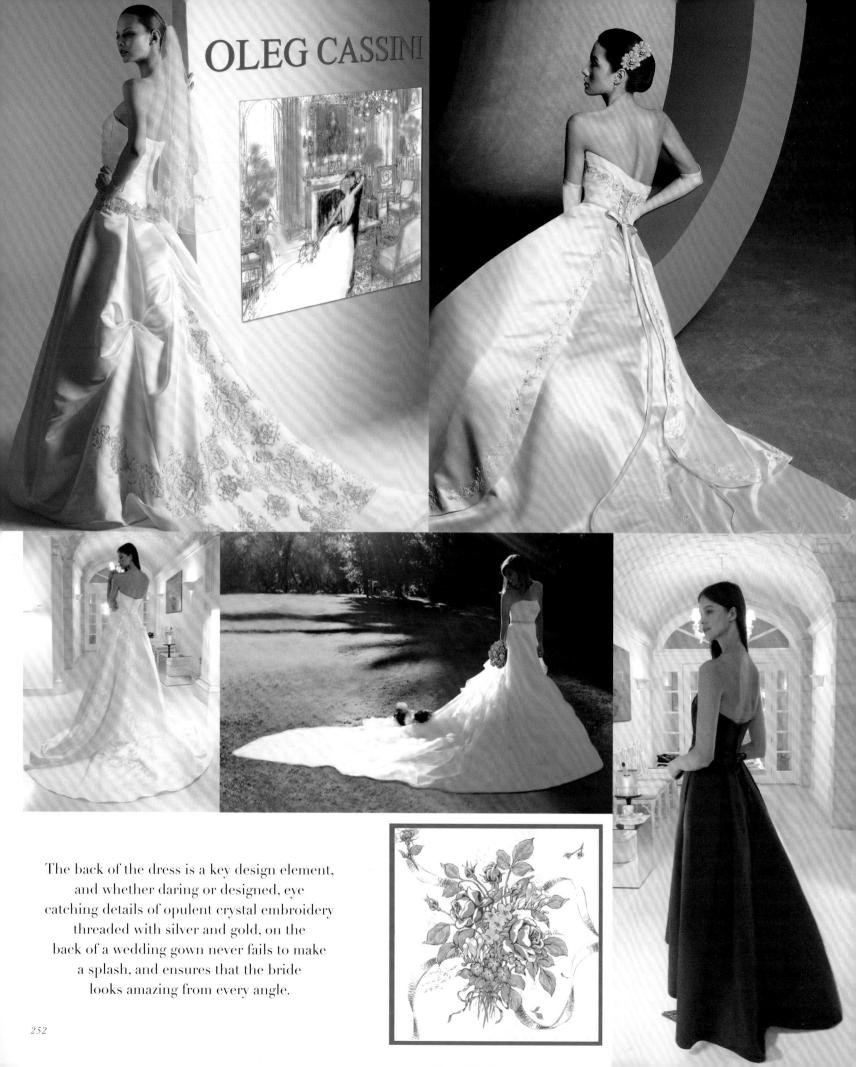

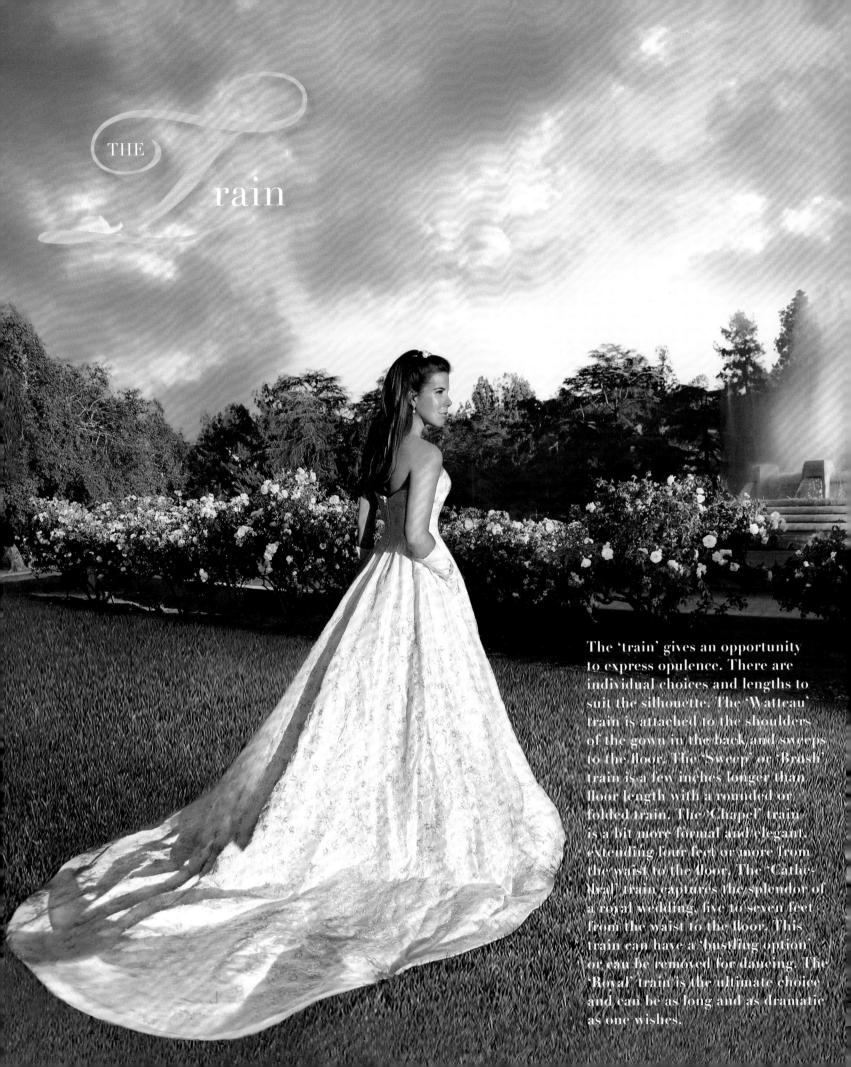

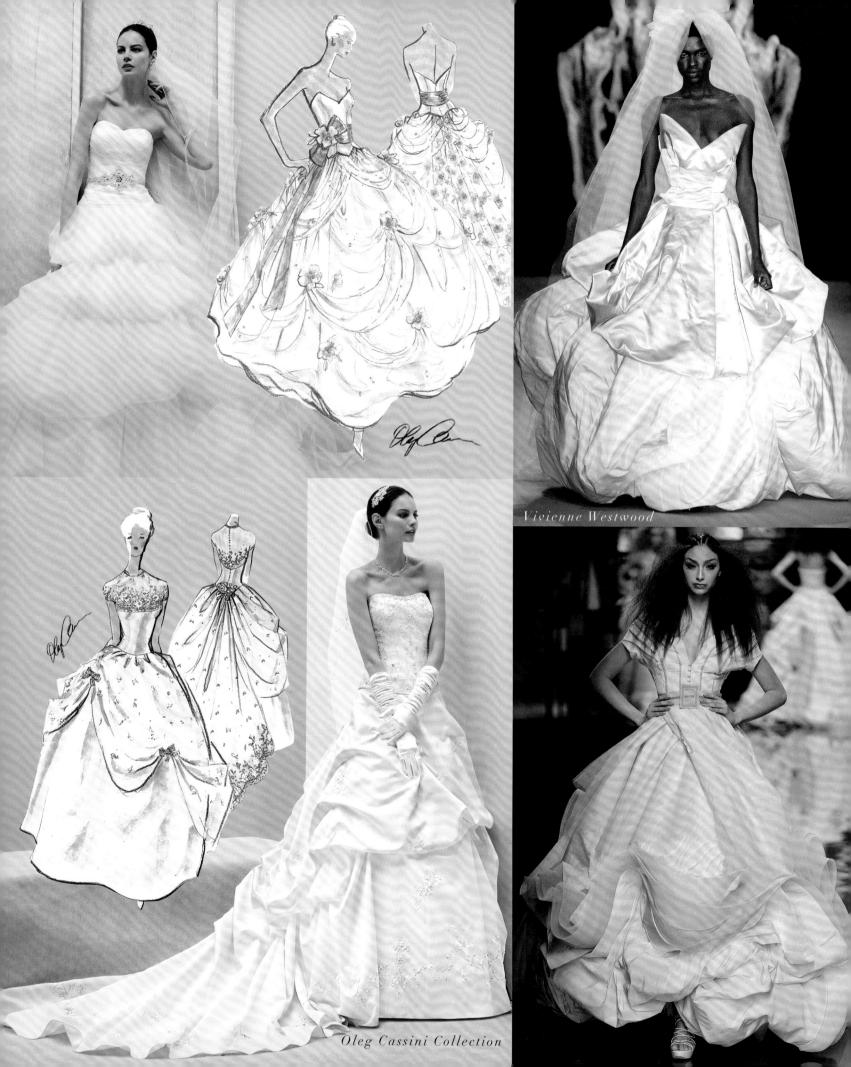

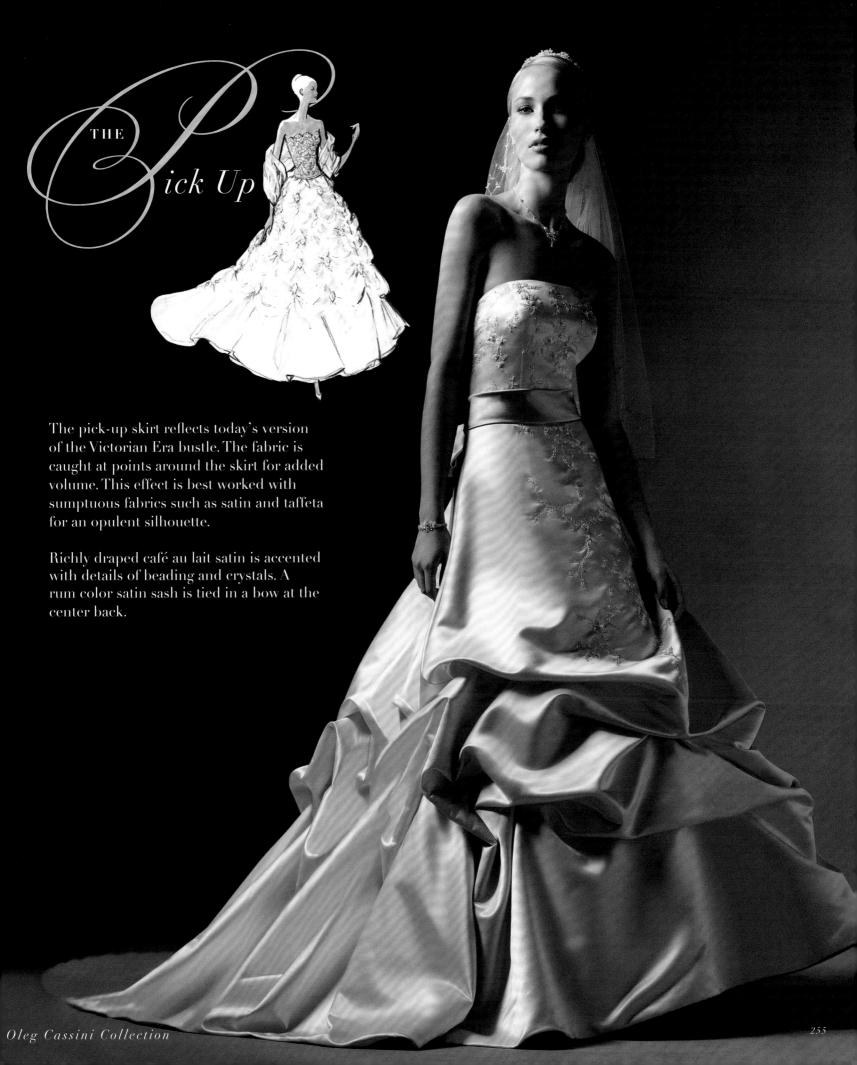

THE //emline

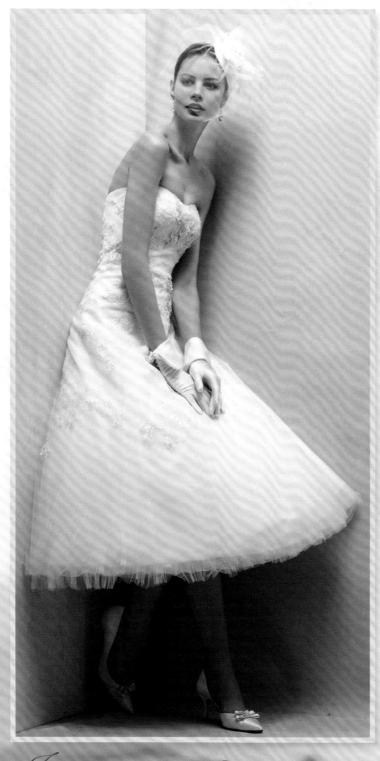

It's stime for tea...

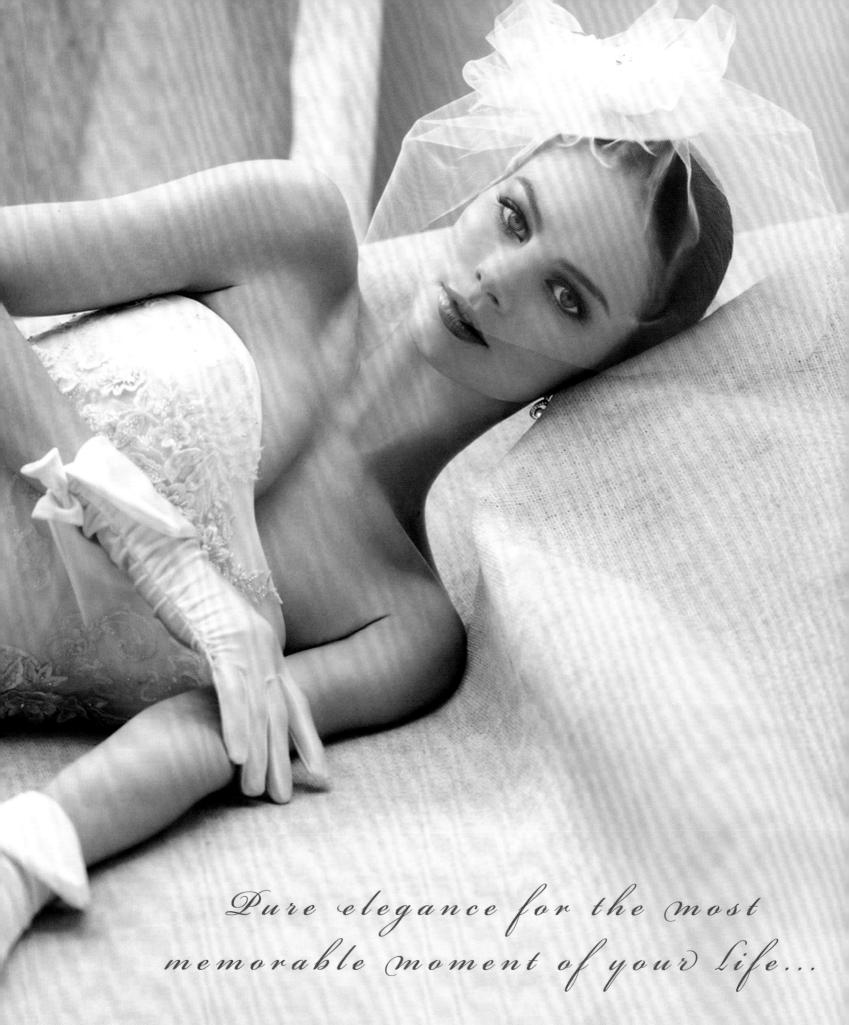

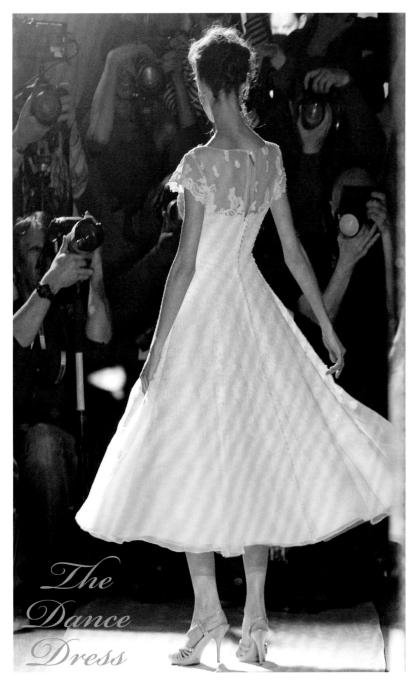

Like the variations on the traditional bridal white, 'long' comes in many shades. The few inches between a floor length gown and a tea length gown, can speak volumes about the occasion's mood and formality.

Known as a tea, dance or the prima ballerina length skirt, the shorter skirt is a subtle departure from the traditional floor length gown. A tea length skirt, hits a few inches above the ankle and evokes an ingénue-like sensibility, and when paired with a ball gown silhouette, achieves a glamorous, debutante or ballerina look.

The tea length is traditionally less formal than the longer hemlines, so it's a lovely choice for a daytime, a late afternoon garden ceremony, or, as the second gown after the ceremony—the 'let's dance' party dress. Tea length or dance length, it is perhaps the perfect second dress or a most sophisticated and stylish wedding dress.

Destination Wedding.

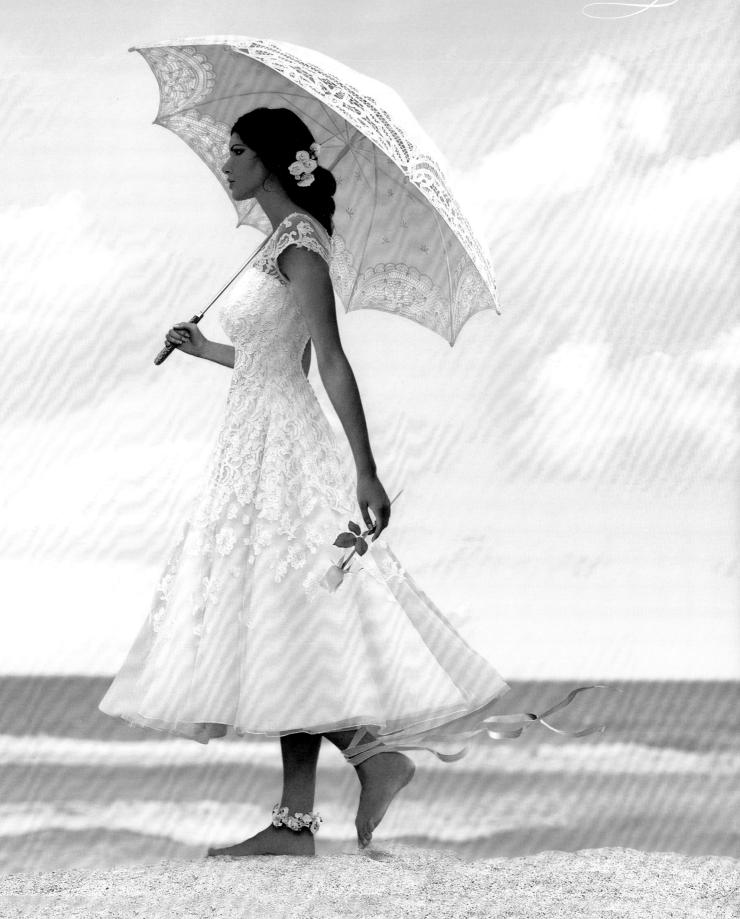

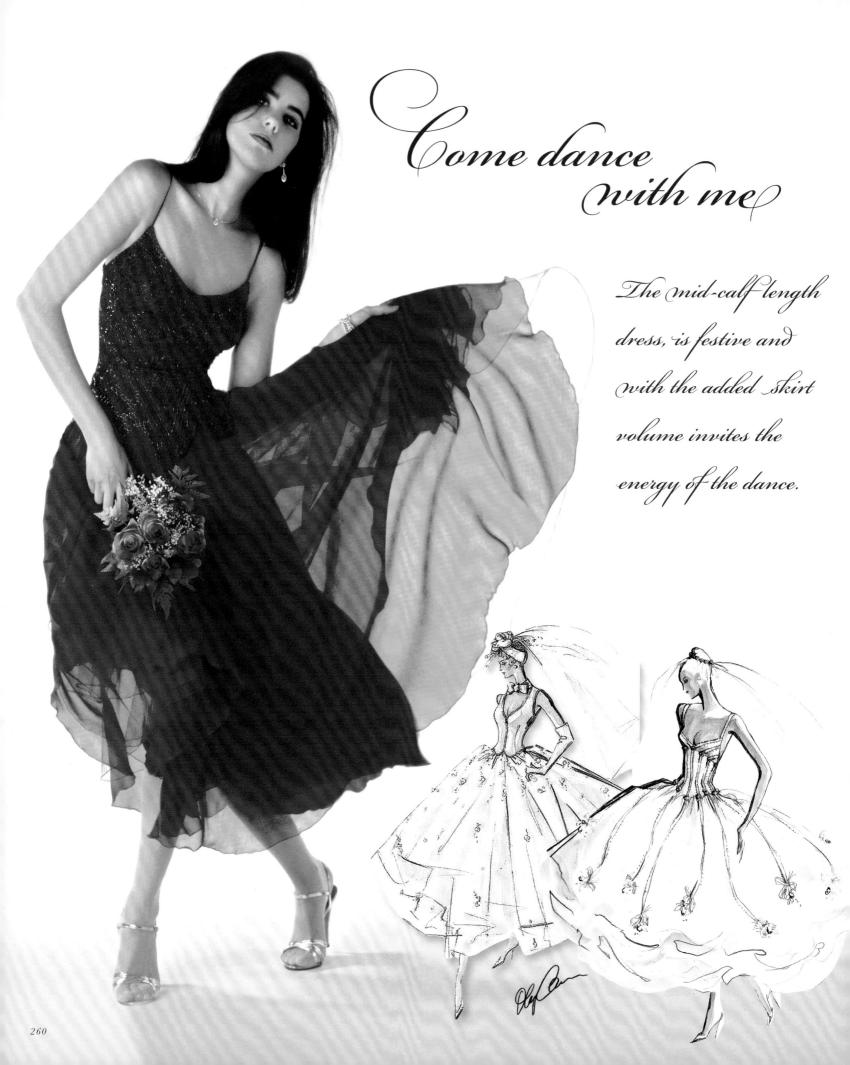

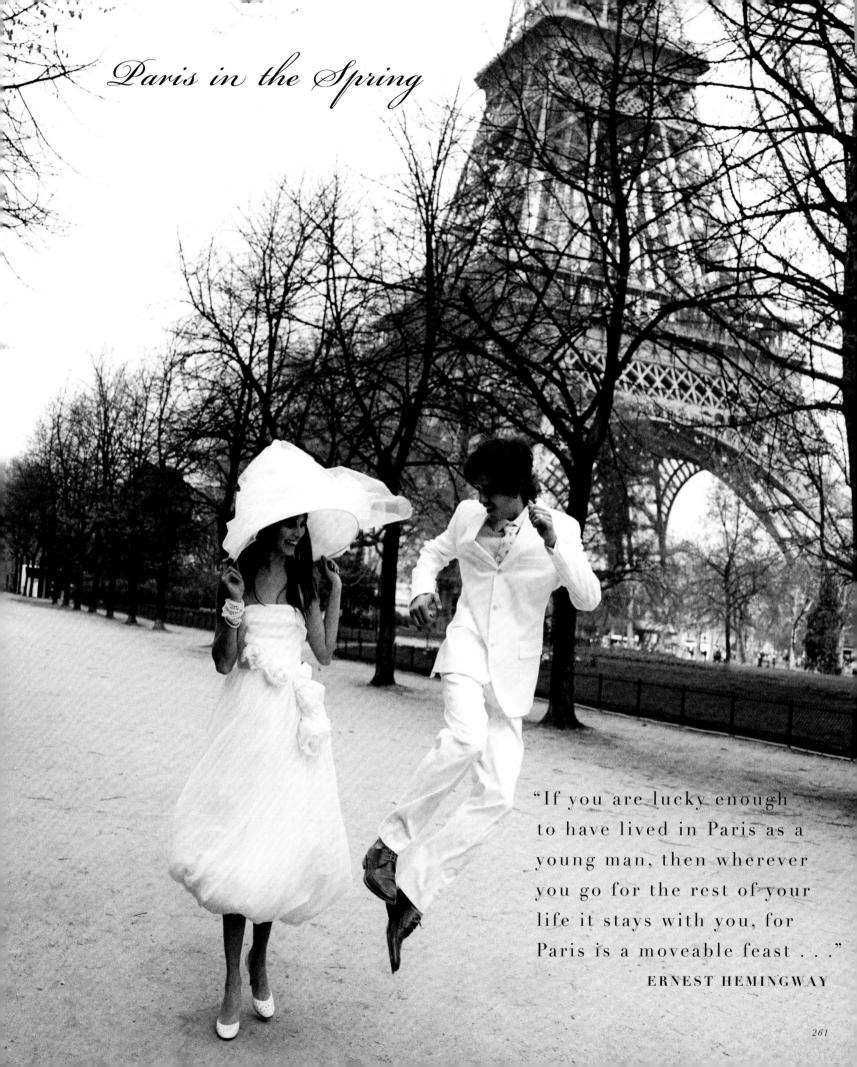

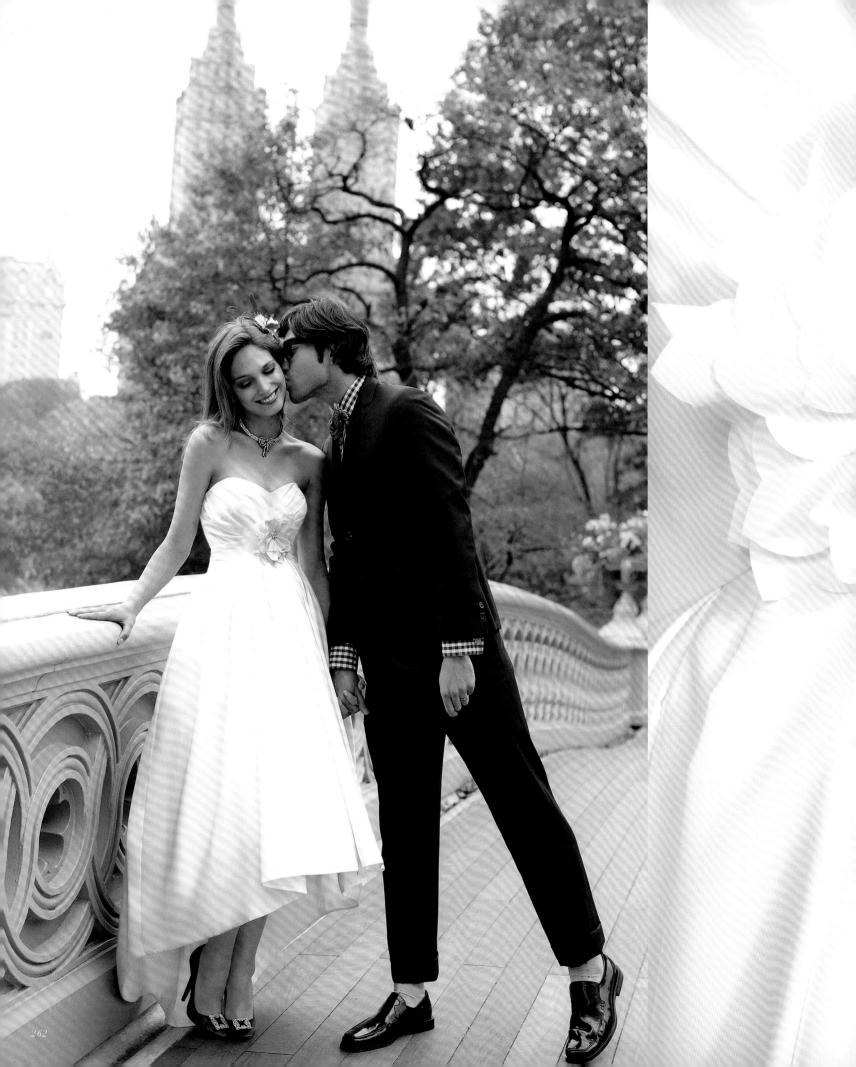

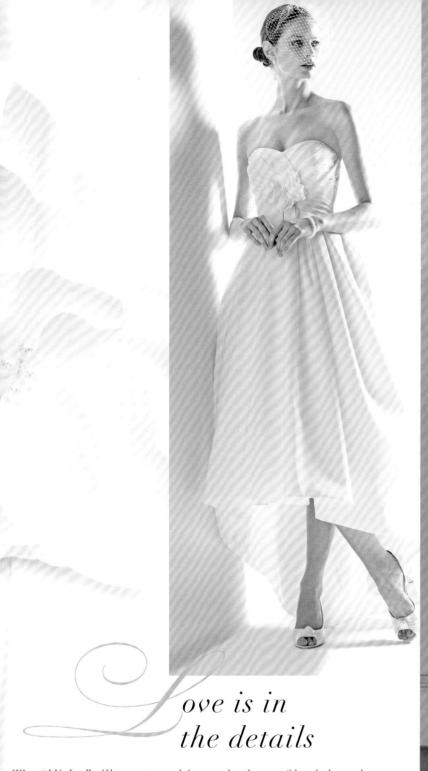

The "Hi-Lo" silhouette, achieves the best of both lengths, "tea" with a train. The skirt is softly gathered to tea length in front, revealing fabulous dancing shoes, and drapes to the more formal floor length train at the back of the dress. The sculpted flower at center front is detailed with pearls.

This look suits both a sophisticated reception, a twilight ceremony on a beautiful beach, or the legendary curved bridge in Central Park. On the runway in NYC a fabulous dress, with all over lace and lace illusion edged with embroidered eyelash lace at the deep v neck and at the hem of the extravagant hi lo skirt.

OPPOSITE Photo by McConnell / Brides ©Condé Nast Publications

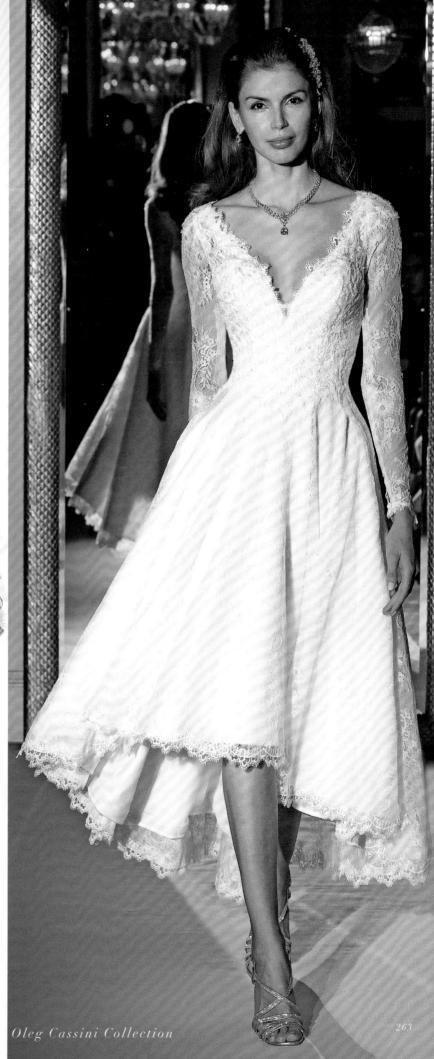

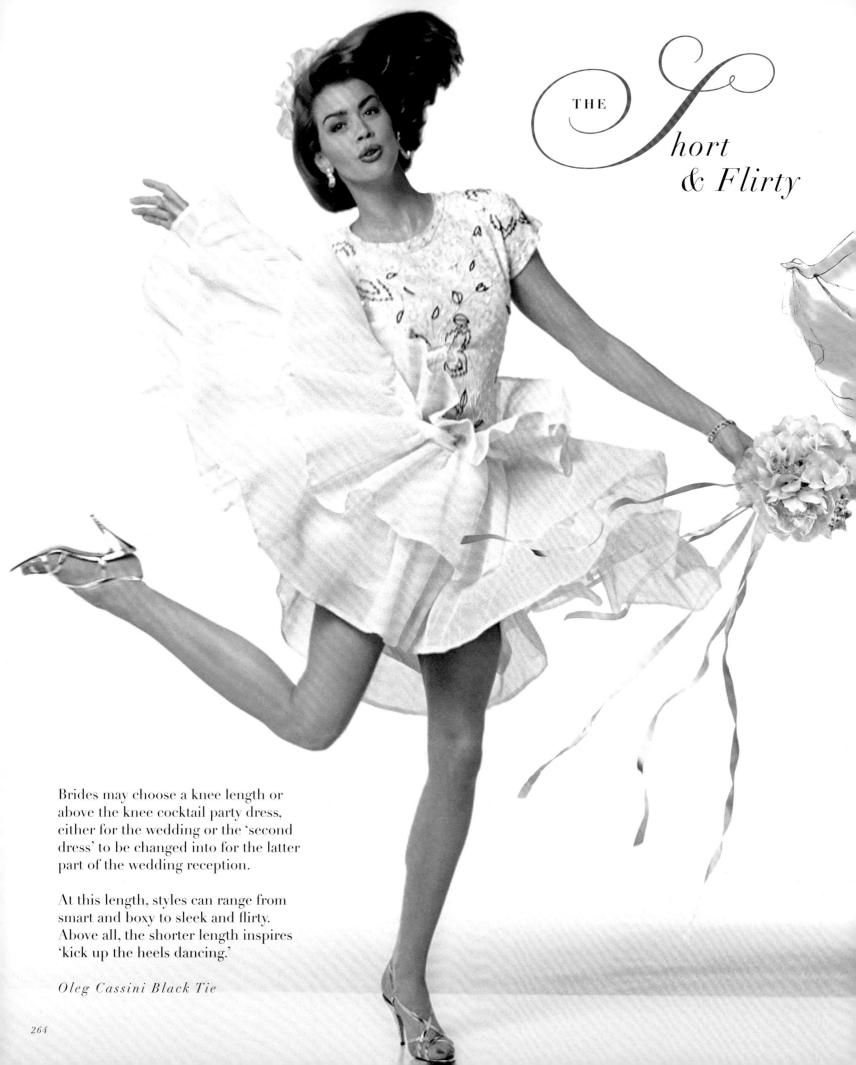

The Little

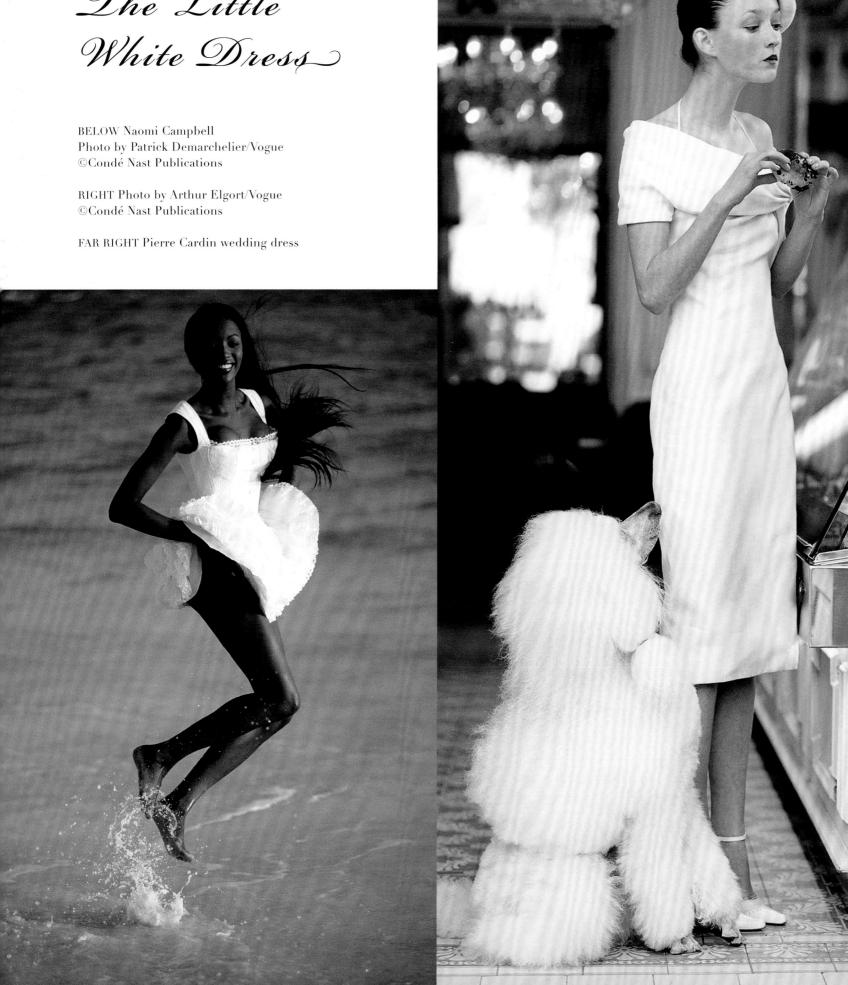

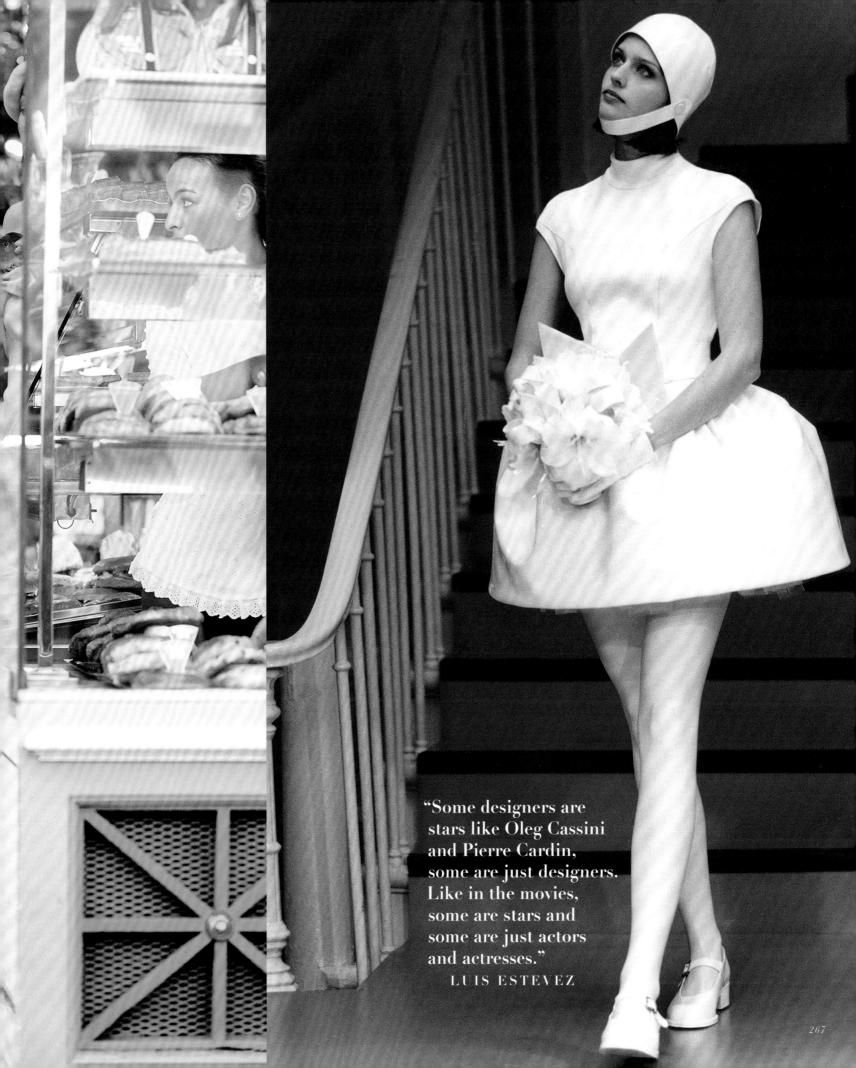

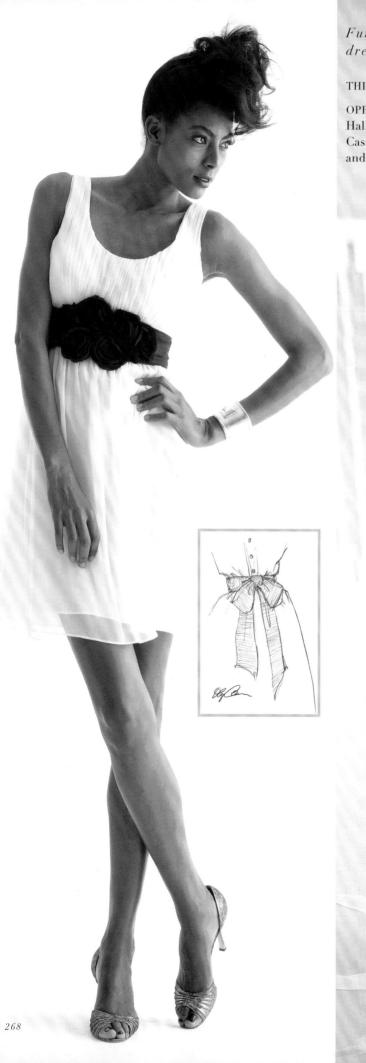

Fun and flirty, the Cassini dresses are designed for dancing.

THIS PAGE Photo by Stefan Anderson OPPOSITE, TOP Actor Anthony Michael Hall wears an ivory and ebony Oleg Cassini Tuxedo, with an ivory silk shirt and vest.

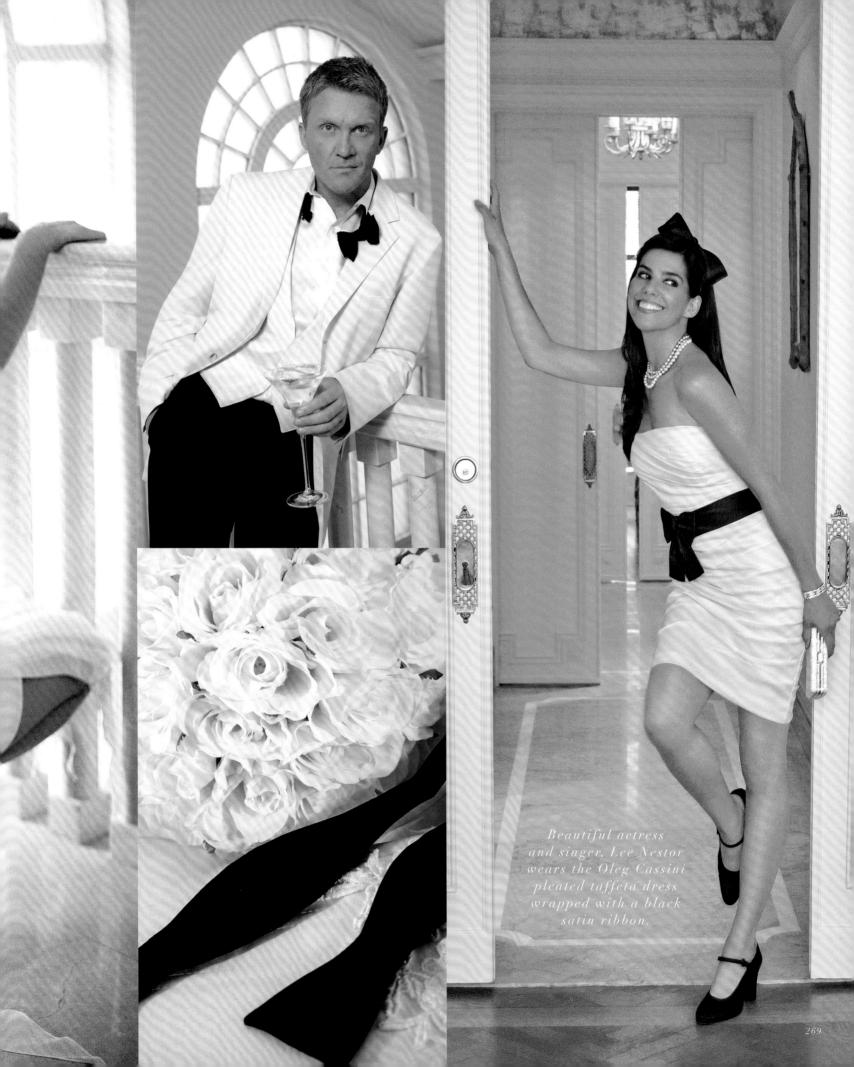

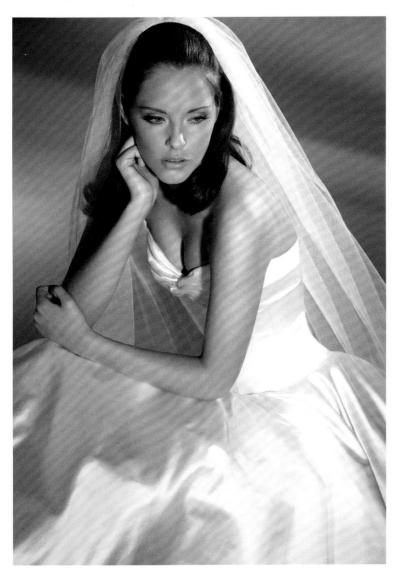

"I had to go to the President to ask permission to allow Jackie to wear a shoulder baring gown."

OLEG CASSINI

THIS PAGE In London: She wears a lustrous silk satin gown with a ruched Sweetheart strapless neckline. The elongated waistline is seamed to the luxury of a full circle skirt. Gown from Oleg Cassini Icon Collection.

OPPOSITE PAGE Strapless and poolside Margaux Hemingway at nineteen. Photo by Francesco Scavullo / Vogue © Condé Nast Publications

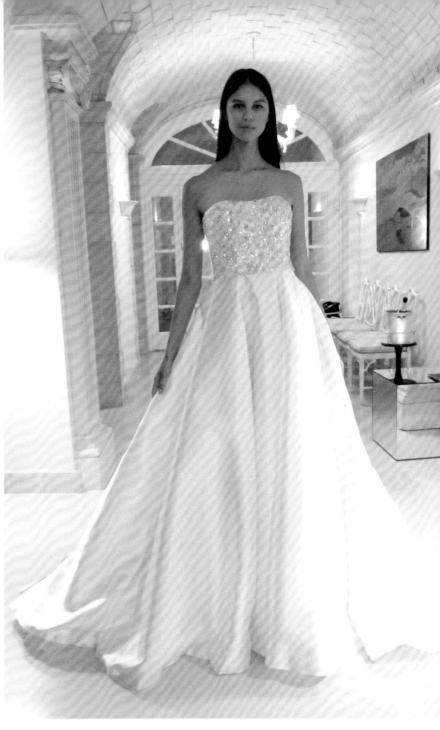

Model expert Peggy Nestor with her client: Margaux Hemingway. In the Guiness Book of Records as the biggest model contract - The Million Dollar Babe

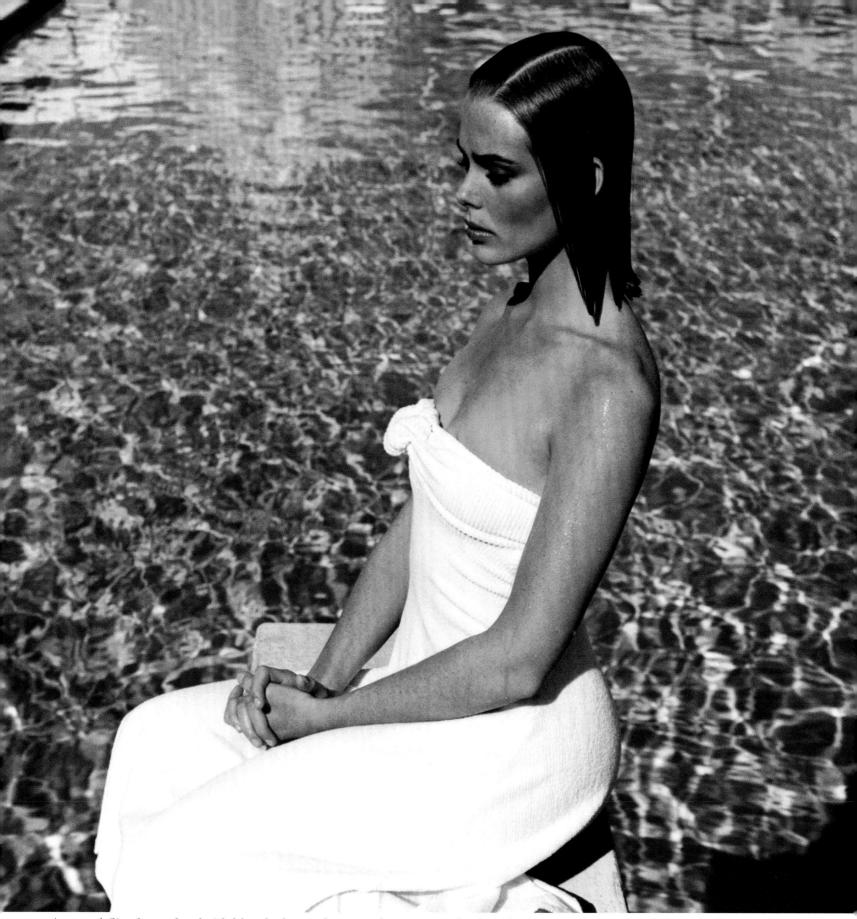

A casual flip through a bridal book shows that strapless gowns, far from being risqué, are now positively de rigueur. While it has not been so many years since a bride with bare shoulders would guarantee raised eyebrows, in recent years strapless gowns have become such a popular choice for brides, both daring and demure, that this neckline graces dresses that run the full gamut from traditional ball gowns to the dramatic mermaid. Despite its popularity, there are enough possible variations on a strapless bodice, that it continues to look breathtaking and special each time it appears on a bride. A notch or sweetheart shape adds eye catching detail to an otherwise unadorned silhouette.

Notch necklines are eye candy for a strapless bodice. Ruching, a cowl, a cuff fold, also dress up the strapless bodice.

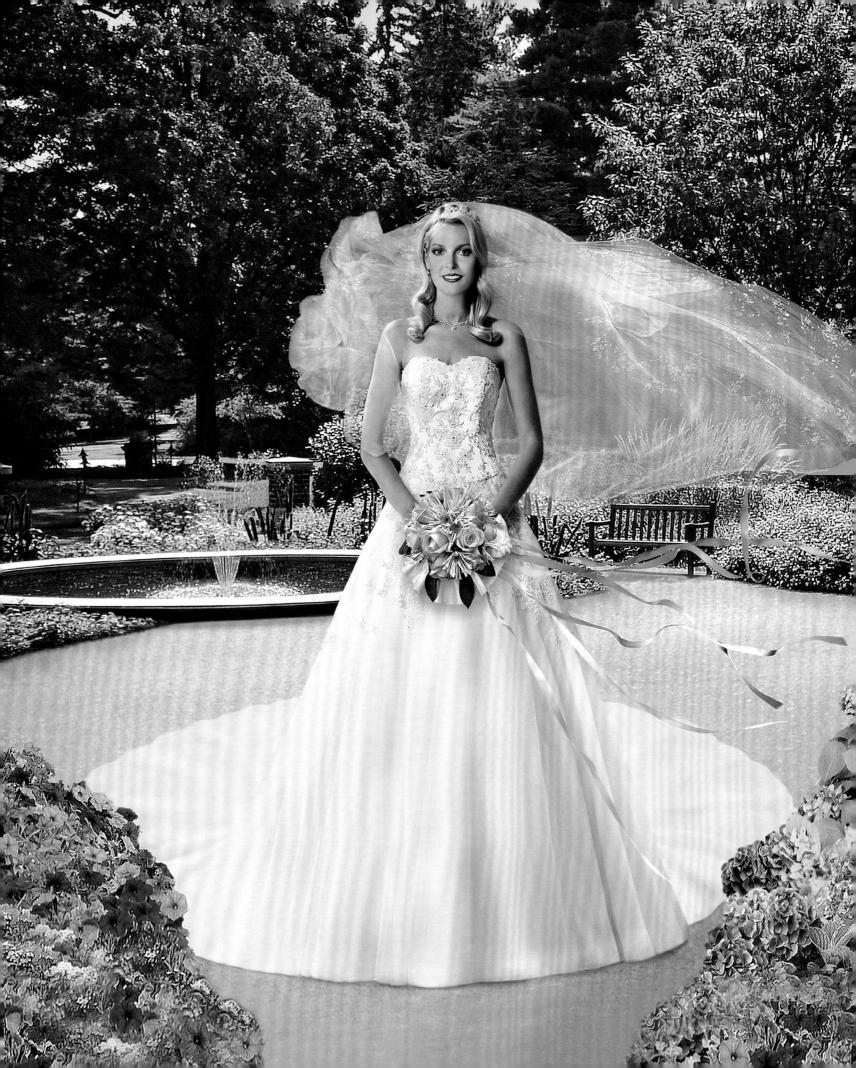

Bride on a perfect day . . .

Lady Brenda in her serene, elegant and historic surroundings at Box Hill Mansion. Set on over 400 acres of rare flowers and rolling hills. This grand historic site, which brings to mind the mood of an aristocratic English country estate is in Regents' Glen, York, Pennsylvania, near the Delaware River and was granted to William Penn in settlement of a debt by the King of England.

On a perfect day in June, she wears an Oleg Cassini Princess in Wonderland gown, a vision of enchantment and luxury. June is named after Juno, the Roman goddess of love and marriage.

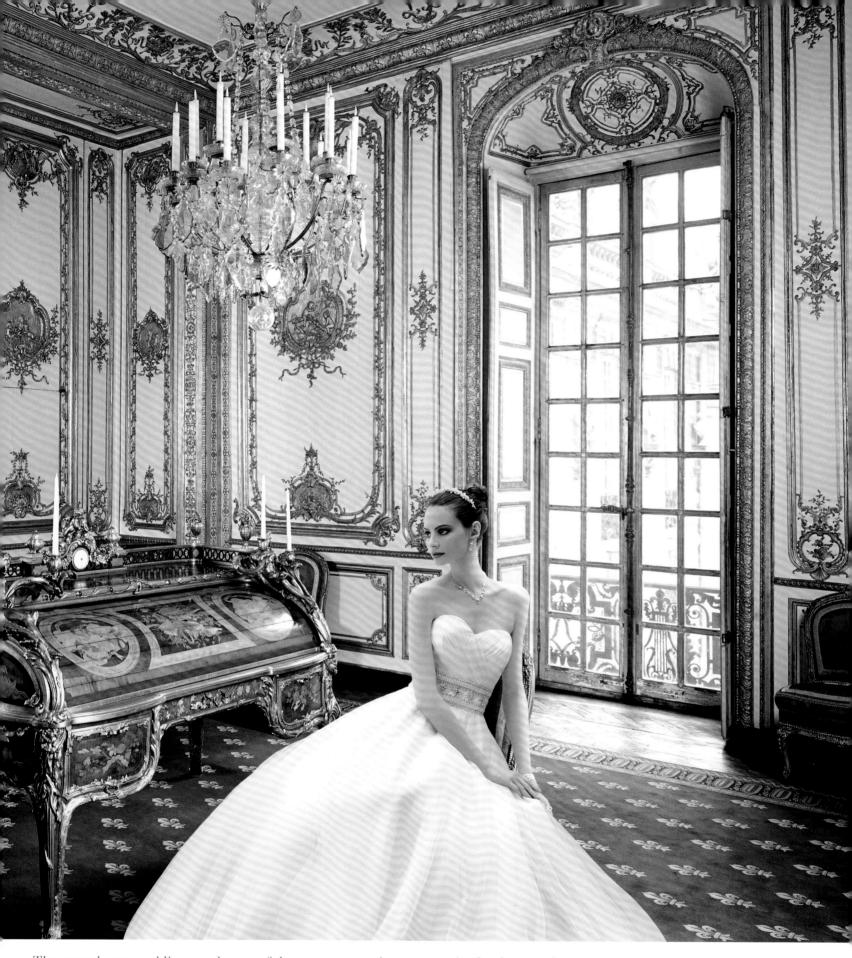

The sweetheart neckline sends one of the most romantic messages in the design of a gown, both flattering and evocative, the shaping of the bodice reflects the characterization of the heart, and many a Valentine's Day message bears the image. Historians have traced the origin of Valentine's day to the ancient Roman empire, which honored Juno the Goddess of women and marriage. Named after Saint Valentine, a priest during the reign of Emperor Claudius II. The tradition continues with the sweetheart neckline being the most favored.

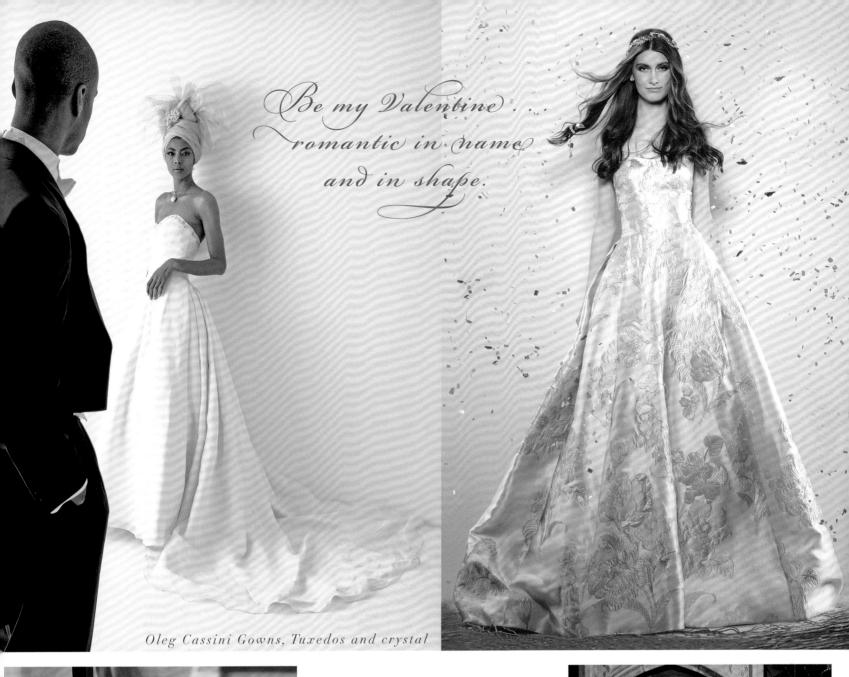

The Gold
Rush... Metallic
threads in gold
and platinum...
toasting flutes
of rose crystal
are trimmed with
rose gold for a
memorable shared
wedding toast.

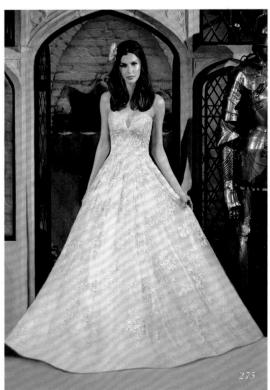

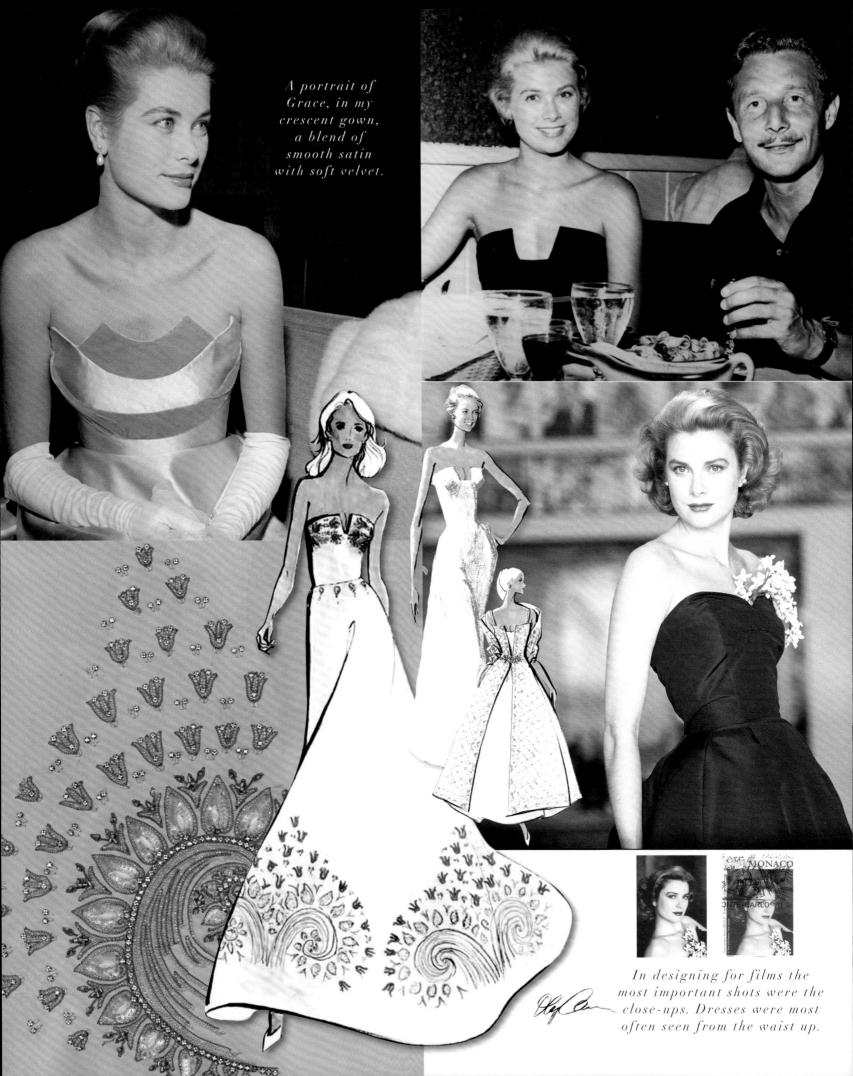

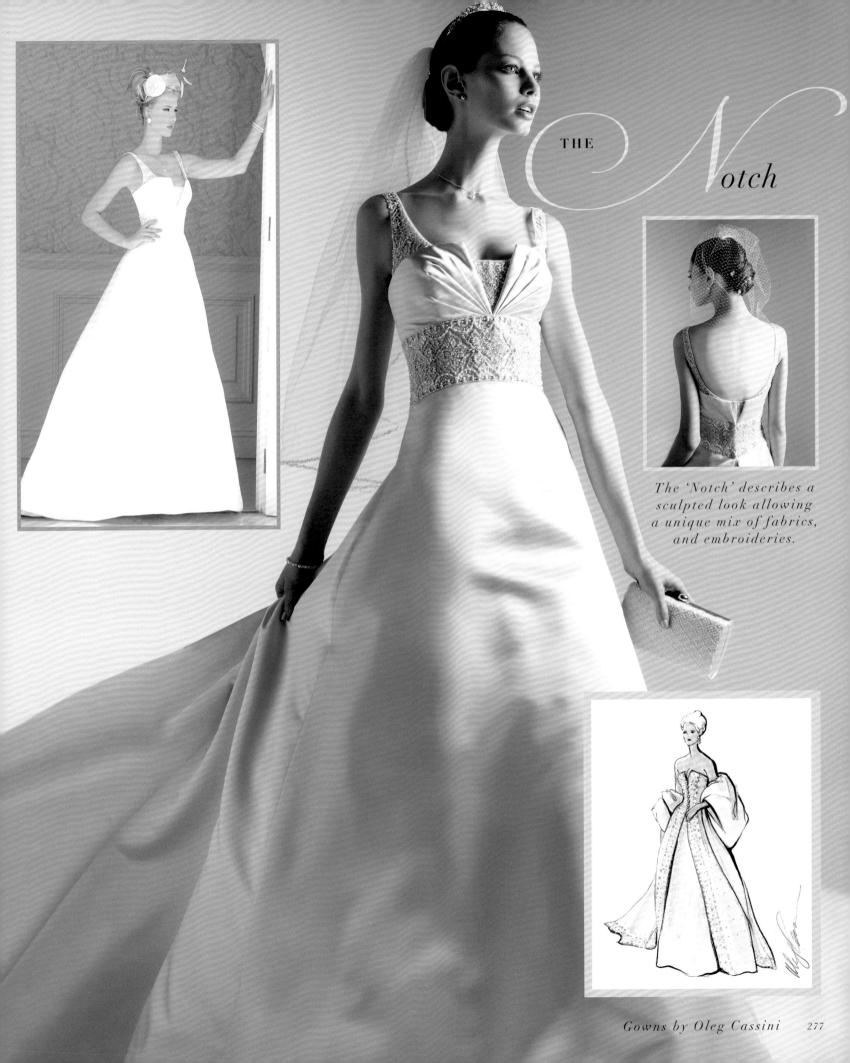

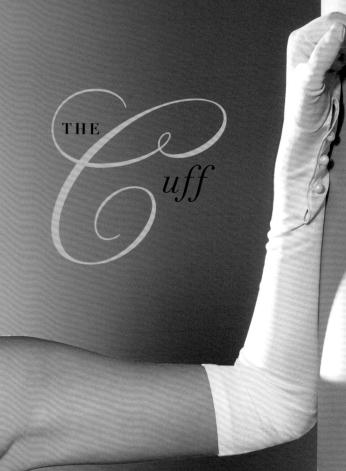

The Cuff gown inspired a wedding dress of exquisite white silk gazar fabric made for the Oleg Cassini Icon Collection in England. The inherent simplicity of the strapless silhouette 'sets the stage' for dramatic jewelry.

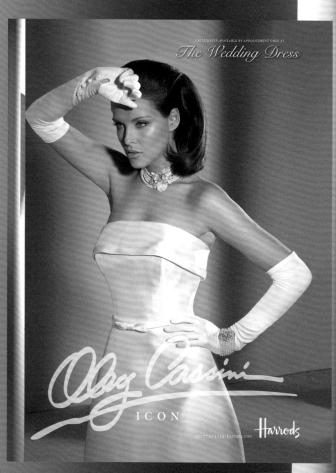

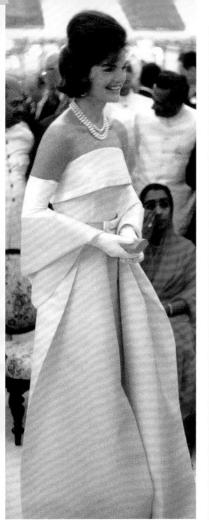

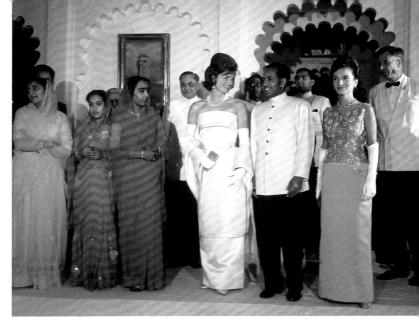

Renée Zellweger, wears the Oleg Cassini "Jackie" Cuff dress, at the Metropolitan Museum's gala evening for 'Jacqueline Kennedy, The White House Years' on April 23, 2001. The oversize cuff is hemmed in a contrasting satin, shaped to the body with a tunic skirt belted at the waist with a satin signature bow.

Jackie and Lee sent me a photo when they returned from their trip. The inscription from Jackie said, "For Oleg—who made us the two best dressed women in Asia." The iconic Cuff neckline reached international recognition in Venezuela and again on her trip to India and Pakistan. As mentioned in *Modern Bride* magazine, the Jackie image from the White House days is the most popular look with today's bride and has a far reaching influence, with the strapless look being the most prevalent choice.

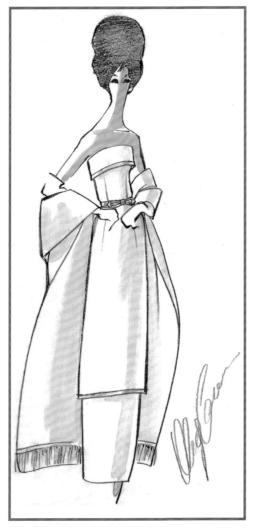

The iconic "Jackie" Cuff gown has made headlines for decades. The photo at left is on the cover of my book, 1000 Days of Magic, Dressing Jacqueline Kennedy for the White House, defining that magical period. The cuff gown, as worn by Jackie, has been used as inspiration for various wedding dresses.

The fabric of time . . .

"Clothing is the fabric that defines and measures time, an envelope to enhance the form, existing in any given moment, and in some cases, for centuries."

OLEG CASSINI

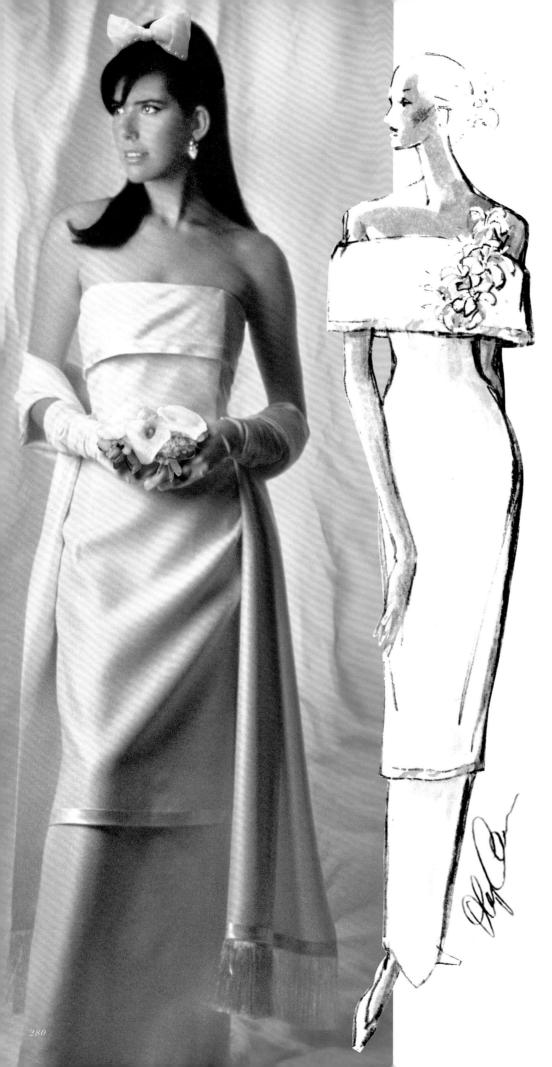

The Oleg Cassini Cuff gowns

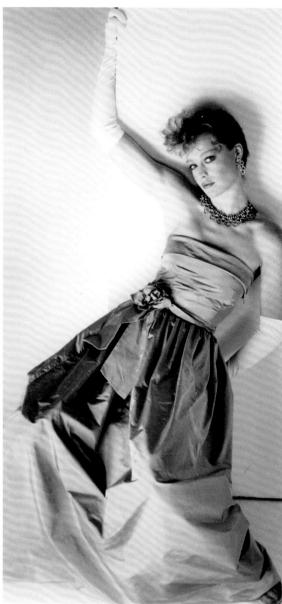

In lavender silk taffeta

English lavender, an ancient symbol of love, loyalty and luck is often mixed in the wedding bouquet to ensure a happy and long marriage.

The Cuff gown, worn by the lovely actress, Suzy Amis, is adorned with taffeta flowers at the sashed waist.

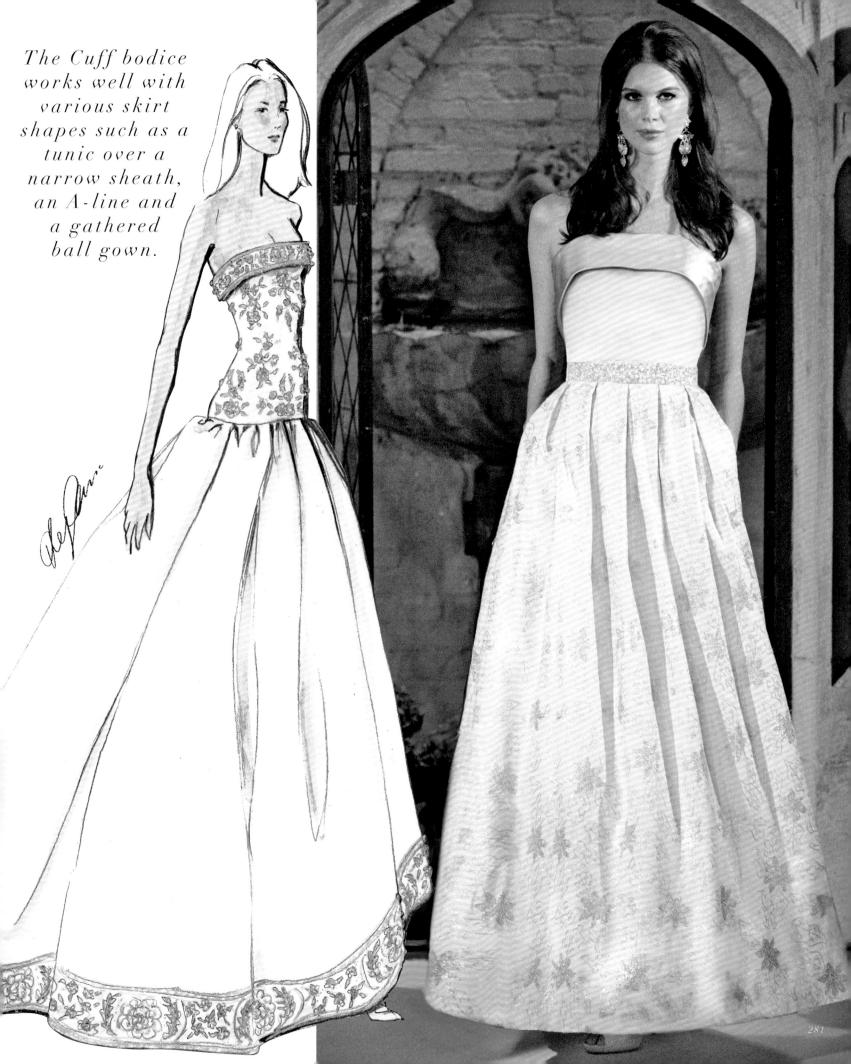

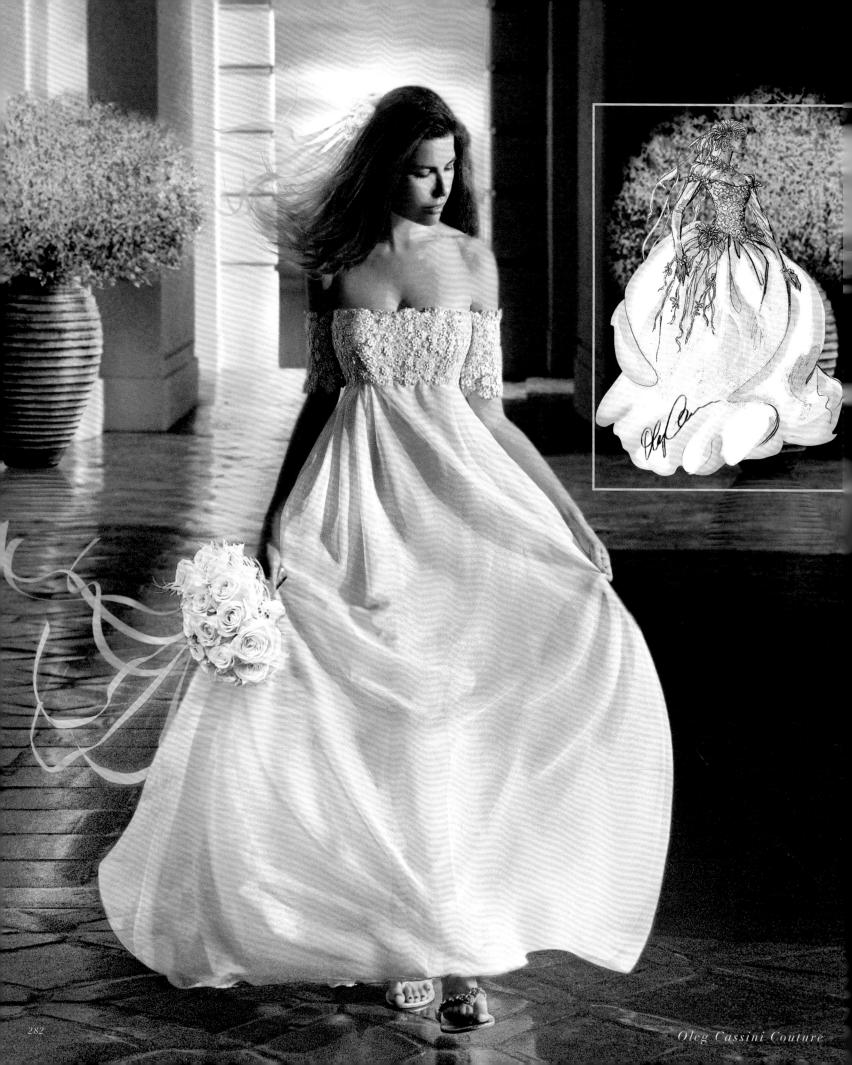

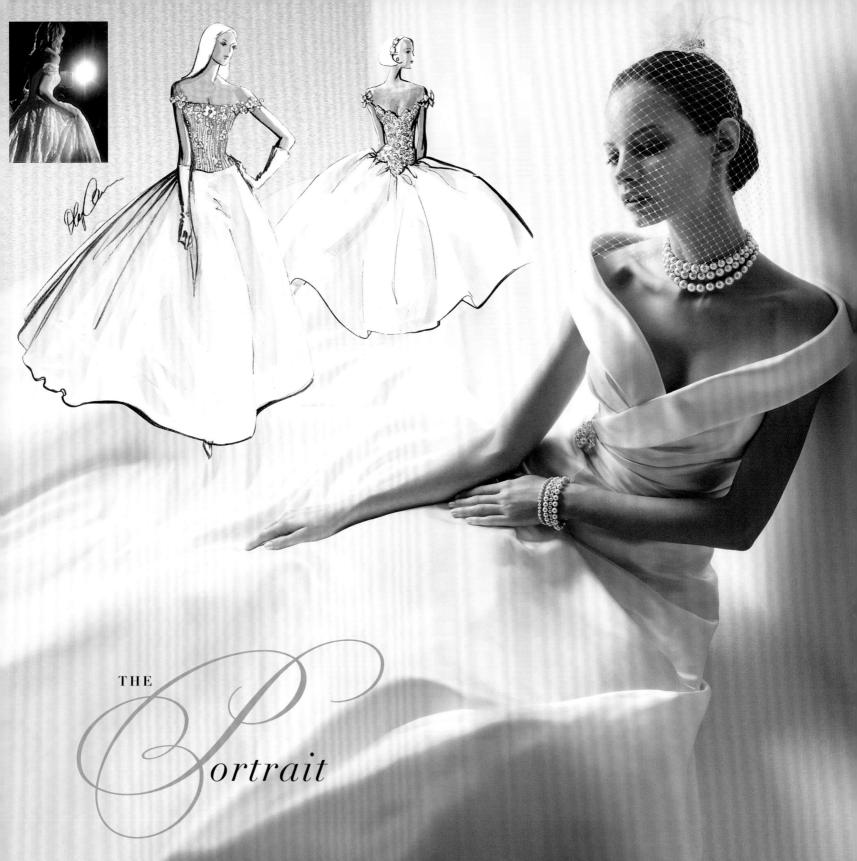

The neckline is the element of the dress that draws the eye toward the face of the leading lady, the bride herself. Full of nuance and specific details, each style of neckline accentuates particular features about the wearer, and there is no more important frame for the face than the Portrait neckline. As in Hollywood films, the white collar framing the face sets off the bride in the most flattering fashion. The romantic off the shoulder neckline frames the face and collarbone area with its soft sweep. It can be worn with many skirt shapes, from voluminous to a delicate flowing Empire. It is also one of the few styles of necklines that pairs nicely with every type of sleeve, and has a very feminine appearance.

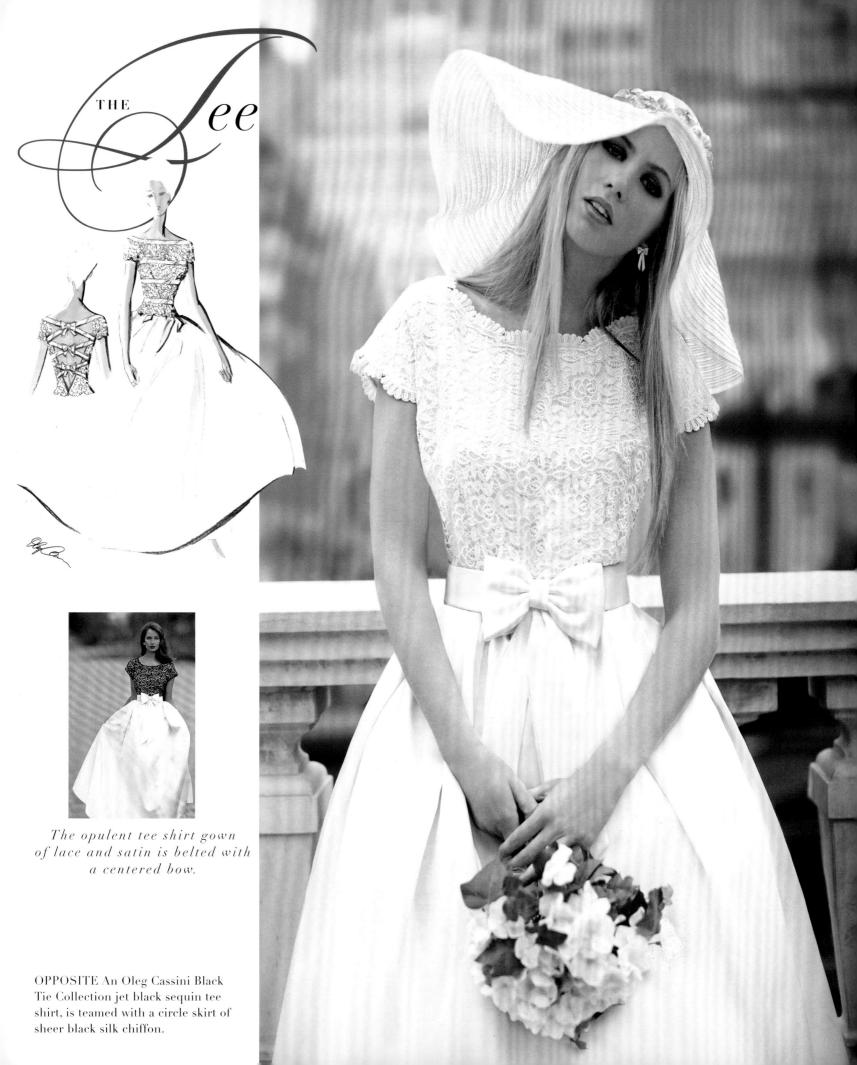

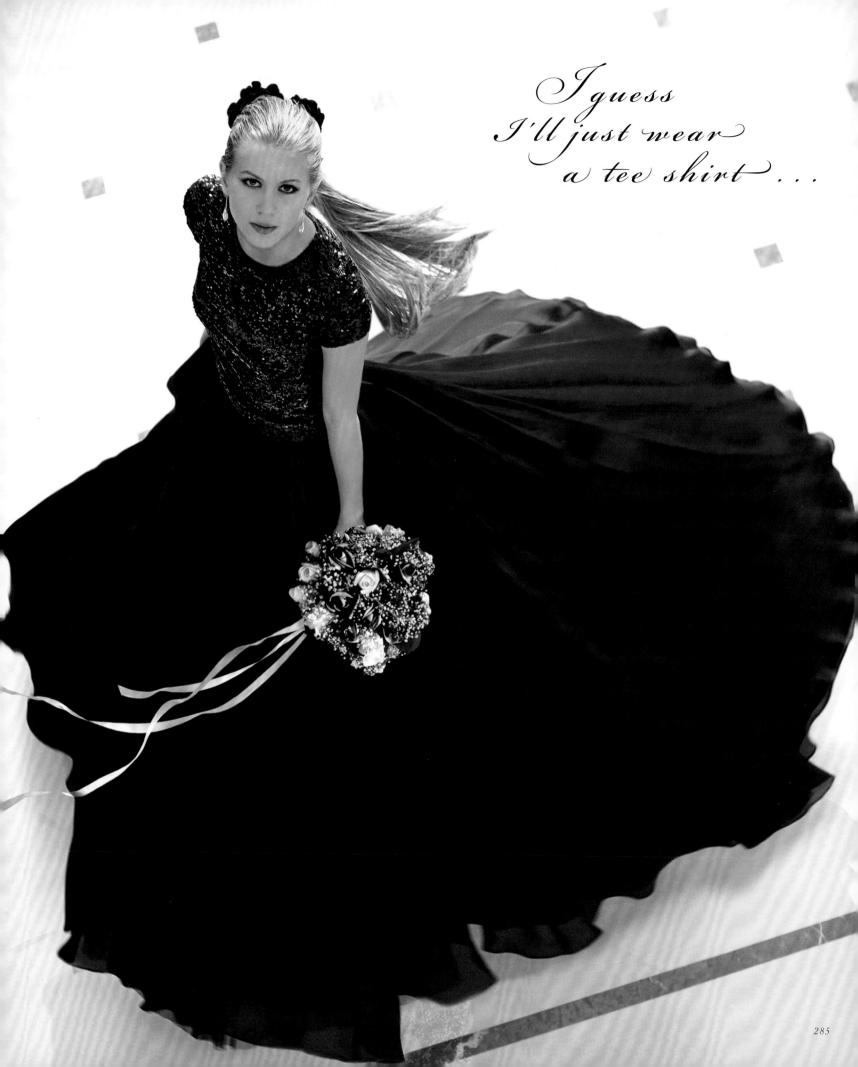

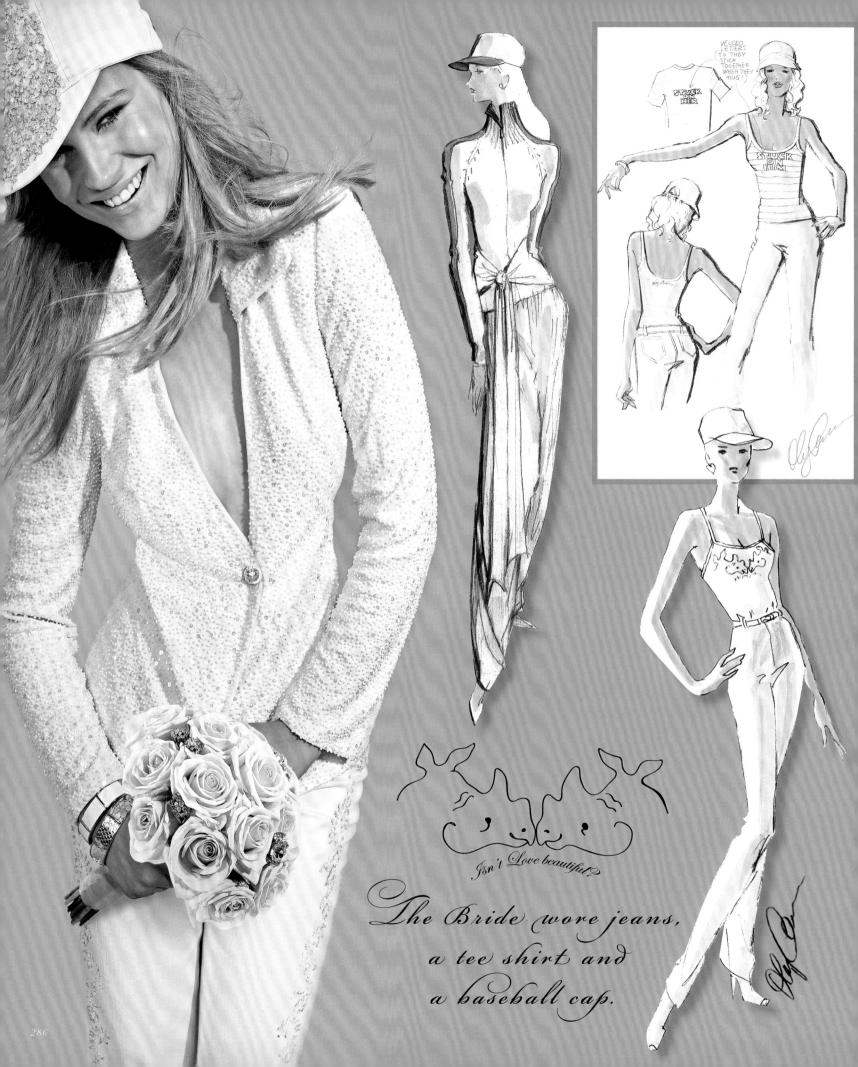

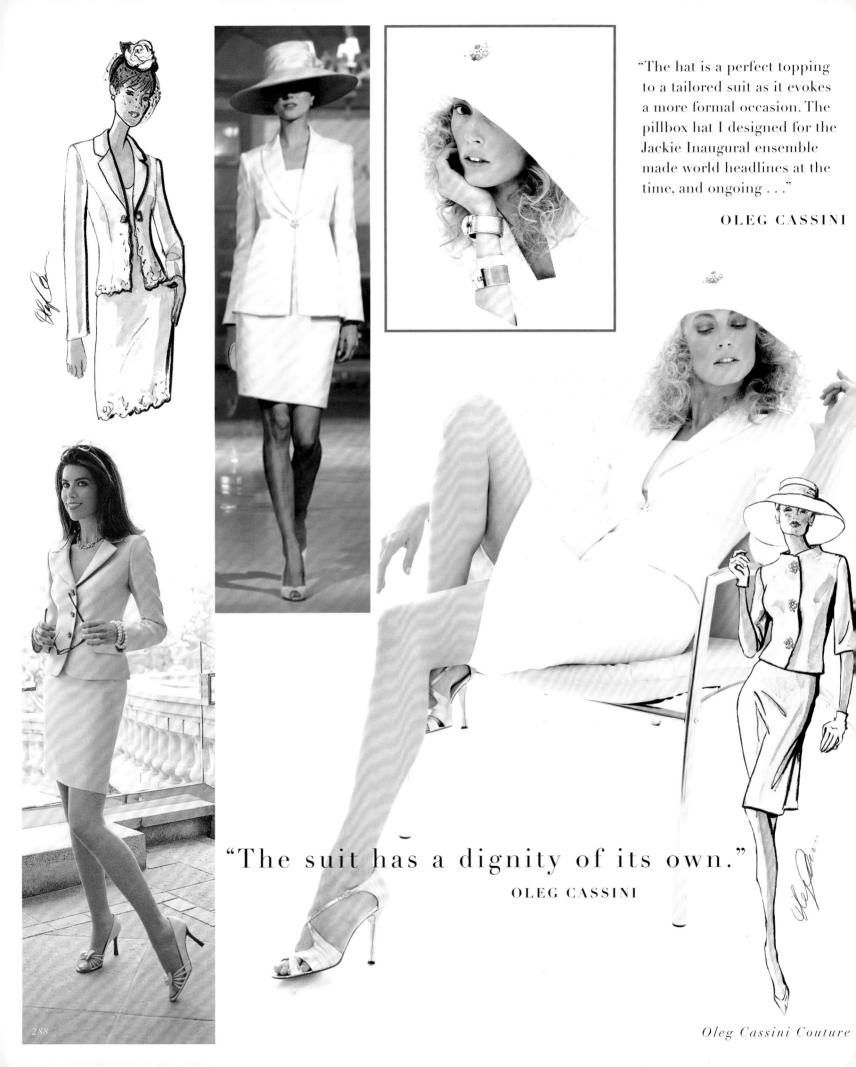

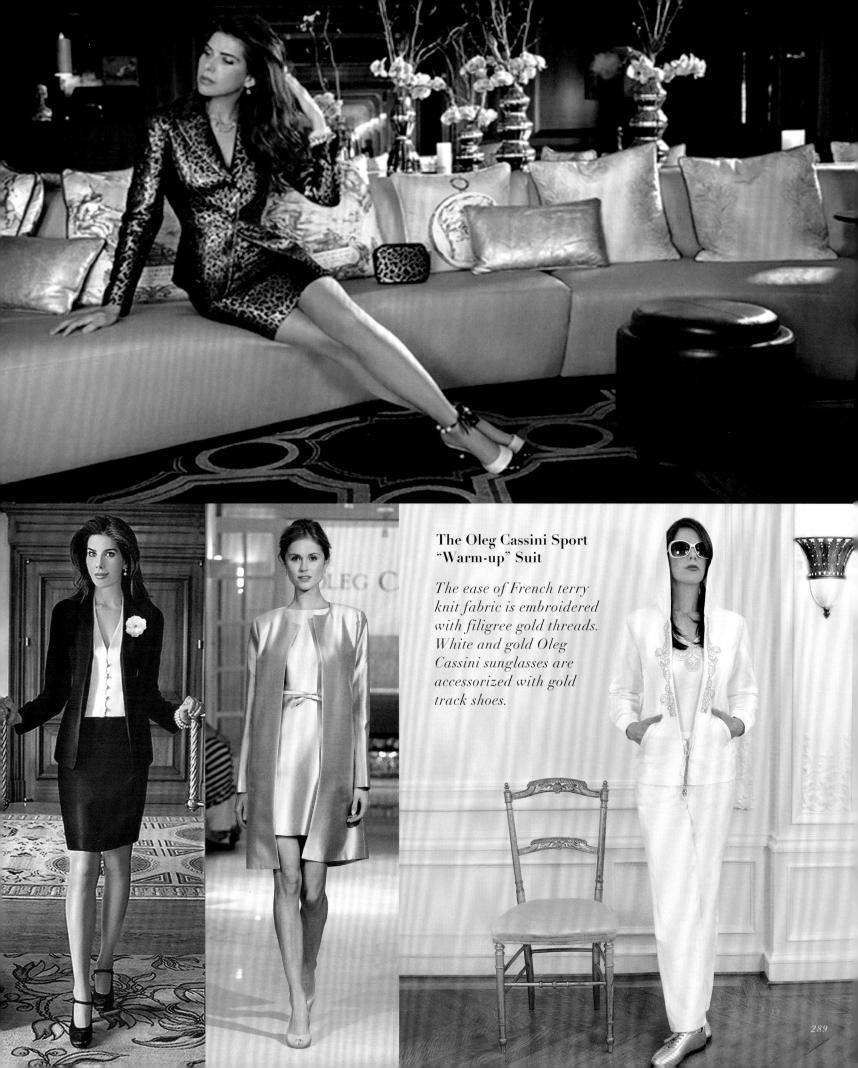

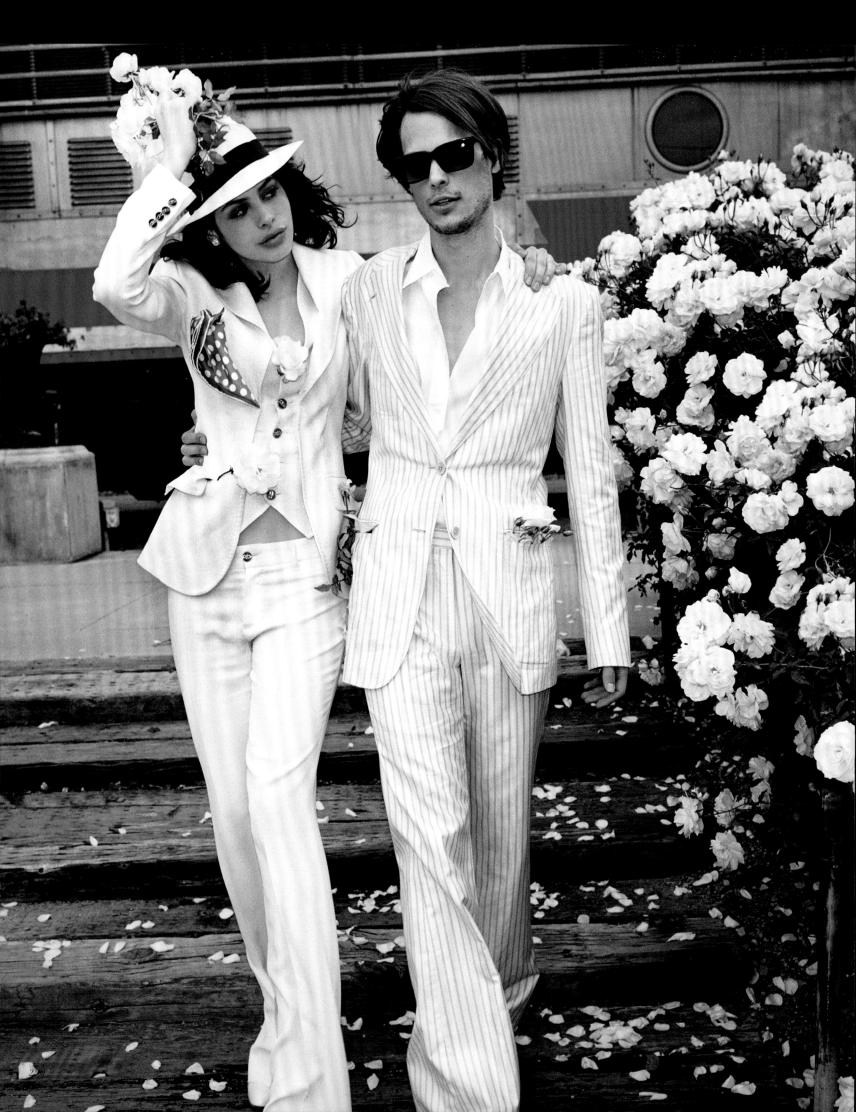

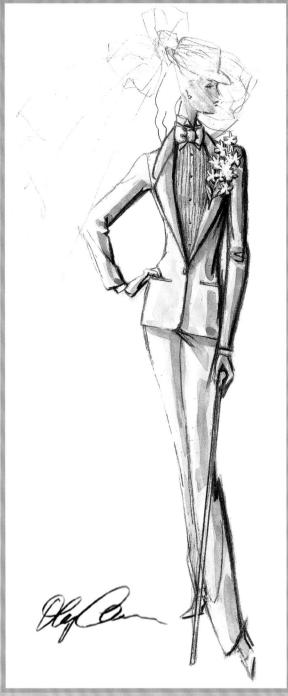

Top Hat & Tales

Her tuxedo is done in a white silk fabric, laced with gold pin-stripes. The notched collar is faced in white satin and worn open to reveal a sheer gold tank top.

A top hat covered in white tulle and crystals completes the look.

Oleg Cassini Couture

The Bold

the Beautiful

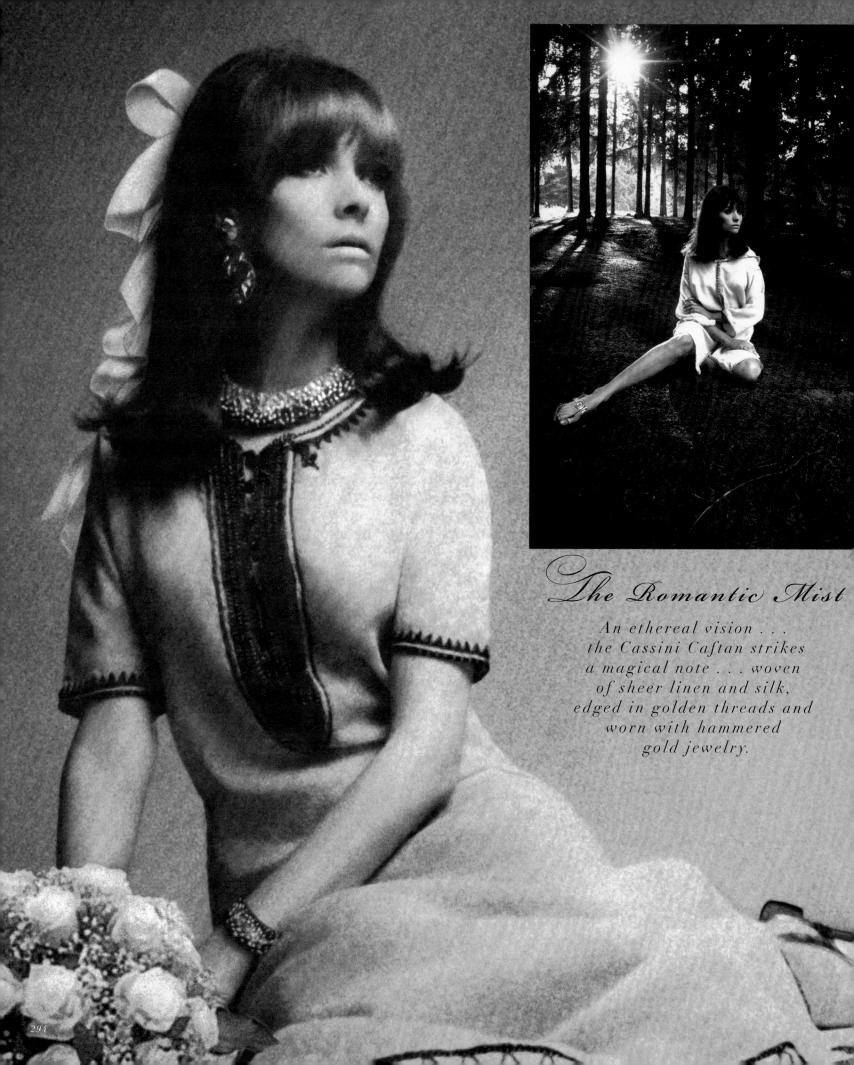

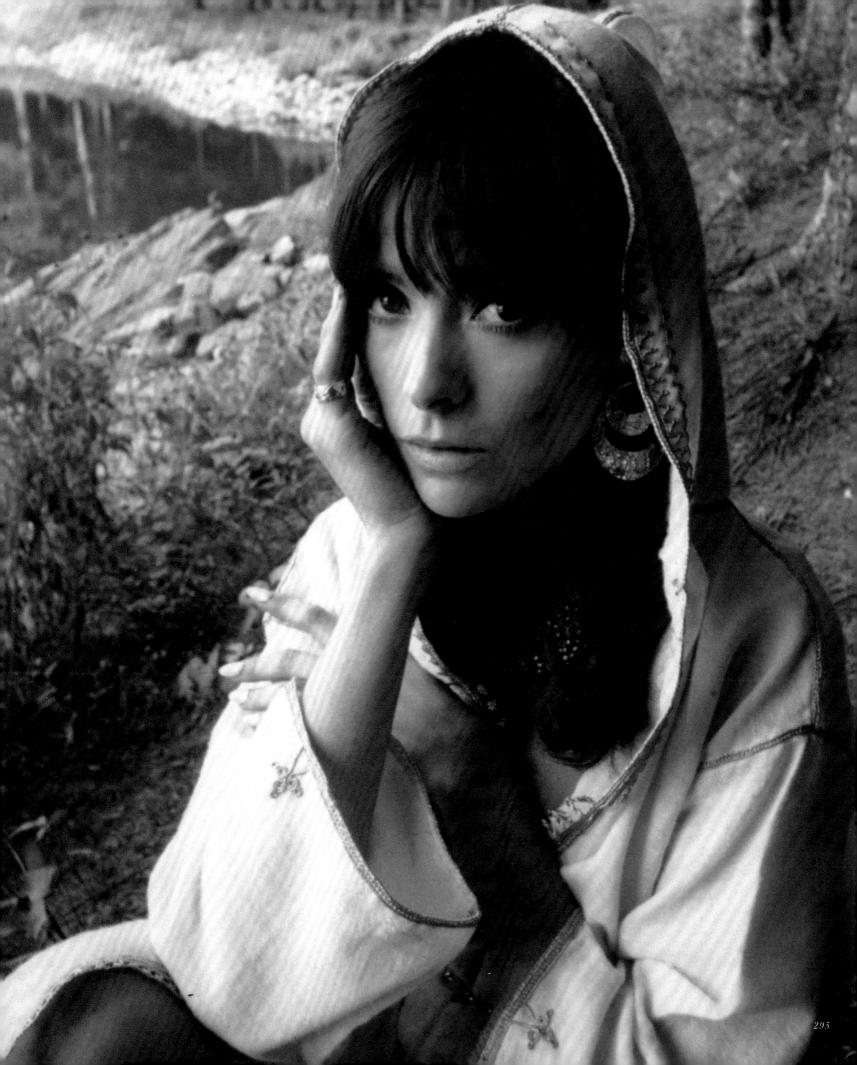

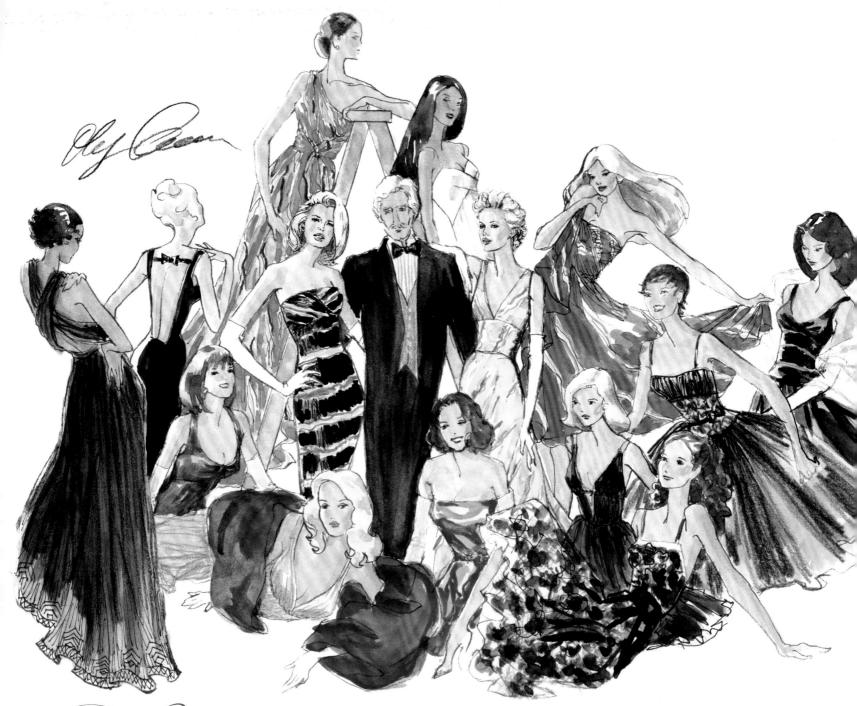

Momen make their fashion selections based on:

Color— is the first thing to catch the eye;

Fabric—she will want to feel the texture;

 $Style/Silhouette/Label- \ {\rm she\ will\ look\ to\ see\ who\ the\ creator} \\ is\ {\rm and\ if\ she\ likes\ the\ concept;}$

Fit—if she likes all the preceding so far, she will then try it; and, Price—if she is convinced on all other points.

The beauty of designing a garment with a printed fabric, is that the print itself can contain subtle shades of seventeen to twenty colors, from soft muted tones to beautiful and bold, which creates a palette of inspiration for the designer.

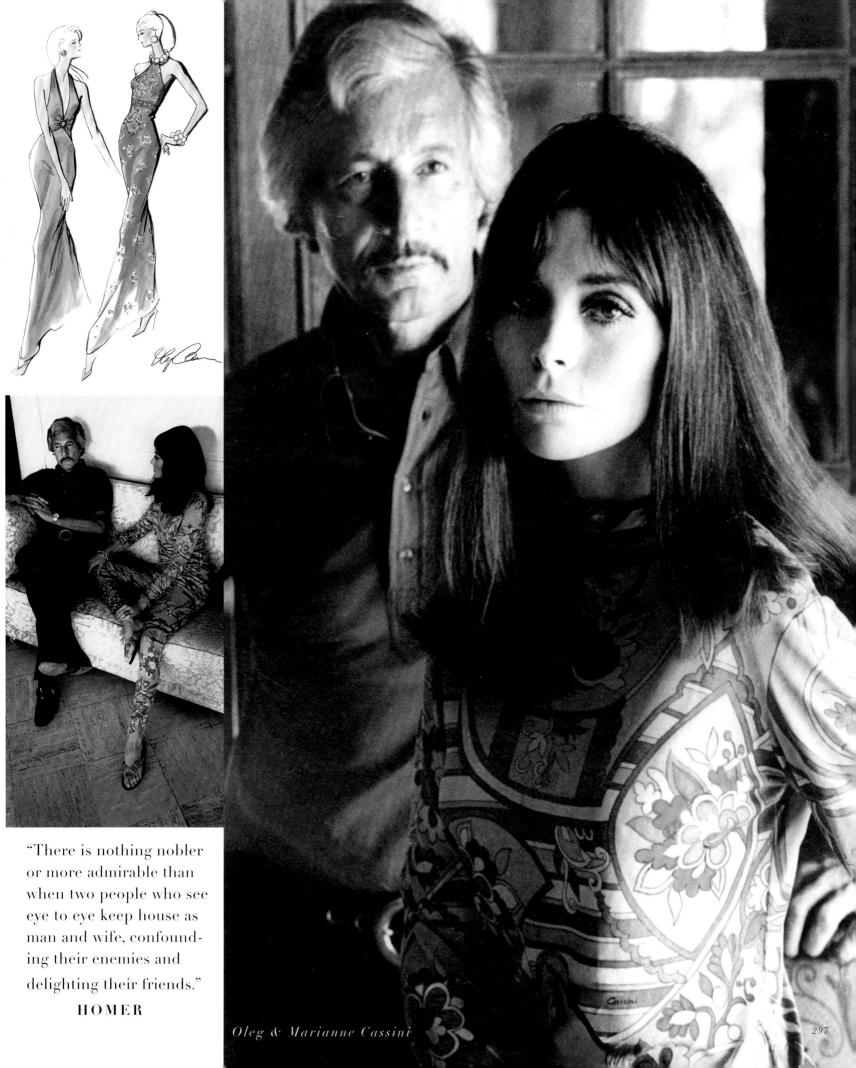

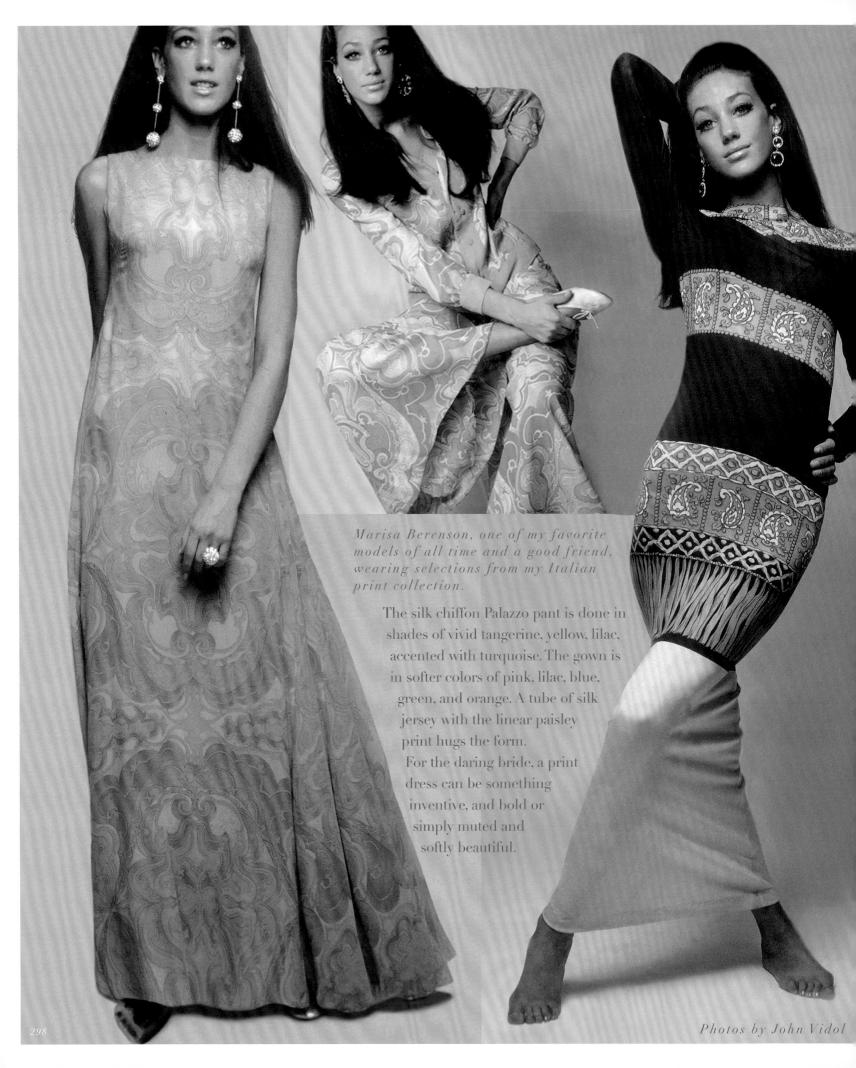

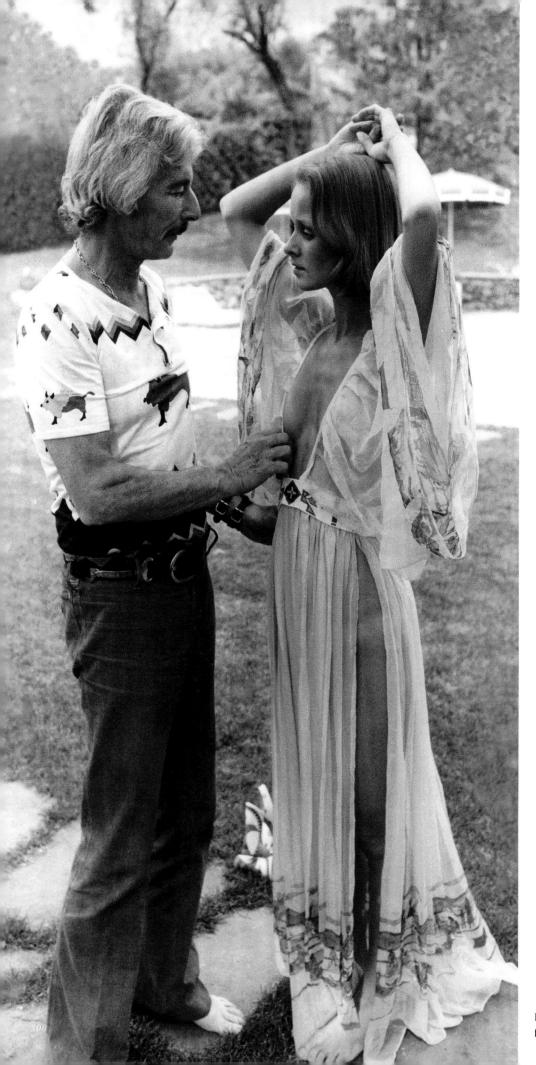

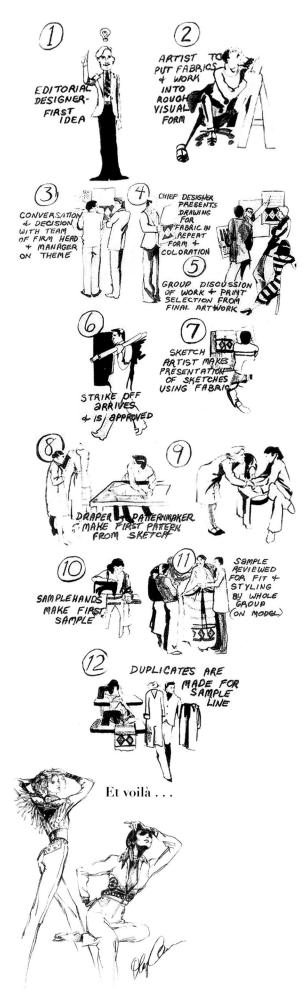

LEFT In the process of fitting a wedding dress in Milan for a fashion show finale.

Inspired by my feelings for Native American culture, I developed print collections in Italy, creating prints in vibrant colors. Bert Stern captured the brilliant colors during a photo shoot in Palm Springs, California. One of the prettiest models, posed at center front is Rita Wilson Hanks who produced the hit film, My Big Fat Greek Wedding, Hollywood's top grossing romantic comedy.

Colin Farrell and Q'orianka portrayed Captain John Smith & Pocahontas, daughter of Powhatan, Chief of the Algonquins, in the film, The New World. She wore Oleg Cassini dresses, that were themed for Pocahontas, to the premiere and awards ceremonies that followed.

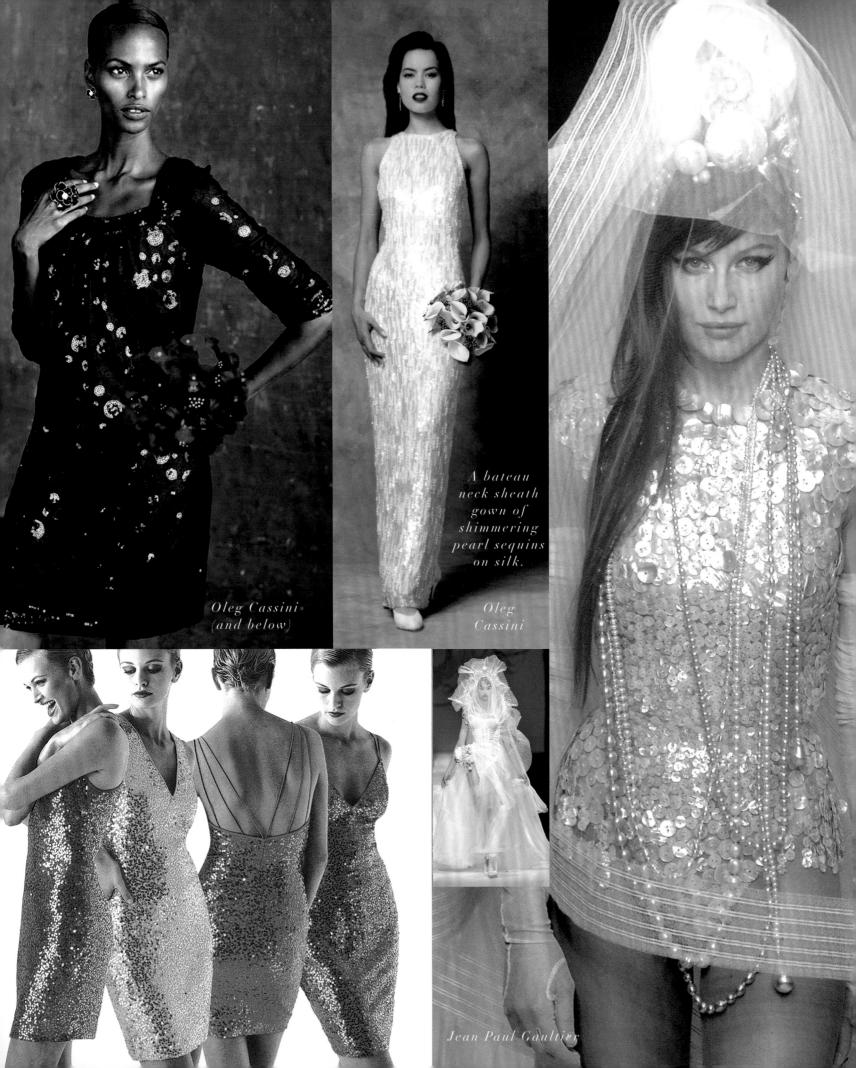

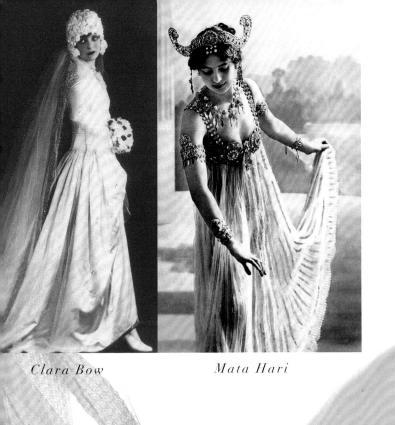

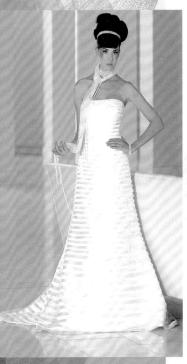

Diamonds
(and pearls)
are a girl's
best friend.

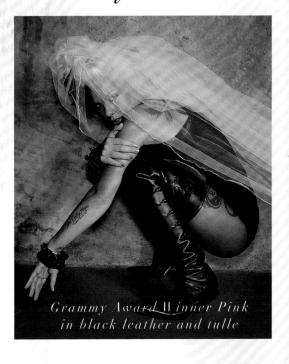

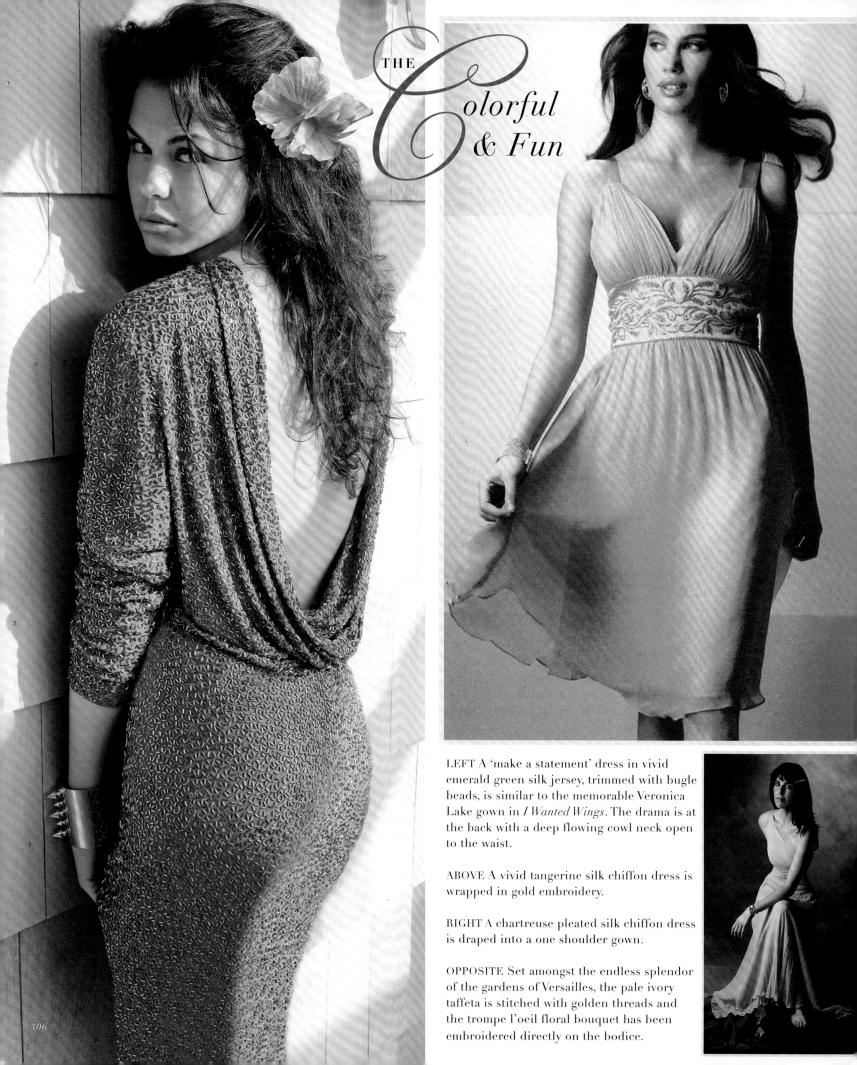

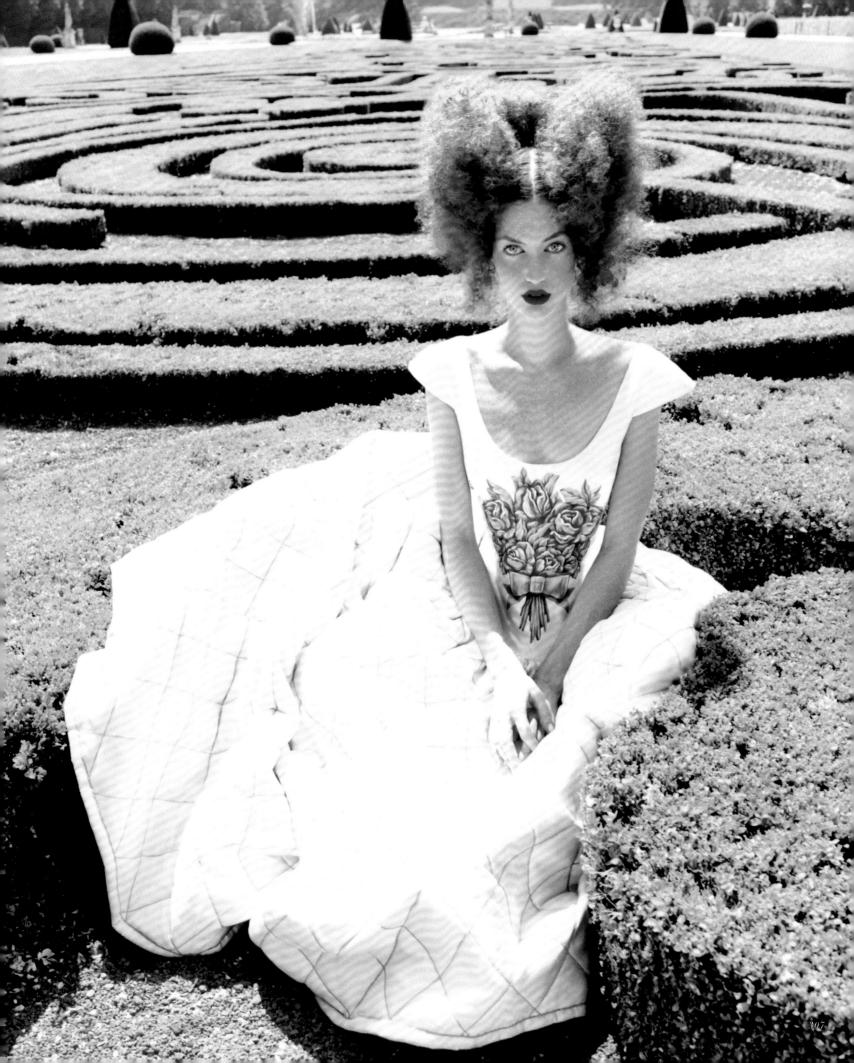

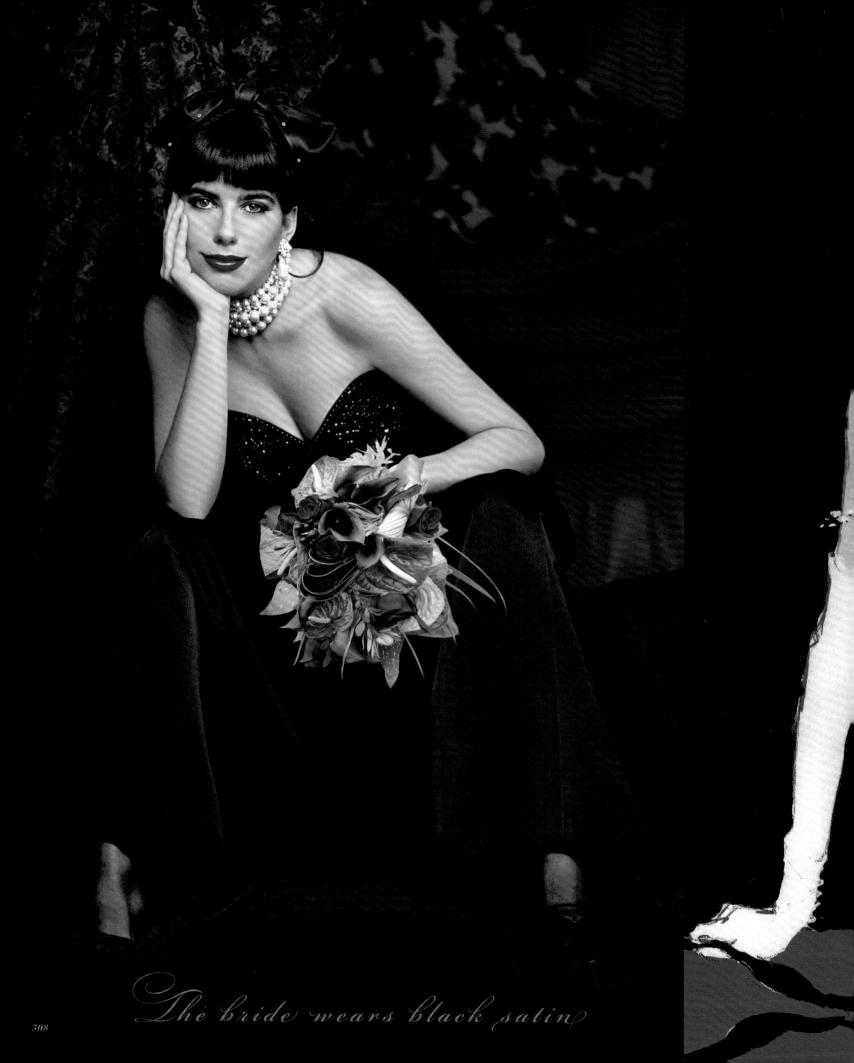

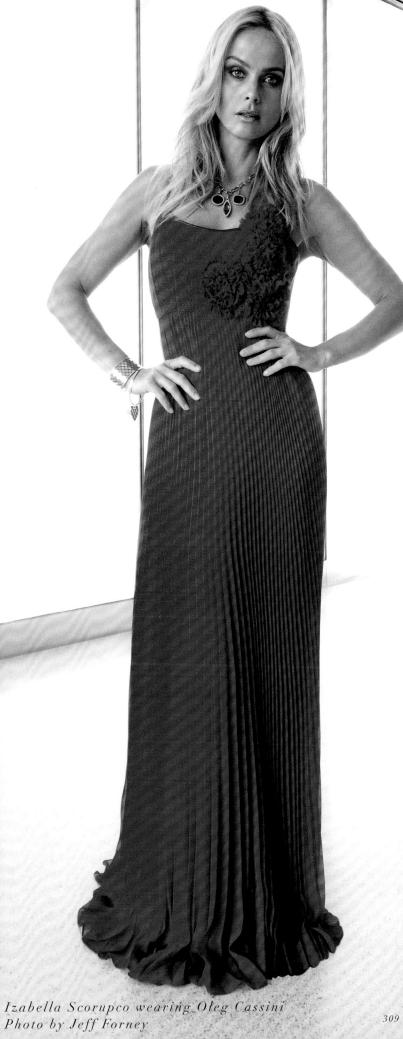

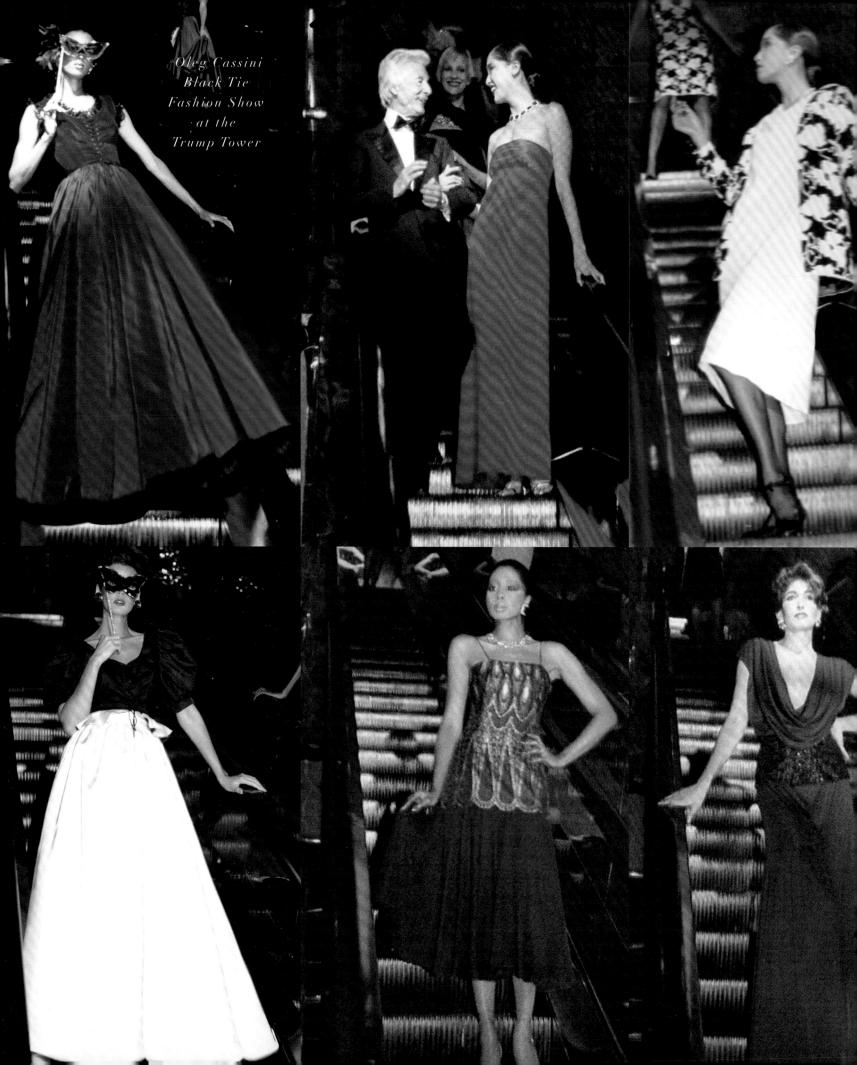

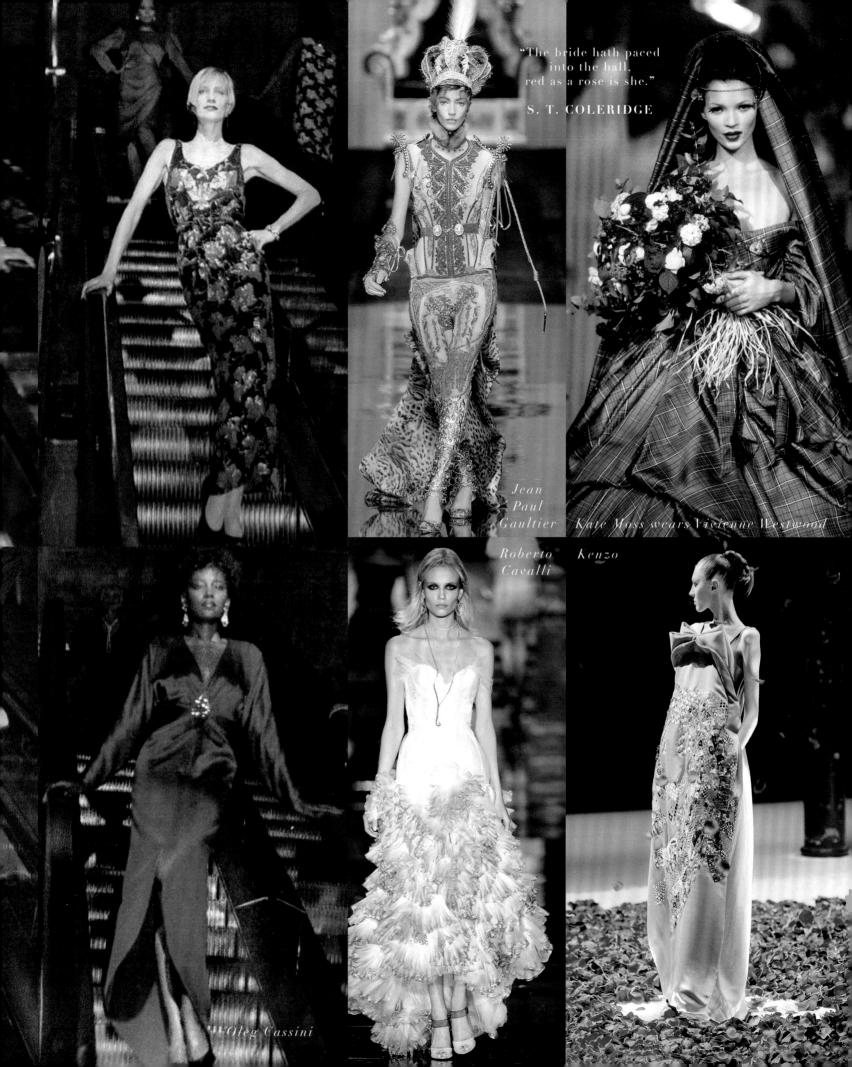

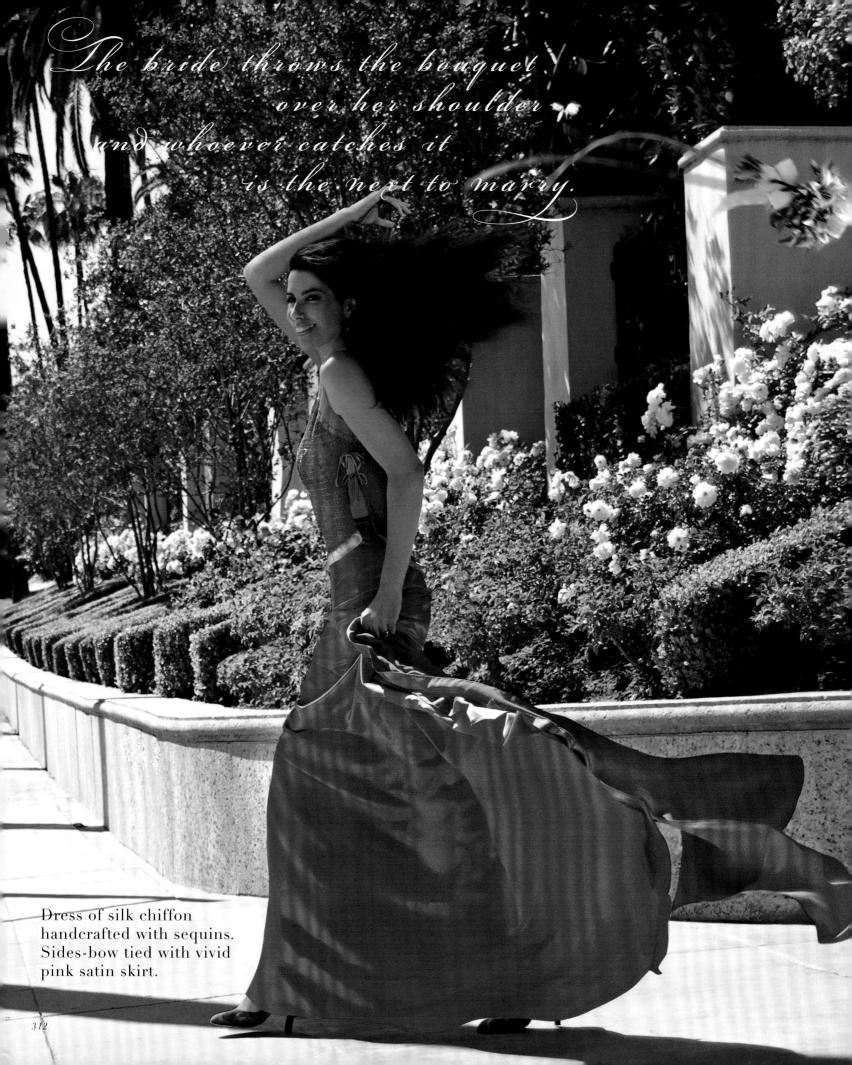

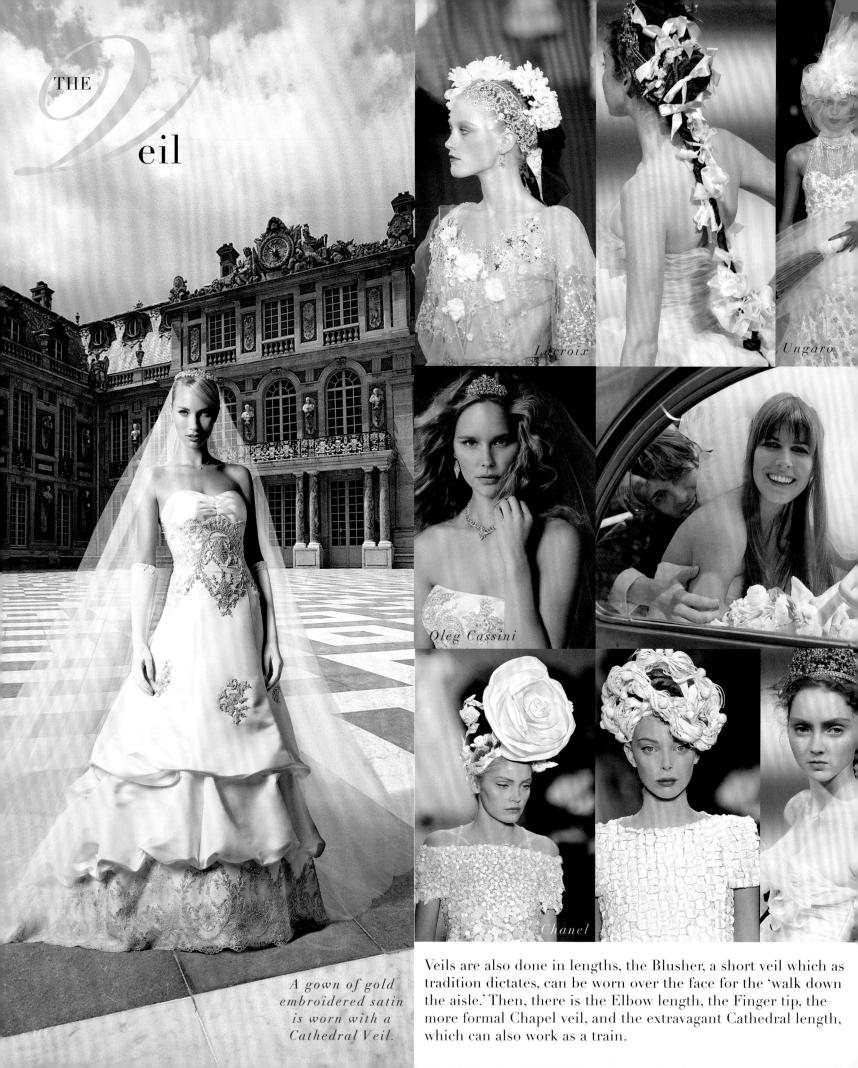

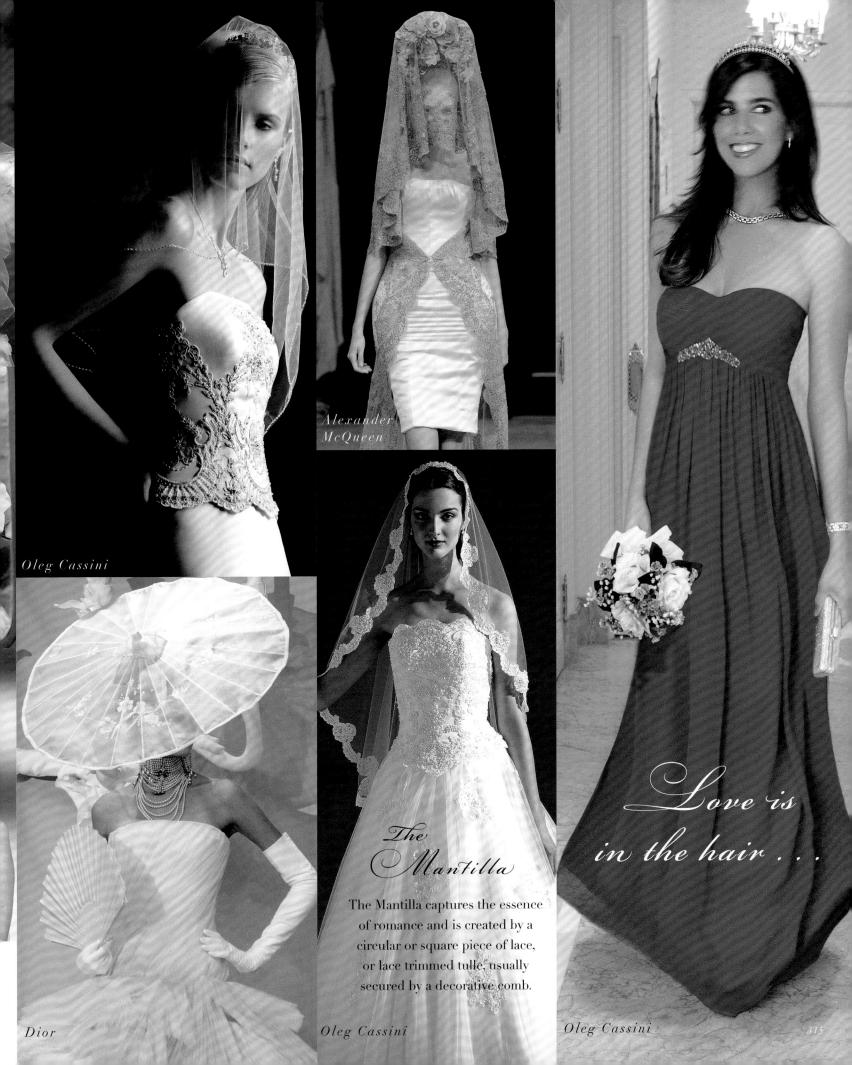

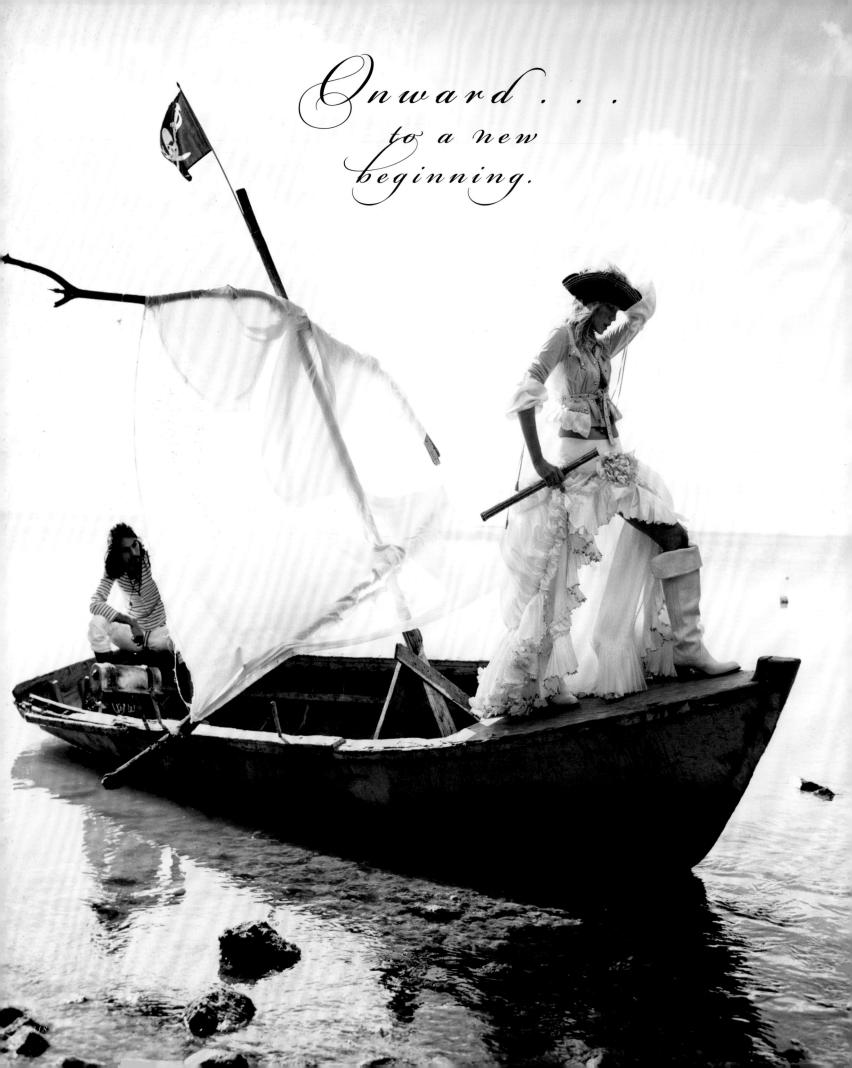

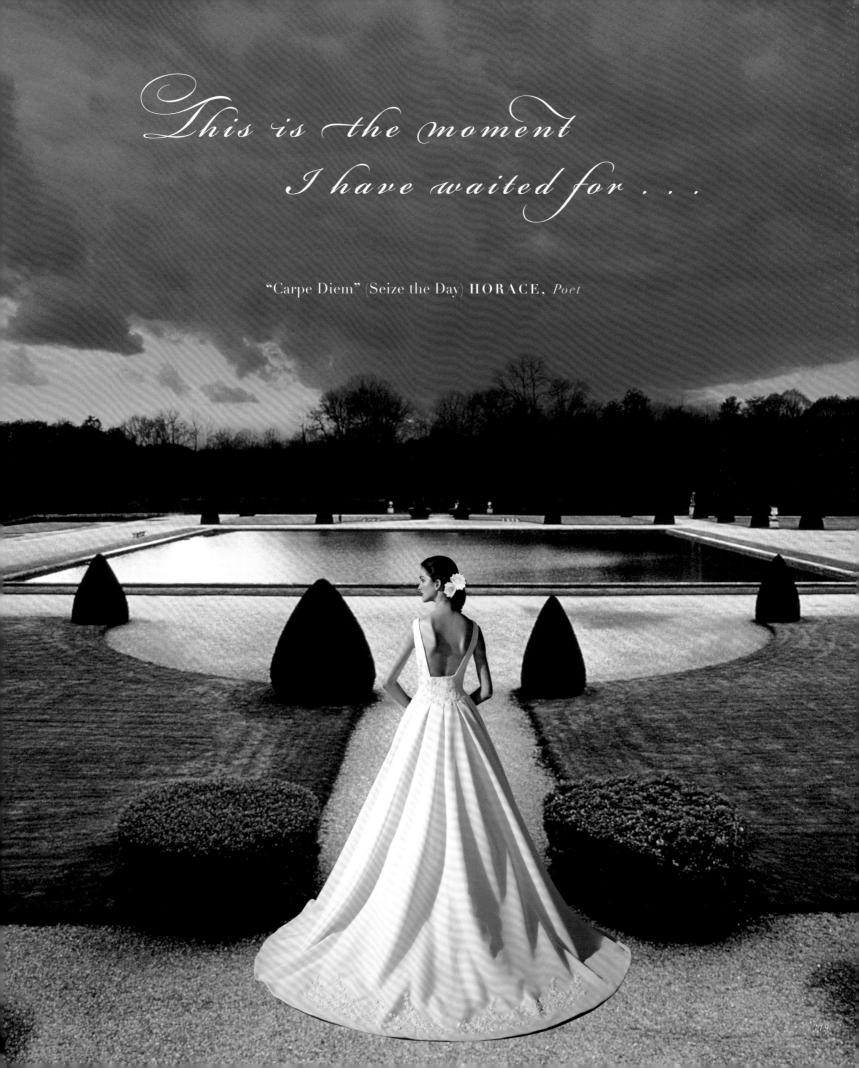

OLEG CASSINI

Creative Director: Peggy Nestor

Preface: Suzy Menkes Foreword: Liz Smith

Commentary by Rosemary Feitelberg, Alex Witchel, Sally Bedell Smith,

Jennifer Sharp, Senator Edward M. Kennedy

Graphic Design: Daniel Johnson Photo Research: Flying Dog Productions

First published in the United States in 2017 by Rizzoli International Publications, Inc. 300 Park Avenue South New York, NY 10010 www.rizzoliusa.com

Copyright © 2017 Oleg Cassini

All rights reserved. No part of this publication may be reproduced, stored in a retrieval system, or transmitted in any form or by any means, electronic, mechanical, photocopying, recording, or otherwise, without consent of the publisher.

ISBN: 978-0-8478-6117-0 Library of Congress Control Number: 2017957080 Printed in Italy

We thank the following contributors for their kind permission to reproduce the following photographs:

Sergio Alteri: pg. 267 (right);

Stefan Anderson: pgs. 62-63, 154 (top right), 156-157, 241, 268 (right), 284 (right and insert), 285;

Vicky Andren Private Collection: pg. 114 (top left);

Arnault/Gancia Private Collection: pg. 106-107;

Clive Arrowsmith: pg. 23o (right top and bottom);

Joe Azrak: pg. 316 (bottom second image);

Rick Bard: pgs. 144-145;

Del Bigtree: pgs. 92-93, 161, 186-187, 312-313;

BRIDAL GUIDE MAGAZINE Images: pgs. 124,

240 (left insert);

Dpa PICTURE-ALLIANCE GmbH: pgs. 84 (top left), 80 (bottom right);

Horst Paul Albert Bohrmann: pg. 250 (bottom left and right);

Box Hill Mansion Studios: pgs. 272-273;

Bride & Co South Africa: pgs. 221 (top), 305 (bottom left), 317 (all bottom half of images);

of mages),

Michael Bristol: pgs. 317 (middle second image and top left);

Henry Brueckner: pg. 302 (painting);

William Cadge: pgs. 211, 294 (top right), 295;

Joseph Cartright: pg. 316 (top left, middle center image, middle row far right);

CATWALKING: pgs. 224 (insert), 254 (top right and bottom), 304 (far right), 311 (top middle and right, bottom far right), 315 (bottom right, bottom second and third from right, top far right, top second and third from right), 316 (bottom left, top center);

Alex Cayley: pg. 248;

Walter Chin: pgs. 174 (left), 179 (right), 218 (top middle), 220 (right), 314 (middle center);

Condé Nast Publications Inc. / Alessandro Dal Buoni: pg. 126 (top right);

Fabio Coppi: pgs. 4-5, 177;

CORBIS: pgs. 25, 29 (top right), 39 (top left), 40 (top left), 86 (bottom right), 87 (top right, bottom right), 90, 91 (top left, bottom), 94, 99 (top second image), 102 (top right and top far right insert, bottom and bottom right insert); John Cowan: pg. 200 (far right);

Bruno Dayan: pgs. 202-203;

Patrick Demarchelier: pgs. 152 (bottom insert), 197, 199, 266 (left);

Drew Doggett: pgs. 180;

Mattias Edwall: pgs. 140-141, 173, 217;

Carlos Eguiguren: pgs. 260, 265;

Arthur Elgort: pgs. 210, 216, 267 (right);

Sebastian Faena: pg. 265;

Robert Fairer Photography: pg. 219 (left);

Jeff Forney: pgs. 139 (top right and bottom left),

300 (right):

GETTY IMAGES: pgs. 2-3 (background), 14 (left and top right), 16 (top right, right center, right bottom), 19, 28 (bottom right), 30, 36, 39, 47-49, 51 (bottom right), 72, 74, 75 (bottom), 76, 78-83, 84 (bottom left), 85, 86 (bottom right), 87 (top row), 89, 90 (top and bottom left), 91 (top right), 95, 96 (bottom left), 97 (top left), 98, 99 (top left, top third image, bottom row), 101 (top right, second row, far right, bottom second and bottom middle), 104 (top left, top middle left insert, top middle right insert), 104, 105 (top left and right and bottom right), 108 (bottom), 110-111, 114 (bottom right), 138 (bottom right), 146-147 (background), 153 (background), 158-159 (background), 163, 184 (top images), 185 (top and bottom right), 192-193 (background), 205 (background), 225 (background), 243 (background), 246-247 (background), 250 (top), 269 (bottom left), 274 (background), 276 (top left and middle right), 279 (top center), 302 (top), 305 (top left and right inserts), 319 (background);

Marco Glaviano: pgs. 8, 148 (top right), 206-207; Benno Graziani: pgs. 16 (left), 17, 108 (top left and right), 109 (top left and right);

Milton H. Greene: Cover, pg. 38 (bottom left and right), 39 (far right), 41 (second row, second image); Olexa/Greenfield Collection: pg. 114 (middle center

Pamela Hanson: pgs. 208, 261, 314 (middle right); HILLWOOD MUSEUM & GARDENS: pgs. 22-23;

Marc Hom: pg. 305 (bottom right);

Jean Howard: pg. 46;

Matthew Hranek: pg. 249 (top right);

Imageman Photography: pg. 218 (bottom center); Ron Jaffe: pg. 33 (bottom third and fourth images);

Daniel Johnson: pg. 316 (bottom right);

Joshua Jordan: pgs. 148 (background image), 149-151, 220 (top and bottom left), 222 (top left and right), 228 (left), 231 (right), 236 (left), 242, 243 (foreground image), 254 (bottom center, top left), 256-257, 262 (right),

Thank you: Charles Miers, Anthony Petrillose, Kathleen Javes, Maria Pia Gramaglia, Kavleigh Jankowski, Reed Seifer, Rebecca Gully, Shannon Merson, Walt Shepard, Art Scangas, Juli Alvarez, Thomas Canny, Nancy Allan, Angelina Jolin, Thomas Cassidy, David Boatman; Manhattan Bride: Rick Bard; Bridal Guide: Diane Forden, Jim Duhe, Rachael Dichter Capo, Naima DiFranco; Brides: Lori Silver, Rachel Leonard; C Weddings: Annina Mislin, Renee Marcello; Harper's Bazaar: Glenda Bailey; Martha Stewart Weddings: Darcy Miller; Town & Country Weddings: Craig Montague, Annemarie Deslauriers; Angela Anton, Jason Feinberg, Tina Guiomar; Ken Eade; Catherine Alestchenkoff, Grimaldi Forum Monaco; Box Hill Mansion, York, Pa.; Hillwood Museum; Royal Collection H.M. Queen Elizabeth II.; Langham Huntington; Bel Air Hotel; & San Ysidro Ranch.

263 (left and center images), 277 (center and top right insert), 283 (background);

JFK Library: pg. 46 (right);

Rugen Kory: pg. 308;

David LaChapelle: pgs. 64, 307;

Inez van Lamsweerde & Vinoodh Matadin: pg. 214; Lord Patrick Litchfield: pgs. 74, 114 (bottom left);

Konstantin Makovski: pgs. 21 (painting), 26-27 (painting);

Ericka McConnell: pg. 262;

 $Meeno:pgs.\ {\scriptstyle 1},{\scriptstyle 16o\ (left)},{\scriptstyle 165};$

Anne Menke: pg. 318;

Frank Micelotta: pg. 163; Peter Murdock: pg. 21 (right);

Dewey Nicks: pg. 290;

Morgan Norman: pg. 170 (top left);

CASSINI STUDIOS: pgs. 10, 12 (collage), 13 (top left), 15, 18 (top left, top right and lower right), 20 (top right and bottom images), 21 (top and bottom left), 28 (left), 29 (top left, bottom right and far right), 31, 32 (bottom left), 33 (top, bottom left and bottom left middle), 34, 38 (top), 39 (top left and right), 40-43, 44 (correspondence), 46 (top left and bottom left), 50, 51 (correspondence), 52-61, 80 (left), 96 (bottom right), 97 (bottom), 115, 126, (top left and bottom right), 138 (top right), 154 (left), 162, 168-169, 181 (right), 182-183, 188, 191, 194-195, 200 (left), 201, 212, 215 (image), 220 (bottom left), 227, 228 (top center and bottom right), 229 (image), 23o (left), 238, 241 (right), 244, 249 (left), 252 (top right), 253, 255, 269 (right), 276 (top right), 279 (top left, top right, bottom left), 280, 281 (illustration), 282, 289 (top and bottom right), 299 (top right and bottom right), 300 (left), 301, 303, 304 (top left, top center, and bottom left), 3o6 (top right and bottom right), 310 (top left and bottom left), 315 (right), 316 (second row, far right);

OLEG CASSINI ILLUSTRATIONS: pgs. 14 (bottom right), 18 (bottom left), 46 (middle), 47 (middle), 48 (middle), 49 (middle), 51 (left), 53 (bottom left), 77, 114 (top left), 126 (bottom left), 138 (bottom center), 146, 160 (sketch and fabric), 172 (all sketches), 174 (center sketches), 176, 178-179 (sketches), 182 (sketches), 185 (sketches), 188 (top right), 190, 194, 200 (center), 212 (sketches), 215 (left), 220 (bottom center), 221 (bottom sketches), 222 (top right), 226, 228 (bottom center), 229 (top left), 231 (bottom left), 237 (left), 239 (bottom left), 244 (right),

254 (sketches), 255 (top left), 260 (bottom right), 265 (left), 268 (sketch insert), 269, 276 (sketch and fabric), 277 (bottom right), 279 (bottom right), 280 (center sketch), 281 (left), 282 (top right), 283 (top left sketch), 284 (top left sketch), 286 (right sketches), 288 (top left and bottom right sketches), 201 (top right), 207 (top left sketch), 200 (left), 300 (bottom left), 302 (bottom left), 309 (center); Clifton Parker for Patrick McMullan Co.: pg. 269 (top left);

Norman Parkinson: pgs. 234-235; Susan Patrick: pg. 310 (top left and bottom left);

Al Pucci: pg. 40 (top left corner);

Irving Penn: pg. 245;

Murray Radin: pgs. 13, 297 (right and center left); Liz Rodbell Private Collection: pg. п4 (top row,

Gunter Sachs Private Collection: pg. 109 (all bottom

Sølve Sundsbø: pgs. 209, 224, 251, 292-293;

John Swannell: pgs. 174 (bottom right), 175 (right), 237 (right), 270 (top left), 278;

Yoshi Takata: pg. 267 (right);

center image); row images); Susan Salinger: 2, 147, 158, 205, 247, 315 (bottom center), 319; Francesco Scavullo: pg. 271; Sam Shaw: pg. 35; Sarah Silver: pgs. 168, 236, 316 (top right); Bert Stern: pgs. 103, 303;

The Crosby Collection: pg. 101 (top left); THE GETTY RESEARCH INSTITUTE: pgs. 68-69; THE IMAGE WORKS: pgs. 20 (top left), 70-71, 73,

75 (top), 100 (top left and bottom left), 101 (bottom right corner), 105 (bottom right);

THE PICTURE DESK: pgs. 32 (top), 99 (top fourth image), 152 (top left);

THE ROYAL COLLECTION: pgs. 66-67;

Laurits Regner Tuxen: pgs. 24-25 (painting);

Diego Uchitel: pgs. 168, 244, 315 (top left);

Andrew Unangst: pg. 183;

Antoine Verglas: pgs. 178 (left), 198 (top left), 189 (all images), 198 (right), 212 (left), 213, 223, 233, 268 (left), 275 (top left), 286 (left), 287, 288 (top insert and right image), 291 (left), 305 (center), 306 (left);

John Vidol: pgs. 294 (left), 298;

Merie Wallace: pg. 302 (bottom right insert);

Hans Wiedl: pg. 249 (bottom right);

Troy Word: pgs. 151, 232, 248, 249 (left).

Designers: Oleg Cassini, Pierre Cardin, Caroline Castigliano, Robero Cavalli, Viola Chan, Chanel by Karl Lagerfeld, Jean Paul Gaultier, Dior by John Galliano, Dolce & Gabanna, Kenzo, Christian Lacroix, Ron Lovece, Alexander McQueen, Rochas, Richard Tyler, Ungaro, Ursula D., Vivienne Westwood

Every effort has been made to trace the copyright holders and we apologize in advance for any unintentional errors or omissions, and would be pleased to insert the appropriate credit in any subsequent publication.

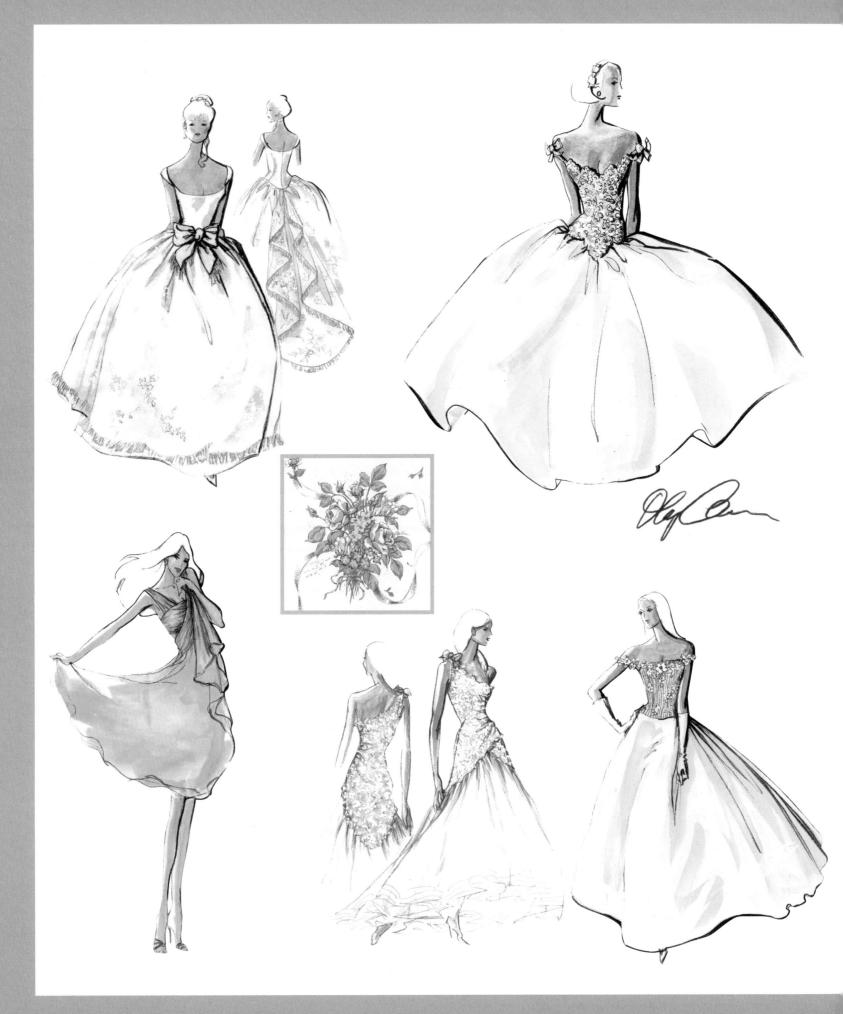